THE BLACK ARTIST IN AMERICA:

An Index to Reproductions

compiled by
DENNIS THOMISON

The Scarecrow Press, Inc.
Metuchen, N.J., & London
1991

British Library Cataloguing-in-Publication data available

Library of Congress Cataloging-in-Publication Data

Thomison, Dennis, 1937-
 The Black artist in America : an index to reproductions / compiled
by Dennis Thomison.
 p. cm.
 Includes index.
 ISBN 0-8108-2503-1 (acid-free paper)
 1. Afro-American art--Indexes. I. Title.
N6538.N5T46 1991
016.704'0396073--dc20 91-33050

DEDICATED IN LOVING MEMORY TO

"BILL"

WILLIAM THOMAS WILSON
1944-1990

CONTENTS

PREFACE

America's Black artists were rediscovered in the 1960s as part of a general awakening of interest in the cultures of the nation's minorities. Major contributions of Blacks in such areas as music and literature have long been recognized and appreciated by the general public, but recognition of significant talent in the fine arts has been much slower at arriving. Perhaps it was the overdue nature of the discovery, in addition to a growing insistence by minorities for recognition, that led to a rash of Black shows in galleries and museums across the country during the decade. Some were successful and others were considered by a few people to be dismal failures, but they all contributed something to a consciousness-raising of the public. Not since the Harlem Renaissance of the 1920s was so much attention focused on the culture of the Black people.

As is often the case, that enthusiasm and interest of the period did not last. It was succeeded by a continuing but, by contrast, low level of interest and smaller number of shows. At the same time, major shows in traditional institutions were much more likely than before to include at least a small number of Blacks among the exhibiting artists. One must of necessity add that this was occasionally the result of pressure and criticism from the Black community.

From this succession of shows, and multiplicity of books and articles on the subject, there has developed a much greater awareness of Black art in this country. Names such as Robert Duncanson, Edmonia Lewis, and Henry Tanner--artists almost forgotten--were resurrected, as were their works of art. More modern masters--Romare Bearden, Barbara Chase-Riboud, Jacob Lawrence, Horace Pippin, and others--have become frequent participants in major shows. This change in acceptance, although extremely slow in coming, has certainly contributed to a growing awareness of the artistic achievements of African Americans.

In spite of this widening interest in the Black artist, however, it has still been possible for scholars to write histories of American art without including any Blacks. It is still possible for a large segment of the American public to be almost totally unaware of the contributions

of African American artists. Out of knowledge of this situation grew
my interest in promoting the achievements of these artists by making it
easier to locate reproductions of their works of art. The present
publication is a result of that interest.

"Is there a Black Art?" became a frequent rhetorical question
as interest in the field developed. While that question was a significant
one to numerous authors and speakers, it was not at issue in the
development of this book. The basic purpose of this work is not to
delineate Black Art from White Art, or from any other group, but to
identify those Black artists who have made a contribution to our culture
through their published works of art. It is undoubtedly true that most
Black artists would prefer to be recognized as artists rather than for
their ethnic background or color. Yet it is also important for others to
be aware of the contributions of these artists who happened to be
Black. People have often made this distinction in some other areas of
the humanities, and to a certain extent with other ethnic groups. One
might hope that ethnic awareness, pride in one's own race or
background, and perhaps even a greater appreciation for the humanities
may result from such identification. Thus it is not the purpose of this
book to promote a separate category of artists, but rather to help give
recognition where it is due.

INTRODUCTION

Most indexes start out with a known and definite body of material, proceeding from there to provide the needed access to the material through either names or subject entries. That accepted methodology was not possible in this instance because Black artists have been so poorly represented in the traditional collections of reproductions. Therefore, the procedure was to build a database of artists first, and then to examine all of the appropriate publications which might have relevant information in an effort to identify the photographic reproductions of those artists.

The Black Artist in America: An Index to Reproductions was developed in order to provide easy access to the published reproductions of fine art by American Black artists as they have appeared in books, periodicals, and exhibition catalogs. Black artists have been identified through a variety of sources, such as dictionaries, bibliographies, histories, and other reference tools which helped to establish their ethnic background. In compiling the work the need to establish biographical data was recognized, partially in order to insure positive identification but also because of the lack of such information in most bibliographies. In the process, decisions often had to be made about the inclusion or exclusion of certain artists, usually on the basis of where they were born or where their principal residence had been. As an example, Wilfredo Lam, who is often included in lists of Black artists, was excluded not because he is Cuban but because he is not American and has not worked extensively in the U.S. On the other hand, numerous Jamaican-born artists have been included because it was clear that their principal place of residence was the United States. And occasionally an artist was excluded, although listed elsewhere as a Black artist, simply because the evidence was pretty strong that he was white.

The reader is also directed to other biographical sources where appropriate in order not to duplicate the information provided elsewhere. Information on awards and exhibitions has not been included because of the existence of such publications as Theresa Cederholm's *Afro-American Artists: A Bio-Bibliographical Directory*. Similarly, bibliographical information on specific artists has been of a

selective nature because of the ready availability of such facts by the means of printed and online indexes.

SCOPE

The Black Artist in America: An Index to Reproductions is a reference tool designed to aid the user in locating printed photographic reproductions of works of fine art. The artists range in time from Joshua Johnston in the colonial period to Betye Saar, Richard Hunt, and Raymond Saunders of the present time. It includes those reproductions that have appeared in books, periodicals, and exhibition catalogs through 1990, published for the most part in the United States, and which are or have been generally available. No effort has been made to be judgmental of the artists involved; the present compiler has relied on the qualifications of the critics, editors, authors, and panelists who chose the artists and their works for publication. "American" has been defined as including Blacks who were either born in this country or who have made their home here regardless of their birthplace.

ARRANGEMENT

To achieve the goal of helping to develop a greater appreciation of the role played by Black artists in American culture, the material has been divided into three major sections. The first section is concerned with the publications and institutions cited in the main body of the book and acts to identify all abbreviations used. The second section, which is the major part of the book, is the index to the published reproductions and is arranged by artist. The last section is composed of a series of bibliographies, designed to help the researcher do more extensive investigation in the area of Black art. A subject index to the works of art cited in the main artist section concludes this publication.

TYPES OF WORKS OF ART INDEXED

Originally, it was intended to limit the term "fine art" to paintings and sculpture, but as the work progressed it became clear that this was too narrow a definition, and so the scope was broadened to include

prints, drawings, collages, assemblages, and other media where the artist worked in either of the two major areas. This became a serious problem with the proliferation of books and articles in the 1980s about folk artists, many of whom are Black. The decision was made to err on the side of comprehensiveness rather than to present too narrow a focus, and therefore most of these artists are included.

PUBLICATIONS INDEXED

The publications indexed include all known books, periodicals, monographs, and catalogs in which reproductions of fine art by Blacks have been included, if they are or have been generally available. In a few cases books were omitted because of their publication date and the unlikelihood that they would ever be reprinted. No such decision was made with periodicals since even the smallest and most esoteric of journals may well be available in microform or reprint edition. Occasionally, however, reproductions in journals were omitted because their poor quality made it doubtful they would be of use to the researcher. It was for that reason that newspaper reproductions were for the most part not included. Some exhibition catalogs were also omitted because their limited distribution made it unlikely that they would be available other than in the largest art libraries. With very few exceptions, the indexed publications are of American origin, since these would be the most readily available in U.S. libraries. Furthermore, the nature of the subject has of course resulted in its greatest coverage in domestic publications. In keeping with standard practice, books devoted to single artists, such as those on Romare Bearden, Horace Pippin, and Henry Tanner have not been indexed. Instead, they have been included in the "Further References" section of the artist's entry, with full bibliographic information.

INFORMATION GIVEN IN THE ARTIST ENTRY

The main segment of this book is alphabetically arranged by name of the artist using the name most frequently used by that person. Cross references are given when an artist has produced under more than one surname. A typical entry will contain the following information, depending on the availability of facts:
(1) Personal information. Full name, dates, place of birth and

place of death (if appropriate), media in which the artist has worked, other sources of biographical information, and sources of portraits or photographs of the artist. A question mark indicates that the artist is known or presumed to be be dead, but the date of death is not known. Where the date of birth is followed simply by a hyphen, the artist is still alive according to the information available to the author.

(2) Title of work. Alternative titles are given following the main title. If the title is part of a series, the title of the series is given in parentheses.

(3) Medium as reported by the publication in which the reproduction appeared.

(4) Date of the work. If the date is approximate, a small "c" precedes the year.

(5) Location of the original. The institution, collection, or city in which the original is reported to be located is indicated by a keyword in parentheses. The list of cited institutions appears in the preliminary pages of the book.

(6) Publication in which the reproduction appears. Books, periodicals, and catalogs are indicated by initialisms, which are listed in the preliminary pages under the heading "Key to Symbols Used in Index." Periodical references include volume, date, and page. Color illustrations are shown as (c).

(7) Further References. Where further information is available and deemed to be useful to the researcher, full bibliographical information is given. No attempt has been made to compile an exhaustive bibliography for an individual artist. The emphasis has been on the quality of the information, and all articles cited have been seen by the compiler.

BIBLIOGRAPHIES

It has been written that one important sign of the emergence of a field is the development of its bibliography. If that is indeed true, the field of Black art in this country shows significant signs of maturity. As a by-product of the awakening of interest in the artistic endeavors of Blacks, there has also been an expanded interest in documenting the literature relating to them. A decade ago it was common for a general bibliography on the cultural achievements of Blacks to have only a page or two of citations about art and artists. That, fortunately, is no

longer justifiable (if it ever was), since the literature relating to art has expanded in concert with the growing interest in Black life and history. Thus an important part of the present work is to bring up to date the relevant literature of the field. But it should be clear to the user that this is not a bibliography, and no claim is made for comprehensiveness of the references. In both the artist entries and in the general bibliographies the intent has been to provide a good selection of information and the emphasis has been on publications which bring new information or a new point of view to the subject.

SUBJECT INDEX

A selective subject index to the works of art is provided. As a result, it is now easy to compare how various artists have dealt with such common topics as American life, going to church, Christ, the flag, and war. Most non-representational works are not included in the index.

ACKNOWLEDGMENTS

As noted above, the compiler began by developing a database of known Black artists from other printed sources. This work, then, would not have been possible without the earlier efforts of those bibliographers, artists, and art historians who have provided a point from which to start. Although all of these people and their publications are cited elsewhere, I wish to call special attention to the major contributions of David C. Driscoll, Samella Lewis, Theresa Cederholm, Alain Locke, and James A. Porter. These people, most of whom are or were also artists, recognized the need to raise the consciousness level of the American people by identifying those Black artists who have contributed to the development of art during the past two hundred years. Art historians and bibliographers will always be indebted to these researchers.

In addition, I would like to express my appreciation to the staffs of the Library of Congress, the Chicago Public Library, the Art Institute of Chicago, the Los Angeles Public Library, the Brand Art Library in Glendale, the California Museum of Afro-American History, and to other institutions emphasizing Black culture cited elsewhere. Special thanks to Holly Ewing, Jean Thurnell, and Juanita Lapinski for

their careful work in developing parts of this volume; their valuable assistance over the years has made my work much easier.

Finally, I wish to acknowledge the assistance from my own institution, the University of Southern California. The long hours of doing research at its Architecture and Fine Arts Library made me especially aware of its fine collection and staff. I am deeply grateful to both the library and university administration for the granting of a sabbatical that made completion of the project possible. The Library Faculty Development Fund grant, voted by my colleagues, made the financial part of the project less burdensome. Thanks to the Assistant University Librarian for Public Services, Joyce Toscan, whose gentle pressure brought about the rekindling of interest in a project I had almost given up. My appreciation to Dr. Danielle Mihram, who as head of the Reference Center has been most supportive, both in approving the sabbatical and in promoting research. And finally, thanks to my fellow reference librarians in the Reference Center who, without too much complaint, have been understanding during the time I have been away.

Dr. Dennis Thomison
Associate Professor
University of Southern California

LIST OF ABBREVIATIONS

attrib	attributed to artist
aut	autumn
bw	black and white
c	approximately
co	company
et al	and others
fa	fall
jr	junior
linocut	linoleum cut
litho	lithograph
q	quarter
sc	sculpture
sp	spring
su	summer
v	volume
wi	winter

LIST OF INSTITUTIONS

The following institutions and collections are represented in the Index; the boldfaced part of the name is the keyword which is used in the artist entries, and which appears there in parentheses.

Museum of **African Art** (Frederick Douglass Museum), Washington, DC

Albany Institute of History and Art, Albany, NY

Museum of **American Folk Art**, New York

University of **Arizona**

Boston **Athenaeum**

Atlanta University, Atlanta, GA

Berkeley, University of California

Boston Museum of Fine Arts

Bowdoin College Museum of Art, Brunswick, ME

Bronx Museum, New York

Brooklyn Museum, New York

Brooks Memorial Art Gallery, Memphis, TN

Brown University, Providence, RI

Canada, National Gallery of Canada, Ottawa, Ontario

Capitol, Washington, DC

Carnegie Institute, Pittsburgh

Art Institute of **Chicago**

Chrysler Museum, Norfolk, VA

Clark Atlanta University, Museum of Afro-American Art, Atlanta, GA

Cleveland Museum of Art

Connecticut Historical Society, Hartford, CT

Corcoran Art Gallery, Washington, DC

Cornell University, Ithaca, NY

Crite Art Museum, Boston

Dallas Museum of Art

Delaware Art Museum, Wilmington, DE

Denver Art Museum

Detroit Institute of Arts

DuSable Museum of African American History, Chicago

Museum of **Early Decorative Arts**, Winston-Salem, NC

Ebony Magazine, Johnson Company, Chicago

Fisk University, Nashville, TN

Gibbes Museum of Art, Charleston, SC

Golden State Insurance Company, Los Angeles

Hampton Institute, Hampton, VA

Harlem River House, New York

Harmon Collection, National Archives, Washington, DC

Harvard University, Cambridge, MA

High Museum of Art, Atlanta, GA

Hirshhorn Museum and Sculpture Garden, Smithsonian Institution, Washington, DC

Chicago **Historical** Society

Harlem **Hospital**, New York

Houston Museum of Fine Arts

Howard University, Washington, DC

Indiana State Museum, Indianapolis, IN

Johnson Publishing Company, Chicago

LAMAAA, Los Angeles Museum of African American Art

LaSalle University Art Museum, Philadelphia

Los Angeles County Museum of Art

Louisiana State Museum, New Orleans

Maryland Historical Society, Baltimore

Center for Southern Folklore, **Memphis**, TN

Metropolitan Museum of Art, New York

Minneapolis Public Schools, Minneapolis, MN

University of **Mississippi**, University, MS

Museum of **Modern Art**, New York

Montreal Museum of Fine Arts, Montreal

Morgan State University, Baltimore, MD

Morris Museum of Art, Augusta, GA

Musee National d'Art Moderne, Paris

National Center of Afro-American Artists, Boston

National Gallery of Art, Washington, DC

National Portrait Gallery, Washington, DC

University of **Nebraska**, Omaha

New Haven Colony Historical Society, New Haven, CT

New Jersey State Museum, Trenton, NJ

New Orleans Museum of Art

Newark Museum, Newark, NJ

NYPL, New York Public Library

Oakland Museum, Oakland, CA

Ohio College of Applied Sciences, Cincinnati

Pennsylvania Academy of Fine Arts, Philadelphia

Philadelphia Museum of Art

Phillips Memorial Art Gallery, Washington, DC

Portland Art Museum, Portland, OR

Providence Art Club, Providence, RI

Musee du **Quebec**, Montreal

Raleigh Museum of Art, Raleigh, NC

Rhode Island Historical Society, Providence, RI

RISD, Rhode Island School of Design, Museum of Art, Providence

Roosevelt University, Chicago

St. Louis Art Museum

San Francisco Museum of Art

San Jose Public Library, San Jose, CA

Schomburg Collection, New York Public Library

Seattle Art Museum

Smithsonian Institution, Washington, DC

Spelman College, Atlanta, GA

Syracuse University Art Collection, Syracuse, NY

Taft Museum, Cincinnati

Talladega College, Talladega, AL

Tennessee Botanical Gardens and Fine Arts Center, Nashville, TN

Terra Museum, Evanston, IL

University of **Texas**, Austin

Texas Southern University, Houston

Tucson Museum of Art, Tucson, AZ

Tuskegee Institute (Carver Museum), Tuskegee, AL

UCLA, University of California, Los Angeles

Virginia Historical Society, Richmond

Wesleyan University, Middletown, CT

Whitney Museum of American Art, New York

Wilberforce University, Wilberforce, OH

Winston, Museum of Early Southern Decorative Arts, Winston-
 Salem, NC

Yale University, New Haven, CT

KEY TO SYMBOLS USED IN INDEX

This section contains all books, periodical articles, and exhibition catalogs indexed for works of art. The symbols listed are those which appear in the artist entries in the main section of this book.

AA	*American Artist* (periodical)
AAA	*Afro-American Artists; A Bio-Bibliographical Directory*, by Theresa B. Cederholm. Boston: Boston Public Library, 1973.
AAA3	*American Art Annual*. Washington, DC: American Federation of Arts, 1933.
AAAC	*Afro-American Art and Craft*, by Judith Chase. New York: Van Nostrand Reinhold, 1971.
AAAET	*African-American Artists 1880-1987; Selections from the Evans-Tibbs Collection*. Washington, DC: Smithsonian Institution Press, 1989.
AAAJ	*Archives of American Art Journal* (periodical)
AAAP	*Advancing American Art; Politics and Aesthetics in the State Department Exhibitions, 1946-1948*. Montgomery, AL: Montgomery Museum of Fine Arts, 1984.
AAASN	*Afro-American Artists Since 1950*. Brooklyn, NY: Brooklyn College, 1969.
AAAT	*America as Art*, by Joshua C. Taylor. Washington, DC: Smithsonian Institution Press, 1976.

AAATC *Art Across America; Two Centuries of Regional Painting, 1720-1920*, by William H. Gerdts. New York: Abbeville Press, 1990.

AAAZ *American Art Analog*, comp. by Michael D. Zellman. 3v. New York: Chelsea House, 1986.

AABH *Art in America; A Brief History*, by Richard McLanathan. New York: Harcourt, Brace, Jovanovich, 1973.

AADAM *American Art From the Denver Art Museum*. Denver: Denver Art Museum, 1969.

AAH *American Art at Harvard*. Cambridge, MA: Fogg Art Museum, Harvard University, 1972.

AAJ *American Art Journal* (periodical)

AAN *American Art Now*, ed. by Edward Lucie-Smith. New York: William Morrow, 1985.

AANC *American Art at the Nineteenth-Century Paris Salons*, ed. by Lois M. Fink. Washington, DC: Smithsonian Institution Press, 1990.

AAOC *American Art of Our Century*, by Lloyd Goodrich and John I.H. Baur. New York: Whitney Museum of American Art, 1961.

AAPS *American Art: Painting, Sculpture, Architecture, Decorative Arts, Photography*, ed. by Milton W. Brown, et al. New York: Prentice Hall, 1979.

AAR *American Art Review*. Los Angeles: Kellaway Pub. Co., 1973.

AASC *American Artists '76; A Celebration*. San Antonio, TX: Marion Koogler McNay Art Institute, 1976.

AASN *American Art Since 1945*, by Dore Ashton. New
 York: Oxford University Press, 1982.

AATC *American Art of the 20th Century*, by Sam Hunter
 and John Jacobs. New York: Abrams, 1973.

AATN *American Art to 1900*, by Milton Brown. New York:
 Abrams, 1977.

AATNM *American Art in the Newark Museum; Paintings,
 Drawings, and Sculpture*. Newark,NJ: Newark Mu-
 seum, 1981.

AAW *American Art*, by John Wilmerding. New York: Pelican,
 1976.

ABA *ABA: A Journal of the Affairs of Black Artists*
 (periodical)

ABP *American Battle Painting, 1776-1918*. Washington,DC:
 National Gallery of Art, 1944.

ABWA *American Black Women in the Arts and Social
 Sciences; A Bibliographic Survey*, by Ora Williams.
 Metuchen, NJ: Scarecrow Press, 1978.

AC *American Collector* (periodical)

ACFNB *The Art Collection of the First National Bank of Chi-
 cago*. Chicago: The Bank, 1978.

ACPS *The American Canvas; Paintings from the Collec-
 tion of the Fine Arts Museum of San Francisco*, by
 Marc Simpson. New York: Hudson Hills Press, 1989.

ACW *Art: Contributions of Women*, by Carol Fowler.
 Minneapolis, MN: Dillon Press, 1976.

AD *Art Digest* (periodical)

ADMC *Art, Design and the Modern Corporation.* Washing-
 ton, DC: Smithsonian Institution Press, 1985.

AE *Art Education* (periodical)

AEM *Artists of Early Michigan*, by Arthur Hopkin Gibson.
 Detroit: Wayne State University, 1975.

AEPLN *American Expatriate Painters of the Late Nineteenth
 Century*, by Michael Quick. Dayton, OH: Dayton Art In-
 stitute, 1976.

AF *Architectural Forum* (periodical)

AFATC *American Folk Art of the Twentieth Century*, by Jay
 Johnson and William C. Ketchum, Jr. New York:
 Rizzol, 1983.

AFP *American Folk Painting*, by Mary Black and Jean Lip-
 man. New York: Praeger, 1971.

AFPR *American Folk Portraits; Paintings and Drawings
 from the Abby Aldrich Rockefeller Folk Art Center.*
 Boston: New York Graphic Society, 1981.

AFSB *American Folk Sculpture*, ed. by Robert Bishop. New
 York: Dutton, 1974.

AFTM *Art for the Millions*, by Francis O'Connor. Green-
 wich, CT: New York Graphic Society, 1973

AG *Art Gallery* (periodical)

AGW *Art Against War; 400 Years of Protest in Art.* New
 York: Abbeville Press, 1984.

AH *American Heritage* (periodical)

AHAP *A History of American Painting*, by Matthew Baigell.
 New York: Praeger, 1971.

AHHA *The American Heritage History of the Artists' America*. New York: American Heritage, 1973.

AI *Art International* (periodical)

AIA *The Artist in America*. New York: Norton, 1967.

AIAP *Art Inc; American Painting from Corporate Collections*. Montgomery, AL: Montgomery Museum of
 Fine Arts, 1979.

AIC *Art in California* (periodical)

AIM *Art in America* (periodical)

AIPP *Art in Public Places in the United States*, compiled
 by Emma L. Fundaburk and Thomas G. Davenport.
 Bowling Green, OH: Bowling Green University
 Popular Press, 1975.

AIS *Arts in Society* (periodical)

AISP *American Imagination and Symbolist Painting*, by
 Charles C. Eldridge. New York: Grey Art Gallery, 1799.

AITS *An Invitation to See: 125 Paintings from the Museum of Modern Art*. New York: Museum of Modern
 Art, 1973.

ALIA *Art and Life in America*, by Oliver Larkin. Rev. ed.
 New York: Holt, Rinehart and Winston, 1960.

AMNGA *American Masterpieces from the National Gallery of
 Art*, ed. by John Wilmerding. Hudson Hills Press,
 1980.

AMNCA *The Art-Makers of Nineteenth Century America*, by
 Russell Lynes. New York: Atheneum, 1970.

AN *Art News* (periodical)

ANA *Art and Artists* (periodical)

ANCS *American Neo-Classic Sculpture: The Marble Resur-
 rection*, by William H. Gerdts. New York: Viking
 Press, 1973.

ANG *Angeles* (periodical)

ANP *American Naive Paintings from the National Gallery
 of Art*. Evanston, IL: Terra Museum of American Art.

ANPEN *American Native Painting of the 18th and 19th Cen-
 turies*. New York: American Federation of Art, 1969.

ANPL *American Narrative Painting*. Los Angeles: Los Angeles
 County Museum of Art, 1974.

ANT *Antiques* (periodical)

ANY *The Art of New York*, comp. by Seymour Chwast and
 Steven Heller. New York: Abrams, 1983.

AO *American Originals: Selections from Reynolds House
 Museum of American Art*. New York: Abbeville,
 1990.

AOC *The Art of California; Selected Works from the Col-
 lection of the Oakland Museum*. Oakland, CA: Oakland
 Museum, 1984.

AOT *Art in Our Times; A Pictorial History, 1890-1980*,
 ed. by Peter Selz. New York: Abrams, 1981.

AOTT *Art of the Thirties: The Pacific Northwest*, by Martha

Kingsbury. Seattle: University of Washington Press, 1972.

AP *Artists Proof* (periodical)

APAP *American Prints and Printmakers*, by Una E. Johnson. Garden City, NY: Doubleday, 1980.

APAS *American Paintings and Sculpture.* Washington, DC: National Gallery of Art, 1969.

APCMA *American Painting: A Catalogue of the Metropolitan Museum of Art.* Greenwich, CT: New York Graphic Society, 1965.

APCS *American Painting Collection of the Sheldon Memorial Art Gallery.* Lincoln: University of Nebraska Press, 1981.

APG *American Painting*, by Donald Goddard. New York: Macmillan, 1990.

APHM *American Paintings in the High Museum; A Bicentennial Catalogue.* Atlanta, GA: High Museum,1975.

APHR *American Paradise: The World of the Hudson River School.* New York: Metropolitan Museum of Art, 1987.

APMFA *American Paintings in the Museum of Fine Arts.* Boston: Museum of Fine Arts, 1969.

APMMA *American Paintings in the Metropolitan Museum of Art*, ed. by Kathleen Luhrs. New York: Metropolitan Museum of Art, 1985.

APNC *American Painting of the Nineteenth Century: Realism, Idealism and the American Tradition*, by Barbara Novak. New York: Praeger, 1969.

APO *Apollo* (periodical)

APPA *American Paintings in the Pennsylvania Academy of
 the Fine Arts*, comp. by Nancy Fresella-Lee. Phila-
 delphia: Pennsylvania Academy of the Fine Arts,
 1989.

APRIHS *American Paintings in the Rhode Island Historical
 Society*, by Frank H. Goodyear. Providence: The So-
 ciety, 1974.

APTC *American Painting in the 20th Century*, by Henry
 Geldzahler. New York: Metropolitan Museum of Art,
 1965.

APTE *American Painting: The Eighties; A Critical Inter-
 pretation*, by Barbara Rose. New York: Urizen
 Books, 1979.

ARAC *Arts and Activities* (periodicalcal)

ARAN *Art and Antiques* (periodical)

ARC *Architecture* (periodical)

ARDE *Architecture Digest* (periodical)

ARIP *American Realist and Impressionist Paintings*. South-
 ampton, NY: Parrish Art Museum, 1982.

ART *Arts* (periodical)

ARTA *The Artary* (periodical)

ARTF *Artforum* (periodical)

ASAP *The American Scene: American Painting of the 1930s*,
 by Matthew Baigell. New York: Praeger, 1971.

ASP *American Sculpture in Process, 1930-1970*. Boston:
 New York Graphic Society, 1975.

ATL	*Atlanta Magazine* (periodical)
ATO	*Against the Odds: African-American Artists and the Harmon Foundation.* Newark, NJ: Newark Museum, 1989.
ATPN	*Art of the Thirties: The Pacific Northwest.* Seattle: University of Washington Press, 1972.
AUSA	*Artists/USA, 1972-73; A Guide to Contemporary American Art.* Festerville, PA: Artists/USA, 1972.
AUSPS	*Arts of the United States; A Pictorial Survey,* by William H. Pierson, Jr. and Martha Davidson. New York: McGraw-Hill, 1960.
AV	*American Visions* (periodical)
AVD	*Artists--Varying Directions; January 26,1975-February 23, 1975.* Los Angeles: Otis Art Institute, 1975.
AW	*Artweek* (periodical)
AWA	*American Women Artists, 1830-1930.* Washington, DC: National Museum of Women in the Arts, 1987.
AWAP	*Art in Washington and Its Afro-American Presence: 1940-1970,* by Keith Morrison. Washington, DC: Washington Project for the Arts, 1985.
AWCF	*American Watercolors,* by Christopher Finch. New York: Abbeville Press, 1986.
AWSR	*American Women Sculptors; A History of Women Working in Three Dimensions,* by Charlotte S. Rubinstein. Boston: G.K. Hall, 1990.

BAA *Black Arts Annual 1987/88*, ed. by Donald Bogle.
 New York: Garland, 1989.

BAAL *Black Art Ancestral Legacy; The African Impulse in
 African-American Art*. Dallas: Dallas Museum of Art,
 1989.

BABC *The Blues Aesthetic; Black Culture and Modernism*.
 Washington, DC: Washington Project for the Arts,
 1989.

BACW *The Barnett-Aden Collection*. Washington, DC:
 Government Printing Office, 1974.

BAGAA *The Beauty of America in Great American Art*. Wau-
 kesha, WI: Country Beautiful Foundation, 1965.

BANG *Black Artists of the New Generation*, by Elton Fax.
 New York: Dodd, Mead, 1977.

BAOA *Black Artists on Art*. Vol. 1, by Samella S. Lewis
 and Ruth G. Waddy. Los Angeles: Contemporary Crafts,
 1969.

BAOA-1 *Black Artists on Art*. Vol. 1, rev. ed. by Samella
 S. Lewis and Ruth G. Waddy. Los Angeles: Contemporary
 Crafts, 1976. (Indexing provided only for those artists
 not in previous edition).

BAOA-2 *Black Artists On Art*. Vol.2, by Samella S. Lewis
 and Ruth G. Waddy. Los Angeles: Contemporary Crafts,
 1971.

BAOT *Black Artists of Toledo*. Toledo: Museum of Art,
 1973.

BAP *American Painting From Its Beginning to the Armory
 Show*, by Jules D. Brown. Geneva: n.p.,1970.

BAQ *Black Art Quarterly* (periodical) Note: In 1984 it
 became the *International Review of African Ameri-
 can Art.*

BAWPA *The Black Artist in the WPA, 1933-43; An Exhibit of
 Drawings, Paintings, and Sculpture.* Brooklyn, NY: New
 Muse Community Museum, 1976.

BBB *Black Books Bulletin* (periodical)

BC *Black Collegian* (periodical)

BCR *Black Creation* (periodical)

BDCAA *Black Dimensions in Contemporary American Art*, by
 J. Edward Atkinson. New York: New American Lib-
 rary, 1971.

BDIA *Bulletin of the Detroit Institute of the Arts*
 (periodical)

BDWA *Biographical Dictionary of Women Artists in Europe
 and America Since 1850*, ed. by Penny Dunford.
 Philadelphia: University of Pennsylvania Press,
 1989.

BE *Black Enterprise* (periodical)

BEAA *Britannica Encyclopedia of American Art*, ed. by
 Milton Rugoff. Chicago: Encyclopaedia Britannica
 Educational Corp., 1973.

BF *Black Forum* (periodical)

BFAA *Black Folk Art in America, 1930-1980*, ed. by
 Jane Livingston and John Beardsley. Washington,
 DC: Corcoran Gallery of Art, 1982.

BFPA *Folk Painting of America*, by Robert Bishop. New

York: E.P. Dutton, 1979.

BHAP *A History of American Painting*, by Ian Bennett.
 London: Hamlyn, 1973.

BHBA *Biographical History of Blacks in America Since
 1528*, by Edgar Toppin. New York: McKay, 1971.

BHBV *Black History/Black Vision; The Visionary Image in
 Texas*, by Lynne Adele. Austin, TX: Huntington Art
 Gallery, 1989.

BIS *Baking in the Sun: Visionary Images from the South.*
 Lafayette, LA: Lafayette Art Museum, 1987.

BLC *Black Life and Culture in the United States*, by
 Rhoda L. Goldstein. New York: Crowell, 1971.

BMAP *The Brooklyn Museum; American Paintings.* Brook-
 lyn, NY: Brooklyn Museum, 1979.

BMIA *The Black Man in Art*, by Rena Coen. Minneapo-
 lis: Lerner Pub. Co., 1970.

BS *Black Shades* (periodical)

BSAP *Bright Stars: American Painting and Sculpture Since
 1776*, by Jean Lipman and Helen Franc. New York:
 Dutton, 1976.

BSC *Black Scholar* (periodical)

BT *Black Theatre* (periodical)

BUN *Blacks:USA:1973*, by New York Cultural Center.
 New York: The Center, 1973.

BW *Black World* (periodical)

BWSB *An Exhibition of Black Women Artists*. Santa Barbara: University of California, 1975.

CA *Contemporary Art*, by Rosamond Frost. New York: Crown, 1942.

CAC *The Connecticut Artists Collection*. Waterbury, CT: Mattatuck Historical Society, 1968.

CACE *Continuity and Change: Emerging Afro-American Artists, California, 1986*. Los Angeles: California Afro-American Museum, 1986.

CACF *Content; A Contemporary Focus, 1974-1984*. Washington, DC: Smithsonian Institution Press, 1984.

CACN *Contemporary Artists*, ed. by Colin Naylor. London: St. James Press, 1989.

CANO *Contemporary Artists* ed. by Colin Naylor and Gensis P-Orridge. New York: St. Martin's Press, 1977.

CAP *Contemporary American Painting*, by the editors of Encyclopaedia Britannica. New York: Duell, Sloan, and Pearce, 1945.

CAS *Contemporary Art/Southwest* (periodical)

CAWS *Contemporary American Women Sculptors*, by Virginia Watson-Jones. Phoenix, AZ: Oryx Press, 1986.

CBAM *Contemporary Black Artists*. Minneapolis: Institute of Arts, 1969.

CBAR *Collecting Black Americana*, by Dawn Reno. New York: Crown, 1986.

CCAP *A Catalog of the Collection of American Paintings*

in the Corcoran Gallery of Art, Vol. 2: "Painters
Born from 1850 to 1910." Washington, DC: Corcoran
Gallery of Art, 1973.

CCW *Catalog of the Collection.* New York: Whitney
 Museum of American Art, 1975.

CCWM *Catalogue of the Collection.* New York: Whitney
 Museum of American Art, 1973.

CGB *Contextures,* by Linda Good-Bryant and Marcy S.
 Phillips. New York: Just Above Midtown, 1978.

CH *Craft Horizons* (periodical)

CL *Current Literature* (periodical)

CLA *Clarion* (periodical)

CLP *The Lives of the Painters,* by John Canaday. New
 York: Norton, 1969.

CM *Carnegie Magazine* (periodical)

CMO *Ceramics Monthly* (periodical)

CMUB *Bulletin of the Cleveland Museum of Art* (periodical)

CNHB *Celebrating Negro History and Brotherhood; A Fo-
 lio of Prints by Chicago Artists.* Chicago: Seven Arts
 Workshop, 1956.

CONN *Connoisseur* (periodical)

CPNW *California Painters: New Work,* by Henry T. Hop-
 kins. San Francisco: Chronicle Books, 1989.

CRI *Crisis* (periodical)

CS *Chicago Sculpture*, ed. by James Riedy. Urbana:
 University of Illinois Press, 1981.

CTAL *Critical Temper of Alain Locke; A Selection of His
 Essays on Art and Culture*, ed. by Jeffrey C. Stewart.
 New York: Garland, 1983.

CVAH *The Critical Vision; A History of Social and Politi-
 cal Art in the U.S.*, by Paul Von Blum. Boston: South
 End Press, 1982.

CWA *Compilation of Works of Art and Other Objects in the
 United States Capitol*, by the U.S. Architect of the
 Capitol. Washington, DC: Government Printing Office,
 1965.

CWDP *Catalogue of Watercolors, Drawings and Pastels*.
 Reading, PA: Reading Public Museum and Art Gal-
 lery, 1964.

DAAA *Amistad II: Afro-American Art*, by David C. Driscoll.
 Nashville, TN: Fisk University, 1975.

DAAS *A Dictionary of American Artists, Sculptors, and En-
 gravers from the Beginnings Through the Turn of the
 Twentieth Century*, ed. by William Young. Cambridge,
 bridge, MA: William Young and Co., 1968.

DAED *Design for Arts in Education* (periodical)

DAHHA *The American Heritage History of the Artists'
 America*, by Marshall Davidson. New York: American Heri-
 tage, 1973.

DANA *American Negro Art*, by Cedric Dover. Greenwich, CT:
 New York Graphic Society, 1960.

DAS *Dictionary of American Sculptors; 18th Century To
 the Present*, ed. by Glenn B. Opitz. Poughkeepsie,

NY: Apollo, 1984.

DBLJ *Dimensions of Black.* Exhibition at the La Jolla
 Museum of Art, February 15-March 29, 1970. La Jolla, CA:
 Museum of Art, 1970.

DCAA *A Dictionary of Contemporary American Artists*, by
 Paul Cummings. London: St. James, 1988.

DCBAA *Contemporary Black Artists in America*, by Robert M.
 Doty. New York: Whitney Museum of American Art, 1971.

DENA *Exhibition 1973, January 14 to February 28, 1973,
 at the Anacostia Neighborhood Museum*, by the District
 of Columbia Art Association. Washington, DC: Smith-
 sonian Institution, 1973.

DIAA *Directions in Afro-American Art.* Ithaca, NY: Her-
 bert F. Johnson Museum of Art, Cornell University,
 1974.

DIAB *Detroit Institute of Arts Bulletin* (periodical)

DOM *Domus* (periodical)

EAAA *Eight Artistes Afro-Americains.* Geneva, Switzer-
 land: Musee Rath, 1971.

EAFA *Emerging Artists: Figurative Abstraction.* Los An-
 geles: California Afro-American Museum, 1989.

EANE *Emerging Artists: New Expressions.* Los Angeles:
 California Afro-American Museum, 1990.

EB *Ebony* (periodical).

EBSU *Existence/Black; An Exhibition of African American
 Artists.* Edwardsville: Southern Illinois University,
 1972.

EGPS *Early Georgia Portraits, 1715-1870.* Athens: University of Georgia, 1975.

ENC *Encore* (periodical).

EOAR *Encyclopedia of the Arts*, ed. by Dagobert Runes and Harry Schrickel. New York: Philosophical Library, 1946.

ESQ *Esquire* (periodical)

ESS *Essence* (periodical)

EU *Ex Umbra* (periodical)

EWCA *East-West: Contemporary American Art.* Los Angeles: California Afro-American Museum, 1985.

EWTA *Exposures; Women and Their Art*, by Betty Ann Brown and Arlene Raven. Pasadena, CA: NewSage Press, 1989.

FA *Flash Art* (periodical)

FAAA *The Afro-American Artist; A Search for Identity*, by Elsa H. Fine. New York: Holt, 1973.

FAEI *An Enduring Image: American Painting from 1665*, by William Freegood. New York: Crowell, 1970.

FAL *Fragments of American Life; An Exhibition of Paintings*, by John R. Willis. Princeton, NJ: Art Museum, 1976.

FAMTCA *A Treasury of Contemporary Art; Famous Artists Annual 1.* New York: Hastings House, 1969.

FAR *Fine Art Reproductions, Old and Modern Masters; A Comprehensive Illustrated Catalog of Art Through*

	the Ages. Greenwich, CT: New York Graphic Society, 1972.
FBA	*Five Black Artists*, by Samella S. Lewis. Los Angeles: Contemporary Crafts, 1971.
FDAP	*Mantle Fielding's Dictionary of American Painters, Sculptors and Engravers*. New York: James F. Carr, 1965.
FFAA	*Forever Free; Art by African-American Women, 1862-1980*, ed. by Arna A. Bontemps. Alexandria, VA: Stephenson, Inc., 1980.
FFBA	*Five Famous Black Artists*. Roxbury, MA: National Center of Afro-American Artists, 1970.
FFNY	*The Figurative Fifties: New York Figurative Impressionism*. Newport Beach, CA: Newport Harbor Art Association, 1988.
FHBI	*Facing History: The Black Image in American Art 1710-1940*, by Guy C. McElroy. Washington, DC: National Gallery of Art, 1990.
FIBO	*Festival in Black; Otis Art Exhibition; August 2- August 28, 1977*. Los Angeles: Otis Art Institute, 1977.
FRE	*Freedomways* (periodical)
FSBA	*Seventeen Black Artists*, by Elton Fax. New York: Dodd, Mead, 1971.
FTA	*Fifty Texas Artists*, by Annette Carlozzi. San Francisco: Chronicle Books, 1986.
FTCA	*The Figure in 20th Century American Art: Selections from the Metropolitan Museum of Art*, comp. by

Lowery S. Sims. New York: Metropolitan Museum of Art, 1984.

FTWM *The Figurative Tradition and the Whitney Museum of American Art; Paintings and Sculpture from the Permanent Collection*, by Patricia Hills and Roberta K. Tarbell. New York: Whitney Museum of American Art, 1980.

FUF *Fifteen Under Forty; Paintings by Young New York State Black Artists*. Albany, NY: State Education Department, 1970.

FVVE *Varieties of Visual Experience*. 2nd ed.by Edmund B. Feldman. New York: Abrams, 1971.

FW *First World* (periodicdical)

FWCA *50 West Coast Artists; A Critical Selection of Painters and Sculptors Working in California*. San Francisco: Chronicle Books, 1981.

FWO *Fine Woodworking* (periodical)

GAE *Art & Ethics: Background for Teaching Youth in a Pluralistic Society*, by Eugene J. Grigsby. Dubuque, IA: William C. Brown, 1977.

GANS *American Neoclassic Sculpture*, by William H. Gerdts. New York: Viking, 1973.

GASP *A Sense of Place: The Artist and the American Land*, by Alan Gussow. New York: Saturday Review, 1971.

GD *Graphic Design* (periodical)

GGP *Gallery of Great Paintings*, by Aimee Crane. New York: Crown, 1944.

GNPP3 *Great Negroes Past and Present*, by Russell Adams.
 Third ed. Chicago: Afro-American Pub. Co., 1969.

GT *Grade Teacher* (periodical)

HAAM *A History of American Art*, by Daniel M. Mendelo-
 witz. New York: Holt, Rinehart, Winston, 1970.

HAGC *The Herbert A. Goldstone Collection of American
 Art*. Brooklyn, NY: Brooklyn Museum, 1965.

HAL *High and Low; Modern Art and Popular Culture*.
 New York: Museum of Modern Art, 1990.

HAPNG *A Heritage of American Paintings From the National
 Gallery of Art*, by William James William. New
 York: Rutledge Press, 1981.

HAR *Harvard Art Review* (periodical)

HAWS *History of the American Watercolor Society: The
 First Hundred Years*, by Ralph Fabri. New York: Ameri-
 can Watercolor Society, 1969.

HCPT *Human Concern/Personal Torment; The Grotesque
 in American Art*, by Robert Doty. New York: Whit-
 ney Museum of American Art, 1969.

HG *House and Garden* (periodical)

HHR *Harlem Renaissance*, by Nathan I. Huggins. New York:
 Oxford University Press, 1971.

HMSG *The Hirshhorn Museum and Sculpture Garden,
 Smithsonian Institution*. New York: Abrams, 1974.

HN	*History News* (periodical)
HOR	*Horizon* (periodical)
HRABA	*Harlem Renaissance; Art of Black America*. New York: Abrams, 1987.
HW	*Humble Way* (periodical)
HWCPA	*History of Water Color Painting in America*, by Albert Gardner. New York: Reinhold, 1966.
IBA	*In Black America; 1968: The Year of Awakening*, by Patricia Romero. Washington, DC: United Pub. Corp., 1969.
ICAA	*Introspectives: Contemporary Art by Americans and Brazilians of African Descent*. Los Angeles: California Afro-American Museum, 1989.
IEUC	*If Elected; Unsuccessful Candidates for the Presidency, 1796-1968*. Washington, DC: National Portrait Gallery, 1972.
IIBM	*The Image of the Indian and the Black Man in American Art*, by Elwood Parry. New York: George Braziller, 1974.
ILAAL	*International Library of Afro-American Life and History*. Vol. 6: "The Afro-American in Music and Art." New York: Publishers Agency, 1976.
ILL	*Illustrator* (periodical)
IMMA	*The Image Makers; Man and His Art*, by Harold Spencer. New York: Scribner, 1975.
INS	*Instructor* (periodical)

IOL *Images of Labor.* New York: Pilgrim Press, 1981.

IS *International Studio* (periodical)

ITA *In this Academy, The Pennsylvania Academy of the Fine Arts, 1805-1976.* Philadelphia: The Academy, 1976.

JAA *American Arts*, by Rilla E. Jackman. Chicago: Rand McNally, 1940.

JAAUW *Journal of the Association of American University Women* (periodical)

JAF *Journal of American Folklore* (periodical)

JAMC *James A. Michener Collection of Twentieth Century American Painting.* Austin: University of Texas Art Museum, 1977.

JBP *Journal of Black Poetry* (periodical)

JBS *Journal of Black Studies* (periodical)

JET *Jet* (periodical)

JJ *Jamaica Journal* (periodical)

KCNCP *The Kahn Collection of Nineteenth Century Paintings by Artists in California*, by Marjorie Arkelian. Oakland: Oakland Museum, 1975.

KQ *Kennedy Quarterly* (periodical)

LA *Liturgical Arts* (periodical)

LAAA *Art: African American*, by Samella S. Lewis. New York: Harcourt, Brace, Jovanovich, 1978.

LACMA *Los Angeles County Museum of Art Bulletin*
 (periodical)

LATCM *The Los Angeles Times Book of California Museums*,
 by William Wilson. New York: Abrams, 1984.

LC *Local Color; A Sense of Place in Folk Art*, by
 William Ferris. New York: McGraw-Hill, 1982.

LCT *The Lane Collection; 20th Century Paintings in the
 American Tradition*, by Theodore E. Stebbins, Jr.,
 and Carol Troyen. Boston: Museum of Fine Arts,1983.

LEO *Leonardo* (periodical)

LIB *Liberator* (periodical)

LIF *Life* (periodical)

LJ *Library Journal* (periodical)

LMW *Louisiana Major Works 1980*. New Orleans: Con-
 temporary Center, 1980.

LNIA *The Negro in Art; A Pictorial Record of the Negro
 Artist and of the Negro Theme in Art*, by Alain
 Locke. Washington, DC: Associates In Negro Folk
 Education, 1940.

LOO *Look* (periodical)

LPP *Louisiana Painters and Paintings from the Collec-
 tion of W.E. Groves*. Gretna, LA: Pelican Pub. Co.,
 1971.

MA *Magazine of Art* (periodical)

MAA *Modern Art: Americans*, by Edward A. Jelvell.

New York, n.p., 1930.

MAAM *Masterworks of American Art from the Munson-Williams-Proctor Institute.* New York: Abrams, 1989.

MAPA *Modern Art: A Pictorial Anthology*, ed. by Charles. McCurdy. New York: Macmillan, 1958.

MAPOC *Milestones of American Painting in Our Century*, by Frederick Wight. New York: Chanticleer Press, 1940.

MAPS *Mirror to the American Past, A Survey of American Genre Painting, 1759--1900*, by Hermann W. Williams. Greenwich, CT: New York Graphic Society, 1973.

MAS *Modern American Sculpture*, ed. by Dore Ashton. New York: Abrams, 1968.

MCAM *Masterpieces from the Cincinnati Art Museum.* Cincinnati Art Museum, 1984.

MES *Messinger* (periodical)

MHDA *McGraw-Hill Dictionary of Art*, ed. by Bernard Meyers. New York: McGraw-Hill, 1969.

MHM *Maryland Historical Magazine* (periodical)

MIAP *Mallett's Index of Artists: International-Biographical Including Painters, Sculptors, Illustrators, Engravers, and Etchers of the Past and Present.* New York: Peter Smith, 1948.

MIUA *Made in U.S.A.; An Americanization in Modern Art, the '50s & '60s*, ed. by Sidra Stich. Berkeley: University of California Press, 1987.

MJMC *The Martha Jackson Memorial Collection*, ed. by
 Harry Rand. Washington, DC: Smithsonian Institu-
 tion Press, 1985.

MMA *Museum of Modern Art* (periodical)

MMB *Metropolitan Museum Bulletin* (periodical)

MMP *Masters of Modern Painting; Modern Primitives of
 Europe and America.* New York: Museum of Modern
 Art, 1948.

MN *Museum News* (periodical)

MNA *Masters of Naive Art; A History and Worldwide Survey*,
 by Oto Bihaljii-Merin. New York: McGraw-Hill, 1975.

MOT *Motive* (periodical)

MPAI *Master Paintings in the Art Institute of Chicago.*
 Chicago: The Art Institute, 1988.

MR *Massachusetts Review* (periodical)

MRAA *The Modern Renaissance in American Art*, by Ralph
 Pearson. New York: Harper, 1954.

MS *Ms.* (periodical)

MTM *Making Their Mark; Women Artists Move into the
 Mainstream, 1970-85*, comp. by Randy Rosen and
 Catherine C. Brawer. New York: Abbeville Press,
 1989.

MWP *Made With Passion; The Hempill Folk Art Collection
 in the National Museum of American Art*, ed. by Lin-
 da R. Hartigan. Washington, DC: Smithsonian Insti-
 tution Press, 1990.

NA *The Negro Artist Comes of Age: A National Survey*
 of Contemporary American Artists. Albany, NY: Al-
 bany Institute of History and Art, 1945.

NACA *19 Sixties; A Cultural Awakening Re-Evaluated,*
 1965-1975. Los Angeles: California Afro-American
 Museum, 1989.

NAE *New Art Examiner* (periodical)

NAHF *Exhibit of Fine Arts/Productions of American Negro*
 Artists. New York: Harmon Foundation, 1928.

NAI *Negro Artists; An Illustrated Review of Their*
 Achievements. New York: Harmon Foundation, 1935.

NALF *Negro American Literature Forum* (periodical)

NAR *National Antiques Review* (periodical)

NAT *Nation* (periodical)

NBEW *1989 Biennial Exhibition; Whitney Museum of Ameri-*
 can Art. New York: Whitney Museum of American
 Art, 1989.

NCA *Nineteenth Century Art*, ed. by Robert Rosenblum
 and H.W. Janson. New York: Abrams, 1984.

ND *Negro Digest* (periodical)

NENY *New York* (periodical)

NEW *Newsweek* (periodical)

NEWO *Neworld*

NGAW *National Gallery of Art, Washington*, by John Walker.

New York: Abrams, 1984.

NGR *National Gallery Report* (periodical)

NGSBA *Next Generation: Southern Black Aesthetic*. Winston-
 Salem, NC: Southeastern Center for Contemporary
 Art, 1990.

NH *Negro Heritage* (periodical)

NHB *Negro History Bulletin* (periodical)

NIA *Nature in Abstraction; The Relationship of Ab-
 stract Painting and Sculpture to Nature in Twentieth-
 Century Art*, by John I.H. Baur. New York: Whitney
 Museum of American Art, 1958.

NM *New Masses* (periodical)

NPFC *The 1980s; Prints from the Collection of Joshua P.
 Smith*, ed. by Ruth Fine. Washington, DC: National
 Gallery of Art, 1989.

NPG *National Portrait Gallery*. Washington, DC: Smith-
 sonian Institution, 1978.

NSR *National Sculpture Review* (periodical)

NY *New Yorker* (periodical)

NYT *New York Times Magazine* (periodical)

OAAL *The Other America; Art and the Labour Movement in
 the United States*, by Philip S. Foner and Reinhard
 Schultz. London: Journeyman Press, 1985.

OAWA *Originals; American Women Artists*, by Eleanor
 Munro. New York: Simon & Schuster, 1979.

OHMB	*One Hundred Masterpieces of American Painting from Public Collections in Washington, DC*, by Milton Brown. Washington, DC: Smithsonian Institution Press, 1983.
OIA	*The Olympics in Art; An Exhibition of Works of Art Related to Olympic Sports*. Utica, NY: Museum of Art, 1980.
ONPB	*New Perspectives in Black Art*. Oakland, CA: Oakland Museum, 1968.
OPP	*Opportunity* (periodical)
OSAE	*Other Sources: An American Essay*. San Francisco: San Francisco Art Institute, 1976.
OTAP	*Of Time and Place; American Figurative Art from the Corcoran Gallery*. Washington, DC: Corcoran Gallery, 1981.
OUT	*Outlook* (periodical)
OW	*Our World* (periodical)
PAN	*Pantheon* (periodical)
PANA	*Prints by American Negro Artists*, ed. by T.V. Roelof-Lanner. Los Angeles: Cultural Exchange Center of Los Angeles, 1965.
PAPM	*A Panorama of American Painting; The John J. McDonough Collection*. New Orleans: New Orleans Museum of Art, n.d.
PAR	*Parnassus* (periodical)
PARU	*The Painters' America: Rural and Urban Life, 1810-1910*, by Patricia Hills. New York: Praeger, 1974.

PAS *Portraits of the American Stage, 1771-1971.* Wash-
 ington, DC: National Portrait Gallery, 1971.

PASMOMA *Painting and Sculpture in the Museum of Modern Art,*
 by Alfred H. Barr. New York: Museum of Modern Art,
 1948.

PCNHC *The Painting Collection of the New Haven Colony
 Historical Society.* New Haven, CT: The Society,
 1971.

PEAA *The Pluralist Era; American Art, 1868-1981,* by
 Corinne Robbins. New York: Harper & Row, 1984.

PEO *People* (periodical)

PHTC *A Proud Heritage: Two Centuries of American Art.*
 Chicago: Terra Museum of American Art, 1987.

PHY *Phylon* (periodical)

PIAM *Politics in Art,* by Joan Mondale. Minneapolis, MN:
 Lerner Publications, 1977.

PIUS *Painting in the United States, 1944.* Pittsburgh: Car-
 negie Institute, 1944.

PIUS,1945 *Painting in the United States, 1945.* Pittsburgh: Car-
 negie Institute, 1945.

PKAU *Afro-USA; A Reference Work on the Black Experience,* ed.
 by Harry Ploski and Ernest Kaiser. New York: Bellwether,
 1971.

PMNA *Modern Negro Art,* by James A. Porter. New York:
 Dryden Press, 1943; New York: Arno Press, 1969.

PMR *Princeton Museum Record* (periodical)

PNAP *The Portrayal of the Negro in American Painting.*
 Brunswick, ME: Bowdoin College, 1964.

PORT *Portfolio* (periodical)

PPA *Primitive Painters in America, 1750-1950*, by Jean
 Lipman and Alice Winchester. New York: Dodd, 1950.

PR *Print* (periodical)

PRO *Prologue* (periodical)

PSFA *Painting and Sculpture from Antiquity to 1942; Al-
 bright-Knox Art Gallery*, ed. by Steven Nash. New
 York: Rizzoli, 1979.

PSIC *Painting and Sculpture in California: The Modern
 Era.* San Francisco: Museum of Modern Art, 1977.

PSIM *Painting and Sculpture in Minneapolis, 1820-1914*,
 by Rena Coen. Minneapolis: University of Minnesota
 Press, 1976.

PSMOMA *Painting and Sculpture in the Museum of Modern
 Art, 1929-1967.* New York: Museum of Modern Art,
 1977.

PSSF *Painting and Sculpture; The San Francisco Art As-
 sociation.* Berkeley: University of California
 Press, 1952.

PSTCA *Perceptions of Spirit in Twentieth Century Ameri-
 can Art.* Indianapolis, IN: Museum of Art, 1977.

PTCA *Philadelphia: Three Centuries of American Art.*
 Philadelphia: Museum of Art, 1976.

PTS *Painting in the South: 1564-1980.* Richmond:
 Virginia Museum, 1983.

PUSA *Painting in the U.S.A.*, by Alan D. Gruskin.
 New York: Doubleday, 1946.

QU *Quadrum* (periodical)

RAM *Ramparts* (periodical)

RAR *Realism and Realities; The Other Side of American
 Painting, 1940-1960.* New Brunswick, NJ: Rutgers
 University Art Gallery, 1982.

RARP *American Romantic Painting*, by Edgar P. Richard-
 son. New York: Weyhe, 1944.

RCAF *The Rites of Color and Form; Paintings, Prints,
 Ceramics and Sculpture by Earl Hooks and David
 Driskell.* Nashville, TN: Carl Van Vechten Gallery,
 1974.

RD *Reader's Digest* (periodical)

RFAA *Religious Folk Art in America; Reflection of Faith*,
 by C. Kurt Dewhurt, et al. New York: Dutton, 1983.

RISD *Rhode Island School of Design Museum Notes*
 (periodical)

RPIA *Painting in America: From 1502 to the Present*, by
 Edgar P. Richardson. New York: Crowell, 1965.

SA *School Arts* (periodical)

SACB *The Story of America*, by the Editors of Country
 Beautiful. Waukesha, WI: Country Beautiful, 1976.

SAH *Some American History*, by Larry Rivers. Houston, TX:
 Rice University, 1971.

SAQ *South Atlantic Quarterly* (periodical)

SBMAA *Six Black Masters of American Art*, by Romare Bear-
 den and Harry Henderson. Garden City, NY: Doubleday,
 1972.

SCJ *Schomburg Center Journal* (periodical)

SEP *Sepia* (periodical)

SFAC *Selections from the American Collections*. Memphis,
 TN: Brooks Memorial Art Gallery, 1975.

SFMA *San Francisco Museum of Modern Art: The Painting
 and Sculpture Collection*. New York: Hudson Hills
 Press, 1985.

SFQ *Southern Folklore Quarterly* (periodical)

SG *Survey Graphic* (periodical)

SIE *XXe Siecle* (periodical)

SLJ *School Library Journal* (periodical)

SLM *St. Louis Museum Bulletin* (periodical)

SMI *Smithsonian* (periodical)

SMIH *Studio Museum in Harlem Quarterly Bulletin*
 (periodical)

SNCAAA *Selections of Nineteenth Century Afro-American Art*,
 by Regina A. Perry. New York: Metropolitan Museum
 of Art, 1976.

SP *Studio Potter* (periodical)

SR *Saturday Review* (periodical)

SRV *Sculpture Review* (periodical)

SSAA *Smithsonian Studies in American Art* (periodical)

ST *Sharing Traditions: Five Black Artists in Nine-
 teenth Century America.* Washington, DC: Smith-
 sonian Institution Press, 1985.

STHR *Since the Harlem Renaissance; 50 Years of Afro-
 American Art.* Lewisburg, PA: Center Art Gallery of
 Bucknell University, 1985.

STU *Studio* (periodical)

SW *Southern Workman* (periodical)

SWA *Southwest Art* (periodical)

TAAP *Ten Afro-American Artists of the 19th Century;
 An Exhibition Commemorating the Centennial of Howard
 University,* by James A. Porter. Washington, DC:
 Howard University, 1967.

TAB *The Artist,* by Edmund Burke Feldman. Englewood
 Cliffs, NJ: Prentice-Hall, 1982.

TAM *The Artist's Mother; Portraits and Homages.* Hunt-
 ington, NY: The Heckscher Museum, 1988.

TCAA *Philadelphia: Three Centuries of American Art.*
 Philadelphia: Museum of Art, 1976.

TCAFA *Twentieth-Century American Folk Art and Artists,*
 by Herbert W. Hemphill, Jr., and Julia Weissman.
 New York: Dutton, 1974.

TCBA *Thirty Contemporary Black Artists.* Minneapolis,

MN: Institute of Arts, 1968.

TCBAA *Two Centuries of Black American Art*, by David C.
 Driskell. New York: Knopf, 1976.

TCNL *Contributions of Negro Artists in Louisiana*, by
 Morris T. Thomas. Pineville, LA.: n.p., 1973.

TEAAA *The Evolution of Afro-American Artists, 1800-1950.*
 New York: City College, 1967.

TFYA *Twenty-Five Years of the Artists Contemporary Gal-
 lery.* Sacramento, CA: Crocker Art Gallery, 1984.

THFY *Two Hundred and Fifty Years of Painting in Mary-
 land.* Baltimore: John D. Lucas, 1945.

THYAC *Three Hundred Years of American Art in the Chrys-
 ler Museum*, ed. by Dennis R. Anderson. Norfolk,
 VA: Chrysler Museum, 1975.

THYAP *Three Hundred Years of American Painting*, by
 Alexander Eliot. New York: Time, Inc., 1957.

THYAPC *Two Hundred Years of American Painting from Pri-
 vate Chicago Collections.* Evanston, IL: Terra Museum
 of American Art, 1988.

TIM *Time* (periodical)

TIMAPN *American Painting, 1900-1970.* New York: Time,
 Inc., 1970.

TNA *Ten Negro Artists from the U.S.; First World Festi-
 val of Negro Arts, Senegal, 1966.* New York: October
 House, 1966.

TNAP *The Negro Almanac; A Reference Work on the Afro-Ameri-
 can*, by Harry Ploski and Warren Marr. New York: Bell-

wether, 1976.

TNMA	*Treasures from the National Museum of American Art*. Washington, DC: Smithsonian Institution Press, 1985.
TNMP	*This New Man; A Discourse in Portraits*. Washington, DC: National Portrait Gallery, 1968.
TOYAP	*Two Hundred Years of American Painting: The Muson-Williams Proctor Institute*. San Francisco: Art Museum Association of America, 1986.
TRA	*The Responsive Arts*, by Judy Nagle. Sherman Oaks, CA: Alfred Pub. Co., 1980.
TTT	*They Taught Themselves; American Primitive Painters of the 20th Century*, by Sidney Janis. New York: Dial Press, 1942.
UA	*United Asia* (periodical)
UW	*Urban West* (periodical)
VIS	*Visions* (periodical)
VN	*Voice of the Negro* (periodical)
VO	*Vogue* (periodical)
VPTA	*The Vincent Price Treasury of American Art*, by Vincent Price. Waukesha, WI: Country Beautiful, 1972.
VVE	*Varieties of Visual Experience*, by Edmund Burke Feldman. New York: Abrams, 1972.
WA	*Women Artists; Recognition and Reappraisal, From the Early Middle Ages to the Twentieth Century*, by Karen Peterson and J.J. Wilson. New York: New York

University Press, 1976.

WAA *American Art*, by John Wilmerding. New York: Pen-
 guin, 1976.

WAAA *What is American in American Art*, by Mary Black.
 New York: Clarkson Potter, 1971.

WAAC *Women Artists in America; Eighteenth Century to the
 Present*, by Jim L. Collins. Chattanooga: n.p.,
 1973.

WAHC *Women Artists; An Historical, Contemporary and
 Feminist Bibliography*, ed. by Donna G. Bachmann
 and Sherry Piland. Metuchen, NJ: Scarecrow, 1978.

WAIH *Women Artists; An Illustrated History*, ed. by
 Nancy G. Heller. New York: Abbeville, 1987.

WAJ *Woman's Art Journal* (periodical)

WAMS *Wall Art; Megamurals and Supergraphics*, text by
 Betty Murken. Philadelphia: Running Press, 1987.

WAN *Women Artists News* (periodical)

WAWC *Women Artists in Washington Collections*, by Jo-
 sephine Withers. College Park: University of
 Maryland Art Gallery, 1979.

WBAH *Black Art in Houston; The Texas Southern Uni-
 versity Experience*, by John Weems. College Station:
 Texas A & M University Press, 1978.

WCBI *West Coast '74 Black Image*. Sacramento, CA: Crocker
 Art Gallery,1974.

WCSS *West Coast '76: The Chicago Connection*. Sacramento,
 CA: Crocker Art Gallery, 1976.

WEAL	*West '80; Art and the Law.* St. Paul: Minnesota Museum of Art, 1980.
WERK	*Werk* (periodical)
WINT	*Winterthur Portfolio* (periodical)
WJBS	*Western Journal of Black Studies* (periodical)
WLB	*Wilson Library Bulletin* (periodical)
WMAB	*Bulletin of the Whitney Museum of American Art* (periodical)
WT	*World Today* (periodical)
WWA	*Who's Who in America.* Chicago: Marquis, 1899- .
WWAA	*Who's Who in American Art.* New York: R.R. Bowker and the American Federation of Arts, 1936- .
WWABA	*Who's Who Among Black Americans.* Northbrook, IL.: Who's Who Among Black Americans, Inc.,1976- .
WWAE	*Who's Who in American Education.* Nashville: Who's Who in American Education, 1928- .
WWAW	*Who's Who of American Women.* Chicago: Marquis, 1958- .
WWCA	*Who's Who in Colored America.* Yonkers, N.Y.: Burkell, 1927- .
WWE	*Who's Who in the East.* Chicago: Marquis, 1943- .
WWW	*Who's Who in the West.* Chicago: Marquis, 1949- .
WWWA	*Who Was Who in American Art.* Madison, CT: Sound View Press, 1985.

YTCW *Yesterday and Tomorrow; California Women Ar-*
 tists. New York: Monarch Press, 1989.

INDEX TO BLACK ARTISTS

AARON, JESSE, 1887-1979; sculptor
Published Reproductions:
"Bulldog" cedar, fiberglass 1969 AA 42(3-90),169(c); AC 42
(6/7-82),23(c); AIM 70(Su-82),33; FA #114(11-83),32(c);
FW #49(11/12-84),cover(c)
untitled wood sc CLA #397(3-85),48

ABRAMSON, CHARLES; graphic artist
Published Reproductions:
"The Bending of Osa Nyin" mixed media 1986 AA 78(3-98),169
(c); AW 21(3-8-90),16

ADAIR, MARIA; painter
Published Reproductions:
untitled 1987 ICAA

ADAM, LAUREN; b. in Oakland, CA; mixed media
Portrait: CACE
Published Reproductions:
"Gracie's House" wood,paint,collage 1986 AW 17(12-6-86),6;
CACE

ADAMS, OVID P., 1931- ; graphic artist
Published Reproductions:
"Running Out of Time" SEP 22(4-73),72

ADAMS, RON, 1934- ; graphic artist
Biographical Sources: LAAA
Portrait: BAOA-1
Published Reproductions:
"Apropos the Mini-Car" ID 13(11-66),48
"Drawing" pencil drawing BAOA-1

"Drawing" pencil drawing BAOA-1
"Skull" ink wash 1968 LAAA

ADKINS, TERRY, 1953- ; b. in Washington, DC; mixed media
Biographical Sources: NGSBA
Published Reproductions:
"Gallis Pole" wood 1990 NGSBA(c)
"Leadbelly" painted wood sc 1989 BABC
"Mvet Jazar" wood 1989 NGSBA(c)
"Sigil Lithia" wood 1990 NGSBA(c)
"Sounds of Sculpture" mixed media 1989 NGSBA(c)

AHEARN, JOHN; painter
Published Reproductions:
"Car Painter" oil 1987 BABC

AIKEN, TA SOUMBA T.
Published Reproductions:
"Sun-Ra" BAQ 2(Wi-78),56

AKINS, JACQUES; sculptor
Portrait: SEP 19(1-70),27
Published Reproductions:
"Dean Martin" wood relief SEP 19(1-70), 27
"Kings Dream" wood SEP 19(1-70), 27
"Madonna" wood SEP 19(1-70), 27
"Mona Lisa" wood SEP 19(1-70), 27

ALEXANDER, LAWRENCE E.; painter
Published Reproductions:
"Andromeda Returns" oil WBAH

ALLEN, TINA, 1955- ; born in Grenada, West Indies
Biographical Sources: ESS 19(5-88),91
Published Reproductions:
"A. Phillip Randolph" bronze sc 1988 BAQ 9(#2-90),45
"Day's End" sc 1986 BAQ 9(#2-90),43; ESS 19(5-88),93(c)
"Ethiopia" sc ESS 19(5-88),91(c)
"Firebird" sc 1986 ESS 19(5-88),93(c)

"Gioya" sc 1988 ESS 19(5-88),93(c)
"Malcolm X" clay sc BAQ 9(#2-90),44
"Marcus Garvey" sc ESS 19(5-88),91(c)
"My Love" bronze sc 1987 BAQ 9(#2-90),42; BC 20(#1-89),158
 (c); ESS 19(5-88),92(c)
"Options Without His Cage" sc 1986 ESS 19(5-88),92(c)
"Spring Dance" bronze sc 1986 BC 20(#1-89),158(c)
Further References:
Anthony, Cynthia, "Tina Allen: Positive Validations," BAQ 9
 (#2-90),42-5.

ALLEY-BARNES, PAULINE; painter
Published Reproductions:
"Omawale" Seattle mural NALF 8(Fa-74),239

ALSTON, CHARLES HENRY, 1907-1977; b. in Charlotte, NC;
 painter
Biographical Sources: AAA; LAAA; MIAP; TNAP; WWAA,1970;
 WABA
Portrait: AN 65(9-66),48; CRI 84(8/9-77),351; EB 18
 (9-63),131; ILAAL
Published Reproductions:
"America, America" oil GAI
"Another On the Way" oil AG 11(4-68),46
"Back Room - Gin Mill" oil AAC; NA; NAHF; OPP 12(6-34),186
"Barn and Hayrick: Maine" watercolor LNIA
"Black Man and Woman - USA" oil 1967 AG 13(4-70),17(c); EB
 23(2-68),116(c); FAAA; GAI; HW 7(3rdQ-68),11(c); LAAA
"Blues Song" oil 1958 (LAAA)
"California Mural" oil PKAU; TNAP
"Dead End" oil 1956 APCS
"Exploration and Colonization" oil (Golden State) LAAA
"Family" oil 1955 (Whitney) AAAC; BAWPA; DANA; DBLJ;
 EB 29(12-73),38; FAAA(c); INS 98(2-89),56(c); TCBAA
"Family, No. 1" oil 1950 BC 3(5/6-73),27(c); ESS 2(4-72),66(c);
 ESS 4(11-73),22(c); ESS 4(12-73),29(c)
"Family, No. 4" oil 1968 CRI 76(2-69),94; CRI 78(11-71),cover
 (c); CRI 84(8-77),cover(c)
"Formal" oil AAAC

"Frederick Douglass" oil CRI 76(2-69),cover; CRI 77(1-77),16
"Girl in a Red Dress" oil 1934 AAAET(c)
"Head" wood sc LNIA
"Head of a Girl" oil OPP 12(6-34),186
"Head of a Woman" oil CRI 76(2-69),95
"Magic and Medicine" mural (Hospital) 1935 ART 52(10-77),12;
 BACW; DANA; LAAA; PMNA
"Martin Luther King, Jr." bronze 1970 NPG
"Modern Medicine" mural 1935 (Hospital) LNIA; ART 52(10-77),
 123
"Modern Science in Medicine" mural 1935 (Hospital)
 FAAA
"Mother and Child" pastel c1930 STHR
"Negro in California History" oil 1949 LAAA; TNAP
"Night People" oil AIPP
"Nobody Knows" oil 1965 AN 65(9-66),49
"Pieta" oil (Atlanta) CRI 76(2-69),96
"Primitive Medicine" oil mural (Harlem Hospital) FAAA; LNIA
"Settlement and Development" oil 1949 (Golden State) LAAA
"Sons and Daughters" oil 1966 DBLJ
"Torso" limestone sc c1950 (Howard) ANA 18(1948),128; DANA;
 FAAA
"Walking" oil 1958 CRI 76(2-69),95; FAAA
"Woman With Two Sons and Another on the Way" oil AG 11
 (4-68),46; EB 23(2-68),116(c)
Further References:
 "Charles Henry'Spinky'Alston, Artist and Teacher," ANA 18
 (1948), 351-4.
 Glueck, Grace, "The Best Painter I Can Possibly Be," NYT
 (12-8-70), 8.

ALSTON, FRANK H., 1913- ; b. in Providence, RI; painter
Biographical Sources: AAA
Portrait: DANA
Published Reproductions:
 "The President's House" oil (Howard) BACW

AMEVOR, CHARLOTTE, 1932- ; b. in New York City; painter
Biographical Sources: AAA

Portrait: FSBA
Published Reproductions:
 "Determination" oil FSBA
 "Village Drummers" oil FSBA
Further References;
 Fax, Elton. *Seventeen Black Artists*. New York: Dodd,Mead, 1971.

AMOS, EMMA, see **LEVINE, EMMA AMOS**

ANDERSON, ALLIE, 1921- ; sculptor
Published Reproductions:
 "Specter of River Rouge" welded steel 1969 LAAA

ANDREWS, BENNY, 1930- ; b. in Madison, GA; mixed media,
 painter
Biographical Sources: BDCAA; FAAA; WWAA,1991; WWABA
Portraits: AG 11(4-68),36; BA 1(Su-77),45; FSBA; NEW
 75(6-22-70),89; TIM 97(4-12-71),64
Published Reproductions:
 "Amen Corner" litho BAQ 7(#4-87),23(c)
 "American Gothic" oil 1971 (Metropolitan) AA 52(4-88),44(c)
 "Apple Pie" oil collage 1969 AAASN
 "The Blacksmith" AN 89(10-90),186
 "Brownie" acrylic 1980 AN 80(3-81),228
 "The Champion" oil and collage 1967 AAAC; AANB; AR 44
 (Su-70),18; BC 3(5/6-73),27(c); ESS 4(11-73),22(c); ESS 4
 (12-73),29(c); FAAA; NEW 75(6-22-70),89
 "Coming Storm" acrylic,collage 1987 AV 3(4-88),26(c)
 "Cop" etching WEAL
 "Death of the Hero" acrylic,collage 1987 AV 3(4-88),28(c)
 "Did the Bear" oil 1969 ABA 1(#1-72),7; STHR
 "Dinnertime" oil 1965 BLC
 "Dreamer" oil,collage 1970 (High) APHM
 "Eulogy" oil 1967 AG 11(4-68),35
 "Eve" oil and collage 1977 AR 52(6-78),35
 "Every Man" collage sc 1968 BAOA-2
 "First Day" oil 1965 FAAA
 "Fliers" acrylic,collage 1971 BC 19(#1-88),134
 "Flight" 1978 ART 53(3-79),52; ART 55(12-80),26

"Georgian Funeral" ink 1965 BDCAA
"Guitar Man" oil,collage 1970 FBA(c)
"Here Comes the Wind" acrylic IOL(c)
"Intruder" mixed media 1964 STHR
"L.D." oil and collage 1969 ARTF 9(1-71),82
"Man and His History" oil,collage AG 13(4-70),14
"Mama" oil,collage ATL 12(#9-73),15
"Meditation" oil,collage 1962 BAOA-2
"Mesa" mixed media 1981 ART 56(12-81),52
"Miss Emma" oil,collage 1988 AV 4(4-89),18(c)
"Miss Maggie" AN 77(4-78),188(c); ART 52(3-78),73
"Ms Liberty" oil,collage 1978 AAN
"Mules Communicating" acrylic,collage 1987 AV 3(4-88),27(c)
"Nice and Easy" ink 1970 LAAA
"No More Games" oil,cloth 1970 (Modern Art) FAAA
"One of Twelve Parts of Trash" oil,collage 1971 OAAL(c)
"Operation" etching 1972 BAQ 6#4-85),20
"Portrait of Despair" oil,collage EB 41(5-86),46(c)
"Portrait of Alice Neel" oil AA 52(4-88),45
"Portrait of Duchamp" oil 1985 AA 52(4-88),45
"Portrait of George Andrews" oil 1986 AA 52(4-88),42(c)
"Portrait of Norman Lewis" oil AV 4(6-89),23(c)
"Portrait of Ray Johnson" oil 1986 AA 52(4-88),44; AIM 75
 (6-87),158(c)
"Portrait of the Preacher" oil,collage 1987 AV 44-89),20(c)
"Portrait of Viola Andrews" oil,collage 1986 AA 52(4-88),43(c);
 TAM(c)
"Presence" acrylic 1975 ART 50(1-76),25
"Put Up" ink 1971 LAAA
"Serenity" AIM 71(5-83),166(c)
"Set Up" oil,collage 1982 BC 19(#1-88),134(c)
"Sexism" oil,collage 1974 ENC 4(2-3-75),23
"Sexism Study #22" oil,collage 1973 AIM 63(3-75),1(c)
"Struggle Study #2" AN 84(Su-85),122
"Strung Out" oil,collage 1971 AIM 63(3/4-75),134
"Study for War, No. 16" oil,collage 1974 ART 49(6-75),7
"Symbols" oil,collage 1971 ENC 4(2-3-75),23; PTS
"Teacher" oil ENC 4(2-3-75),10; FSBA
"Thanksgiving" oil,collage 1988 ARTF 27(4-89),169

"Trash" oil,collage 1971 BAQ 6(#4-85),20; FAAA
untitled oil AIM 61(1-73),128
untitled AN 81(9-82),38
untitled BE 6(12-75),61(c)
untitled ink 1970 MN 60(1/2-82),27
"War" oil,collage 1974 AIM 63(3-75),1(c)
"War (Study No. 16)" oil,collage 1974 AR 49(6-75),7
"War Baby" oil,collage 1968 AGW; BAOA-2(c); LAAA(c)
"Witness" oil,collage 1968 FBA(c)
"Woman" mixed media (Chrysler) THYAC
Further References:
Campbell, M.S., "Critical and Cynical," AN 74(10-75),81-2.

ARCHER, EDMUND MINOR, 1904- ; b. in Richmond, VA; painter
Biographical Sources: WWAA,1978; WWWA
Published Reproductions:
"Howard Patterson of the Harlem Yankees" oil 1940 (Whitney)
PNAP

ARGUDIN, Y PEDROSA, 1889-?; b. in Havana, Cuba; painter
Published Reproductions:
"Breton Women: Concarneau" oil LNIA
"Bretons Coming From the Market Place" oil LNIA
"The Gardens of Versailles" oil LNIA

ARNOLD, ANNA; b. in South Euclid, OH; mixed media
Portrait: EAFA
Published Reproductions:
"Balancing Act" mixed media 1984 EAFA
"The Harlequin" mixed media 1984 EAFA(c)

ARNOLD, RALPH, 1928- ; b. in Chicago; graphic artist,
painter
Biographical Sources: WWAA,1984; WWABA
Published Reproductions:
"Celebration" crayon,pencil DCBAA
"Fan" acrylic 1974 DIAA
"Market Place" acrylic 1974 DIAA
"The Sum of Two Numbers" oil,collage EB 29(12-73),39(c)

untitled litho PANA(c)

ARTIS, WILLIAM ELLSWORTH, 1914-1977; b. in Washington, NC;
sculptor
Biographical Sources: AAA; BAOA-2; MIAP; TCBAA; TNAP;
WWABA
Portrait: BAOA-2; BA 1(Su-77),21; DANA
Published Reproductions:
"African Youth" ceramic sc 1940 DANA; ENC 5(12-20-70),23;
PHY 6(2ndQ-45),120; TCBAA; TIM 45(4-9-45),65
"C.C. Spaulding" plaster sc 1947 DANA
"Draped Head" plaster sc 1941 LI 21(7-22-46),63; NAI
"Head of a Boy" terra cotta sc 1940 (Fisk) AAR 3(11/12-76),111
(c); ANA 11(10-76),10; ATO(c); TCBAA
"Head of a Girl" plaster sc DANA; SW 62(4-33),179
"Head of a Negro Boy" ATO(c); PMNA
"Head of a Woman" sc ATO
"Head of Boy" plaster sc LNIA
"Louis Tompkins Wright" terra cotta sc 1946 NPG
"Michael" terra cotta sc 1962 (Raleigh) ATO; BAOA-2; NSR 20
(Fa-71),13
"Nylsterier" 1967 AUSA
"Quiet One" sc 1951 AJ 30(Sp-71),322; TIM 57(4-9-51),89
"Six Heads" DANA
"Supplication" terra cotta sc 1971 AUSA; LAAA; NSR 20
(Wi-71/2),8
"Woman With Kerchief" terra cotta sc (Atlanta) SRV 37(#1-88),27
Further References:
"Racial Strength," TIM 57(4-9-51),89.
Weinman, Robert, "Art...Evidence of the Spirit," NSR 20(Wi-71),
8-13.

ASANTEY, KWAI SEITU, 1942- ; b. in Jackson, MS.; painter
Biographical Sources: WWAA, 1978
Published Reproductions:
"Black Cowboys" acrylic DIAA
"The Greatest" acrylic 1971 BC 2(11/12-71),24; EB 27(12-71),
66-7.
"Jack Johnson" acrylic BC 2(11/12-71),24; EB 29(12-73),42(c)

ASHBY, STEVE, 1904-1980; b. in Delaplane, VA; painter, mixed media
Biographical Sources: BFAA
Portrait: BFAA
Published Reproductions:
"Cat Head" mixed media 1970 AC 42(6/7-82),20(c); BFAA(c)
"Figure" mixed media 1974 BFAA
"Goat" mixed media 1970 BFAA
"Man With Scythe" wood,paint,cloth,metal c1978 BFAA
"Mermaid" wood,metal c1965 BFAA
"Pregnant Woman" mixed media c1970 BFAA(c)
"Standing Woman in Red Striped Skirt" painted wood,cloth c1970 BFAA(c)

AULD, ROSE A., 1946- ; b. in Washington, DC; painter
Biographical Sources: FFAA
Portrait: FFAA
Published Reproductions:
"Jubilation" acrylic 1978 FFAA(c)

AUSBY, ELLSWORTH, 1942- ; b. in Portsmouth, VA; painter
Biographical Sources: AAA; WWAA,1991
Portrait: DIAA
Published Reproductions:
"Ancestral Spirit" acrylics AAANB
"Imperialism" acrylics 1968 NBA
"Madonna and Child" pastel 1969 SAH(c)
"Portrait of Harriet Tubman" pastel 1969 SAH(c)
"Portrait of Sojourner Truth" pastel 1969 SAH(c)
"Reptiles" acrylics 1968 NBA
"Shabazz" acrylic 1974 DIAA
"Spirits Revisited #1" oil 1970 FUF
"Sunrise - Sunset" acrylic 1974 DIAA
untitled oil 1970 AIM 58(9-70),61
untitled acrylic BCR 3(Sp-72),40
untitled painted wood DCBAA
untitled oil ENC 1(9-72),56
Further References:

Combs, Orde, "Ausby Paints That Special Feeling," ENC 1(9-72),
 56-7.
Rose, Barbara, "Black Art in America," AIM 58(9-70),61.
Williams, Randy, "Ellsworth Ausby and Bill Rivers: Artists of the
 Soul," BC 3(Sp-72),40-2.

AVERY, HENRY, 1906- ; b. in Morganton, NC; painter, sculptor
Biographical Sources: AAA; MIAP; WWAA,1940; WWWA
Published Reproductions:
 "Martha Seated" oil LNIA
 "Still Life" tempera LNIA
Further References:
 Motley, Willard F., "Negro Art in Chicago," OPP 18(12-15-41),19-
 22.

AXT, CHARLES, 1935- ; b. in New York City; painter, sculptor
Published Reproductions:
 "Female Form" mahogany sc NBAT

AYERS, ROLAND, 1932- ; b. in Philadelphia; graphic artist
Published Reproductions:
 "Atlantis Rising, II" ink on paper DCBAA

BACCHUS, JOAN; painter
Published Reproductions:
 "Medgar Evans" pastel CRI 80(6/7-73),cover(c)
 "Minority Cooperation" pastel CRI 80(6/7-73),cover(c)
 "Mother and Child" pastel FRE 15(1stQ-74), cover
 "The Three Kings" oil CRI 84(12-77),cover(c)

BACOT, ANNABELLE; painter active in Washington, DC in 1970s
Biographical Sources: DENA
Portrait: DENA
Published Reproductions:
 "Field Flowers" oil DENA

BAILEY, CALVIN, 1915- ; b. in Philadelphia; painter
Biographical Sources: BDCAA
Published Reproductions:

"Calvin Bailey," BDCAA; EB 8(10-53),81-4
"Old Man" oil 1968 BDCAA(c)
"Solo Session" oil 1958 BDCAA(c)

BAILEY, HERMAN KOFI, 1931-81; painter, printmaker
Biographical Sources: LAAA
Portrait: BAQ 4(#4-81),25
Published Reproductions:
 "Birth" mixed media LAAA
 "The Carpenter" ND 16(7-67),53
 "Dead Man" 1970 RHY 1(#1-70),22-3
 "Dr. DuBois" acrylic BAQ 8(#2-88),15(c)
 "Gabriel" BSC 14(1/2-83),cover
 "Hausa Boy" charcoal wash LAAA
 "Mother and Child" (Golden State) BAQ 2(Sp-78),36
 "Martin Luther King, Jr. and the Poor People's Campaign" mixed
 media BAQ 8(#2-88),49
 "Our Image" mixed media BAQ 8(#2-88),63(c)
 "President Kwame Nkrumah" BAQ 4(#4-81),27
 "Unity" mixed media 1961 LAAA
 untitled BSC 14(9/10-83),cover
 untitled drawing BAQ 2(Sp-78),37
Further References:
 Graham, Lorenz, "Herman Kofi Bailey," BAQ 4(#4-81),25-8.

BAILEY, MALCOLM, 1947- ; b. in New York City; painter
Biographical Sources: FAAA; WWAA,1978
Portrait: FAAA
Published Reproductions:
 "Hold (Separate But Equal)" FAAA; GOY(1-70),237; TIM 95
 (4-6-70),80(c)
 "How to Beat a Pig" acrylic AAANB
 "Separate But Equal Series" acrylic 1969 AIM 58(9/10-70),62
 untitled (head) acrylic AG 13(4-70),cover(c)
 untitled (slave ship) acrylic 1969 AIM 58(9-70),62
 untitled (standing figures) acrylic AIM 58(9-70),62
 "Untitled No. 4" enamel on plexiglass 1971 ARI 17(1-73),66
 "Untitled No. 7" enamel on plexiglass FAAA(c)
Further References:

Fine, Elsa H., "Mainstream, Blackstream and the Black Art Movement," AJ 30(Su-71),374-5.

BAKER, ANNABELLE, 1925- ; b. in Hampton, VA; painter
Biographical Sources: AAA; WWWA
Published Reproductions:
"Laundry Woman" oil DES 46(9-44),20

BALLARD, E. LORETTA; painter
Biographical Sources: DENA
Portrait: DENA
Published Reproductions:
"Space" wood collage DENA

BALLENTINE, JENE, 1942- ; b. in Memphis, TN; painter
Biographical Sources: AAA
Published Reproductions:
"Born Free" 1968 BAOA-1
"Had I Been Bold or Slightly Brave" 1967 BAOA-1

BANJO, CASPER, 1942- ; born in Memphis, TN; sculptor
Biographical Sources: AAA; WWABA
Portrait: BAOA-2
Published Reproductions:
untitled wood sc BAOA-2

BANKS, BILL; painter active in Washington, DC in 1970s
Biographical Sources: DENA
Portrait: DENA
Published Reproductions:
"The Journey to the Mountain Top" oil DENA

BANKS, ELLEN, 1938- ; b. in Boston; painter
Biographical Sources: AAANB; WWABA
Portrait: NEW 75(6-22-70),89
Published Reproductions:
"Black and White Plus #180" acrylic 1970 AAANB
"Black and White Plus #194" acrylic 1970 AAANB

BANKS, JOHN W., 1912- ; b. in Seguin, TX; mixed media
 Biographical Sources: BHBV
 Portrait: BHBV
 Published Reproductions:
 "African Life on the Safari" felt tip 1982 BHBV
 "Baptism" pen,crayon BHBV
 "Second Coming of Christ" pen,paint BHBV
 "Selling of Slave in Makon, Georgia" pen 1985 BHBV
 untitled crayon,marker 1982 BHBV

BANNARN, HENRY WILMER, 1910- ; b. in Wetunka, OK; painter,
 sculptor
 Biographical Sources: MIAP; WWAA,1940
 Portrait: DANA; NAI
 Published Reproductions:
 "Daywork" stone sc (Atlanta) DANA
 "John Brown" limestone sc DANA; LNIA
 "Lynch Victim" wood sc AN 41(1-15-43),10
 "Portrait" sc (Harmon) DANA
 "Winter Sports" oil AD 19(4-15-43),10; PHY 6(2ndQ-45),101
 "Woman Scrubbing" sc LNIA
 Further References:
 "Negro Annual," AD 17(4-15-43),14

BANNISTER, EDWARD MITCHELL, 1828-1901; b. in St. Andrews,
 New Brunswick; d. in Providence, RI; painter
 Biographical Sources: AAAC; BHBA; FAAA; GNNP3; LAAA;
 MIAP; SNCAAA; TCBAA
 Portrait: CRI 11(1933),248
 Published Reproductions:
 "After the Shower" oil c1895 (African Art) AIS 5(Su/Fa-68),258; FAAA
 "After the Storm" oil 1875 (Rhode Island) DANA; PMNA
 "Approaching Storm" oil 1886 (African Art) AAATC; AAW; AG
 13(4-70),4(c); DBLJ; EB 23(2-68),cover(c); FAAA(c); HW 7
 (#3-1968),18(c); LAAA(c); ST(c); TCBAA; TEAA; WAA
 "At the Oakside Beach" oil 1877 RISD 63(4-77),58
 "By the Brook" oil 1877 (Providence) LNIA
 "Christian Carteaux Bannister" oil ST
 "Dorchester, N.H." oil 1856 KQ 10(4-71),181; ST

"Driving Home the Cows" oil 1881 (African Art) ILAAL; LAAA; TCBAA

"Fishing" oil 1881 EB 32(2-77),33(c); RD 112(6-78),177(c); TCBAA(c)

"Five Cows in a Pasture" oil 1892 ST

"Flower Study" oil (Providence) DANA

"Governor Sprague's White Horse" oil 1869 (Rhode Island) APRIHS

"Homeward" oil 1895 ST

"Lady With Bouquet" oil AAAC

"Landscape" oil PMNA

"Landscape" oil 1881 (Providence) AAAC; LNIA

"Landscape" oil 1879 BACW

"Landscape" oil 1879 BACW

"Landscape" oil 1882 (Rhode Island) LAAA; PMNA

"Landscape" oil 1895 TAAP

"Landscape Near Newport, Rhode Island" oil c1877 ST

"Landscape With Home" oil BE 17(12-86),90(c)

"Landscape With a Boat" oil 1898 AAAET(c)

"Landscape With Man on Horse" oil 1884 ST

"The Milkmaid" oil 1882 CRI 11(1933),248; DBLJ

"Moon Over a Harbor" oil c1868 ST

"Newspaper Boy" oil CBAR; SMI 7(10-76),86(c); ST; TCBAA

"Oak Trees" oil 1870 (African Art) ST; TCBAA(c)

"Sabin Point" oil 1875 (Brown) DANA

"Sad Memories" pencil 1882 DANA; FAAA

"Seaweed Gatherers" oil 1898 (Smithsonian) AAAZ(c); ST

"Street Scene" oil 1895 (Rhode Island) FAAA; LAAA; RISD 63 (4-77)18(c)ST

"Sunset" oil 1875 ST

"Swale Land" oil 1898 (African Art) FAAA; LAAA

"Under the Oak Tree" oil 1895 AAAZ(c)

untitled watercolor c1885 (African Art) BAQ 2(Wi-78),59

Further References:

Brown, John S., "Edward Mitchell Bannister," CRI 40(11-33),248.

Skerett, Joseph, "Edward M. Bannister, Afro-American Painter (1828-1901)," NHB 41(5/6-78),829.

Wellington, Muriel, "Edward M. Bannister," NHB 5(10-41),18.

BARNES, CURTIS R.; painter

Published Reproductions:
"Omowale" Seattle mural NALF 8(Fa-74),cover

BARNES, ERNIE E., JR.; b. in Durham, NC; painter
Biographical Sources: AAA; WWABA
Published Reproductions:
"The American War Game" acrylic EB 28(3-73),40(c)
"Coffee Break" acrylic ESS 15(7-84),100(c)
"Come Sunday" acrylic BC 10 (#4-80),222(c); EB 33(3-78),7(c)
"Contact" acrylic EB 28(3-73),41
"Cup Protection" acrylic EB 28(3-73),42
"Den Iniquity" acrylic EB 28(3-73),40
"Dreams" acrylic EB 28(3-73),42(c)
"The Finish" poster PEO 22(7-9-84),55
"First, Second, Third" CRI 90(5-83),cover(c)
"Fist City" acrylic BE 17(12-86),85(c)
"From Here On Up" acrylic EB 28(3-73),41
"The Graduate" acrylic BC 10(#4-80),222(c); EB 33(3-78),7(c)
"High Aspirations" acrylic 1971 BC 10(#4-80),222(c); EB 33
 (3-78),7(c)
"Jake" acrylic 1969 BC 10(#4-80),223(c) EB 28(3-73),42(c); EB
 33(3-78),7(c)
"99-100" acrylic BC 10(4-80),223(c); EB 33(3-78),7(c)
"The Plan" acrylic EB 28(3-73),44(c)
"Relay" acrylic ESS 15(7-84),99(c)
"Rhythmic Gymnast" poster ESS 15(7-84),100(c)
"The Runner" acrylic EB 28(3-73),41(c)
"Shea Stadium at Night" acrylic EB 28(3-73),42(c)
"Storyteller" acrylic BC 10(#4-80),223(c); EB 33(3-78),7(c); EB
 33(3-78),7(c)
"Strike" acrylic EB 28(3-73),42(c)
"Sugar Shack" acrylic EB 33(3-78),7(c)
untitled acrylic EB 28(3-73),42(c)
untitled NEW 103(3-26-84),12
Further References:
"An Ex-Pro Football Lineman, Ernie Barnes Comes Out of the
 Trenches to Score as an Olympic Artist," PEO 22(7-9-84),5,59.
Keerjoda, Eileen, "The Athlete as Artist,"NEW 103(3-26-84),12.
Robinson, Louie, "The Violent Brush of Ernie Barnes," EB 28(3-73),

40-50.

BARNSLEY, JAMES MACDONALD; painter
Published Reproductions:
 "Paris Evening" oil 1883 BACW

BARTHE, RICHMOND, 1901-89; b. in Bay St. Louis, MO; painter,
 sculptor
 Biographical Sources: BHBA; GNNP3; LAAA; NAI; TCBAA;
 TNAP; WWABA
 Portrait: AD 17(8-43),15; DES 44(2-43),16; EB 18(9-63),131;
 ILAAL; NAHF; OFF 18(7-40),cover
 Published Reproductions:
 "Abraham Lincoln" sc AD 15(5-15-41),6; EB 1(12-45),46
 "African Boy Dancing" bronze sc PAR 12(3-40),10; SRV 37
 (#1-88),26
 "African Dancer" plaster sc 1933 (Whitney) AN 41(4-1-42),14;
 BAAL(c); BAQ 6(#1-84),5; FAAA; HHR; LNIA; PAR 12
 (3-40),13; TNAP
 "African Head" plaster sc AD 9(8-35),18; BMQ 22(7-35),138
 "African Man" bronze sc NAF
 "African Woman" bronze sc NAF; OPP 13(7-35),219
 "Angry Christ" sc AD 20(5-1-46),11; AJ 30(Wi-70-1),165; AN 20
 (5-1-46),11; EB 1(8-46),46
 "Awakening of Africa" bronze sc c1968 ND 16(5-57),53; NSC
 18(Fa-69),9
 "Benga" bronze sc 1935 BAQ 7(#4-87),57(c)
 "Birth of the Spirituals" sc CTAL
 "Blackberry Woman" bronze sc 1932 (Whitney) ALIA; BAQ 1
 (Fa-76),13 DANA; DES 44(2-43),16; FAAA; LAAA; LNIA;
 NSC 25(F-76),3; NBAT; LNSR 25(Fa-76),3; PAR 12(3-40),10;
 SA 70(11-70),30; SA 79(10-79),59; TNAP
 "Blanche" sc CTAL; OPP 17(4-39),135
 "Booker T. Washington" bronze sc 1946 BAQ 8(#2-88),9; CRI 53
 (6-46),186; DANA; EB 1(9-46),35; NPG; NSR 27(Sp-78),17;
 OPP 6(11-28),334; OPP 24(Fa-46),204
 "Boxer" bronze sc 1942 (Metropolitan) AN 41(1-1-43),15;
 FAAA; NEWO 3(#1-76),29; OPP 21(1-43),18; PMNA; TCBAA
 "Boy With Flute" bronze sc 1940 (Harmon) ILAAL

"The Breakaway: Dance Figurine" AMA 23(9-31),219; CTAL; LNIA

"Bust of Dr. Trevor Arnett" sc AD 22(9-48),18; AN 47(9-48),56

"Canada Lee" plaster sc c1940 (Schomburg) FAAA

"The Comedian" sc OPP 6(11-28),334

"Dance" marble relief 1938 (Harlem) DANA; FAAA; LNIA; PAR 13(3-40),15

"Dance From the Green Pastures" PAR 12(3-40),11

"Dawn Radin" NAHF

"Edgar Kaufman, Jr." PAR 12(3-40),12

"Exodus" marble relief DANA; FAAA; PAR 12(3-40),12

"Fallen Aviator" bronze sc NAI

"Feral Benga" bronze sc 1935 (Newark) ATO; DANA; HHR; LNIA

"Figure" bronze sc BAQ 1(Wi-76),29; MN 60(1/2-82),41

"General Dessalines" sc DANA

"George Washington Carver" bronze sc AAAC; DANA; EB 32 (7-77),103; NSR 27(Sp-78),17

"Harmonica Player" bronze sc 1934 PAR 11(3-39),29; PAR 12 (3-40),12; PNIA

"Harold Kreutzberg" sc AN 45(2-47),48; LNIA; PAR 12(3-40),15

"Head" bronze sc BAQ 6(#1-84),13; LIF 21(7-22-46),62; OPP 6 (11-28),334

"Head of a Woman" plaster sc c1933 (Fisk) ENC 5(12-20-76),23; TCBAA

"Henry Tanner" bronze sc 1928 DANA

"James Weldon Johnson" sc SG 31(11-42),454

"Jimmy Daniels" marble sc AD 21(2-15-47),17; BAQ 6(#1-84),16; LNIA; OPP 17(5-39),cover

"John Gielgud as Hamlet" AN 39(12-21-40),6

"John the Baptist" plaster sc 1946 (Phillips) AWAP; DES 44 (2-43),17

"The Jubilee Singer" bronze sc OPP 6(11-28), cover

"Judith Anderson" bronze sc (Harmon) ILAAL

"Julius" bronze 1942 (Pennsylvania) ATO

"Katherine Cornell" sc AD 19(4-1-45),56; NPG; NSR 27(Sp-78), 17; PMNA

"Kalombwan" bronze 1934 (Hampton) ATO

"Langston Hughes" drawing 1930 DANA; NHB 1(5-38),5; NHB 17(4-54),164

"Laurence Olivier" bronze sc DANA
"Lot's Wife" bronze NSR 14(Wi-65-66),11
"Male Figure" AN 45(9-46),42; NAHF; OPP 13(7-35),209
"Mangbetu Woman" plaster sc (DuSable) ATO
"Marathon Runner" 1938 AJ 31(S-72),400
"Mary" bronze DANA
"Mary M. Bethune" bronze sc BAQ 8(#2-88),52
"Masai Man" bronze sc 1933 BAQ 7(#4-87),56(c); BAQ 9(#1-90),
 57(c); BAQ 9(#2-90),cover(c)
"Mask of Boy" AD 5(2-15-31),219; CTAL
"Maurice Evans as Richard III" bronze sc AN 41(4-1-42),14
"Moses, Aaron, and Hezekiah" marble relief 1938 (Harlem)
 FAAA; LNIA
"The Mother" sc BC 1(Wi-72),45; CRI 46(4-39),120; CTAL; OPP
 17(5-39),132
"Mother and Son" plaster sc 1939 LNIA
"Mrs. Bethune" bronze sc BAQ 6(#1-84),12
"Negro Athlete" sc CRI 77(2-70),51
"The Negro Looks Ahead" plaster sc c1944 (Schomburg) AV 1
 (7/8-86),62; DANA; FAAA; HRABA
"Paul Laurence Dunbar" sc OPP 6(11-28),334
"Paul Robeson as Othello" bronze sc BAQ 8(#2-88),53
"Portrait of Harold Jackman" charcoal 1929 AAAET(c)
"Portrait of Maurice Evans" AN 41(4-1-42),14
"Ram Gopal" sc DANA
"Rose McClendon as Serena" plaster sc LNIA; PAR 12(3-40),16
"Sacred Heart" sc AD 23(1-15-49),9; LIF 17(2-49),48
"Seated Figure" AN 43(10-1-44),7
"The Seeker" sc BAQ 6(#1-84),20
"Self-Portrait" PAR 12(3-40),10
"Shoe Shine Boy" sc 1938 AD 13(3-1-39),20; DANA; LNIA; PAR
 12(3-40),176; PMNA
"Singing Slave" bronze sc 1940 (Schomburg) AG 13(4-70),8(c);
 CTAL; EB 23(2-68),122; FAAA; HRABA; HW 7(3rdQ-68),10(c)
"Spanish Woman and Child" NEW 14(7-24-39),39
"Stevedore" bronze sc (Harmon) DES 44(2-43),16; LNIA; NEW
 13(2-6-39),26; PKAU; TNAP
"Supplication" bronze sc c1948 AN 47(3-48),20; FAAA
"Unknown Dancer" bronze (Yale) ATO

untitled BAQ 6(#1-84),16
untitled bronze sc MN 60(#1/2-82),41
"West Indian Girl" 1930 AD 5(2-15-31),219; MA 23(9-31),210
"Wetta" bronze sc DANA; LAAA; MA 32(4-39),232; NAHF
Further References:
Locke, Alain, "Sculpture of Barthe," DES 44(2-43),16-17.
"Painter's Paradise," EB 9(7-54),95-8.

BASQUIAT, JEAN MICHEL, 1960-1987; painter
Portrait: AN 88(1-89),96
Published Reproductions:
 "Back of the Neck" AN 83(10-84),86(c)
 "Baptism" AIM 70(1082),35
 "Bird as Buddha" ARTF 23(10-84),91
 "Black Picasso and the Lie Detector" DOM #642(9-83),99
 "Brown Sots" 1984 AN 88(1-89),99; FA #119(11-84),41
 "Carbon/Oxygen" acrylic 1984 APG(c)
 "Catharsis acrylic 1983 AW 16(5-11-85),4
 "Crash Crop" acrylic 1984 AIM 72(Su-84),55(c)
 "Crosby Street" acrylic,oil 1984 ART 60(10-85),62
 "Danny Rosen" mixed media 1983 STHR
 "Deaf" acrylic AN 83(9-84),167
 "Despues de un Puno" acrylic 1987 ART 63(11-88),25(c)
 "Discography II" acrylic 1983 ARTF 25(5-87),119(c)
 "Embittered" FA #133(4-87),115
 "Eroica II" 1988 AN 88(1-89),98(c)
 "Famous Moon King" AIM 78(6-90),103(c)
 "Famous Negro Athlete #47" ARTF 20(12-81),36
 "Flash in Naples" mixed media 1983 AAN
 "Glassnose" 1987 NR 199(11-21-88),34
 "Grillo" oil 1984 ART 59(5-85),140
 "Gringo Pilot" ARTF 20(12-81),42
 "Hardware Store" acrylic 1983 ARTF 22(9-83),7(c)
 "Hector" acrylic 1983 ARTF 25(5-87),116(c)
 "His Glue-Sniffing Valet" oil 1984 ART 59(5-85),14(c)
 "History of Black People" acrylic 1983 ARTF 28(12-89),53(c)
 "Hospital Painting" acrylic ARTF 23(2-85),99
 "Humidity" GD #90(6-83),26(c)
 "Iscarus Esso" acrylic,oil AIM 78(1-90),27(c)

"Jersey Joe" acrylic 1983 ARTF 25(5-87),118(c)

"K" acrylic PAN 42(4/6-84),177

"Levitation" 1987 ARTF 26(2-88),8(c)

"Masonic Lodge" acrylic,oil 1983 ART 60(10-85),62

"Maurice" acrylic 1983 ARTF 25(5-87),117(c)

"Max Roach" 1984 ARTF 23(1-85),b.cover(c)

"Mona Lisa" 1983 ARTF 22(6-84),66

"Moses and the Egyptians" acrylic 1983 AIM 72(1-84),19(c);
 ARTF 25(5-87),118(c)

"MP" 1984 AN 88(1-89),101(c)

"Painting #23" (with A. Warhol) acrylic 1984 ARTF 23(4-85),
 cover(c)

"Parts" oil 1984 ART 59(5-85),141

"Pater" acrylic ART 60(2-86),130

"Phillistines" acrylic FA #115(1-84),28

"Portrait of Jean Kallina" DOM #646(1-84),66

"Price of Gasoline in the Third World" mixed media 1982 ARTF
 21(3-83),13(c)

"Respo Mundial" ARTF 20(12-81),35

"St. Joe Louis Surrounded By Snakes" AN 88(1-89),100

"Samo Is Dead" ARTF 20(12-81),43

"Slaveships: Tobacco" 1984 AN 89(5-90),103(c)

"Tar and Feathers" 1982 AN 88(1-89),98(c)

"Three Eighty Seven" oil ARTF 28(2-90),118(c)

"To Repel Ghosts" acrylic 1986 ARTF 25(5-87),120(c)

untitled AIM 77(10-89),23(c)

untitled ARTF 24(Su-86),49(c)

untitled ARTF 24(5-86),cover(c)

untitled DOM #641(7/8-83),37(c)

untitled FA #139(3/4-88),98(c)

untitled NEWY 21(9-26-88),36(c)

untitled NEWY 21(9-26-88),38(c)

untitled NEWY 21(9-26-88),39(c)

untitled NEWY 21(9-26-88),40(c)

untitled NEWY 21(9-26-88),41(c)

untitled NEWY 21(9-26-88),42(c)

untitled NEWY 21(9-26-88),44(c)

untitled acrylic 1984 AIM 77(11-89),95(c)

untitled acrylic AIM 77(11-89),24(c)

untitled acrylic AIM 78(5-90),12(c)
untitled installation 1982 ART 57(12-82),81
untitled mixed media 1981 ARTF 27(3-89),130
untitled mixed media 1981 BABC(c)
untitled collage 1984 HAL
untitled acrylic,oil 1982 STHR
untitled acrylic,oilstick,canvas 1983 CACF(c)
untitled oil 1985 ART 59(5-85),140
"Walking on Sunshine" DOM #646(1-84),67
"World Crown" ARTF 20(12-81),42
Further References:
Decker, Andre, "The Price of Fame," AN 88(1-89), 96-101.
Hoban, Phoebe, "Samoa is Dead," NEWY 21(9-26-88),36-44.
Robert Hughes, "Requiem for a Featherweight," NR 199(11-21-88), 34-36.

BEARD, DANIEL CARTER, 1850-1941; b. in Cincinnati; painter
Biographical Sources: WWWA
Published Reproductions:
"Amused" oil EAAA
"Love's Crucible" oil EAAA
"Lumberman" oil EAAA
"Waiting" oil EAAA
Further References:
"Celebrating the Fourth in New York in 1834," NYT (7-4-37),45.

BEARDEN, ROMARE, 1914-88; b. in Charlotte, NC; mixed media, painter
Biographical Sources: AN 65(9-66),49; DCAA; LAAA; TCBAA; WWAA,1978; WWABA
Portrait: AN 63(10-64),24; DANA; EB 18(9-63),131; FSBA; NEW 77(4-5-71),52
Published Reproductions:
"Adoration of the Magi" oil AD 20(10-1-45),16
"Adoration of the Wise Men" oil 1945 NBAT
"Africa Speaks the West" AN 76(2-77),30
"After Church" gouache 1941 AN 40(12-15-41),24; ATO; NM 41 (12-30-41),27; NAI
"Allegheny County Colored Baptist Sunday School Picnic" AI 22

(2-79),24

"Annunciation" collage 1942 ESS 6(5-75),73(c)

"Approaching Storm" collage 1967 LEO 2(1-69),14

"At Connie's Inn" collage 1974 (Brooklyn) BC 11(#2-80),88(c);
 BMAP

"At Five in the Afternoon" 1946 AAAP

"Autumn Lamp" oil,collage 1983 ARTF 22(5-84),70

"Back Stage" tempera 1952 BAQ 5(#3-82),32

"Backyard" collage 1967 MIUA(c)

"Baltimore Uproar" Baltimore mural BE 13(6-83),42(c)

"Banderillas of Darkness" collage AD 20(4-1-46),13; AN 45
 (4-46),53

"Baptism" collage 1964 ENC 1(10-72),58; FAL; LEO 2(1-69),13

"Bar 'n Grill" poster paint 1937 BAQ 5(3-82),10(c)

"Battle of the Sun God" serigraph AN 77(4-78),79(c)

"Battle With Cicones" collage 1970 AN 72(5-73),61; MR 18
 (Wi-77),683(c)

"Bayou and Heron" mixed media 1982 EWCA(c)

"Before the Dark" collage 1971 MAAM(c); TOYAP(c)

"Before the First Whistle" collage 1970 AN 72(5-73),61

"Black Manhattan" collage 1969 (Schomburg) APG(c); ESS 6
 (5-75),73(c); MIUA(c)

"Black Mother and Child" collage 1970 AV 2(12-87),cover(c)

"Blue Interior, Morning" collage 1968 AIAP(c)

"Blue Monday" collage 1969 ARIA 59(5-71),129

"Blue Note" collage AD 21(12-1-46),15

"The Block" collage AN 79(12-80),64-5

"Blue Is the Smoke of War, White the Bones of Men" tempera
 c1960 BALF 23(Su-89),275

"Blue Lady" oil 1955 AN 85(11-86),116(c)

"Boy of Odysseus" collage 1977 HOR 22(8-79),24(c)

"The Builders" gouache 1974 BAQ 5(#3-82),52(c)

"The Builders" gouache" 1974 BAQ 5(#3-82),53(c)

"The Builders" graphite BAQ 5(#3-82),37

"The Builders" graphite BAQ 5(#3-82),44

"The Builders" graphite BAQ 5(#3-82),45

"The Builders" graphite BAQ 5(#3-82),38

"The Builders" graphite BAQ 5(#3-82),39

"The Builders" graphite BAQ 5(#3-82),42

"The Builders" graphite BAQ 5(#3-82),43
"The Builders" graphite BAQ 5(#3-82),40
"The Builders" graphite BAQ 5(#3-82),41
"The Builders" graphite BAQ 5(#3-82),38
"The Builders" graphite BAQ 5(#3-82),39
"The Builders" graphite 1981 BAQ 5(#3-82),36
"Burial" collage AN 63(10-64),25
"Byzantine Dimension" collage 1971 AIM 69(12-81),141(c);
 BAQ 8(#2-88),43(c); BC 11(#2-80),89(c); FAL
"Byzantine Frieze" collage ARTF 9(3-71),13
"Cabinet" gouache BAQ 5(#3-82),22(c)
"Carolina Blue" screen print collage AG 13(4-70),27(c)
"Carolina Interior" acrylic collage ARTF 9(3-71),13
"Carolina Shout" collage 1974 AJ 35(Fa-75),58; AN 79(12-80),
 63(c)
"Childhood Memories" collage c1966 ARTF 22(5-84),65; MIUA
 (c)
"Christ Driving Out the Money Changers" collage AN 44
 (10-15-45),28
"Cinque" serigraph 1979 BAQ 8(#2-88),3(c)
"Circe Preparing a Banquet for Ulysses" mixed media 1968 AANB
"Circe Turns a Companion of Odysseus Into a Swine" collage MR
 18(Wi-77),684(c)
"Coins" gouache BAQ 5(#3-82),19(c)
"Conjunction" litho AN 79(4-80),173(c)
"Conjur Woman" collage 1964 AIA 69(12-81),138(c)
"Conjur Woman" collage 1971 AASN; AIM 69(12-81),138(c); FAL
"Conjur Woman" collage 1975 AIM 69(12-81),139(c)
"Conjur Woman and the Virgin" collage 1978 AIM 69(12-81),140
 (c)
"Conjure Woman" collage 1964 CRI 77(3-70),80; GAI
"Conversations" collage BE 17(12-86),88(c)
"Daybreak Express" collage HOR 22(8-79),18(c)
"Depression" casein 1950 (Whitney) BAQ 5(#3-82),31(c)
"Dove" collage 1964 AN 79(12-80),66; BAQ 8(#2-88),40; QU 17
 (1964),110
"Dream" collage 1970 AANM; AATNM; NBAT
"Early Morning" collage 1967 (Howard) AWAP(c); FFBA
"Eastern Barn" collage 1968 (Whitney) AIPP; CCW; CCWM;

FAAA; FTWM

"Eighth Avenue Market, New York City" collage CRI 13(1-35),22

"Evening" collage 1964 NEW 64(10-19-64),105

"Evening at 9:30, 461 Lennox Avenue" collage 1964 AIM 57
 (1/2-69),32; DBLJ; FAAA

"Evening Lamp" collage,watercolor AV 1(11/12-86),25(c)

"Evening Meal of Prophet Peterson" collage 1964 FFBA

"Evening of the Blue Snake" collage 1986 AIM 75(2-87),149(c)

"Exploration" 1980 (Howard) BAQ 5(#3-82),25

"Factory Workers" oil AN 43(2-1-45),6; LIF 21(7-22-46),64(c);
 NAI

"Family" water,gouache 1948 AAATC(c)

"Family" print 1969 AIM 63(11-75),19(c); AN 74(11-75),65(c);
 AN 74(12-75),3(c); ART 50(11-75),59(c); CANO; ID 46
 (11-75),63(c)

"Family Group" collage 1969 VVE

"Farewell Eugene" 1978 AIM 68(10-80),80(c); AN 79(10-80),25
 (c)

"Farewell to Liza" collage AW 11(10-18-80),20

"Funeral" poster paint BAQ 5(3-82),7(c)

"Games" gouache 1979 BAQ 5(#3-82),3(c)

"Gardens of Babylon" oil 1955 AAR 3(11/12-76),117(c); TCBAA
 (c)

"General Toussaint L'Ouverture, Statesman and Military Genius..."
 BAQ 5(#3-82),55

"Gospel Song" collage FSBA

"Green Man" watercolor 1982 APO #121(3-85),194

"Guitar Executive" collage 1967 ARTF 22(5-84),65; FFBA

"Gut Chorus" collage 1979 AIM 68(10-80),80(c); AN 79(10-80),
 24(c)

"Harriet Tubman" poster BAQ 5(#3-82),60(c)

"He Is Arisen" watercolor,ink 1945 (Modern Art) DANA; FAAA

"High Priestess" watercolor 1985 BAAL

"Home to Ithaca" collage MR 18(Wi-77),688(c)

"House in Cotton Field" collage EB 30(11-75),116(c)

"Ice Man" poster paint BAQ 5(#3-82),11(c)

"Illusionists at 4 P.M." collage 1967 LEO 2(1-69),17

"In the Silent Valley of Sunrise" oil,casein 1959 BMMA 28
 (#2/4-61),37

"Mountains of the Moon" tempera 1956 AN 79(12-80),67(c); BAQ
 8(#2-88),34(c)

"Mysteries" photomontage 1964 AIS 5(Su/Fa-68),256-7; AN 65
 (9-66),49; EB 23(2-68),70; FAAA; LAAA; QUA 17(1964),99

"1930's, Chicago Jazz" collage 1964 FFBA

"Noah, Third Day" acrylic 1972 (High) AE 39(5-86),cover(c);
 APHM

"Odysseus" serigraph AN 77(4-78),79(c)

"Odysseus and Penelope Reunited" collage 1977 AIM 69(12-81)
 141(c); AN 76(10-77),141; AN 76(Wi-77),685(c)

"Odysseus: Circe Turns Her Companion into Swine" AN 79
 (10-80),221(c)

"Odysseus: Home to Ithaca" serigraph AN 79(11-80),171

"Odysseus Leaves Circe" collage 1977 AG 20(5-77),21; HOR 22
 (8-79),21(c); MR 18(Wi-77),687(c)

"Odysseus Leaves Nausicaa" collage 1977 MR 18(Wi-77),687(c)

"Odysseus: Sirens Song" serigraph AN 79(12-80),195(c)

"Old Couple" collage 1967 AN 66(10-67),45; LEO 2(1-69),16(c)

"Olympics" serigraph AIM 63(9-75),32; AN 73(12-74),4; OIA

"Opening at the Savoy" watercolor,collage 1987 AN 89(5-90),34
 (c)

"Opening Statement" watercolor,collage 1978 AN 88(5-89),49(c)

"Ordeal of Alice" tempera 1963 BAQ 5(#3-82),54

"Palm Sunday Procession" collage 1967 AAAC; ANA 4(5-69),15

"Patchwork Quilt" collage 1970 AI 15(Su-71),34; AN 79(12-80),
 62(c)

"Pittsburgh Memories" collage 1978 BAQ 8(#2-88),38; BC 11
 (#2-80),89(c)

"The Persistance of Ritual: Baptism" collage (Hirshhorn) HMSG

"The Prevalence of Ritual" silkscreen 1974 APAP

"The Prevalence of Ritual: Baptism" collage 1964 (Smithsonian)
 AOT; CRI 77(3-70),80; FAAA(c); LAAA; PSTCA; QUA 17
 (1964),99; TAB

"The Prevalence of Ritual: Conjure Woman" collage 1964 AIS 10
 (#1-73),58; QUA 17(1964),100

"The Prevalence of Ritual: Conjure Woman as Angel" collage LEO
 2(1-69),16; QUA 17(1964),105

"The Prevalence of Ritual: Tidings" collage 1967 AJ 28(Wi-68/69),
 206; EB 23(2-68),cover(c); LAAA; PTS

"Prince Cinque" 1967 AG 19(6/7-76),72; AJ 38(Wi-78/79),127
"Prologue to Troy No.1" collage 1972 BC 11(#2-80),89(c); HOR
 22(8-79),25(c)
"Quilting Time" collage 1985 (Detroit) AN 85(10-86),120(c); APO
 #124(11-86),544; BDIA 63(#1/2-87),12(c); BE 12(12-82),59(c)
"Railroad Shack Sporting House" HOR 22(8-79),19(c)
"Rebellion" tempera 1946 BAQ 5(#3-82),26(c)
"Return of Maudelle Sleet" 1982 AV 3(10-88),47(c)
"Return of Odysseus" collage 1977 AN 66(10-67),44(c); ART 52
 (9-77),29
"Reunion" collage 1970 ARTF 9(3-71),13
"Rhythm Ensemble" watercolor, collage 1987 ARAN 6(5-89),17(c)
"Rites of Spring" collage 1967 AN 66(10-67),44; HW 7(3rdQ-68),
 15(c); STHR
"Ritual Bayou" collage 1970 AIM 59(3-71),20(c); ARTF 9(3-71),
 13
"River Mist" collage AN 85(10-86),119(c)
"Roots Odyssey" silkscreen 1978 OAAL
"Saturday Morning" collage 1969 AATC(c)
"Sea Nymph" collage MR 18(Wi-77),686(c)
"Sedation" casein 1950 (Modern Art) BAQ 5(#3-82),30(c)
"Self-Portrait" gouache 1977 BAQ 5(#3-82),cover(c)
"Serenade" collage 1968 (National Center) AAAZ(c); AG 16
 (3-73),9
"Sermons: The Walls of Jericho" collage 1964 (Hirshhorn) BABC;
 EB 32(2-77),34(c); MS 5(1-77),27(c)
"She-Ba" collage 1970 FSBA; TNAP
"Shipping Out" tempera 1946 (Whitney) BAQ 5(#3-82),28
"Show Time" collage 1974 AN 79(10-80),113; BAQ 4(#3-80),62;
 DAED 85(1/2-84),26; ESS 7(11-76),48(c)
"Silent Valley of Sunrise" oil 1959 MMA 28(#2/4-61),37;
 PSMOMA
"Soldiers in Bunk" tempera 1946 (Whitney) BAQ 5(#3-82),27(c)
"Solo Flight" oil,collage 1981 ARAN 7(Su-90),19(c)
"Some Drink! Some Drink! Some Drink! Some Drink!" oil 1946
 (Texas) JAMC
"Soul Never Dwells in a Dry Place" collage AD 21(3-1-47),19
"Soul Three" oil 1968 SA 68(4-69),23; SEP 18(3-69),48-9
"Spring Way" QUA 17(1964),110

"Stomp Time" litho AN 78(Su-79),152(c); AN 82(Su-83),76

"Storyville Interlude" oil 1975 AIM 64(11-76),124

"Street" collage 1964 AAW; AN 63(10-64),24; AN 82(9-83),16; ANY; ARTF 22(5-84),69; EAAA; ENC 1(10-72),59; ILAAL; LEO 2(1-69),13; PEAA; WAA

"Street Orator" casein BAQ 5(#3-82),6(c)

"Studio" gouache BAQ 5(#3-82),2(c)

"Summertime" collage 1967 BC 3(5/6-73),27(c); ESS 2(4-72),66 (c); ESS 4(11-73),22(c); ESS 4(12-73),29(c); TIM 90(10-27-67), 65(c)

"Sunday Morning at Avila" etching AN 82(5-83),25(c)

"Sunrise for China Lamp" mixed media 1986 AN 87(10-88),41(c)

"Sunset Limited" collage 1978 AIM 68(10-80),80(c); AN 79 (10-80),24(c)

"Sunset-Moonrise with Maudell Sleet" collage AA 44(10-80),89; AIM 69(12-81),136(c)

"The Swearing In" gouache 1927 BAQ 5(#3-82),52(c)

"Three Folk Musicians" tempera AN 79(12-80),67(c); ARTF 22 (5-84),66

"Tomorrow I May Be Far Away" collage TIM 90(10-17-67),65(c)

"Trading Fours" collage HOR 22(8-79),20(c)

"Train" etching AIM 63(3-75),106(c); AN 74(3-75),14

"Trojan War Series: At the Oracle" watercolor ANA 11(10-76),14

"Two of Them" collage EB 27(9-72),87(c); EB 29(12-73),37(c); EB 30(11-75),116(c)

"Two Women" collage 1967 AG 11(4-68),28(c); BALF 23 (Su-89),279; LEO 2(1-69),18

untitled AIM 68(9-80),138

untitled AN 78(1-79),149(c)

untitled print 1976 AN 88(2-89),49(c)

untitled print (Golden State) BAQ 1(Wi-76),16

untitled CONN 371(1-83),64(c)

untitled PR 37(5/6-83),75(c)

untitled #2 collage 1964 BAQ 8(#2-88),35(c)

untitled watercolor 1951 BALF 23(Su-89),270

"Uptown Manhattan Skyline" oil ARC 73(5-84),240

"Urban Blues" collage 1971 AI 15(Su-71),34

"The Visitation" oil 1941 PMNA

"A Walk in Parade Gardens" oil 1955 BACW

"Walls of Troy" watercolor AD 23(11-15-48),32
"War" litho BACW
"Warriors at a City Gate" 1947 AAAZ(c)
"Watching the Trains Go By" collage 1964 CRI 77(3-70),85;
 FFBA; HMSG(c)
"What a Great Bullfighter in the Ring" ink,watercolor c1947 BALF
 23(Su-89),265
"Woman in Harlem Courtyard" collage 1964 AN 63(10-64),54
"Woman On a Rock" ink,watercolor 1948 BALF 23(Su-89),267
"Woman Seated on Rock" watercolor 1948 AN 79(12-80),66(c)
"Woman with the Roses" collage 1976 NAE 14(6-87),22
"The Woodshed" collage 1969 (Metropolitan) FTCA(c); RD 112
 (6-78),183(c); TCBAA
"Woodshed College" collage AJ 30(W-70/71),165
"Wrapping It Up at the Lafayette" collage 1978 ANY(c); CMUB
 73(2-86),60(c)
"Young Students" collage HOR 22(8-79),22(c)
Further References:
The Art of Romare Bearden. Text by M. Bunch Washington.
 New York: Abrams, 1972.
Campbell, Mary, "Romare Bearden Rites and Riffs," AIM 69
 (12-81),134-41.
Childs, Charles, "Bearden: Identification and Identify," AN 63
 (10-64),24-5.
Douglas, Carlyle, "Romare Bearden," EB 31(11-75),116-18.
Ellison, Ralph, "Romare Beaden: Paintings and Projections," CRI
 77(3-70),80-6.
Markus, J., "Romare Bearden's Art Does Go Home Again - To
 Conquer," SMI 11(3-81),70-4.
Nash, Dawn, "The Legacy of Bearden," BE 18(6-88),49.
Schwartzman, Myron. *Romare Bearden; His Life and Art.* New
 York: Abrams, 1990.
Sims, Lowery, "The Unknown Romare Bearden," AN 85
 (10-86),116-20.
"Touching at the Core," TIM 90(10-27-67),64-5.

BEASLEY, PHOEBE; b. in Cleveland; painter
 Biographical Sources: ESS 7(12-77),6
 Portrait: BAQ 5(#1-82),15; ESS 7(12-77),6; ESS 19(2-89),34

Published Reproductions:
 "The Boys Market" collage 1981 BAQ 5(#2-82),11(c)
 "Comfort Zone" collage 1981 BAQ 5(#2-82),6(c)
 "Dinner Friends" collage BC 19(#4-89),178(c)
 "Girls of Tustic Grove, Jamaica" collage 1980 BAQ 5(#2-82),
 cover(c)
 "His Grandmother's Quilt" collage BC 19(#4-89),178(c)
 "Morning Ritual" collage 1981 BAQ 5(#2-82),10(c)
 "Musical Chairs" litho BAQ 5(#2-82),9
 "The Passing of Sister Sookie" collage 1976 BAQ 5(#2-82),
 3(c)
 "Precipitation" collage 1981 BAQ 5(#2-82),6(c)
 "Street Wise" litho BAQ 5(#2-82),8
 untitled ESS 19(2-89),34
 untitled AV 3(4-88),47(c)
 untitled collage AIM 69(5-81),181
 "Wolf Tickets" collage 1976 BAQ 5(#2-82),7(c)
Further References:
 "Phoebe Beasley," BAQ 5(#2-82),4-11.

BEAZER, G. FALCON; b. in New York; graphic artist, painter
Published Reproductions:
 "Growth" pen,ink BT (#6-72),37
 "Heritage Revealed" drawing BT (#6-72),37
Further References:
 Richardson, Freddie, "The Art of Life is the Most Important Art,"
 BF 1(Wi-76/77),4-10.

BECK, ARTHELLO J., 1941- ; b. in Dallas; painter
Biographical Sources: WWABA
Published Reproductions:
 "Black Woman" oil BC 3(9/10-72),29
 "Girl Eating an Orange" BC 6(1/2-76),26(c)
 "Mother Holding the Dead Christ" oil BC 3(9/10-72),29
 "The Scarf" oil BC 3(9/10-72),29
 untitled BC 7(11/12-76),38(c)
 untitled BC 3(9/10-72),30-1(c)
Further References:
 "Beck," BC 3(9/10-72),29-31.

BECK, SHERMAN; b. in Chicago; mixed media, painter
 Biographical Sources: AAA
 Published Reproductions:
 untitled mixed media BW 19(10-70),89

BEGAUD, WILSON, see **BIGAUD, WILSON**

BELLOW, CLEVELAND J., 1946- ; b. in San Francisco; painter,
 printmaker
 Biographical Sources: BAOA-2; EBSU; LAAA; WCBI
 Portrait: BAOA-2; ENC 4(8-18-75),42
 Published Reproductions:
 "Catch Eve" acrylic,silk screen WCBI
 "Catch Some California Time" mural 1973 BAQ 2(Sp-78),39
 "Celestial Nimba" drawing BC 9(#5-79),cover(c)
 "Duke" acrylic DBLJ
 "Emancipation of a Son" ink BAOA-2
 "Homage to Sargent Johnson" color,ink EBSU
 "Nimba Bearing Fruit" drawing BC 9(#5-79),52(c)
 "Nimba Conceiving" drawing BC 9(#5-79),52(c)
 "Nimba Discovering" drawing BC 9(#5-79),52(c)
 "Nimba Giving Birth" drawing BC 9(#5-79),52(c)
 "Nimba with Crown" drawing BC 9(#5-79),52(c)
 "Nimba with Full Moon" mixed media 1975 OSAE
 "Nimba with Halo" BC 9(#5-79),52(c); ENC 4(8-18-75),42
 "There is No Need for a Title (#5)" LAAA(c)
 "There is No Need for a Title (#7)" LAAA(c)

BENNETT, GWENDOLYN, 1902- ; b. in Giddings, TX; painter
 Published Reproductions:
 "Winter Landscape" oil 1936 LNIA

BENNETT, HERBERT; mixed media
 Published Reproductions:
 "Justice and Allegory Series" print BAQ 1(Wi-76),17
 untitled lino 1966 BAQ 6(#4-85),13

BERIAL, EDWARD, 1937- ; sculptor

Biographical Sources: AAA
Published Reproductions:
 "Stuka - JU 87" assemblage 1960 ARTF 2(Su-64),39

BERRY, ARTHUR, 1923- ; b. in Tulsa, OK; sculptor
Portrait: BAOA-1
Published Reproductions:
 untitled stone sc BAOA-1

BERRY, DEVOICE, 1937- ; printmaker
Biographical Sources: AAA
Published Reproductions:
 "Figures" litho 1970 LAAA

BEY, BEN, 1938- ; b. in Chicago; painter
Biographical Sources: WWABA
Published Reproductions:
 "Expressions" acrylic BC 2(11/12-71),25

BIGAUD, WILSON; b. in Haiti; painter
Published Reproductions:
 "Cockfight" oil 1950 AWAP(c); BACW
 "Indoor Wedding" oil BAQ 2(#4-78),15
 "La Negresse" oil c1948 BAAL
 "The Wake" oil BAQ 2(#4-78),14(c)

BIGGERS, JOHN THOMAS, 1924- ; b. in Gastonia, NC; painter,
 printmaker
Biographical Sources: BDCAA; LAAA; TCBAA; WWAA,1991
Portraits: BAAL; EB 18(9-63),131; FSBA; FTA; ILAAL
Published Reproductions:
 "Birth From the Sea" Houston mural WBAH(c)
 "The Contributions of Negro Women to American Life and Edu-
 cation" Houston mural 1953 DANA; WBAH
 "Christia V. Adair" mural EB 39(3-84),89(c)
 "Cradle" crayon 1950 (Houston) DANA; GAI; TCBAA
 "Dye Distillers" conte crayon WBAH
 "Dying Soldier" tempera mural BAQ 7(#3-87),47; DES 46(9-44),
 20; WBAH

"Shotgun" oil,acrylic 1987 BAAL(c)
"Starry Crown" acrylic 1987 (Dallas) ARAC 107(5-90),29(c);
 BAAL(c)
"Taharga, King of Nubia" BC 12(#4-82),88(c); EB 34(11-78),86-7
"Third Ward" acrylic EB 39(3-84),89
"Three Kings" conte 1960 BAAL(c)
"Three Kings, Ghana" conte 1957 SA 79(10-79),58
"Third Ward" EB 39(3-84),89(c)
"The Time of Ede, Nigeria" conte crayon 1964 DBLJ; LAAA
"25th Precinct, 3rd Ward: Houston" mixed media 1984 FTAC
"Two Heads" litho 1952 GAI
untitled drawing FSBA
untitled mural EB 39(3-84),87(c)
"Washer Woman" pencil 1945 LAAA
"Web of Life" Texas mural ILAAL; BAQ 3(#3-79),53; WBAH
"Wheel in Wheel" oil,acrylic 1986 BAAL(c)
Further References:
 Fax, Elton C. *Seventeen Black Artists*. New York: Dodd, Mead,
 1971.
 Martin, Thad, "John T. Biggers: Artist Who Influenced a Gener-
 ation," EB 39(3-84),87-90.

BILLOPS, CAMILLE, 1934- ; b. in Los Angeles; sculptor
Biographical Sources: BAQ 1(Su-77),31-51; LAAA; TNA; WWABA
Portrait: BAQ 1(Su-77),39; BAOA-1; BE 6(12-75),56
Published Reproductions:
 "Black Suffering Jesus and Yellow Man" clay, wood BAOA-1
 "Black Suffering Jesus Shows Us His Bleeding Heart" ESS 3(7-72),
 50
 "The Bride" ceramic,wood,cloth BAQ 1(Su-77),36
 "For Japanese With Mirrors" etching 1975 BAQ 6(#4-85),18(c)
 "Mother" ceramic sc 1971 FFAA(c)
 "Mother of the Black Suffering Jesus" MS 2(9-73),26
 "Remember Vienna" BALF 17(Sp-83),cover
 "The Story of Man" ceramic sc 1981 BABC;STHR
 "Tenure" wood and ceramic 1973 BUNY
 "Three-Headed Fountain" ceramic 1969 BAQ 1(Su-77),cover(c);
 BAQ 1(Su-77),61(c)
Further References:

Jackson, Peggy, "Sculptured Reality," ESS 2(7-72),50-1.

BIRCH, WILLIE M., 1942- ; b. in New Orleans; painter, sculptor
Published Reproductions:
 "For Moboerane, Motaung, and Mololol" gouache BC 15
 (11/12-84),45(c)
 "Promised Land" litho 1985 BAQ 7(#4-87),26
 "Voices from the Belly of the Earth" BC 15(#1-84),36(c)
 "Wiping Away the Minstrel Grin" gouache 1988 BABC

BISHOP, ELOISE, 1921- ; b. in Pittsburgh; painter, sculptor
Biographical Sources: AAA
Published Reproductions:
 "Head of a Boy" plaster sculpture LIF 21(7-22-46),62; NAI

BLACKBURN, ROBERT, 1921- ; b. in Summit, NJ; graphic artist,
 painter
Biographical Sources: AAANB; TNAP
Published Reproductions:
 "Blue Thing" woodcut 1968 AAANB; AP 11(1971),33; BAQ 2
 (Sp-78),6(c)
 "Boy With Green Head" litho 1948 (Atlanta) DANA
 "The Toiler" drawing 1938 (Harmon) DANA; LNIA; OAAL
 untitled TNAP
 "Upper New York" litho 1938 DANA; LNIA
Further References:
 Whatley, JoAnn, "Bob Blackburn's Print Workshop," ABA 1
 (#1-71),11-13.

BLACKWELL, TARLETON, 1956- ; b. in Manning, SC; painter
Biographical Sources: NGSBA
Published Reproductions:
 "The Hog Series XVI" oil 1983 NGSBA(c)
 "The Hog Series I" oil 1984 NGSBA
 "The Hog Series II" 1984 graphite NGSBA
 "The Hog Series VII" graphite 1984 NGSBA
 "The Hog Series XXXIII" oil 1987 NGSBA(c)
 untitled EB 45(2-90),93(c)

BLANCO, TEODORO RAMOS., 1901-?; b. in Havana, Cuba; sculptor
Biographical Sources: BACW
Published Reproductions:
"Cabeza de Negro" plaster sc (Harmon) CRI 38(9-31),299; LNIA
"Country People" stone sc (Schomburg) LNIA
"Dejection" sc CRI 38(9-31),299
"Eternal" mahogany sc LNIA; SG 31(11-42),509
"Guitar Player" clay sc BACW
"Inner Life" marble sc LNIA; MA 22(7-39),421
"Jilma" sc CRI 56(1-49),15
"La Rumba" sc CRI 56(1-49),15; CRI 58(12-51),663
"Lincoln" sc SG 31(11-42),509
"Maternidad" sc CRI 56(1-49),16
"Monument to Mariana Grajales, Mother of the Maceo Brothers"
 sc CRI 38(9-31),299; OPP 8(10-30),cover
"Negra Linda" terra cotta sc CRI 56(1-49),17
"Negrita" sc CRI 56(1-49),17
"Placido" sc CRI 56(1-49),16
"Self Portrait" sc OPP 8(11-30),334
"Torso" mahogany sc CRI 56(1-49),17

BLAND, LAMONT K.; graphic artist
Biographical Sources: DENA
Portrait: DENA
Published Reproductions:
"The Drug Addict" charcoal DENA

BLAYTON, BETTY, 1937- ; b. in Williamsburg, VA; mixed media,
 painter
Biographical Sources: AAANB; CBAM; FAAA; WWAA,1991
Portrait: AG 13(4-70),56; ENC 4(6-23-75),64
Published Reproductions:
"Childhood's End" oil IlAAL
"Concentrated Energies" oil 1969 FAA; FFAA(c); FUF; NBAT
"Conductive Mind" oil collage 1968 CBAM
"I Am Me" 1968 FAAA
"Iconograph" oil,collage 1970 FAAA
"No Game, No Fun" collage AG 11(4-68),47
"Reaching for Center" oil 1969 AAC; AG 13(4-70),24(c)

"Souls Interact" oil collage 1970 AAANB
"Vibes Penetrated" acrylic 1983 BALF 19(Sp-85),33
Further References:
"Women in the Arts," EB 21(8-66),90-4.

BOHANON, GLORIA, 1941- ; b. in Atlanta; painter
Biographical Sources: BAOA-2; BWSB
Portrait: BAOA-2
Published Reproductions:
 untitled oil BAOA-2(c)
 untitled AVD

BOLDEN, HAWKINS, 1914- ; b. in Memphis, TN; mixed media
Biographical Sources: NGSBA
Published Reproductions:
 untitled mixed media 1987 NGSBA(c)
 untitled mixed media 1987 NGSBA(c)
 untitled mixed media 1988 NGSBA(c)
 untitled mixed media 1988 NGSBA(c)

BOLLING, LESLIE G., 1898- ?; b. in Dendron, VA; sculptor
Biographical Sources: AAA; MIAP; WWAA,1959; WWWA
Portrait: ATO
Published Reproductions:
 "Aunt Monday and Sister Tuesday" wood sc AD 9(2-15-35),23
 "The Boxer" wood sc (Yale) ATO
 "Cousin-on-Friday" wood sc 1935 (Richmond) ATO
 "Mama on Wednesday" wood sc 1936 LNIA
 "Market Woman" wood sc MA 26(1-33),45
 "Parson on Sunday" wood sc 1936 LNIA; OPP 15(8-37),240
 "Salome" wood sc (Harmon) DANA; MA 27(1-34),38; PMNA
 "Sister Tuesday" wood sc 1935 AD 9(2-15-35),23; OPP 15(8-37),
 240
 "Washerwoman" wood sc (Harmon) DANA
 "Woman's Head" wood sc (Yale) ATO(c)
Further References:
 "Negro Woodcarver of Richmond, Va.," OPP 18(6-40),184.

BOLTON, SHIRLEY, 1942- ; b. in Lexington, GA; painter

Biographical Sources: AAA; BAOA-2; EBSU
Portrait: BAOA-2
Published Reproductions:
 "Black Man" oil 1969 BAOA-2
 "Opus 1" acrylic 1971 BAOA-2

BOND, HIGGINS; painter
Published Reproductions:
 "Akhenaton--Pharaoh of Egypt" oil BC 12(4-82),168(c); EB 33
 (7-78),72(c)
 "The Black Church" CRI 89(11-82),cover(c)
 "Mansas Kankan Mussa--King of Mali" oil BC 12(4-82),168(c);
 EB 31(8-76),78(c)

BOOKER, ERMA; b. in New Jersey; painter, sculptor
Portrait: BAQ 6(#3-85),53
Published Reproductions:
 "Family" terra cotta sc BAQ 6(#3-85),54
 "Madonna and Child" mahogany sc BAQ 6(#3-85),60
 "Quiet One" oil BAQ 6(#3-85),56
 "Still Life" oil BAQ 6(#3-85),58
 untitled wood sc BAQ 6(#3-85),59

BORDERS, MICHAEL, 1946- ; b. in Hartford, CT; painter
Published Reproductions:
 "Now Go Have a Coke and a Hotdog" oil (Fisk) DAAA

BOUTTE, RONALD; b. in Boston; graphic artist, painter
Biographical Sources: AAA
Published Reproductions:
 "Interior With Figures" charcoal,pencil AANB

BOWENS, SIRAS, ?-1966; active in Sunbury, GA; sculptor
Published Reproductions:
 untitled sc MR 18(Au-77),494

BOWERS, DAVID BUSTILL, see **BOWSER, DAVID BUSTILL**

BOWERS, LYNN, 1933- ; b. in Canada; mixed media, painter

Biographical Sources: AAA; WWAA,1978
Published Reproductions:
 "Barbara in Three Parts" acrylic 1969 AAANB

BOWLING, FRANK, 1936- ; b. in Guyana; painter
 Biographical Sources: AAA; WWAA,1991
 Published Reproductions:
 "Birthday" oil STU 164(11-62),195
 "Cathedral" 1975 CGB
 "Cybele's Yellow Door to Fishes" ART 58(9-83),10
 "Fani Ciotti" oil ART 46(2-72),45(c)
 "Giving Birth Astride a Grave" acrylic AI 19(5-15-75),23
 "Great Thames I" ART 64(10-89),106
 "Herbert Spencer Revisited" acrylic AI 19(5-15-75),25(c)
 "Jack" ARTF 18(9-79),76
 "Mel Edwards Decides" oil 1969 AAANB; ART 44(Su-70),34(c)
 "Middle Passage" oil 1970 SAH(c)
 "Mirror" oil 1966 AI 20(12-76),64; ANA #236(5-86),18
 "Night Journey" acrylic 1969 AI 20(12-76),63
 "Nile Geese" oil 1974 AI 19(5-15-75),25; ARTF 13(3-75),69
 "Pisces I & II" AIM 74(74(10-86),1(c)
 "Polish Rebecca" ART 46(12-71),58
 "Scottseyetooth" oil AIM 71(11-83),229(c)
 "The Stork's Monotone" acrylic 1974 AI 19(5-15-75),24(c)
 "Valley" acrylic 1977 CGB(c)
 "Vitacress" ART 57(1-83),37
 "Weather Is Clement" acrylic 1973 AI 19(5-15-75),23
 "Where Is Lucienne?" acrylic 1970 AI 19(5-15-75),23; DCBAA(c)
 "Whoosh" 1974 AIM 63(1/2-75),86(c)

BOWSER, DAVID BUSTILL, 1820-1900; b. in Philadelphia; painter
 Biographical Sources: LAAA; SNCAAA
 Published Reproductions:
 "Portrait of John Brown" oil c1858 AAAC
 "Portrait of Lincoln" oil 1865 ANT 107(2-75),321

BOYD, DAVID PATTERSON, 1913- ; b. in St. Louis; painter
Biographical Sources: AAA
Published Reproductions:
 "St. Louis Blues" oil OPP 11(3-33),81

BRADFORD, DAVID PHILLIP, 1937- ; b. in Chicago; painter
Biographical Sources: AAA; EBSU; LAAA
Portrait: BAOA-1; DIAA
Published Reproductions:
 "Africa Series II" charcoal,collage 1972 DIAA
 "Black Woman Series I" charcoal 1972 DIAA
 "Stars, Bars and Bones" oil 1970 LAAA(c)
 untitled oil BAOA-1(c); BAOA-2(c)
 "Yes, LeRoi" oil 1968 BAOA-1(c); LAAA

BRADFORD, HAROLD; painter
Published Reproductions:
 "Coach Larry" acrylic WJBS 1(3-77),30(c)
 "Same Old Thing" acrylic WJBS 1(3-77),31(c)

BRADLEY, PETER A., 1940- ; b. in Connellsville, PA; painter
Biographical Sources: AAA; CBAM; WWAA,1978
Published Reproductions:
 "Marcus Garvey" construction 1970 SAH
 "M.F.R." oil 1968 CBAM
 "Ruling Light" acrylic 1973 ART 49(11-74),78
 "Wulfenite" acrylic 1974 ART 48(4-74),68

BRAGG, FRED; muralist
Published Reproductions:
 "Visions" mural 1967 WBAH(c)

BRANCH, WINSTON, 1947- ; b. in Castries, St. Lucia; painter
Biographical Sources: BAQ 2(Wi-78),4-8
Portrait: BAQ 2(Wi-78),5
Published Reproductions:
 "Magical Recall" acrylic BAQ 2(Wi-78),6(c)
 "Ralph Schueler Visits" acrylic 1976 BAQ 2(Wi-78),7(c)
 "Three Black Men" acrylic ANA 4(7-69),72

untitled acrylic BAQ 2(Wi-78),cover(c),73(c); BAQ 3(#1-79),
 64(c)

BRANDON, BRUMSIC, JR., 1927- ; b. in Washington, DC; graphic
 artist
Biographical Sources: AAA; WWABA
Published Reproductions:
 "Capital Punishment" FRE 18(4thQ-78),cover,216
 "Escapism" FRE 18(4thQ-78),217
 "Luther" SEP 20(11-71),76-7
 "Unemployment" FRE 18(4thQ-78),218
 "White Flight" FRE 18(4thQ-78),213

BRANTLEY, JAMES, 1945- ; painter
Biographical Sources: AAA
Published Reproductions:
 "The Informer" oil DCBAA

BRAXTON, WILLIAM ERNEST, 1878-1932; b. in Washington, DC;
 painter
Biographical Sources: AAA; TNAP; WWWA
Published Reproductions:
 "Figural Study" oil (Schomburg) EB 23(2-68),121(c); TEAAA

BRICE, BRUCE, 1942- ; b. in New Orleans; painter
Biographical Sources: AFATC
Published Reproductions:
 "Treme Wall Mural" New Orleans mural 1971 AFATC(c)
 "Self-Portrait" acrylic 1971 AFATC(c)

BRITT, ARTHUR L., SR., 1934- ; b. in Cuthbert, GA; painter
Biographical Sources: AAA; BDCAA; EBSU; WWAA,1978
Portrait: BAOA-1; EBSU
Published Reproductions:
 "The Dream" mixed media BAOA-1
 "Swamp" mixed media BAOA-1
 "Swamp Fire" oil 1968 BDCAA(c)

BRITTON, JAMES; painter active in the 1970s

Published Reproductions:
 "Jesus Before Pontius Pilate" oil BCR 4(Fa-72),47

BRITTON, SYLVESTER, 1926- ; b. in Chicago; painter, printmaker
 Biographical Sources: AAA
 Published Reproductions:
 "Beyond the Looking Glass" oil EB 13(4-58),35(c)
 untitled BC 2(11/12-71),24
 untitled PANA
 Further References:
 "Leading Young Artists," EB 13(4-58),33-35.

BROOKER, MOE, 1940- ; b. in Philadelphia; painter, printer
 Biographical Sources: CMUB 65(5-78),154
 Published Reproductions:
 "Afternoon Delight II" oil 1977 CMUB 65(5-78),154
 "Doingwhatyalikethemost" CMUB 68(5-81),140
 "The Nicer the Nice, the Higher the Price" mixed media 1977
 CMUB 65(5-78),160
 "This One's for You, Musa" litho 1985 BAQ 7(#4-87),27(c)
 "Tis My Kind of Music" CMUB 66(5-79),157

BROOKS, BERNARD W., 1939- ; b. in Alexandria, VA; graphic
 artist
 Biographical Sources: AAA; DENA; WWABA
 Portrait: DENA
 Published Reproductions:
 "Strangers When We Meet" serigraph DENA

BROOKS, MABLE RANDOLPH, 1899- ; b. in Port Tobacco, MD;
 painter
 Biographical Sources: AAA
 Published Reproductions:
 untitled tempera CRI 39(4-32),133

BROOKS-EL, ORASTON, 1937- ; b. in Brooklyn; painter
 Biographical Sources: AAA
 Published Reproductions:
 "Black Anthology" FRE 12(4thQ-72),cover

BROWN, DAVID SCOTT, 1931- ; b. in Greenwich, CT; painter
Biographical Sources: AAA
Published Reproductions:
"Gospel Singers" oil 1968 AAASN
"Musicians" oil 1969 ARTF 8(11-69),78

BROWN, ELMER W., 1909- ; b. in Pittsburgh; painter
Biographical Sources: AAA; MIAP; WWAA,1939
Published Reproductions:
"Freedom of Expression" mural DANA; PMNA
"Rip Van Winkle and Dwarfs" ceramic sc AAR 2(7/8-75),116
"Rip Van Winkle Awakes" ceramic sc AAR 2(7/8-75),109

BROWN, FRED, 1941- ; b. in Conway, AR.; painter
Biographical Sources: AAA; BAOA-1
Portrait: BAOA-1
Published Reproductions:
untitled oil BAOA-1
"Wisdom and Love" EB 44(2-89),103(c); ESS 19(2-89),128(c)

BROWN, FREDERICK, 1945- ; b. in Greensboro, GA; painter
Biographical Sources: WWAA,1991
Published Reproductions:
"Bleecker Street" oil 1981 AN 84(11-85),144
"De Sade's Castle" oil AN 83(11-84),78(c)
"Geronimo and His Spirit" AN 83(11-84),78(c)
"John Henry" oil 1985 ART 60(9-85),24; ARTF 24(12-85),91
"Last Supper" oil AN 82(11-83),199(c)
"Max Beckmann" oil 1987 AIM 76(1-88),134(c)
"Nathan Beauregard" oil 1989 AN 88(11-89),165(c)
"Reverend Thomas Reid" ART 58(9-83),39
"Smoking Women" oil 1985 AIM 73(9-85),39
"Wisdom and Love" BE 19(2-89),139(c)

BROWN, GRAFTON TYLER, 1841-1918; b. in Harrisburg, PA;
painter
Biographical Sources: AAA; FAAA; LAAA; NYDA; TCBAA
Portrait: FAAA
Published Reproductions:

"The Gorge" oil 1883 FAAA
"Grand Canyon from Lookout Point Yellowstone National Park"
 oil 1886 ANT 131(4-87),795(c)
"Grand Canyon of the Yellowstone from Hayden Point" oil 1891
 (Oakland) LAAA
"Iron-Clad Mine" litho 1880 AAAET
"Long Lake" oil 1883 FAAA
"Mount Tacoma" oil 1895 (Oakland) AOC; DBLJ; EB 32(2-77),
 38(c); KCNCP; TCBAA
"Mount Tacoma From Lake Washington" oil 1884 AAATC
"San Francisco" litho 1877 LAAA
"Yosemite Falls" oil 1888 AAAET(c)

BROWN, JAMES ANDREW; b. in Paterson, NJ; mixed media
 Biographical Sources: WWAA,1991
 Portrait: BAQ 5(#2-82),12
 Published Reproductions:
 "Home" installation 1979 BAQ 5(#2-82),13
 "Sanctuary" BAQ 5(#2-82),15(c)
 untitled assemblage 1979 BAQ 5(#2-82),13
 untitled assemblage BAQ 5(#2-82),14(c)
 untitled assemblage BAQ 5(#2-82),15(c)

BROWN, JOSHUA, b. in Benton Harbor, MI; painter
 Biographical Sources:
 "Inside South Africa" oil 1985 BC 21(#2-90),24(c)

BROWN, KAY, 1932- ; b. in New York City; graphic artist
 Biographical Sources: BANG; FAAA
 Portrait: BANG
 Published Reproductions:
 "Ghana Market" 1973 MS 2(9-73),25(c)
 "Mother and Child" etching BT(#4-70),42
 "Sister Alone in a Rented Room" etching 1972 BUNY
 "Take It Now" collage 1968-71 FAAA
 untitled drawing BANG
 Further References:
 Fax, Elton. *Black Artists of the New Generation*. New York: Dodd,
 Mead, 1977.

BROWN, MARVIN PRENTISS, 1943- ; b. in New York City;
 painter
 Biographical Sources: AAA; AAANB; WWAA,1984
 Published Reproductions:
 "Location Piece" mixed media 1970 AIM 58(9-70),61
 "Saratoga's Memory" liquitex 1969 AAANB
 untitled oil 1970 DCBAA

BROWN, RICHARD LONSDALE, 1886-1917; b. in Muskogee, OK;
 painter
 Portrait: CRI 15(1-18),130
 Published Reproductions:
 "Seer of Beauty" CRI 15(1-18),130
 untitled CRI 3(4-12),cover

BROWN, SAMUEL JOSEPH, 1907- ; b. in Wilmington, NC; painter
 Biographical Sources: AAA; ATO; BACW; MIAP
 Published Reproductions:
 "Abstraction #1" watercolor 1934 (Philadelphia) ATO
 "Child with Toy Horn" watercolor 1934 LNIA
 "Girl in Blue Dress" watercolor 1936 (Metropolitan) ATO
 "Little Boy Blue" watercolor 1937 LNIA
 "Moments of Thought" watercolor 1938 LNIA
 "Mrs. Simmons" watercolor (Modern Art) AFTM; ATO; LNIA;
 NBAT; PAR 8(10-36),4; PMNA; STU 130(7-45),15
 "Mrs. Simpson" watercolor LNIA; PMNA
 "Prodigy" watercolor MA 29(8-36),506
 "Scrub Woman" watercolor 1937 LNIA; OAAL
 "Smoking My Pipe" watercolor 1930 (Philadelphia) ATO(c)
 "The Twins" watercolor 1945 BACW
 "Two Smart Girls" watercolor 1938 LNIA
 "Writing Lesson" watercolor 1937 LNIA

BROWNE, VIVIAN E., 1929- ; b. in Laurel, FL; graphic artist,
 painter
 Biographical Sources: AAA; BAOA-2; EBSU; WWAA,1991
 Portrait: BAOA-2
 Published Reproductions:
 "Benin Equestrian" acrylic 1973 FFAA(c)

"Collisions, Rumblings and Waters" oil 1984 BALF 19(Sp-85),49
"Fishermen of Lake Rudolph" batik BC 11(8/9-80),201(c)
"Fred's Girl" batik BC 11(8/9-80),201(c)
"Getting Out" aquatint 1970 BAOA-2
"Gigantea I & II" diptych,oil 1989 BAQ 9(#2-90),18(c)
"Jazz Man" batik BC 11(8/9-80),200(c)
"Jimi" batik BC 11(8/9-80),200(c)
"Lady Sings the Blues" batik BC 11(8/9-80),201(c)
"Masai" batik BC 11(8/9-80),200(c)
"Metasequoia" oil 1987 BAQ 9(#2-90),19(c); WAN 12(6-87),28
"Mother and Son" batik BC 11(8/9-80),201(c)
"Peopled Mountain" aquatint 1970 BAOA-2
"Pinacea" oil 1987 BAQ 9(#2-90),19(c)
"Plaiting" batik BC 11(8/9-80),201(c)
"Secrets" batik BC 11(8/9-80),201(c)
"Sempervirens" oil 1987 BAQ 9(#2-90),18(c)
"Seven Deadly Sins" oil 1968 AAASN; BAOA-2
"Versatile Source" acrylic 1987 BAQ 9(#2-90),17
"Warning" aquatint 1968 SA 68(4-69),24
Further References:
Hamalian, Leo, "Talking to Vivian Browne," BALF 19(Sp-85),48-9.

BROWNLEE, HENRY, 1940- ; b. in Savannah, GA; painter
Biographical Sources: AAA
Portrait: BAOA-1
Published Reproductions:
"Three Black Sisters" oil BAOA-1

BUCHANAN, BEVERLY, 1940- ; b. in Fuquay, NC; mixed media
Biographical Sources: NGSBA
Published Reproductions:
"Barnesville" oil 1989 NGSBA(c)
"Bogard, Georgia" oil 1989 NGSBA(c)
"Cameron, South Carolina" oil 1989 NGSBA(c)
"County Line Shacks, Georgia" WAN 15(Sp/Su-90),27
"Lillington" wood,metal 1989 NGSBA(c)
"Oliver McKay's Cabin" wood,tin 1989 NGSBA(c)
"Shack Grouping" mixed media BAAG
"Tar Top" wood,paper 1989 NGSBA(c)

BURAL, EDWARD, see **BERIAL, EDWARD**

BURKE, SELMA HORTENSE (KOBBE), 1901- ; b. in Mooresville,
 NC; sculptor
 Biographical Sources: AAA; BAQ 1(Su-77),41; EB 18
 (9-63),132; TCBAA; WWWA
 Portrait: BAQ 1(Su-77),41; EB 18(9-63),132; PKAU
 Published Reproductions:
 "Compassion" cast sc EB 2(3-47),34
 "The Falling Angel" wood sc 1958 FFAA(c)
 "Franklin Delano Roosevelt" bronze relief EB 21(8-66),91; OPP
 24(Sp-46),70
 "Grief" stone sc NAI
 "Jim" plaster sc (Schomburg) HRABA; SMIH (12-77),4
 "Lafayette" plaster sc 1938 PMNA
 "Mother and Child" alabaster sc AV 3(10-88),38(c); ENC 5
 (12-6-76),4; TCBAA
 "Mother and Two Children" sc 1972 RD 112(6-78),184(c)
 "Negro Woman" OW 6(5-51),31
 "Peace" alabaster sc 1972 LAAA
 "Seated Nude" sc EB 2(3-47),34
 "Temptation" limestone sc 1938 DANA; TCBAA
 "Victory" OPP 24(Sp-46),70
 Further References:
 "Selma Burke," EB 2(3-47), 32-5.

BURKE-MORGAN, ARLENE, 1950- ; b. in Philadelphia; mixed
 media
 Biographical Sources: NGSBA
 Published Reproductions:
 "Cliff Dueller" ceramic,oil 1988 NGSBA(c)
 "The Seed" ceramic,oil 1988 NGSBA(c)
 "Spirit Catcher" ceramic,oil 1988 NGSBA(c)

BURNETT, CALVIN, 1921- ; b. in Cambridge, MA; graphic artist,
 painter
 Biographical Sources: BDCAA; EBSU; TCBAA; WWAA,1991
 Portrait: BAOA-1
 Published Reproduction:

"Black Profile" mixed media BAOA-1(c)
"The Box" litho CONN 164(3-67),195
"Figure and Bird" AIS 5(Fa/Wi-68),477
"Girl Waiting" serigraph AP 11(1971),27
"Insect" oil 1963 BDCAA(c)
"I've Been in Some Big Towns" tempera 1942 TCBAA
"Jennifer" oil 1968 AAANB
"Sisters" mixed media AIS 5(Fa/Wi-68),475
"Soul Sister" drawing AIS 5(Fa/Wi-68),302
"Street Sisters" litho EBSU
"Three Crippled Drunks" serigraph PANA(c)
"Vote Victim" AIS 5(Fa/Wi-68),473
"War Workers" oil AN 45(11-46),21

BURROUGHS, MARGARET TAYLOR GOSS, 1916- ; b.in St. Rose
 Parrish, LA; printmaker, sculptor
 Biographical Sources: BAOA-2; LAAA; TCBAA; TNAP; WWAA,
 1991
 Portrait: BAOA-2; FFAA
 Published Reproductions:
 "Abstraction" linocut PANA
 "Black Queen" bronze sc 1968 BDCAA
 "Blowing Bubbles" oil 1968 BDCAA(c)
 "Crispus Attucks" print 1961 FRE 2(9-62),160
 "Emma Lazarus" litho CNHB
 "Head" marble sc 1968 LAAA
 "Head of a Woman" bronze 1976 FFAA(c)
 "Homage to Marion Perkins" EB 27(9-72),92-3
 "Mexican Landscape" print DANA
 "Playground--Peace" print FRE 2(9-62),294
 "Riding Together" print FRE 2(9-62),294
 "Slum Child" oil 1950 TCBAA
 "Sojourner Truth" print DANA; FRE 2(9-62),294
 "Still Life" oil 1943 AAATC(c)
 "Two Girls" TIM 45(4-9-45),65

BURTON, CECIL, 1941- ; b. in Williamsburg, VA; sculptor
 Published Reproductions:
 untitled polyester resin sc BAOA-1(c)

BURWELL, CHARLES; mixed media
Published Reproductions:
"The Portal--With Directions" mixed media 1987 AIM 76(1-88), 143(c)
Further References:
Rubin, David, "Charles Burwell at Sande Webster," AIM 76(1-88), 143-44.

BUSTION, NATHANIEL, 1942- ; b. in Gadsden, AL; painter
Biographical Sources: AAA; BAOA-2
Portrait: BAOA-2; AVD
Published Reproductions:
"Black Illusion" oil BAOA-2(c)

BUTLER, DAVID, 1898-?; b. in Good Hope, LA; painter, sculptor
Biographical Sources: BFAA; BIS; TCBAA; TCNL
Portrait: BFAA; BIS; TCNL
Published Reproductions:
"Animal" painted tin and plastic 1975 BFAA
"Head Hunter" 1986 BIS
"Locomotive Engine with Rooster" tin and plastic c1980 BFAA
"Man on Elephant" 1984 BIS
"Man with Flag" 1984 BIS
"Nativity Scene" tin,paint BAQ 7(#3-87),10(c); CLA 14(Wi-89), 27(c)
"Rabbit" painted tin and plastic c1975 BFAA
"Ship" 1950 painted tin BIS(c); TCBAA
"Shrine" tin,wood BC 20(#1-89),158(c)
"Skunk" painted tin and plastic c1975 BFAA
"Train" 1983 BIS
"Walking Stick with Figure" painted tin,plastic,wood AC 42 (6/7-82),23(c); BC 15(#1-84),37(c); BFAA; PORT 5(5-83),91
"Whirligig" tin,wood,wire BFAA; CLA 12(Sp/Su-87),9(c)
"Windmill with Man Riding Flying Elephant" tin,wood 1975 (New Orleans) BFAA(c)
"Window, Nativity Scene" mixed media BC 20(#1-89),158(c)
"Window Screen" enamel 1984 BIS(c)
"Winged Creature with Gourd" tin,plastic,gourd c.1980 BFAA(c)

BYARD, CAROLE, 1941- ; b. in Atlantic City, NJ; graphic
 artist, painter
 Biographical Sources: BANG; WWAA,1991
 Portrait: BANG; BE 6(12-75),29
 Published Reproductions:
 "Idaka Believes in Spirits" linocut 1974 BCR 6(1974-5),58
 "May You Realize Your Gifts" litho BE 6(12-75),71
 "May Your Aspirations Unfold" litho BE 6(12-75),70
 "May Your Spirit Rejoice" litho BE 6(12-75),71
 "Slave Ship" oil,charcoal BANG
 untitled AIM 64(9-76),124; ART 51(1-76),66; ART 51(10-76),50;
 ART 51(11-76),24
 Further References:
 "An Artist's Lifestyle," BE 6(12-75),29-32.

BYRD, ALBERT A., 1927- ; b. in Baltimore; painter
 Biographical Sources: WCBI
 Published Reproductions:
 "Helmeted Head" mixed media WCBI

CADE, WALTER, III, 1936- ; b. in New York City; mixed media
 Biographical Sources: WWAA, 1984; WWABA
 Published Reproductions:
 untitled mixed media 1970 DCBAA

CADOO, JOYCE; mixed media
 Biographical Sources: AAA
 Published Reproductions:
 "Decline and Fall" woodcut PANA(c)

CAMERON, BERNARD; painter
 Published Reproductions:
 "Genesis" SMIH 2(1-75),1

CAMPBELL, ELMER SIMMS, 1906-1971; b. in St. Louis; painter
 Biographical Sources: AAA; GNNP3
 Portrait: EB 2(8-47),12
 Published Reproductions:
 "Blues Singer Backstage" OPP 7(10-29),1

"Creole Woman Started It" watercolor LNIA
"Haitian Gardener" ESQ 9(4-38),63(c)
"Impressions of Haiti" ESQ 9(4-38),64(c)
"Mountains Over Port-au-Prince" ESQ 9(4-38),63(c)
"Thelma" OPP 7(7-29),cover
"Voodoo Drummer" litho ESQ 9(4-38),62
Further References:
"Cartoonist for Playboy," JET 39(2-18-71),12-13.
"Country Gentleman," EB 2(8-47),9-12.

CAMPBELL, FREDERICK, 1926- ; b. in Philadelphia; painter
Biographical Sources: AAA; BACW
Published Reproductions:
"Burn Baby Burn" ND 16(8-67),92
"The Hustler" ND 16(8-67),91
"Portrait of Mr. James V. Herring" oil BACW
"The Testimonial" ND 16(8-67),90
"The Young Lions" ND 16(8-67),92
Further References:
"Painting It Like It Is: The Ghetto" ND 16(8-67),90-2.

CANNON, THOMAS, 1926- ; b. in Richmond, VA; painter
Biographical Sources: EB 29(5-74),54-6
Portrait: EB 29(5-74),54
Published Reproductions:
"Black Woman" oil EB 29(5-74),58
"Crucifixion" oil EB 29(5-74),59

CANYON, NICHOLAS L., 1931- ; painter
Published Reproductions:
"James Dean, Melancholy Genius" EB 13(4-58),38
"Meditation" EB 13(4-58),38

CARLIS, JOHN, JR., 1927- ; b. in Chicago; painter
Biographical Sources: AAA; MIAP
Portrait: EB 5(12-49),4
Published Reproductions:
"Two Women" oil 1940 LNIA
"Two Young Men" oil AN 40(10-15-41),25

Further References:
 "Speaking of People: Christmas Card Designer," EB 5(12-49),4.

CARRAWAY, ARTHUR, 1927- ; b. in Ft. Worth, TX; painter
 Biographical Sources: BAOA-1; LAAA
 Portrait: BAOA-1; DIAA
 Published Reproductions:
 "Across the Hudson" oil BAOA-1(c); JBP 1(Su/Fa-69),44
 "African Symbol" oil 1965 JBP 1(Su/Fa-69),40
 "African Symbol of Freedom" oil BAOA-1
 "Ancestral Shrine" gouache c1970 DIAA
 "Fetish Form" oil BAOA(c)
 "Fetish Form Series II" oil 1968 (Oakland) AOC; JBP 1(Su/Fa-69),
 43; LAAA; ONPB
 "Fetish Form Series IV" oil BDCAA(c); JBP 1(Su/Fa-69),45
 untitled oil JBP 1(Su/Fa-69),42
 "Zulu Warfare, Series I" oil c1968 DIAA
 Further References:
 Jeffries, Rosalind, "Arthur Carraway, Charles Searles and Houston
 Conwill: Work of Three North American Black Painters," un-
 published Ph. D. dissertation, Yale University, 1979.

CARTER, ALBERT JOSEPH, 1915- : b. in Washington, DC;
 painter
 Biographical Sources: AAA; DENA; WWAA,1978
 Portraits: DENA
 Published Reproductions:
 "Still Life" oil DENA

CARTER, ALLEN D., 1947- ; b. in Washington, DC; mixed media
 Biographical Sources: NGSBA
 Published Reproductions:
 "Fishing For the Color Blue" mixed media AV 5(4-90),14(c)
 "I Made a Step" mixed media 1987 NGSBA
 "Run Rabbit Run" mixed media 1989 NGSBA

CARTER, GEORGE C., 1931- ; b. in Jamaica, NY; mixed media,
 painter
 Biographical Sources: CBAM

Published Reproductions:
"Le Roi" mixed media 1969 CBAM

CARTER, GRANT; painter
Published Reproductions:
"Missouri Share Croppers" oil DES 47(2-46),11
"The Studious Blacksmith" oil OPP 13(3-35),81

CARTER, IVY; painter active in 1970s
Biographical Sources: DENA
Portrait: DENA
Published Reproductions:
"In America?" oil 1972 DENA

CARTER, KEITHEN; painter active in 1970s
Published Reproductions:
"Resurrection" Chicago mural EB 26(4-71),177(c)
untitled mural EB 26(4-71),177(c)

CARTER, ROBERT, 1938- ; b. in Louisville; graphic artist
Biographical Sources: AAA
Published Reproductions:
"New Breed" FRE 10(4thQ-70),cover
untitled oil (Denver) AADAM

CARTER, WILLIAM S., 1909- ; b. in St. Louis; muralist, painter
Biographical Sources: AAA; ILAAL; PKAU; TNAP
Published Reproductions:
"Ballerina" oil 1939 PMNA
"Clouds Over Kinlock" oil 1944 (Albany) NA; NAI
"Midwestern Landscape" oil MA 34(8-41),373
"Still Life" oil 1941 (Harmon) ILAAL
"Study in Gray" watercolor 1939 LNIA
"Tete-a-Tete" tempera 1938 LNIA; OPP 18(1-40),21

CARTER, YVONNE PICKERING, 1939- ; painter
Published Reproductions:
"Morning Mist" acrylic 1983 ICAA

CARVER, GEORGE WASHINGTON, 1864-1943; b. in Diamond
 Grove, MO; painter
 Biographical Sources: AAA; CB,1940; WWAA,1940
 Published Reproductions:
 "The Yucca" oil TIM 38(11-24-31),82
 Further References:
 Moss, Wade, "The Wizard of Tuskegee," OPP 14(11-36),362-5.

CASEY, BERNARD TERRY (BERNIE), 1939- ; b. in Wyco, WV;
 painter
 Biographical Sources: AAA; BDCAA; FBA; LAAA
 Portrait: AG 11(4-68),42; AG 13(4-70),30; BAOA-1; FBA
 Published Reproductions:
 "Come" AIM 57(9-69),21(c)
 "An Excerpt from a Ferry Trip" oil AG 13(4-70),31(c)
 "Freedom" acrylic 1970 FBA
 "Freedom Sound" acrylic BAOA-1(c)
 "In Little Ways" acrylic 1969 BDCAA(c)
 "My Unconscious Mind" acrylic 1971 BAQ 3(#3-79),3(c); BAQ
 3(4-79),3(c); FBA(c)
 "Orbital Moonscape" acrylic 1968 LAAA(c)
 "Other Side of Paisley" acrylic 1967 AG 11(4-68),cover(c)
 "Schizophrenic Moon Folly" acrylic 1968 BAOA-1
 "The Spectral Singing of the Moon" oil 1969 BAOA-1(c)
 "White Bird" acrylic 1968 DBLJ
 "You Can Win the Game if It's Your Turn" oil 1966 BDCAA(c);
 HW 7(3rdQ-68),15(c)
 Further References:
 Casey, Bernie. *Look at the People.* New York: Doubleday, 1969.
 Casey, Bernie, "Why I Paint," AG 13(4-70),30-1.
 "Pigskins and Pigment," AG 11(4-68),43.

CATCHINGS, YVONNE, 1935- ; b. in Atlanta; painter
 Biographical Sources: AAA; BAOA-2; FFAA; WWABA,1978
 Portrait: BAOA-2; FFAA
 Published Reproductions:
 "The Chains Are Still There" acrylic 1971 BAOA-2
 "The Detroit Riot" collage 1967 BAOA-2; FFAA(c)

CATLETT, ELIZABETH, 1915- ; b. in Washington, DC; painter,
 printmaker, sculptor
Biographical Sources: ILAAL; TCBAA; WWAA,1991; WWABA
Portrait: BAOA-2; DANA; FFAA; FSBA; IDAW
Published Reproductions:
 "Baile (Dance)" linocut 1970 BAQ 1(Fa-64),31(c); BC 10(#5-80),
 152
 "Black Maternity" SMIH 2(1-75),5
 "Black Unity" walnut sc 1968 AWSR; BAOA-2(c); EB 32(2-77),
 36; ENC 5(12-20-76),23; LAAA; TCBAA
 "Black Woman Speaks" litho BC 10(#5-80),153(c); SMIH 2
 (1-75),5
 "Black Woman Speaks" wood sc 1970 AWAP; BAQ 1(Fa-76),37
 (c); BAQ 2(Wi-78),71(c); BAQ 2(#3-78),71(c); BAQ 2 (#4-78),
 71(c); BAQ 3(#1-79),71(c); DAAA; GAI
 "Boys" linocut 1975 BAQ 1(Fa-76),3(c); BAQ 2(Fa-77),61(c);
 BAQ 2(#3-78),72(c); BAQ 2(#4-78),69(c); BAQ 3(#1-79),64(c)
 "Bronze Head" sc BAQ 1(Fa-76),27
 "Cabeza" litho 1967 BAQ 1(Fa-76),34
 "Cansada" terra cotta sc (Howard) BAQ 1(Fa-76),34
 "Cartas" litho 1986 BAQ 7(#4-87),58
 "Celie" litho 1986 BAQ 7(#4-87),62
 "Figura" mahogany sc AG 8(4-70),17(c); EB 24(1-70),100; BE 6
 (12-75),69; HW 7(3rdQ-68),15(c)
 "Girls" serigraph ESS 16(6-85),86(c)
 "Glory" bronze sc ESS 16(6-85),85(c)
 "Harriet" wood engraving 1946 BAQ 1(Fa-76),32; BAQ 3(#1-79),
 68; CBAR; ESS 16(6-85),86(c); NAE 16(6-89),48
 "Head" bronze sc BAQ 6(1-84),13
 "Homage to My Young Black Sisters" cedar sc BAQ 1(Fa-76),35;
 BAQ 6(1-84),21; BAQ 7(#2-87),28; EB 24(1-70),94; FSBA; WA
 "Homage to the Panthers" linocut 1970 BAOA-2(c)
 "I Have Special Reservations" linocut 1946 BAQ 2(Sp-78),13
 "Latin America Says No" linocut 1968 BSH 6(6-75),11
 "Louis Armstrong" bronze sc BAQ 7(#2-87),30
 "Lovey Twice" litho 1976 BAQ 3(#2-79),64
 "Madonna" litho 1982 BAQ 5(#4-84),59; ESS 16(6-85),88(c)
 "Malcolm Speaks for Us" linocut BAQ 1(Fa-76),33(c); DBLJ; EB
 24(1-70),100; GAI; LAAA; MN 60(1/2-82),45

"Maternity" sc AIM 78(3-90),168; FRE 14(1stQ-74),cover
"Mother and Child" sc 1972 AN 43(2-1-45),16(c); AV 2(12-87),
 19(c); BAQ 1(Fa-76),cover(c); BAQ 1(Wi-76),25; CAWS;
 DANA; TCBAA; CR 49(8-42),262
"Mother and Son" SMIH 2(1-75),5
"My Reward Has Been Bars Between Me and the Rest of the Land"
 linocut 1946 (Howard) BAQ 2(#3-78),16
"Negro Es Bello (Black Is Beautiful)" litho 1968 BC 11(10/11-80),
 99; LAAA
"Negro Girl" marble sc 1939 LNIA
"Negro Woman" bronze sc 1946 AV 1(9/10-86),41; NHB 46
 (10/11/12-83),cover
"Negro Woman" marble sc DANA
"Nude Torso" marble sc 1984 EWCA(c)
"Olmec Bather" bronze sc BAQ 7(#2-87),32; EB 24(1-70),98
"Pensive" bronze sc SRV 37(#1-88),27
"Pensive Portrait" oil 1945 BACW
"Phillis Wheatley" bronze sc 1973 BAQ 7(#2-87),29; BAQ 8
 (#2-88),27; BSH 6(6-75),13; BW 23(1-74),cover; EB 29(3-74),
 94; NALW 9(Wi-75),123
"Protection" sc 1970 AG 18(6-1-44),15
"Rebozos" BC 10(#5-80),153(c)
"Recognition" onyx sc AV 2(12-87),23(c); BAQ 1(Fa-76),30(c);
 BC 6(11/12-75),cover(c)
"Red Leaves" litho 1978 ESS 16(6-85),87(c)
"Sharecropper" woodcut AAATC(c); AW 17(3-8-86),5; BAOA-2
 (c); BAQ 1(Fa-76),30(c); BC 10(#5-80),152(c); ESS 16(6-85),
 87(c); PW 213(1-30-78),99
"Singing Head" marble sc 1970 FSBA
"Skipping Rope" SMIH 2(1-75),5
"Students Aspire" bronze sc (Howard) BAQ 2(Sp-79),59
"Target" bronze sc ANA 11(10-76),cover(c); NALF 10(Sp-76),13;
 NHB 30(10-67),9
"Target Practice" bronze sc 1970 ANA 11(10-76), cover; SA 79
 (10-79),58
 "There's a Woman in Every Color" wood sc 1975 ESS 20
 (12-89),104
"These Two Generations" litho 1987 BAQ 7(#4-87),59
"Tired" terra cotta 1946 (Howard) AIM 70(Su-82),35; NHB 30

(10-67),9; STHR
"Torso" walnut sc BAQ 1(Fa-76),36(c); BAQ 2(Wi-78),71(c);
 BAQ 2(#3-78),71(c); BAQ 2(#4-78),71(c); BAQ 3(#1-79),71(c);
 BAQ 4(#1-80),68
"Two Generations" litho 1979 BAQ 3(#3-79),64; BAQ 6(#4-85),
 32
"Unity" wood sc AIS 11(#1-74),48
untitled sc BAQ 6(1-84),19
untitled sc BC 10(#5-80),152(c)
untitled woodcut CBAR
"Watts/Detroit/Washington/Harlem/Newark" linocut 1970 BAQ 1
 (Fa-76),30(c); BAQ 8(#2-88),58
"Which Way" litho 1975 BAQ 1(Fa-76),39; BSH 6(6-75),57;
 NALF 10(Sp-76),3
"Women" linocut 1975 BSH 6(6-75),61; NALF 10(Sp-76),3
"Working Woman" oil 1947 BACW; WAWC
"Young Girl" plaster sc 1946 (Atlanta) EB 1(7-46),49; ILAAL
Further References:
 Fax, Elton, "Four Rebels in Art," FRE 4(Sp-61),215-25.
 Fax, Elton. *Seventeen Black Artists.* New York: Dodd, Mead,
 1971.
 Lanker, Brian. *I Dream a World; Portraits of Black Women Who
 Changed America.* New York: Stewart, Taberi and Chang,
 1989.
 Lewis, Samella. *The Art of Elizabeth Catlett.* Claremont, CA:
 Hancrafstudios, 1983.
 "My Art Speaks for Both My People," EB 25(1-70),94-6.

CATLETT, FRANCIS DUNHAM, 1908- ; b. in Hartford, CT;
 painter
 Biographical Sources: AAA
 Published Reproductions:
 untitled watercolor ONPB

CATON, MITCHELL, 1930- ; b. in Chicago; muralist, painter
 Biographical Sources: AAA
 Published Reproductions:
 "Quest for Higher Knowledge" mural BS 2(10-72),21
 "Rip Off" Chicago mural 1970 BAOA-2(c)

CATTI (CATHERINE JAMES), 1940- ; b. in Mount Vernon, NY; painter
Biographical Sources: AAA; WWAA.1978
Portrait: ESS 4(4-73),51; FFAA
Published Reproductions:
 "Fly-Butter-Fly" construction 1984 BALF 19(Sp-85),43
 "Intro-Time" mixed media 1979 FFAA(c)
 "Man, Moon, and Earth" synthetic polymer 1970 DCBAA
Further References:
 Andrews, Peter, "Catti," ESS 4(5-73),50-1.

CHAMBLISS, CHARLOTTE JACKSON, 1910- ; b. in Wilson, LA; graphic artist
Biographical Sources: AAA
Published Reproductions:
 "How Wild the Wind" ink ONPB

CHANDLER, DANA C., JR.,1941- ; b. in Lynn, MA; muralist, painter
Biographical Sources: BANG; BAOA; LAAA; WWAA,1991
Portrait: BANG; BAQ 1(Sp-77),14; BAOA-1; TNAP
Published Reproductions:
 "Black Family" 1970 BAQ 1(Sp-77),17
 "Black Man Break Free" acrylic 1974 BC 11(#2-80),99(c)
 "Boston Mural" mural ART 45(9-70),31
 "The Brother's Remedy" acrylic GAI
 "Death of Uncle Tom" acrylic 1968 BAOA-1
 "Fetish #2" acrylic GAI
 "4(00) More Years" acrylic 1973 LAAA(c)
 "400 Year Old Prisoner" oil BAQ 1(Sp-77),14(c)
 "Fred Hampton's Door" acrylic 1970 AAANB; LAAA; TIM 95
 (4-6-70),80(c); TNAP
 "Ghetto" AIM 71(5-83),37(c)
 "A History of Amerikkkan Lynchings, 1619-Present" acrylic 1971
 STHR
 "Household Weapons: Turpentine, Bullets, Salt, Pepper" acrylic
 1975 FAAA; LAAA(c)
 "King Assassinated" NEW 75(6-22-70),89
 "Knowledge Is Power, Stay in School" mural 1972 AJ 39(Su-80),

293; BAQ 1(Sp-77),18(c); ENC 7(9-18-78),31; LAAA(c)
"Land of the Free" acrylic 1967 BAOA-1
"Land of the Free #2" acrylic 1967 BAOA-1
"Le Roi Jones--House Arrest" acrylic BAOA-1
"Moses Brings the World to His People" acrylic 1967 BAOA-1
"Nail Polish and Matches" oil 1972 BAQ 1(Sp-77),15(c)
"Nigger...You Are a Four Hundred Year Prisoner" oil BAOA-1
"Noddin Our Liberation Away" drawing 1973 GAI
"Pan-African Man" litho 1970 BAQ 1(Sp-77),19(c)
"Penal Colony" 1971 FAAA
"Ready!" oil 1968 BAQ 1(Sp-77),15(c)
"Rebellion 68" acrylic BAOA-1
"Street Mural" mural AN 68(9-69),30

CHANDLER, JOHN EDWARD, 1943- ; b. in VA; painter
Biographical Sources: AAA
Published Reproductions:
"Garvey's Quest" oil DCBAA
"Kulu Se" acrylic 1969 AAANB; AIM 58(9-70),59(c)
"Statis 4" oil 1968 FUF

CHANDLER, ROBIN; mixed media
Portrait: AV 4(12-89),40
Published Reproductions:
"Coltranian II" collage AV 4(12-89),42(c)
"Take Me to da Water" collage 1988 AV 4(12-89),43(c)
"Taking Away the Medicine" mixed media AV 4(12-89),41(c)
"Trois Danseurs" collage AV 4(12-89),43(c)

CHASE-RIBOUD, BARBARA DEWAYNE, 1930- ; b. in Philadel-
phia; printmaker, sculptor
Biographical Sources: FAAA; LAAA; WWAA,1991; WWABA
Portrait: CH 32(4-72),24; DANA; EB 21(8-66),90
Published Reproductions:
"Adam and Eve" bronze sc 1958 DANA
"Bathers" aluminum,silk 1972 AN 71(3-74),2
"Black Zanzibar Table" bronze,silk sc 1974 AIM 70(Su-82),35;
FFAA(c)
"Bulls" drawing 1958 DANA

"Cape" sc 1973 CAWS; EB 37(8-82),150(c); OAWA; WAIH(c)
"Confessions for Myself" construction 1972 WA
"Going to Memphis" bronze,hemp 1971 AN 71(3-72),28
"Han Shroud" CR 37(2-77),33
"The Last Supper" bronze sc 1958 DANA; FAAA; STHR
"Le Manteau" hanging 1973 CH 37(2-77),33(c)
"Monument III" bronze,silk 1970 DCBAA
"Monument IV" cast bronze,silk CH 32(4-72),23
"Monument to Malcolm X" bronze,silk AG 13(4-70),25
"Monument to Malcolm X, II" bronze,wool 1969 (Newark)
 AANM; AATNM; AIM 58(9-70),64; AIPP; FAAA; NBAT
"Mother and Child" wood sc 1956 DANA; FAAA
"She #1" polished bronze,silk 1972 CH 32(4-72),22
"Sheila" cast aluminum,silk CH 32(4-72),22
"Study of a Nude Woman as Cleopatra" wood,copper,bronze 1983
 AWSR; EWCA(c)
"Time Womb" aluminum,silk CH 32(4-72),24
"The Toreador" bronze sc AG 13(12-69),49
untitled charcoal drawing 1971 AN 71(3-72),29
"Victorious Bullfighter" bronze sc 1958 DANA
"Why Did We Leave Zanzibar?" bronze,silk 1971 AN 71(3-72),
 28(c); CH 32(4-72),25
Further References:
 Lasner, Fay, "Barbara Chase-Riboud," CH 32(4-72),22-5.
 Nora, Francoise, "From Another Country," AN 71(3-72),28-9.
 "People--Barbara Chase-Riboud," ESS 1(6-70),62.

CHAVIS, KITTY, 1938- ; b. in New York City; painter
 Biographical Sources: AAA
 Published Reproductions:
 untitled oil 1959 DANA

CHRISTMAS, EDWARD; active in the 1960s; painter
 Published Reproductions:
 "Perceive" oil AG 11(4-68),47
 "Wall of Dignity" Detroit mural 1968 FAAA; TNAP

CINTRON, PETRA; painter
 Biographical Sources: AAA

Published Reproductions:
"Mother, Grandmother and Great Grandmother" oil 1972 AIPP

CLACK, GEORGE; b. in Sequin, TX; sculptor
Biographical Sources: BAOA-2
Portrait: BAOA-2
Published Reproductions:
"Afro Form" sc BAOA-2(c)

CLARK, CLAUDE, SR., 1914- ; b. in Rockingham, GA; painter
Biographical Sources: TCBAA; WWAA, 1991
Published Reproductions:
"The Arena" oil DAAA
"Black Man's Burden" oil (Fisk) DAAA
"The Black Orchid" oil TCBAA
"Boats" oil MOT 15(3-55),18
"Crucible" oil 1961 ICAA
"Gladiolus" oil MOT 15(3-55),18
"Growing Flowers" oil MOT 15(3-55),16
"The Ignition" oil ILAAL
"My Church" oil MOT 15(3-55),19
"Old Swayne" oil MOT 15(3-55),19
"Primitive Mill" oil 1950 (Harmon) DANA
"Rain" oil DANA
"Rain in the Tropics" oil MOT 15(3-55),17
"Resting" oil 1944 (Smithsonian) AAAC; TEAAA
"Shrimp Boats" oil MOT 15(3-55),16
"Slave Lynching" oil 1946 BC 8(9/10-77),50(c); TCBAA(c)
"Soldering No. 1" oil (Albany) NAI
"Sponge Fisherman" oil 1950 DANA
"The Vision" oil 1961 ICAA(c)
Further References:
"Exhibition of Paintings of Southern Negro Life at Bonestill Gallery." AG 20(10-1-45),17.
Gibbs, Jo, "Emotional Statements," AD 20(5-1-46),16.

CLARK, CLAUDE LOCKHART, JR., 1945- ; b. in Philadelphia; painter
Biographical Sources: AAA; WCBI; WWABA, 1978

Published Reproductions:
 "Bitch" brush,ink WCBI
 untitled OSAE

CLARK, EDWARD, 1926- ; b. in New Orleans; painter
 Biographical Sources: AAA; TNAP; WWAA,1991; WWABA
 Portrait: BE 6(12-75),57
 Published Reproductions:
 "The Big Egg" acrylic AAANB; ART 45(11-70),30
 "Black and White and Brown" 1971 AJ 39(Su-80),293
 "Black and White Drawing" acrylic 1970 CGB
 "Broken Rainbow" ART 61(4-87),108
 "Earth Sign" acrylic AI 8(Su-74),30(c)
 "Earth Zone" acrylic 1978 ENC 7(12-4-78),32
 "Gold" AN 80(3-81),230(c)
 "Gray Force" acrylic 1972 AI 17(10-73),37; AN 71(11-72),82;
 ARTF 11(9-72),26; ENC 7(12-4-78),32
 "Hetty" acrylic 1970 ANA 6(2-72),37; AI 17(10-73),37
 "Integrated Oval, I" acrylic 1972 AI 17(10-73),36; CGB(c)
 "Mainstream One" acrylic 1975 AI 19(11-75),65; ART 50(11-75),
 8(c); PEAA
 "Oval Painting" acrylic AI 17(10-73),46(c)
 "Purple" acrylic 1972 AI 17(10-73),36
 "Purple Sketch" acrylic AIM 69(1-81)9,120
 "Spatial Image I" acrylic AN 81(12-82),154
 untitled collage AIM 69(1-81),119
 untitled etching 1978 AAATC(c)
 Further References:
 Ratcliff, Carter, "Edward Clark," AI 19(11-75),65.
 Robins, Corinne, "Edward Clark: Push-Broom and Canvas," AI 17
 (10-73),36-7.
 Wilson, J., "Edward Clark--Directions," AIM 69(1-81),119-21.

CLARK, IRENE, 1927- ; b. in Washington, DC; painter
 Biographical Sources: AAA; AAATC; LAAA
 Portrait: BAOA-1; DANA
 Published Reproductions:
 "African Jail" oil 1970 AAATC(c)
 "Decoration" oil DANA

"Fable Scene" BC 7(3/4-77),39(c)
"Keeper of the Birds" oil 1962 BAOA-1
"Mansion on Prairie Avenue" oil DANA; EB 29(12-73),40(c)
"Playmates" DANA(c)
"Rolling Calf" oil LAAA; ONPB

CLARKE, LEROY, 1938- ; b. in Trinidad; painter
Biographical Sources: AAA; WWABA
Portrait: DIAA
Published Reproductions:
"Christ on the Cross" oil EB 26(4-71),178(c)
"Fern Gully" ENC 6(1-3-77),31-2
"La Diablesse" oil 1973 DIAA
"Lay Me Gently for Tomorrow I Wake" oil 1972 DIAA
"Sans Humanite" oil 1973 AIM 62(11/12-74),42
"Slaveship Called Pregnant Bitch" ENC 6(1-3-77),31-2
"Soucouyant" ENC 6(1-3-77),31-2

CLAY, PAULINE, 1926- ; painter
Biographical Sources: AAA
Published Reproductions:
"Carter's Little Filling Station" oil DES 47(2-46),12; TIM 45
(4-9-45),65

CLEMENS, PAUL LEWIS, 1911- ; b. in Milwaukee; painter
Biographical Sources: WWWA
Published Reproductions:
untitled oil MA 311(11-38),655

COBB, DENISE; painter
Published Reproductions:
"Adam's Gentle Strength" acrylic BC 9(#4-79),76(c)
"Opposites to be Reconciled" acrylic BC 9(#4-79),76(c)
"Relationship" acrylic BC 9(#4-79),76(c)
"The Vision" acrylic BC 9(#4-79),76(c)

COKER, GYLBERT G., 1944- ; b. in New York City; painter,
printmaker
Biographical Sources: WWABA,1978

Published Reproductions:
 untitled collage BCR 6(1974-75),34

COLE, MARION ELIZABETH; muralist
Published Reproductions:
 "Women" Houston mural 1974 WBAH(c)

COLEMAN, ARCHIE; muralist
Published Reproductions:
 "Cotton Pickers" oil 1950 WBAH

COLEMAN, FLOYD, 1937- ; b. in Sawyerville, AL; graphic artist,
 painter
Biographical Sources: BAOA-2; EBSU; LAAA; WWAA,1991
Published Reproductions:
 "Africa Series" mixed media 1971 BAQ 3(#2-80),41; BAQ 7
 (#3-87),7
 "Drawing" mixed media 1969 AAASN
 "Importance of Tradition" oil EBSU
 "In the Park" linocut PANA(c)
 "Like It is" mixed media 1968 BAOA-2(c)
 "One Common Thought" mixed media 1972 LAAA
 "Red Square" acrylic 1967 CBAM
 "Remembrance of Things Past" acrylic ILAAL
 "Self-Portrait" mixed media 1968 BAOA-2
 "Yellow Square" mixed acrylics 1967 LAAA

COLES, DONALD E., 1947- ; b. in Philadelphia; painter
Biographical Sources: AAA; LAAA
Portrait: BAOA-1
Published Reproductions:
 untitled oil BAOA-1
 untitled oil BAOA-1
 untitled drawing LAAA
Further References:
 "San Francisco," ARTF 9(10-70),82.

COLESCOTT, ROBERT H., 1925- ; b. in Oakland, CA; painter
Biographical Sources: WCBI; WWAA,1991

Published Reproductions:
 "Aloha Shirley" AW 17(5-10-86),3
 "An American Rescued in the Desert" 1987 ICAA(c)
 "Apparition of Venus" acrylic 1984 ART 60(1-86),134; ARTF 24
 (11-85),17(c)
 "At the Bathers' Pool: Apparition of Venus" acrylic 1984 ARTF
 28(3-90),114; NAE 16(6-89),37
 "Beauty Is in the Eye of the Beholder" acrylic 1979
 AIM 77(6-89),149(c); NAE 16(6-89),37
 "Billboard Idea Rejected by the Liberty Brassiere Corporation"
 acrylic 1976 OSAE
 "Christiana's Day Off" AW 18(4-18-87),1
 "Colored TV" acrylic 1977 AIM 66(3/4-78),137(c)
 "Crow in the Wheat Field" ARTF 21(11-82),31
 "Desire for Power--Power for Desire" acrylic 1987 CPNW(c)
 "Down in the Dumps" AN 83(9-84),149
 "Dutch Chocolate" acrylic 1974 ARTF 22(3-84),58
 "Eat Dem Taters" acrylic 1975 AIM 77(6-89),150(c); AJ 45
 (Wi-85),313; AW 18(4-18-87),1
 "Ecole de Fontainebleau" acrylic 1978 ART 53(4-79),10(c)
 "End of the Trail" acrylic 1976 AIM 70(10-82),138; AW 13
 (5-1-82),16; SFMA
 "Famous Last Words: The Death of a Poet" acrylic 1988 AIM 77
 (6-89),148(c)
 "Feeling His Oats" 1988 ART 63(2-89),12(c)
 "George Washington Carver Crossing the Delaware" acrylic 1975
 AIM 77(6-89),150(c); NAE 16(6-89),35
 "Hardhats" acrylic 1987 ARTF 26(10-87),49(c); CPNW(c)
 "Hard Time" acrylic 1982 STHR
 "Homage to Delacroix: Liberty Leading the People," acrylic 1976
 ARTF 22(3-84),56
 "I Gets a Thrill Too When I Sees de Koo" acrylic 1978 ARTF 22
 (3-84),57; ARTF 22(6-84),64; AW 18(4-18-87),1
 "Knowledge of the Past Is the Key to the Future" acrylic 1986 AIM
 77(6-89),153(c)
 "Lady Liberty" acrylic 1980 ARTF 22(3-84),56
 "Legend Dimly Told" acrylic 1982 CACF(c)
 "Les Demoiselles d'Alabama: Vestidas" acrylic 1985 AIM 77
 (6-89),151(c); ARAN 6(2-89),38; AW 18(4-18-87),1

"Listening to Amos & Andy" acrylic 1982 ART 57(11-82),76
"Midnight at the Mustank Ranch" 1978 AIM 69(11-81),13
"My Shadow" acrylic 1977 AOC(c); ART 52(11-77),46
"Natural Rhythm: Thank You Jan van Eyck" acrylic 1976 AN 88
 (5-89),158; NAE 16(6-89),36
"Olympic Event" acrylic 1972 ARTF 22(3-84),56
"Pac Man (The Consumer Consumed)" acrylic 1989 BABC(c)
"Poet-Counterpoet" ARAN (10-87),37(c)
"Pygmalion" acrylic 1987 ART 63(12-88),90(c); CPNW(c)
"Shirley Temple Black and Bill Robinson White" acrylic 1980
 AIM 77(6-89),197; AW 17(5-10-86),3; NAE 16(6-89),35
"Some Afterthoughts on Discovery" ART 62(11-87),94
"Sunday Afternoon with Joaquin Murietta" acrylic 1980 ARTF 20
 (Su-82),71
"Susanna and the Elders" acrylic 1980 AIM 69(1-81),137; ARTF
 22(3-84),59; ART 55(1-81),45
"Topless Chicken" acrylic WCBI
"Vestidas" AW 18(4-18-87),cover
"White Boy" 1989 ARTF 28(2-90),16(c)
"Wreckage of the Medusa" acrylic ART 54(9-79),28
Further References:
 Danto, Arthur C., "Robert Colescott," NAT 248(5-22-89),789-13.
 Johnson, Ken, "Colescott on Black & White," AIM 77(6-89),148-
 52.

COLLINS, CAROLYN PORTER, 1935- ; b. in Detroit; painter,
 sculptor
Published Reproductions:
 "Anatomical Man" welded sc EU (Fa-74),6
 "La Mujer Triste" sc EU (Fa-74),37
 "Seven Comes Eleven and I'll Be in Heaven" sc EU (Fa-74),33

COLLINS, PAUL, 1936- ; b. in Muskegon, MI; painter
Biographical Sources: WWAA,1991
Portrait: AA 40(4-76),48
Published Reproductions:
 "Bassari Country" oil 1972 AA 40(4-76),48
 "The Contemporary" EB 26(10-71),178(c)

"Gal" oil EB 26(10-71),175(c)

"Harriet Tubman" BC 9(#5-79),58

"Hawk" oil 1973 AA 40(4-76),48; EB 26(10-71),175(c)

"Ida" oil 1972 AA 40(4-76),49

"La Garde Rouge" oil EB 26(10-71),175(c)

"The Last Prayer" oil 1975 AA 40(4-76),50

"Mamsanou" oil 1971 AA 40(4-76),51; EB 26(10-71),17(c); EB 28(10-73),50

"Mandingo" EB 26(10-71),176(c),180

"N'gore N'diaye" oil 1972 AA 40(4-76),52(c)

"Shaka--King of the Zulus (1818-1828)" BC 9(#5-79),58; BC 12 (#4-82),167(c); EB 32(12-76),78(c)

"Three Boys and a Boat" oil 1971 AA 40(4-76),53(c); EB 26 (10-71),174(c)

untitled oil EB 26(10-71),176(c)

"Yorro Ba" oil EB 26(10-71),178(c)

Further References:

Collins, Paul and Thomas Lee. *Black Portrait of an African Journey*. Grand Rapids: Erdmans, 1971.

COLLINS, RICHARD L., 1942- ; b. in New York City; mixed media, painter
Biographical Sources: AAA
Published Reproductions:
"Mendocino" oil collage ONPB

COLLINS, SAMUEL O., 1880-1932; b. in Washington, DC; painter
Biographical Sources: AAA
Published Reproductions:
"In Maryland" VN 2(10-05),690
"In the Foothills of Virginia" VN 2(10-05),682
"A Sketch of the Potomac" VN 2(10-05),686
untitled VN 2(10-05),686

COMPTON, WILLIAM , see **KOLAWOLE, WILLIAM LAWRENCE COMPTON**

CONCHOLAR, DAN R., 1939- ; b. in San Antonio, TX; painter, printmaker

Biographical Sources: AAA; LAAA; WCBI
Portrait: BAOA-1
Published Reproductions:
"Bury My Heart" felt pen 1973 BAQ 2(Wi-78),66(c); BAQ 2
 (#3-78),71(c); BAQ 2(#4-78),71(c); LAAA(c)
"Fact of Man" oil 1965 BDCAA(c)
"The Greatest Show on Earth" linocut BAQ 2(Sp-78),18(c)
"In Your Womb" mixed media 1965 BAOA-1(c)
"Series of Africa #2" acrylic BDCAA(c)
"War Machine" mixed media 1965 BAOA-1(c)
untitled collage 1968 BAOA-1(c)
untitled collage 1970 LAAA
untitled acrylic GAE
"Woman and Child" woodcut WLB 43(4-69),756

CONWAY, WALLACE X., 1920- ; b. in Washington, DC; painter
Biographical Sources: DENA
Portrait: DENA; MN 50(2-72),4
Published Reproductions:
"Imamu Baraka" oil DENA
Further References:
"Speaking of People," EB 27(4-72),20

CONWILL, HOUSTON, 1950- ; painter, sculptor
Biographical Sources: AAA; BFAA; WWAA,1991
Published Reproductions:
"Atlanta" latex 1983 STHR
"Blues Bag" 1975 ICAA
"Cakewalk" installation BAQ 6(#1-84),60(c)
"A Caustic Name Change" installation 1982 BAQ 6(#1-84),59
"Easter Shout!" installation 1981 BAAL; AIM 69(10-81),149;
 BAQ 6(#1-84),57(c)
"Edison Tale" 1976 CGB
"Juju" installation 1977 BAQ 3(#3-79),12; CGB(c)
"Juju Bag" installation BAQ 3(#3-79),12
"Louisville" 1983 BAQ 6(#1-84),52(c)
"Measure of Light" mixed media 1989 AIM 78(3-90),169(c)
"Memphis" BAQ 6(#1-84),53(c)
"Messinger's Tale" BAQ 3(#3-79),37

"New Orleans" mixed media 1983 EWCA(c); ICAA
"Passages: AN-1" construction 1980 BAAL
"Passages: 1A" AW11(1-19-80),1
"Passages: Earth/Space" sc BAQ 6(1-84),55
"Passion of St. Matthew" AV 1(11/12-86),29(c)
"Puttin' on Dog" glass 1989 BABC
"Rites of Passage" AN 77(11-78),159; BAQ 3(#3-79),37
"Shrine of Magia Sophia" installation 1983 BAQ 6(1-84),64(c)
"Three Worlds" BAQ 3(#3-79),13
untitled BFAA
"Wolii Tale" BAQ3(#3-79),13(c)

COOPER, WILLIAM ARTHUR, 1895-?; b. in Hillsboro, NC; painter
Biographical Sources: AAA; WWCA,1941
Published Reproductions:
"A Serious Lady" oil 1933 LNIA; OPP 11(3-33),80
"Slave and His Hope" oil 1932 LNIA
Further References:
Cooper, William A. *A Portrayal of Negro Life*. Durham: Seeman
Pr., 1936.

COPPEDGE, ARTHUR L., 1938- ; painter
Biographical Sources: WWAA,1991
Portrait: BE 6(12-75),51
Published Reproductions:
untitled BE 6(12-75),51(c)
Further References:
Bowles, Jerry, "Reviews and Previews," AN 70(1-72),10-12.

CORNWELL, JEAN; b. in New York City; mixed media, painter
Portrait: WJBS 78(#1-83),56
Published Reproductions:
"Birth of a Nation" litho WJBS 7(#1-83),57
"Dizzy" watercolor WJBS 7(#1-83),56
"Ghetto Boy" oil WJBS 7(#1-83),57

CORTOR, ELDZIER, 1915- ; b. in Chicago; graphic artist,
painter
Biographical Sources: BACW; FAAA; LAAA; WWAA,1991

Portrait: EB 18(9-63),131; DANA; LIF 28(3-20-50),93
Published Reproductions:
 "Above Is Eva" oil AV 1(9/10-86),40(c)
 "Adjustments" oil 1940 (Howard) STHR
 "Affection" oil 1942 AD 16(12-15-41),5; MRAA
 "Americana" oil 1946 AD 22(10-15-47),11; AIS 5(Su/Fa-68),209;
 DANA; FAAA
 "The Bathers" oil 1944 AD 20(11-1-45),7; AN 44(10-15-45),11;
 FAAA
 "Brother and Sister" oil 1944 OPP 18(1-40),20
 "Classical Study #39" oil 1971 LAAA
 "Dance Composition #8" BAQ 1(Fa-76),15
 "Environment V" intaglio 1969 AP 11(1971),25; FAAA; FSBA
 "A Girl Resting" MA 33(8-40),479
 "Gullah Girl" OW 6(5-61),30-1
 "Haitian Couple" oil LIF 28(3-20-50),101(c)
 "Head" drawing AN 50(3-51),54
 "Interior" oil 1947 AIM 65(3-77),64(c); AN 76(2-77),66(c); EB
 32(2-77),12(c); ENC 6(1-3-77),20(c); TCBAA
 "Lady Knitting" oil EB 29(12-73),39(c)
 "Loneliness" oil 1940 DANA
 "Man with a Sickle" pencil,watercolor 1945 AAATC(c)
 "The Merchants" oil EB 27(9-72),106
 "Night Letter" oil 1938 LNIA; PMNA
 "One Alone" oil MA 37(8-41),374
 "Remembrances" tempera 1939 LNIA
 "Room No. V" oil AD 24(4-1-50),8; DANA; EB 23(2-68),117(c);
 FAAA(c); LAAA; LIF 28(3-20-50),85(c); MRAA
 "She Didn't Forget" oil 1939 LNIA
 "Skin Deep" oil 1947 DANA
 "Southern Gate" oil 1942 LIF 21(7-22-46),63(c); MJMC; NMAA;
 STHR
 "Tete-a-Tete" SMIH(12-77),4
 "Trio V" oil,tempera 1959 FAAA
 "Two Figures on Bed" DANA
 "Two Nudes" oil 1943 MRAA
 "Woman at Window" drawing AD 25(8-1-51),10
Further References:
 "Nineteen Young American Artists," LIF 28(3-20-50),145-59.

COUNTEE, SAMUEL ALBERT, 1909- ; b. in Marshall, TX; painter
Biographical Sources: AAA; MIAP
Published Reproductions:
 "Little Brown Boy" oil 1933 LNIA

COUSINS, HAROLD, 1917- ; b. in Washington, DC; painter, sculptor
Biographical Sources: BACW
Published Reproductions:
 "Mamloi" plastic cast sc BACW
Further References:
 "Harold Cousins: Ex-GI from Washington, D.C. Wins Fame as Best American Sculptor Working in France," EB 8(2-53), 45-8.

CRAWFORD, CLEO, 1892-1942?; painter
Biographical Sources: AAA
Published Reproductions:
 "Christmas" oil DANA; TTT

CREMER, MARVA, 1942- ; b. in Miami; painter, printmaker
Biographical Sources: AAA; WCBI
Portrait: BAOA-1
Published Reproductions:
 "Do You Know What I'm Doing?" litho BAOA-1(c); BAQ 6 (#4-85),27(c)
 "Strange Journey" litho BAOA-1; ONPB
 "Wanda's Birthday" pencil 1973 OSAE; WCBI

CRICHLOW, ERNEST, 1914- ; b. in New York City; painter, printmaker
Biographical Sources: AAA; AAANB; NAI: WWAA,1962
Portrait: AG 13(4-70),51; EB 18(9-63),131
Published Reproductions:
 "Black Angel" acrylic BACPA
 "Crissy" drawing FRE 4(Su-64),cover
 "Cross With Angels" oil CRI 79(4-72),cover(c)
 "The Domestic" oil DANA
 "Girl at Window" oil BAQ 1(Wi-76),49(c)
 "Lend Me a Hand" oil DANA

"Lover" oil AD 16(12-15-41),5; LNIA
"Lovers" litho LNIA
"Mother and Child" oil (Albany) AN 40(10-15-41),25; NAI
"Nathalie" oil 1939 LNIA
"Paulette" gouache 1956 DAED 80(3-79),11
"Ronnie" drawing FRE 4(Su-64),cover
"Shoe Shine" oil 1953 (Brooklyn) BMAP
"Sunday Morning" FRE 4(Su-64),cover
untitled oil GAE
"Waiting" CRI 79(5-72),cover(c)
"White Fence #1" oil 1967 EB 23(2-68),121(c); SA 71(12-71),27
"White Fence #2" acrylic AAANB
"Young Boy" oil 1960 AG 13(4-70),8(c); HW 7(3rdQ-68),14;
 TEAAA; TNA
"Young Lady in Yellow Dress" etching EB 33(10-78),22; ESS 9
 (10-78),115
"Young Mother" oil AD 16(10-15-41),11
Further References:
"Leading Young Artists," EB 13(4-58),131-5.

CRISS, NORMA, 1942- ; b. in Montclair, NJ; painter
Biographical Sources: AAA
Published Reproductions:
"Four Women" oil NBAT

CRITE, ALLAN ROHAN, 1910- ; b. in Plainfield, NJ; painter
Biographical Sources: AAA; MIAP; TCBAA; TNAP; WWAA,1991
Portrait: DANA
Published Reproductions:
"At a Church Fair" pencil 1934 OTAP
"Bass Violin Player" oil 1941 (Athenaeum) ATO(c)
"Beneath the Cross of St. Augustine" oil (Howard) TEAAA
"The Choir Singer" 1941 AAAZ(c)
"Christ and the Doctors" ink SG 24(12-35),595
"City of God" altar painting DANA
"The Depth" OPP 9(5-31),151
"Douglas Square, Boston" oil 1936 LNIA
"Flight into Egypt" ink SG 24(12-35),595
"Heavenly Hosts and the Shepherds" ink SG 24(12-35),594

"Jonah Thrown Out of the Fish" drawing AA 17(3-53),42
"Last Game at Dusk" oil 1939 ILAAL; LNIA; UA 5(6-53),183
"Marble Players" oil 1938 (Athenaeum) ATO
"One of Our Exhibitions and Teas" pencil 1939 TCBAA
"Parade on Hammond Street" 1935 BC 3(5/6-73),27(c); ESS 2
 (4-72), 66(c); ESS 4(11-73),22(c); ESS 4(12-73),29(c)
"School's Out" oil 1939 (Modern Art) AAAJ 20(#1-80),23;
 PMNA
"Self-Portrait" oil 1938 (Athenaeum) ATO
"Settling the World's Problems" oil AD 8(5-15-34),13
"Shadow and Sunlight" 1941 (Smithsonian) AAAZ(c)
"Steal Away" drawing AD 12(5-1-38),23
"Triptych" oil 1935 (Crite) ATO
"Tyre Jumping" oil 1936 DANA
untitled drawing AD 12(5-1-38),23
"Were You There When They Crucified My Lord?" LA 13(5-45),65
Further References:
 Crite, Allan R. *Were You There When They Crucified My Lord?*
 Cambridge: Harvard University Press, 1944.
 Freedberg, Sydney, "This Month in New England: Solos and
 Groups," AN 32(5-12-34),5.

CROPPER, HARVEY TRISTRAN, 1931- ; b. in New York City;
 painter
 Biographical Sources: AAA
 Portrait: EB 13(4-58),34
 Published Reproductions:
 "Midsummer Loneliness" oil EB 13(4-58),34(c)
 Further References:
 Davidson, Bernice, "Fortnight in Review: Harvey Cropper," AD 28
 (9-15-54),25.

CROSSLAND, GERALDINE; muralist
 Published Reproductions:
 "Eden" Houston mural 1976 WBAH(c)
 "Turtle" terra cotta sc 1976 WBAH

CROXTON, RUSHIE E.; b. in Georgia; painter
 Biographical Sources: DENA

Portrait: DENA
Published Reproductions:
 "A Mirror--Self-Portrait" acrylic DENA

CRUDUP, DORIS, 1933- ; b. in Chicago; painter
Biographical Sources: BAOA-1
Portrait: BAOA-1
Published Reproductions:
 "Soul Man" BAOA-1

CRUMPLER, DEWEY, 1949- ; b. in Magnolia, AR; painter
Biographical Sources: WWABA, 1978
Portrait: CACE
Published Reproductions:
 "The Creator" oil BAQ 2(Fa-77),3(c); BAOA-1(c)
 "A Day in the Park Series #IV" construction 1986 CACE(c)
 "Political Prisoner" oil BAOA-1(c)

CRUZ, EMILIO, 1937- ; b. in New York City; painter
Biographical Sources: CBAM; FAAA; LAAA; WWAA,1991
Published Reproductions:
 "Agoraphobia" oil 1986 ICAA(c)
 "Brown or Drown in Secret Blue" acrylic 1972 FAAA
 "Combed Brown" acrylic 1971 FAAA
 "Couldn't I" liquitex,oil AAANB
 "The Dance" oil 1962 MJMC
 "Figure Composition No. 1" oil 1965 LAAA; MJMC; TNA
 "Figure Composition No. 6" oil 1964 AIM 58(9-70),63(c); LAAA
 "Hour Severing the Hour" oil 1986 ICAA
 "Orangescape" acrylic 1971 FAAA
 "Silver Umbrella" oil AG 13(4-70),24(c)
 untitled oil 1967 AG 13(4-70),24(c); ART 42(4-68),58; CBAM
 untitled oil 1968 (Texas) JAMC
 "Veiled Passages Through Archaic Moments" RISD 74(10-87),34
Further References:
 Swenson, G.R., "Reviews and Previews: Emilio Cruz," AN 62
 (11-63), 51.

CULLEN, CHARLES, 1889-?; b. in LeRoy, NY; illustrator

Biographical Sources: AAA
Published Reproductions:
 "Copper Sun" drawing OPP 5(9-27),cover

CULLERS, VINCE; painter
Published Reproductions:
 "Rev. Dr. Martin Luther King, Jr." AV 2(1-87),5(c); AV 3(2-88),3
 (c); AV 4(2-89),19(c); EB 43(1-88),33(c); EB 43(1-88),50(c);
 EB 44(1-89),36(c); EB 44(2-89),141(c); EB 45(1-90),101(c);
 ESS 19(1-89),14(c); ESS 19(2-89),60(c)

CUMMINGS, MICHAEL A., 1950- ; b. in New York City; painter
Portrait: EAFA
Published Reproductions:
 "Flight of the Phoenix" collage BAQ 3(#1-79),26-7
 "Grandma's Porch" fiber,collage 1979 EAFA
 "Haitian Boat People" fiber,collage 1979 EAFA(c)
 "The Magician" collage 1977 BAQ 3(#1-79),26-7

CUMMINGS, URANIA P., 1889-?; b. in St. Thomas, Virgin Islands;
 painter
Biographical Sources: OSAE
Published Reproductions:
 "Caribbean Woman Selling Fruits" oil 1974 OSAE

CUNNINGHAM, DEVON, 1936- ; painter
Published Reproductions:
 "Black Christ" EB 24(3-69),cover,170(c)
 "Portrait of Berry Gordy, Jr., as Napoleon" EB 26(7-70),74

CURTIS, SAMUEL, 1919- ; b. in Charlottesville, VA; painter
Biographical Sources: BAOA-1
Portrait: BAOA-1
Published Reproductions:
 untitled oil BAOA-1(c)

CURTIS, WILLIAM, 1939- ; b. in St. Louis; painter
Biographical Sources: BAOA-1; WWABA
Portrait: BAOA-1

Published Reproductions:
"Riot: USA" oil 1968 BAOA-1

DAMERON, ARTIS; sculptor
Published Reproductions:
"Conquest: The Will to Survive" sc CRI 85(8/9-78),cover(c)
"Runners (Human Race)" bronze sc CRI 87(2-80),cover(c)

DANIEL, MARY REED, 1946- ; b. in East St. Louis, MO; painter
Biographical Sources: AAA; BDCAA; WWABA
Published Reproductions:
"A Friend" acrylic 1969 BDCAA
"Nature Study #20" acrylic 1980 AAATC(c)

DARLING, AARON E.; painter
Published Reproductions:
"John Jones" oil (Chicago) PNAP
"John McAuley Palmer" oil 1869 IEUC
"Mrs. John Jones" oil (Chicago) PNAP

D'ASHNASH-TOSI, BARBARA, see **CHASE-RIBOUD, BARBARA DEWAYNE**

DAVIS, ALONZO JOSEPH, 1942- ; b. in Tuskegee, AL; painter
Biographical Sources: BAOA-2; ILAAL; WWAA,1991; WWABA
Portrait: BAOA-2
Published Reproductions:
"Aerial View" acrylic 1987 NACA(c)
"Afro Imagery" serigraph WLB 43(4-69),756
"Bag Series" acrylic 1971 BAOA-2(c)
"Beyond" acrylic 1977 BAQ 1(Sp-77),61(c); BFAA
"Black Modern Dance" acrylic 1969 BDCAA
"Blanket Series" acrylic 1984 EWCA(c)
"Caution" mixed media 1970 BAOA-2(c)
"Ethnic Pyramids" acrylic 1978 BAQ 6(#3-85),22(c)
"Heart Dance" acrylic 1969 BDCAA(c)
"Homage to Aunt Clara" litho 1980 BAQ 6(#3-85),25
"Levitation" acrylic 1978 BAQ 6(#3-85),23(c)
"Mental Space" 1977 BAQ 6(#3-85),30(c)

"Metamorphosis" acrylic BAQ 1(Sp-77),61(c); BAQ 6(#3-85),32
"Of Nuclear Concern" mixed media 1982 BAQ 6(#3-85),21
"Olympic Study #2" BAQ 6(#3-85),31(c)
"Pyramid #1" mixed media 1977 BAQ 6(#3-85),18(c)
"Pyramid #5" collograph BAQ 6(#3-85),19(c)
"Study #1" 1979 BAQ 6(#3-85),20
"Study #2" acrylic 1982 BAQ 6(#3-85),26
"Study #3" acrylic 1981 BAQ 6(#3-85),27
"Two Red Islands in a Sea of Blue" acrylic 1988 NACA(c)
untitled 1975 NACA
untitled sc AVD
untitled oxidized steel and rope construction GAI
"Whitey's Answer" WLB 43(4-69),758
Further References:
Edwards, Audrey, "Essence Men," ESS 8(2-78),42.

DAVIS, BING, 1937- ; b. in Spartenburg, SC.; painter
Biographical Sources: AAA; BAOA-2; LAAA; WWAA,1978
Portrait: BAOA-2; CM 24(5-76),73
Published Reproductions:
 "Attica" construction NALF 8(Sp-74),182
 "Great American Hang-Up Series #3" mixed media BAOA-2(c);
 LAAA(c)

DAVIS, CHARLES C., 1911- ; b. in Evanston, IL; painter
Biographical Sources: AAA; IIAAL; MIAP; WWAA-1940
Published Reproductions:
 "Perhaps Tomorrow" oil DANA
 "Tycoon Toys" oil ILAAL; LNIA
 "Victory at Dawn" oil 1941 PMNA

DAVIS, DALE B., 1945- ; b. in Tuskegee, AL; sculptor
Biographical Sources: AAA; BAOA-2
Portrait: BAOA-2
Published Reproductions:
 "Ecology #1" assemblage 1970 BAOA-2
 untitled sc GAI
 untitled #2 assemblage 1970 BAOA-2
 untitled #3 assemblage 1970 BAOA-2

Further References:
Young, Joseph, "Los Angeles," AI 15(4-20-71),44.

DAVIS, RACHEL ESTWICK; painter
Biographical Sources: DENA
Portrait: DENA
Published Reproductions:
"When Evening Shadows Fall" pen,ink DENA

DAVIS, THERESA; muralist
Published Reproductions:
"Self-Portrait" terra cotta sc 1970 WBAH

DAVIS, ULYSSES, 1914- ; b. in Fitzgerald, GA; folk sculptor
Published Reproductions:
"Andrew Jackson" mahogany and paint sc c1970 BFFA
"Calvin Coolidge" mahogany and paint sc c1970 BFFA
"Forty Presidents" mahogany and paint sc AC 42(6/7-82),22
"George Washington" mahogany and paint sc c1970 BFAA
"Grover Cleveland" mahogany and paint sc c1970 BFAA
"Harry S Truman" mahogany and paint sc c1970 BFFA
"James Buchanan" mahogany and paint sc c1970 BFFA
"Lyndon Johnson" mahogany and paint sc c1970 BFFA
"Martin Van Buren" mahogany and paint sc c1970 BFFA
"Richard M. Nixon" mahogany and paint sc c1970 BFFA
"Ronald Reagan" mahogany and paint sc c1970 BFFA
"Theodore Roosevelt" mahogany and paint sc c1970 BFFA
"William H. Taft" mahogany and paint sc c1970 BFFA
"Woodrow Wilson" mahogany and paint sc c1970 BFFA
Further References:
Kiah, Virginia, "Ulysses Davis: Savannah Folk Sculptor," SFQ 42
(1978), 271-86.

DAVIS, WALTER LEWIS, 1937- ; b. in Americus, GA; painter
Biographical Sources: AAA; WWAA,1991
Published Reproductions:
"Black Bird Totem" oil 1970 DCBAA
"Monk's Now" oil ILAAL

DAWSON, CHARLES C., 1889-1981; b. in Brunswick, GA; painter
 Biographical Sources: ATO; WWCA,1929; WWAA,1953
 Portrait: ATO
 Published Reproductions:
 "The Bill Poster" watercolor (DuSable) ATO
 "The Last Marble" watercolor (DuSable) ATO(c)
 "Slaughtering Livestock" watercolor (DuSable) ATO
 untitled CRI 34(8-27),cover

DAWSON, WILLIAM; sculptor
 Published Reproductions:
 "Chicken George" wood,paint BAQ 7(#3-87),11(c)
 "Cow" watercolor BAQ 7(#3-87),12(c)
 "Elephant" watercolor BAQ 7(#3-87),12(c)
 "Gorilla" carved and painted wood sc 1977 BFAA
 "Totem" mixed media BAQ 7(#3-87),11(c)

DAY, JUETTE JOHNSON; b. in Richmond, VA; painter
 Biographical Sources: AAA; BDCAA; DENA
 Portrait: DENA
 Published Reproductions:
 "Cathedral" oil 1968 BDCAA
 "Ethereal Way" watercolor DENA
 "Flight" oil 1969 BDCAA

DECARAVA, ROY, 1919- ; b. in New York City; painter
 Biographical sources: AAA; WWAA,1991
 Portrait: FSBA; CAM 39(1-60),22
 Published Reproductions:
 "Hallway" oil 1952 ARTF 17(1-79),22; FSBA
 "Stern Brothers" AN 78(10-79),13
 "Subway Corner" oil AD 23(7-49),20

DE KNIGHT, AVEL; b. in New York City; painter
 Biographical Sources: AAA; BAA; CBAM; DCCA; WWAA,1991
 Published Reproductions:
 "Ancestor Tree II" casein BAQ 4(#1-80),6(c)
 "Angel of Light" casein 1975 AA 40(9-76),45; BAQ 4(#1-80),10
 (c)

"Beach" gouache STU 153(4-57),126
"Chasm" casein BAQ 4(#1-80),15
"Dawn Mirage" casein 1974 AA 40(9-76),47
"The Fall" casein BAQ 4(#1-80),11(c)
"Guardian of the Night" gouache AA 40(9-76),46
"Halo of Memory" casein 1977 ART 52(11-77),11(c); BAQ 4
 (#1-80),cover(c)
"Headdress II" casein BAQ 4(#1-80),5
"Lotus" casein BAQ 4(#1-80),3(c)
"Mediterranean" watercolor HAWS
"Mirage Painting III" gouache 1970 AAANB
"Mirage Painting: Shields" DCBAA(c)
"Nubia" gouache AG 17(11-73),65
"Passage to the Sun" casein 1975 AA 40(9-76),45
"Shadow Mask, 1973-78" casein BAQ 4(#1-80),4
"Shell Flower, Pyramid" casein BAQ 4(#1-80),13
"Shell Mirage" casein BAQ 4(#1-80),12
"Trophis" 1975 BAQ 4(#1-80),7(c)
"Two G.I.s Go Back to Paris" EB 2(3-47),16-18
untitled BAQ 4(#1-80),11(c)
untitled casein BAQ 4(#1-80),9
"Venus Rising" casein 1977 BAQ 4(#1-80),14(c)
Further References:
 Spaulding, Val, "Avel DeKnight--Mirage Paintings," BAQ 4
 (#1-80), 3-16.

DELANEY, BEAUFORD, 1905-1979; b. in Knoxville TN; painter
Biographical Sources: AAA; ATO; LAAA; MIAP; TNAP
Portrait: ATO; DANA
Published Reproductions:
 "Abstraction" oil 1958 AI 17(4-73),73; STHR
 "Attention!" oil AN 50(1-52),44
 "Burning Bush" oil 1941 (Newark) ATO(c)
 "Composition" oil 1956 DANA
 "Dante Pavone" oil AD 24(1-15-50),16
 "Greene Street" oil 1951 ART 53(6-79),20; BAQ 2(Sp-78),62;
 DANA; FAAA(c); TEAAA
 "Light Abstraction" oil AN 77(Su-78),202

"Portrait of A. James Speyer" oil 1966 AIM 55(7/8-67),40(c)
"Portrait of a Boy" pastel 1934 (Morgan) ATO
"Portrait of a Man" pastel 1943 (Newark) ATO; NBAT
"Portrait of a Young Musician" AG 21(4/5-78),4; AN 77(Su-78),29;
 ARTF 16(Su-78),82
"Portrait of Billy Pierce" OPP 8(5-30),148
"Rehearsal" AN 47(5-48),47
"Self-Portrait" oil 1944 ATO
"Still Life" AN 48(2-50),57
"Still Life with Snake and Bird" oil 1946 STHR
"Un Naif Norte Amicano" GOY 114(5-73),394
untitled oil 1946 AAATC(c)
"Yadoo" oil 1952 BAQ 2(Sp-78),63
Further References:
 Miller, Henry. *The Amazing and Invariable Beauford Delaney*. Yon-
 kers, NY: n.p., 1945.

DELANEY, JOSEPH, 1904- ; b. in Knoxville, TN; painter,
 graphic artist
Biographical Sources: MIAP; NAI; TCBAA; TNAP; WWAA, 1978
Portrait: NAI
Published Reproductions:
 "Albert Ammons" oil 1943 FAL
 "Art Students League" oil 1965 STHR
 "Clara" oil 1937 FAAA(c); FAL; LNIA(c)
 "Crows Nest" oil 1942 FAAA
 "Harlem Day Parade" FA 16(5-82),51
 "His Last Address" oil 1930 AHAP
 "Lady in a Hat With Veil" watercolor 1944 FAL
 "Lady in Green Stockings" oil 1945 FAL
 "Massa in the Cold, Cold Ground" oil 1931 FAL
 "Penn Station at Wartime" oil 1943 (Smithsonian)
 TCBAA
 "Studio Party" oil BAWPA
 "V.J. Day, Times Square" oil 1945 EB 23(2-68),121(c); FAAA;
 ILAAL; TEAAA
 "Waldorf Cafe" oil 1945 ARTF 7(2-69),66; FAAA
 "Young Lady" oil 1975 SA 79(10-79),56

DELAWRENCE, NADINE; mixed media
Published Reproductions:
"Ascension" acrylic 1986 BAQ 9(#2-90),46
"Ashteroth" polychrome aluminum 1987 BAQ 9(#2-90),47
Further References:
Lewis, Samella, "Nadine DeLawrence: In Cosmic Form," BAQ 9
(#2-90),46-7.

DELSATE, LOUIS, 1944- ; mixed media
Biographical Sources: AAATC
Published Reproductions:
"Ocean of Time" pencil 1977 AAATC(c)

DEMPSEY, RICHARD WILLIAM, 1919-87; b. in Ogden, UT;
painter
Biographical Sources: AAA; BAA; BACW
Portrait: DANA
Published Reproductions:
"Cityscape" oil 1958 AAATC(c); AG 13(4-70),16(c); DANA
"Dr. Charles Richard Drew" oil 1946 DANA
"Fear" oil ILAAL
"Impression No. 1" oil DANA
"North Carolina" watercolor 1965 AAATC(c)
"Planes & Lines" oil DANA
"Southern Schools" oil 1945 AWAP; BACW
untitled AG 11(4-68),48
"View from My Room, Haiti" oil DANA
Further References:
Fax, Elton, "Four Rebels in Art," FRE 4(Sp-61),215-25.

DENDY, J. BROOKS, III, 1936- ; b. in Asheville, NC; painter
Biographical Sources: BAOA-1
Portrait: BAOA-1
Published Reproductions:
"The Kangamangus Pass" goauche 1966 BAOA-1(c)

DENMARK, JAMES, 1936- ; b. in Winter Haven, FL; painter
Biographical Sources: AAA; AAANB; CBAM
Published Reproductions:

"Head of a Young Black Woman" welded bronze sc 1969 CBAM
"Lena" litho FRE 10(3rdQ-70),cover; FRE 10(4thQ-70),cover
"Standing Woman" AG 15(1-72),29
"The Struggle" wood sc 1969 AAANB; BLC
untitled wood construction 1970 AIM 58(9-70),58
Further References:
Beckley, Bill, "Reviews and Previews: James Denmark," AN 70
(12-71),14.

DEPILLARS, MURRY NORMAN, 1938- ; b. in Chicago; painter
Biographical Sources: BAOA-2; LAAA; WWAA,1991; WWABA
Portrait: BAOA-2; WJBS 6(#1-82),20
Published Reproductions:
"And There Was a Call from the East" oil 1970 BAOA-2
"Aunt Jemima" ink 1968 BAOA-2; BC 11(#2-80),99; DCBAA
"Children at Play" pen,ink BAOA-2; BBB 2(Wi-74),54
"Christ" drawing EB 26(4-71),180
"Fifi and Muh Deah" pen and ink 1970 BAOA-2
"The People of the Sun" pen,ink 1972 BBB 2(Wi-74),53; LAAA
untitled WJBS 6(#1-80),20

DE VILLIS, JOSEPH CLINTON, 1878-1912; b. in Brooklyn; painter
Biographical Sources: AAA
Published Reproductions:
"Girl of Morocco" oil VN 2(10-05),685
"A Poet's Theme" oil VN 2(10-05),688
Further References:
Goodman, Michael, "Joseph Clinton DeVillis: Seaman, Artist,
Churchman," NHB 41(5/6-78),830-33.
Thompson, W.O., "Collins and DeVillis--Two Promising Painters,"
VN 2(10-05),685-91.

D'HUE, ROBERT RALEIGH, JR., 1917- ; b. in Cleveland; painter
Biographical Sources: AAA; BAOA-1; WWABA
Portrait: BAOA-1
Published Reproductions:
"Haze" BAOA-1
Further References:

"Negro GI in Belgium," SEP 12(1-63), 32-4.

DICKERSON, KENNETH, 1935- ; b. in New York City; painter
 Biographical Sources: AAA; BAOA-2
 Portrait: BAOA-2
 Published Reproductions:
 "Climax" BAOA-2

DICKERSON, VORIS; painter
 Published Reproductions:
 "Still Life" oil OPP 13(3-35),80

DICKSON, CHARLES, 1947- ; b. in Los Angeles; sculptor
 Biographical Sources: WCBI
 Portrait: VIS 4(2-87),19
 Published Reproductions:
 "Marie" wood sc WCBI
 "Stepping In, Stepping Out, Stepping On" VIS 4(2-87),19

DILLON, FRANK, 1866-1954; painter
 Biographical Sources: ATO
 Portrait: ATO
 Published Reproductions:
 "Still Life" 1930 oil ATO
 "Still Life" oil 1938 ATO
 untitled oil 1933 ATO

DILLON, LEO (LIONEL J.), 1933- ; b. in Brooklyn; painter
 Published Reproductions:
 "Askia Muhammed Toure--King of Sonhay" BC 9(#5-79),69; BC
 12(#4-82),169(c); EB 31(5-76),78-9(c)
 "Sunni Ali Ber--King of Sonhay" BC 9(#5-79),69

DILLWORTH, ROBERT, 1951- ; b. in Lawrenceville, VA; mixed
 media
 Biographical Sources: AAATC
 Published Reproductions:
 "Abstractions" pencil 1979 AAATC(c)

DONALDSON, JAMES WILLIAM, 1944- ; b. in Cornelius, NC;
 painter
Published Reproductions:
 "Portrait of S.E. Duncan" oil JET 34(1-77),38

DONALDSON, JEFF, 1932- ; b. in Pine Bluff, AR; painter, print-
 maker
Biographical Sources: AAA; LAAA; WWAA,1991; WWABA
Portrait: NAE 17(3-90),28
Published Reproductions:
 "Amos and Andy" mixed media 1972 BW 19(10-70),84
 "Ancestor Spirit" watercolor,aluminum foil GAI
 "For My Daddy and His Generation, Praise" EB 29(12-73),39(c)
 "Message from Tebuti" NAE 17(3-90),28
 "Victory" EB 26(8-81),31(c)
 "Victory at Zimbabwe" mixed media c1977 STHR
 "Victory in the Valley of Eshu" gouache 1971 LAAA(c); STHR
 "Wives of Shango" mixed media BW 19(10-70),88

DORSEY, LILLIAN AGNES (LOPEZ), 1912- ; b. in Philadelphia;
 painter
Biographical Sources: AAA
Published Reproductions:
 "Self Portrait" oil AD 5(2-15-31),7; ART 17(3-31),412; CTAL;
 MA 23(9-31),212; LNIA; SG 65(3-1-31),595

DORSEY, WILLIAM; active c1850-80; painter
Published Reproductions:
 "Made in Brazil" oil SMI 19(1-89),151(c)

DOUGLAS, AARON, 1898-1979; b. in Topeka; painter, printmaker
Biographical Sources: BACW; BDCAA; DAAS; LAAA; MIAP
Portrait: EB 18(9-63),131; NAI
Published Reproductions:
 "Aaron Bontemps" oil LNIA
 "Alexandre Dumas" oil DANA
 "Alta Douglas" oil AG 13(4-70),12(c); BACW; DAAA; HRABA;
 HW 7(3rdQ-68),13(c)
 "Asian Professor" oil UA 5(6-53),182

"Aspects of Negro Life" (Panel 1) oil 1934 (Schomburg) ART 57
(6-83),95; BAQ 1(Fa-76),8; DANA; LAAA
"Aspects of Negro Life" (Panel 2) oil 1934 (Schomburg) BAQ 2
(Fa-77),55; CVAH; DANA; LAAA
"Aspects of Negro Life" (Panel 3) oil 1934 (Schomburg) BC 3
(5/6-73),27(c); DANA; LAAA; ESS 4(11-73),22(c)
"Aspects of Negro Life" (Panel 4) oil 1934 AAAZ(c); DANA;
LAAA
"Aspects of Negro Life: An Idyll of the Deep South" oil 1934
(Schomburg) BAQ 8(2-88),22; HRABA(c)
"Aspects of Negro Life: An Idyll of the Deep South" tempera 1934
HRABA(c)
"Aspects of Negro Life: From Slavery Through Reconstruction"
oil 1934 (Schomburg) AAAZ(c); HRABA(c)
"Aspects of Negro Life: Song of the Towers" oil 1934 (Schomburg)
HRABA(c)
"Aspects of Negro Life: The Negro in an African Setting" oil 1934
(Schomburg) HRABA(c)
"Boy with Cap" oil BAQ 1(Wi-76),47
"Bravado" (Emperor Jones Series) linocut DAAA
"Brutus Jones" (Emperor Jones Series) CTAL
"Building More Stately Mansions" oil 1944 (Fisk) AARE 3
(11/12-76),114(c); AJ 36(2-76),58; BC 8(9/10-77),50(c); BC 11
(#2-80),99; CRI 83(11-76),316; ESS 7(12-76),29; HRABA;
OAAL; SSAA 4(Sp-90),30; TCBAA
"Creation" oil 1935 (Howard) AV 3(6-88),24(c); EB 43 (2-88),38
(c); HRABA; OPP 5(9-27),274; STHR(c)
"Crucifixion" oil 1927 HRABA(c); TCBAA
"Dance Magic" oil OPP 8(12-30),372
"Defiance" (Emperor Jones Series) linocut 1923 AN 86(10-87),
191; AW 19(2-6-88),1; DAAA; HRABA; MN 65(6-87),87
"Drama" mural 1934 (Fisk) DANA
"Drama: Comedy and Tragedy" oil 1930 CRI 86(5-79),cover(c)
"Education of the Colored Man" mural MA 31(11-38),618
"Emperor Jones" CTAL
"Evolution" oil AAAC
"Evolution of the Negro Dance" tempera,oil PMNA
"Flight" (Emperor Jones Series) linocut 1926 DAAA; HRABA
"Flowers with Figure" oil 1958 CRI 86(5-79),103(c)

"Go Down South" oil 1927 HRABA(c); PTS
"Haitian Landscape" oil LNIA
"Harriet Tubman" fresco CRI 39(1-32),449
"High Bridge" oil OPP 12(6-34),186
"Into Bondage" oil 1936 BAAL(c)
"Inspiration" oil 1936 AAATC(c)
"Judgment Day" oil 1939 ENC 5(12-20-76),24; TCBAA
"Jungle Dance" gouache c1930 (RISD) STHR
"Let My People Go" oil 1927 RD 112(6-78),183(c)
"Liberation" oil BE 17(12-86),90(c)
"Ma Bad Luck Card" oil (Schomburg) HRABA
"Marian Anderson" oil DANA
"The Memorial Chapel, Fisk University" watercolor DANA
"Mr. Baker" sketchbook study DANA
"Molly" oil 1937 (Golden State) BAQ 1(Wi-76),27(c)
"Mulatto" oil OPP 3(10-25),cover
"Mural" oil mural CRI 86(5-79),163(c)
"Nashville" oil 1938 BACW
"Old Waterworks" oil (Hampton) HRABA(c)
"Play de Blues" wood sc (Schomburg) HRABA
"Portrait of Dr. Mary McCloud Bethune" oil 1968 (Minneapolis)
 BDCAA(c); LAAA
"Power Plant, Harlem" oil (Hampton) AAAC; HRABA; LNIA
"Rise, Shine for Thy Light Has Come" gouache c1930 (Howard)
 AV 1(5/6-86),66; HRABA(c)
"Siesta" oil 1944 (Albany) NAI
"Song of the Towers" mural (NYPL) ART 57(6-83),95; HHR;
 TEAA
"Street Scene, Accra" watercolor DANA
"Student" drawing 1954 DANA
"Study for 'God's Trombone'" tempera 1926 HRABA(c)
"Study for 'Aspects of Negro Life'" gouache 1933 AWAP
"Study for 'Aspects of Negro Life: An Idyll of the Deep South'"
 tempera 1934 HRABA(c)
"Study for 'Aspects of Negro Life: From Slavery Through Recon-
 struction'" tempera 1934 HRABA(c)
"Surrender" (Emperor Jones Series) linocut DAAA
"Tower Bridge, London" watercolor 1956 DANA
"Triborough Bridge" oil 1935 NBAT

"The Unknown" oil 1935 (Howard) STHR
untitled oil CRI 86(5-79),163(c); CRI 86(11-79),cover(c)
"Urchin" oil 1937 LNIA
"Walter White" oil TIM 13(6-24-29),43
"Window Cleaning" oil 1936 (Nebraska) APCS; DES 46(4-45),10
Further References:
Bearden, Romare, "Farewell to Aaron Douglas," CRI 86(5-79),164-
5.
Leonard, Walter, "Tribute to Aaron Douglas, 1899-1979," CRI 86
(5-79),162-3.

DOUGLAS, EMORY, 1943- ; b. in Grand Rapids, MI; graphic artist
Biographical Sources: BANG
Portrait: BANG
Published Reproductions:
"Black Studies" JBP 1(Fa-68),93
"Future" JBP 1(Fa-68),93
untitled drawing BANG

DOUGLASS, CALVIN, 1933- ; b. in Baltimore; painter
Biographical Sources: AAA
Published Reproductions:
"In" 1969 FUF
untitled soap,polyester AN 65(9-66),51
"Up" polyester resin 1969 AAASN

DOWDELL, GLANTON; active in Detroit in 1960s; painter
Portrait: LIB 7(6-67),14
Published Reproductions:
"Black Madonna" Detroit mural 1967 EB 24(5-69),172; ESS 1
(12-70),23; LIB 7(6-67),14; ND 17(6-67),96; ND 17(11-67),45

DOWELL, JOHN, JR.; b. in Philadelphia; graphic artist, painter
Biographical Sources: AAA; BE 6(12-75),51; WWAA,1991
Published Reproductions:
"Blues for Lacey" watercolor 1976 AIM 67(5-76),25
"For Open Piano and Six Hands" ink 1972 AI 17(3-73),68
"For the Pridgen and the Hunt" litho 1970 AIM 58(9-70),66(c)
"Letter to My Bette II" litho AP 11(1971),32

"Love Concerto" ink,tempera 1972 AI 17(3-73),67

"L.R.W.S." 1976 CGB

"Mountain Dance" ink,tempera 1972 AI 17(3-73),67

"Old Lines with New Color" ink,tempera 1972 AI 17(3-73),67

"Opposite Force" ink,tempera 1972 AI 17(3-73),67

"Piano Piece for Half Hour or More" ink 1972 AI 17(3-73),66

"To Dance Yesterday's Dreams" acrylic 1977 CGB(c)

"To Sing a Strange Sea for Chorus and Ensemble" watercolor 1977
 ART 52(5-78),2(c)

"Tomorrow's Solo" BE 6(12-75),51

"White Wheel of W.T.H." etching DAAA

DOYLE, SAM, 1906-1985; b. in Frogmore, SC; painter, sculptor

Biographical Sources: BFAA; BIS

Portrait: BFAA; BIS

Published Reproductions:

 "Abe Kane" oil on plywood c1970 BFAA

 "Backus Blo" enamel,metal 1984 BIS

 "Bull Dager" enamel,metal 1983 BIS(c)

 "Dr. Buz" enamel,paint,tar c1980 BFAA(c); PORT 5(5-83),87(c);
 TIM 119(3-1-82),70(c)

 "I'll Go Down" oil on wood c1970 BFAA(c)

 "Jack-o-Lanton" enamel,metal 1983 BIS(c)

 "Lincoln in Frogmore" enamel,metal 1985 BIS

 "Lincoln Preaching to the Slaves" watercolor c1970 BFAA

 "Lizard" tar on wood,paint,metal c1970 BFAA

 "No More the Whip" enamel,metal 1985 BIS

 "Pheasant" tar on wood c1970 BFAA

 "Wass A. Guin Mon/U. Dig Me?" enamel on metal 1980 BFAA;
 PORT 5(5-83),87(c)

DRISKELL, DAVID CLYDE, 1931- ; b. in Eatonton, GA; graphic
 artist, painter, curator

Biographical Sources: BACW; BDCAA; WWAA,1991

Portrait: BAOA-1; CRI 83(11-76),316

Published Reproductions:

 "The American Chair" oil 1965 IBA

 "Chieftain's Chair" oil 1966 AWAP

 "Circular Move" mixed media 1984 EWCA(c)

"Compote" woodcut 1967 AG 11(4-68),21(c); AG 13(4-70),18(c)
"Dancing Angel" oil 1973 AIS 13(#1-76),51; RCAF
"Foreign Post" AIM 77(6-89),182
"Gabriel" oil 1965 LAAA
"Gabriel's Horn" 1965 (Howard) NHB 30(10-67),9
"Jonah in the Whale" woodcut 1967 DCBAA
"Lady of Leisure: Fox" oil,collage 1974 RCAF
"Movement, the Mountain" tempera 1980 AAATC(c)
"Our Ancestor's Festival" acrylic,oil 1974 RCAF
"Partial Eclipse #2" woodcut DCBAA
"The Pines" 1946 NIM
"Reflection & Dream" gouache 1968 BDCAA
"Shango Gone" tempera 1972 LAAA
"Spirit Watcher" litho 1986 BAQ 7(#4-87),30; BE 20(12-89),120
"Still Life with Gateleg Table" mixed media BAOA-1
"Swing Low Sweet Chariot" acrylic DAAA
"Tondo" oil BACW
"Woman in Interior" oil,collage 1973 RCAF
"Yoruba Posts" gouache 1983 STHR
Further References:
Morrison, Allan, "New Surge in the Arts," EB 22(8-67),134-6.

DUNBAR, ULRIC S.; active in the 1920s; sculptor
Published Reproductions:
"The Mammy" sc OPP 1(8-23),249

DUNCANSON, ROBERT S., 1817-1872; b. in Cincinnati; painter
Biographical Sources: GNNP3; LAAA; MIAP; TNAP; TCBAA
Published Reproductions:
"Arcadian Landscape" oil 1867 AAJ 15(Wi-83),41
"Arcadian View" oil ANT 117(6-80),1166(c)
"Bishop James Payne and Family" oil 1848 (Wilberforce) LNIA
"Blue Hole, Flood Waters, Little Miami River" oil 1851 (Cincin-
 nati) AAW; AG 11(4-68),14; AIM 39(10-51),120; AIPP; ANT
 49(1-46),412; ANT 101(3-72),503; ANT 117(11-79),1155;
 AUSPS; BC 3(5/6-73),27(c); DANA; ESS 2(4-72),66(c); ESS 4
 (11-73),22(c); ESS 4(12-73),29(c); FAAA(c); LAAA; LNIA;
 MCAM; MFCAM; PMNA; SBMAA(c); ST; TCBAA; WAAA
"Buffalo Hunt" oil 1861 AIM 39(10-51),134; LNIA

"Canadian Falls" oil 1865 (Canada) AAJ 17(8-85),44

"Canadian Landscape" oil 1965 AAJ 17(Au-85),41

"The Catch" oil 1848 ANT 134(10-88),613(c)

"The Caves" oil 1869 SBMAA

"City and Harbour of Quebec" oil AAJ 17(Au-85),31

"The Drunkard's Plight" oil 1845 (Detroit) AEM; AIM 39(10-51), 111; DANA

"Ellen's Isle, Loch Katrine" oil 1870 AAJ 15(Wi-83),46; AAJ 17 (8-85),49; FAAA; PMNA; TAAP

"Encampment with Figures and Waterfall" oil c1849 (Taft) AIM 39(10-51),118

"Evening" oil AIM 24(1-36),23

"Extensive River Landscape" oil 1870 ANT 114(10-78),737

"Faith" oil 1862 AIM 39(10-51),137

"Falls of Minnehaha" oil 1862 (African Art) AAR 3(11/12-76), 104(c); AP 104(12-76),511(c); ER 2(1-77),19(c); PSIM(c); ST; TCBAA(c)

"Forest Landscape" oil 1857 AAATC

"Freeman Grant Cary" oil 1855 (Smithsonian) AIM 39(10-51), 125; ST

"Fruit Bowl" oil (Detroit) AEM

"Fruit Piece" Oil 1860 (Detroit) AAATC(c); AIM 39(10-51),119

"Fruit Still Life" oil c1849 (Corcoran) ST

"Henry Berthelet" oil 1846 (Detroit) AIM 39(10-51),122

"The Hiding of Moses" oil 1866 AIM 39(10-51),138

"Lake Beaupport" oil 1865 (Quebec) AAJ 17(Au-85),41

"Lake Peipin" oil (Cleveland) PSIM

"Lake St. Charles Near Quebec" oil 1864 (Quebec) AAJ 17 (Au-85),40

"Land of the Lotos Eaters" oil 1861 AAJ 15(Wi-83),35; AAJ 17 (8-85),30; FAAA

"Landscape with Ancient Castle" oil c1849 (Taft) AIM 39(18-51), 114

"Landscape with Classical Ruins" oil 1859 AIM 39(10-51),131

"Landscape with Classical Ruins, Temple of Sibilla" oil 1859 AIM 39(10-51),131

"Landscape with Courtiers on Horseback" oil 1848 (Taft) AIM 39(10-51),116

"Landscape with Cows Watering in a Stream" oil 1871 (Modern

Art) APMMA

"Landscape with Huntsmen" oil 1848 (Taft) AIM 39(10-51),113

"Landscape with Lake" oil 1864 ST

"Landscape with Rainbow" oil 1859 ST

"Landscape with Shepherd" oil 1852 (Modern Art) APMMA

"Landscape with Water Cascade" oil 1848 AIM 39(10-51),117

"Lindsay: Landscape" oil 1871 AIM 39(10-51),104

"Loch Long" oil 1867 ST

"Lough Leane" oil 1870 (Fisk) ARTA 1(Sp-84),24; TCBAA

"Louis Benjamin Berthelet" oil 1846 AIM 39(10-51),123

"Montmorency Falls" oil 1865 ANT 118(11-80),1013

"Mount Healthy, Ohio" oil 1844 (Smithsonian) AAAZ(c); CBAR;
 ST

"Mount Royal" watercolor 1864 (Canada) AAJ 17(Au-85),38;
 ANT 118(11-80),1013

"Mount Trempe L'ove on the Upper Mississippi" oil 1870 ANT
 134(12-88),1259(c)

"Mountain Lake" oil 1864 ANT 118(11-80),1013

"Mountain Pool" oil c1870 ST

"Mural" oil 1848 (Taft) AAJ 15(Wi-83),42

"Mural" (Hudson River) oil 1848 FAAA; TNAP

"Nicholas Longworth" oil 1858 (Ohio College) AIM 39(10-51),
 126; DANA; FAAA; SBMAA

"Oil's Head Mountain" oil 1864 ANT 118(11-80),1013

"On the St. Anne's, Canada East" oil 1863 AAJ 17(Au-85),32; KQ
 12(12-73),212; ST

"Owl's Head Mountain" oil 1864 (Canada) AAJ 17(Au-85),40

"The Pass of Leny" oil 1867 AAJ 15(Wi-83),43; AIM 39(10-51),
 139

"Pompeii" oil ST

"The Rainbow" oil 1859 (African Art) TCBAA

"Recollections of Italy" oil 1854 (Howard) AIM 39(10-51),130

"Remembrance of a Scene Near Auerbach" oil c1856 ST

"Robert H. Bishop" oil c1848 AIM 39(10-51),123

"Romantic Landscape" oil c1848 AG 13(4-70),1(c); EB 23(2-68),
 116(c); HW 7(3rdQ-68),12(c); PMNA; SBMAA; ST; TEAAA

"Roses, Still Life" oil c1842 (Smithsonian) ST

"Scottish Landscape" oil 1871 (African Art) ST; TCBAA

"Seascape" oil 1871 (Taft) AIM 39(10-51),143

"Sonntag: Landscape" oil c1850 (Taft) AIM 39(10-51),104

"Still Life" oil (Taft) CMB 3(8-53),11

"Sunset Study" oil 1863 (Montreal) AAJ 17(Au-85),39

"The Surprise" oil 1868 ILAAL

"The Trial of Shakespeare" oil 1843 AIM 39(10-51),109

"Uncle Tom and Little Eva" oil 1853 (Detroit) AEM; AP 95 (6-72),501; AIM 39(10-51),1; BDIA (#1-50/1),21; DBLJ; FAAA; LAAA; ST; TCBAA

untitled oil 1849 ANT 116(11-79),1074

untitled mural c1848 (Taft) LAAA

"Vale of Kashmir" oil 1864 (African Art) AAJ 15(Wi-83),40; AIM 42(10-54),220; CAS 1(4/5-71),21; PMNA; TAAP; TCBAA(c)

"Valley of Lake Pepin" oil c1850 (Cleveland) AAAZ(c); AIM 42 (10-54),220

"Valley Pasture" oil 1857 AIM 39(10-51),132; ST

"View of Cincinnati, Ohio, from Covington, Kentucky" oil 1848 (Taft) ARTA 1(Sp-84),23; FAAA; LAAA; ST

"View of the St. Anne's River" oil 1870 AAJ 17(Au-85),46; SLM 2(3-67),3

"Waiting for a Shot" oil 1869 KQ 11(6-71),21

"Water Nymphs" oil 1868 (Howard) AAJ 15(Wi-83),44; AIM 39 (10-51),141; AIS 5(Su/Fa-68),258

"Waterfall on Montmorency" oil 1864 (Smithsonian) AAJ 17 (Au-85),32

"Wet Morning on the Chaudiere Falls" oil 1868 (Canada) AAJ 17 (Au-85),45

"William Berthelet" oil 1846 (Detroit) AIM 39(10-51),122; FAAA; PMNA

"William Cary" oil 1855 AIM 39(10-51),124

Further References:

Dabney, Wendell, "Duncanson: An American Artist Whose Color Was Forgotten," in *Ebony and Collectanea*. New York: Opportunity, 1927, pp. 128-9.

Porter, James A., "Robert S. Duncanson," AIM 39(10-51),99-154.

Porter, James A., "Early American Painter Robert S. Duncanson," AIM 42(10-54),22

DUNN, EUGENIA V., 1918-1971; b. in Henderson, KY; painter

Biographical Sources: AAA
Portrait: BAOA-1
Published Reproductions:
 "Brush Fire over Arkansas" oil 1964 BAOA-1
 "Carrousel" oil c1958 ILL (Su-59),16
 "Encore" oil DANA
 "Gosman's Dock" oil 1968 BDCAA(c)
 "Invitation to Paradise" acrylic 1959 ILL (Su-59),17
 "Shadows" linocut PANA
 "Unknown" acrylic c1959 ILL (Su-59),17

DUNN, JOHN MORRIS, 1887-?; painter, sculptor
Published Reproductions:
 "Self Portrait" sc EB 8(12-52),140
Further References:
 "Janitor Genius," EB 8(12-52),140-5.

DWIGHT, EDWARD J., JR., 1934- ; sculptor
Biographical Sources: EB 40(2-84),54-8
Portrait: EB 40(2-84),54; PEO 27(5-25-87),115
Published Reproductions:
 "Charlie Parker" bronze sc PEO 27(5-25-87),115
 "Eagle" bronze sc EB 40(2-84),56
 "Satchmo" bronze sc ARTA 1(Sp-84),33
 untitled bronze sc EB 40(2-84),58
Further References:
 Neill, Michael, "He Used to Soar with Eagles, but Now Sculptor
 Ed Dwight Has Landed on His Feet," PEO 27(5-25-87),115-
 116.
 White, Frank, "The Sculptor Who Would Have Gone into Space,"
 EB 40(2-84),54-58.

EALEY, ADOLPHUS, 1941- ; b. in Atlanta; painter
Biographical Sources: AAA
Published Reproductions:
 "Crucifixion" oil 1969 BACW
 "Meditation" oil BACW
 "Spring Forest" watercolor BACW
 "Three Old Women" oil BACW

EDELIN, LAWRENCE; painter
Published Reproductions:
 "Textile" oil NA

EDMONDSON, WILLIAM, 1882-1951; b. in Nashville; sculptor
Biographical Sources: AAA; BFFA; LAAA; TNA
Portrait: BFFA; TCBAA
Published Reproductions:
 "The Angel" limestone sc c1940 AFATC(c); AFSB; BFFA;
 LNIA
 "Angel, Miss Lucy" limestone sc SMI 12(8-81),52(c)
 "Bird" limestone sc c1935 ANT 119(5-81),956
 "Birdbath" limestone sc SMI 12(8-81),52(c)
 "Bride" limestone sc c1930 BFFA
 "Eleanor Roosevelt" limestone sc SMI 12(8-81),54(c)
 "Eve" limestone sc 1935 (Tennessee) EB 32(2-77),36; SMI 12
 (8-81),53(c); TAB; TCAFA
 "Horse" limestone sc c1940 WINT 18(Wi-83),287
 "Lawyer" limestone sc (Modern Art) PMNA
 "Lion" limestone sc SMI 12(8-81),53(c)
 "Mary and Martha" limestone sc c1930 (Hirshhorn) AN 36
 (10-23-37),13; HMSG; RFAA
 "Mother and Child" stone sc 1920 AAAC; AFATC(c); DBLJ;
 LAAA
 "Noah's Ark" limestone sc c1930 BFFA; STHR
 "Preacher" limestone sc 1940 (Modern Art) AFSB; BFFA;
 DANA; LNIA; WINT 18(Wi-83),288
 "Ram" limestone sc 1945 TCAFA
 "Small Angel" limestone sc (Modern Art) PMNA
 "Speaking Owl" limestone sc c1937 AC 42(6/7-82),23(c); AJ 42
 (Wi-82),345; AN 81(5-82),138; BFFA
 "Stone Cross" limestone sc c1883 AFSB; RFAA
 "Turtle" limestone c1940 BAAL(c)
 "Two Birds" stone sc c1939 AANM; AATNM; NBAT
Further References:
 Fuller, Edmund. *Visions in Stone: The Sculpture of William Ed-
 mondson.* Pittsburgh: University of Pittsburgh Press, 1973.
 LeQuire, Louise, "Edmondson's Art Reflects His Faith, Strong and
 Pure," SMI 12(8-81),50-5.

EDWARDS, ANTHONY; muralist
Published Reproductions:
"Holy Family" Houston mural 1969 WBAH(c)

EDWARDS, MELVIN, 1937- ; b. in Houston; sculptor
Biographical Sources: AAA; FAAA; LAAA; TNAP
Portrait: TNAP; EB 41(5-86),47
Published Reproductions:
"Culture" steel sc 1988 ICAA
"Curtain for William and Peter" wire,chain sc 1970 FAAA
"Double Circles" steel sc 1968 AF 133(12-70),64; FAAA
"The Fourth Circle" 1966 CGB; LACMA 27(1983),11
"Fourth Day sc 1988 ICAA
"Gate of Ogun" steel sc 1983 BAQ 7(2-87),37; EWCA(c)
"Holder of the Light" sc BAQ 7(2-87),48(c)
"Homage to the Mentor" welded steel 1979 STHR
"Homage to the Poet Leon Gontran Damas" forged sc 1978
 PEAA; TIM 115(3-31-80),72(c)
"Lifted X" steel sc 1965 AIM 54(3-66),116
"Luxor Variation" LACMA 27(1983),11
"Lynch Fragment: Freedom Weapon" welded steel sc 1986 AIM 78
 (3-90),71(c)
"Lynch Fragment Series" welded steel 1973 STHR
"Message Critic" sc 1988 ICAA
"Mount Vernon Plaza" steel construction EB 41(5-86),47(c)
"My Bell and One Thing" sc ANA 4(5-69),15
"My Turn to Bow" steel sc 1965 ART 44(12-69),20
"A Necessary Angle" steel sc 1965 LAAA
"Pambeii" sc 1988 ICAA
"Pyramid Up and Down Pyramid" sc AN 70(4-71),55
"Sketch for Homage to Coco" steel sc ARTF 9(2-77),72
"Southern Sunrise" stainless steel 1983 BAQ 7(2-87),40; AN 89
 (3-90),71(c); AN 85(9-86),11
"Try, Try" installation 1973 CGB(c)
untitled sc ART 43(5-69),22
untitled welded steel sc BAQ 7(2-87),38
Further References:
Bowling, Frank,"Black Art III," ART 44(12-79),20-2.

EDY, EUGENE, 1939- ; b. in Scotlandville, LA; painter
Biographical Sources: AAA
Portrait: BAOA-2
Published Reproductions:
 "Black Heroes" mural AG 13(4-70),59
 "Wall of Dignity" mural 1968 FAAA(c); TNAP
 "The Wall of Meditation" Chicago mural BAOA-2(c)
 "Wall of Respect" Chicago mural FAAA

ELDER, JOHN; b. in Gastonia, NC; painter
Biographical Sources: DENA
Portrait: DENA
Published Reproductions:
 "Take Five" acrylic DENA

ELLISON, MAURICE; painter, sculptor
Published Reproductions:
 "Campus Life: Turmoil of the 60's" Houston mural 1972 WBAH
 (c)
 "Holy Family" terra cotta sc 1972 BC 9(#2-78),49(c)
 "Ritual" oil 1972 WBAH

ELLISON, WALTER W., 1900- ; b. in Eatonton, GA; painter
Biographical Sources: AAA; WWWA
Published Reproductions:
 "The Sunny South" monotype LNIA

ENGRON, MAE, 1942- ; b. in Indianapolis; painter
Published Reproductions:
 "Butterflies Are Free" oil BAQ 9(#2-90),16(c)
 "Sultan's Jewels" oil BAQ 9(#2-90),15(c)
 "Sunburst" mixed media BAQ 9(#2-90),15(c)

ENSLEY, ANNETTE LEWIS, 1948- ; b. in Birmingham, AL;
 sculptor
Biographical Sources: BAOA-1
Portrait: BAOA-1
Published Reproductions:
 "Bust" sc BAOA-1

EPTING, MARION A., 1940- ; b. in Forrest, MS; painter, printmaker
 Biographical Sources: LAAA; WWAA,1991
 Portrait: AVD; BAOA-1
 Published Reproductions:
 "Alternative" intaglio BAOA-1(c); LAAA(c)
 "Distance 22-9 = +2-9" intaglio DBLJ
 "Hiku" etching 1969 BDCAA(c)
 "Klunk Boom" etching 1969 BDCAA(c)
 "The Moon Also Rises" oil BAOA-1(c)
 "Poem" intaglio BAOA-1(c)
 "Share" intaglio 1967 LAAA

ETTRICK, MELVIN O., 1940- ; painter
 Published Reproductions:
 "Mohammad's Window #2" oil 1973 BUNY

EUBANKS, CLIFFORD, JR., 1944- ; b. in Pittsburgh; painter
 Biographical Sources: AAA
 Portrait: NBA
 Published Reproductions:
 "Father and Son" oil 1969 NBA
 "Three Figures at a Table" oil 1969 NBA

EVANS, MINNIE, 1892-1987; b. in Long Creek, NC; painter
 Biographical Sources: BAAL; TCBAA; WWAA,1978
 Portrait: BAAL; FFAA
 Published Reproductions:
 "Arlie Gardens" oil 1967 WAWC(c)
 "Design" oil AFATC(c)
 "Design Made at Arlie Garden" mixed media 1967 (Smithsonian)
 CRI 83(11-76),317; FFAA; TCBAA
 "Dream" AN 85(4-86),144
 "Landscape with Head and Blue Birds" crayon,pencil 1978 BAAL
 "Modern Art" oil 1965 MS 2(5-74),72
 "Solomon's Temple" oil 1962 AFATC(c)
 untitled drawing AN 76(11-77),242
 untitled oil AG 13(4-70),24(c)
 untitled oil NEW 74(8-4-69),86
 untitled oil AAAC

untitled oil,collage 1967 RFAA; TCAFA(c)
untitled oil 1963 AN 89(3-90),34(c)
Further References:
"Minnie Evans," ART 43(2-69),62.

EVERS, DARRELL KENYATTA; mixed media, painter
Biographical Sources: EANE
Portrait: EANE
Published Reproductions:
"Cowboy Bob Meets the Flaming Baboon" mixed media 1989
EANE
"Pigeons' Roost" acrylic 1990 EANE(c)

EVERSLEY, FREDERICK JOHN, 1941- ; b. in Brooklyn; sculptor
Biographical Sources: AAA; WWAA,1991
Portrait: BE 6(12-75),62; DIAA
Published Reproductions:
"Oblique Prism II" plastic sc 1969 LAAA(c)
"Parabolic Flight" BAQ 4(#4-81),44
"Spiral Wall" acrylic AIM 72(2-84),46(c)
"Until" cast polyester resin sc 1970 AI 15(1-71),29
untitled plastic sc 1969 DBLJ
untitled plastic sc 1970 ARTF 9(2-71),57; AIM 58(9-70),64(c);
FAAA(c)
untitled sc 1970 DCBAA; FAAA
untitled sc 1975 FIBO
untitled polyester sc 1972 DIAA
untitled polyester sc 1970 DIAA
untitled #9 1975 CGB
"Vertical Spire" steel,plexiglass 1983 EWCA(c)
Further References:
McCann, Cecil, "Eversley's Image Traps," AW 2(12-18-71),5.

FABIO, CYRIL, 1921- ; b. in St. Croix, Virgin Islands; sculptor
Biographical Sources: BAOA-2
Portrait: BAOA-2
Published Reproductions:
"Youth Leading the Blind" plastic sc 1966 BAOA-2(c); BAQ 1
(Su-77),2(c)

FAIRFAX, JAMES A., 1941- ; painter
 Portrait: EB 26(5-71),105
 Published Reproductions:
 "Gunship" oil EB 26(5-71),106(c)
 "Happy Drummers" oil EB 26(5-71),106(c)
 "Humanity" oil EB 26(5-71),105(c)
 "Surgeon" EB 26(5-71),106(c)
 untitled oil EB 26(5-71),104(c)
 untitled oil EB 26(5-71),106(c)
 Further References:
 "Marine Combat Artist," EB 26(5-71),104-10.

FALANA, KENNETH, 1940- ; b. in Reddick, FL; painter, print-
 maker
 Biographical Sources: BAOA-2; BAQ 1(Su-77),25-30
 Portrait: BAOA-2
 Published Reproductions:
 "Africa" collograph 1969 BAOA-2
 "African Meeting House" serigraph 1981 BAQ 6(#4-85),45(c)
 "Melon Salad" serigraph BAQ 6(#4-85),44(c)
 "Red Spaces/Black Field" serigraph BAQ 6(#4-85),44(c)
 untitled drawing BAQ 1(Su-77),25
 untitled serigraph BAQ 6(#4-85),41(c)
 untitled drawing BAQ 1(Su-77),27
 untitled drawing BAQ 1(Su-77),29
 untitled drawing BAQ 1(Su-77),30

FARMER, JOSEPHUS, 1894-?; b. in Trenton, TN; painter
 Biographical Sources: AFATC
 Published Reproductions:
 "Let My Son Go" paint,wood 1970 AFATC(c)

FARRAR, JOHN, 1927-1972; b. in Huntsville, MD; painter
 Biographical Sources: BACW
 Published Reproductions:
 "Checker Players" oil BACW
 "The Couple" oil 1947 BACW
 "Grocery Boy" oil 1947 BACW; BC 12(#4-82),7(c)
 "Guitar Player" oil 1944 BACW

"Mrs. Mitchell" oil 1944 BACW(c); BC 12(#4-82),7(c); EB 37
 (2-82),62(C)
"Self Portrait" oil BACW

FARROW, WILLIAM MCKNIGHT, 1885-1967; b. in Dayton, OH;
 painter
Biographical Sources: AAA; ATO; MIAP; WWAA,1940
Portrait: ATO
Published Reproductions:
 "Granny Wilson's House" oil 1923 SW 54(3-25),119
 "The Messenger" etching (Clark) ATO
 "Old Oaken Bucket" watercolor 1938 (Clark) ATO
 "Paul Lawrence Dunbar" oil LNIA
 "Peace" litho (Clark) ATO
 "Ringling House" etching (Clark) ATO
Further References:
 "William A. Farrow -- Etcher," OPP 7(6-29),188.

FAVORITE, MALAIKA; b. in Baton Rouge, LA
Published Reproductions:
 "Black and Blue" acrylic 1985 BAQ 7(#3-87),25(c)
 "Blues Symphony" acrylic 1984 BAQ 7(#3-87),27(c)
 "But She Was Colored" mixed media 1985 BAQ 7(#3-87),29(c)
 "The Flag Needs a Washing" mixed media BAQ 7(#3-87),15(c)
 "Jump Rope" mixed media 1985 BAQ 7(#3-87),26(c)
 "The River Flows Through Our Lives Making Us One" mixed
 media 1985 BAQ 7(#3-87),30(c)

FAX, ELTON CLAY, 1909- ; b. in Baltimore; painter, printmaker
Biographical Sources: AAA; BANG; TNA; WWABA
Portrait: BANG
Published Reproductions:
 "Coal Hopper" oil LNIA
 "Dr. Seth Cudjoe of Ghana" oil DANA
 "In the Marketplace" conte crayon GAI
 "Little Gray Eyes" SG 28(3-39),225
 "Madonna and Child, Kano, Nigeria" drawing IBA
 "A Nigerian Patriarch" litho crayon,ink ILAAL
 "Self Portrait" CTAL; SG 28(3-39),225

"Steel Worker" oil LNIA; SG 28(3-39),225
Further References:
Fax, Elton. *Through Black Eyes*. New York: Dodd, Mead, 1974.

FEELINGS, TOM, 1933- ; b. in Brooklyn; painter
Biographical Sources: AAA; BAOA-2
Portrait: BAOA-2; BN 3(#1-83),24; CRI 70(4-63),228
Published Reproductions:
 "African Girl" SEP 18(9-69),21
 "Bed-Stuy" BC 8(3/4-78),40(c)
 "Bed-Stuy on a Saturday Afternoon" BN 3(#1-83),26
 "Big Band Blues Singer" collage 1961 ILAAL
 "Boy from Brooklyn" SEP 18(9-69),22
 "Branded and Chained" BN 3(#1-83),24
 "The Crossing" BN 3#1-83),27
 "Done" drawing CRI 70(4-63),229
 "A Dream Deferred" mixed media 1960 BAOA-2(c)
 "Long March" PR 33(11/12-79),54
 "The Middle Passage" BC 8(3/4-78),40(c); BN 3(#1-83),25
 "Mother and Child" wood sc BC 8(3/4-78),41(c); FRE 13
 (2ndQ-73),cover
 "Motherhood" oil DANA
 "Senegalese Woman" mixed media 1970 BC 5(11/12-75),33;
 BAOA-2(c)
 "Sonny's Blues" BN 3(#1-83),27
 "To Be a Slave" BC 8(3/4-78),41(c)
 untitled drawing CRI 70(4-63),230
 "West African Girl" drawing SEP 18(9-69),21
 "Young Woman" BN 3(#1-83),25
Further References:
 Baraka, Amiri, "Tom Feelings: A People's Artist," BN 3(#1-83),
 24-7.
 "Tom Feelings, Black Artist," ND 16(9-67),70-3.
 "Tom Feelings, Black Artist," SEP 18(9-69),20-3.

FERGUSON, CLAUDE, 1950- ; b. in Lenoir, NC; painter
Published Reproductions:
 "Man Screaming" EU 7(Fa-69),7

FIELDS, VIOLET; mixed media
 Biographical Sources: EANE
 Portrait: EANE
 Published Reproductions:
 "Even the Sun Refused" mixed media 1989 EANE(c)
 "Homage to Ray Ray" mixed media 1990 EANE

FISHER, LAWRENCE; painter
 Biographical Sources: AAA
 Published Reproductions:
 "Beautiful America" oil ONPB

FLANAGAN, THOMAS JEFFERSON, c1900- ; b. in Lumpkin, GA;
 painter
 Biographical Sources: AAA
 Published Reproductions:
 "Fishing on the Quarters" oil 1957 (Atlanta) DANA

FLAX, WALTER, c1900-1964; sculptor
 Published Reproductions:
 "Ship" sc ENC 5(2-16-76),31

FLEMISTER, FREDERICK, 1916- ; b. in Atlanta; painter
 Biographical Sources: BACW; NAI; TNAP
 Published Reproductions:
 "Madonna" oil 1940 LNIA
 "Man with Brush" oil 1940 CRI 47(9-40),300; DANA; LNIA
 "The Mourners" oil 1942 (Atlanta) DANA
 "Samson and Delilah" oil 1939 LNIA
 "Self Portrait" oil,tempera 1941 AV 1(9/10-86),39(c); BACW;
 PMNA

FLETCHER, MIKELLE, 1945- ; b. in West Virginia; painter
 Biographical Sources: LAAA
 Portrait: BAOA-1
 Published Reproductions:
 "Black Madonna" acrylic BAOA-1(c)
 "Guardian" acrylic 1971 LAAA(c)
 untitled BC 6(1/2-76),26(c)

FLOOD, CURT; painter
 Portrait: EB 23(7-68),70
 Published Reproductions:
 untitled oil EB 23(7-68),70

FOLAYEMI, BABATUNDE, 1942- ; b. in New York City; painter
 Published Reproductions:
 "Spirit of Malik" wood,wire JBP 1(Wi/Sp-70),105
 untitled oil ESS 2(5-71),55
 untitled oil 1969 JBP 1(Wi/Sp-70),61

FORD, GEORGE; painter
 Published Reproductions:
 "Sammy Davis, Jr." pen,ink BT (#6-72),11
 untitled pen,ink BT (#5-71),29
 untitled pen,ink BT (#6-72),12

FOREMAN, DOYLE, 1933- ; b. in Ardmore, CA; sculptor
 Biographical Sources: AAA; EBSU; LAAA; WWABA,1978
 Portrait: EBSU
 Published Reproductions:
 "Corner" bronze sc 1968 LAAA; ONPB
 "Man Split with Vegetation" bronze sc 1971 OSAE
 untitled bronze sc GAI
 Further References:
 Reed, Ishmael, "From Wood Carving to Bronze," ESS 1(Sp-72),
 62-3.

FOSTER, LEROY; b. in Detroit; painter
 Published Reproductions:
 "Lady with a Blackamoor" oil EB 13(4-58),34(c)
 "Voyage au Jardin de Balthazar" EB 13(4-58),34(c)

FOSTER, WALKER, 1890-1964; b. in Charlotte, NC; painter
 Published Reproductions:
 "Woman" oil BAQ 1(Wi-76),45

FRANCIS, JOHN, 1945- ; b. in Philadelphia; painter
 Published Reproductions:

untitled watercolor EB 33(10-76),118

FRANKLIN, RICHARD; painter
Published Reproductions:
"...In the Back of the Bookstore" mixed media 1970 AI 15(1-71),
 31
"Little Orphan Annie Defending the Myth of Daddy Warbucks Be-
 fore the Inquisition" oil AG 13(4-70),25(c)

FRAZIER, ERNEST, 1942- ; b. in Sumter, SC; painter
Published Reproductions:
"Fasolar" acrylic 1970 DCBA
"Rhythm of My People" oil DCBAA

FREELON, ALLAN R., 1895-1960; painter, printmaker
Biographical Sources: AAA; BLC; MIAP; WWAA,1962
Portrait: ATO; DANA
Published Reproductions:
"Drop Forge" etching BACW
"Gloucester Harbor" oil 1930 AV 5(2-90),58(c); ATO; DANA;
 LNIA
"Icing the Boats" oil 1929 MA 21(6-30),350
"Late Afternoon" oil PMNA
"November Night" oil EB 1(12-45),49
"Our Lady of Good Voyage" oil c1935 ATO
"Quayside" oil 1931 LNIA
"Sand Dunes, East Gloucester" oil 1930 DANA
"Still Life" oil ATO
"Unloading" aquatint 1937 PMNA
untitled oil 1928 ATO
Further References:
Holbrook, Francis, "Allan Randall Freelon: Artist-Teacher," SW 53
 (4-24),225-6.

FREEMAN, GLORIA T.; painter
Biographical Sources: DENA
Portrait: DENA
Published Reproductions:
"Birthday Party" acrylic DENA

FRIDAY, PAM; painter
Published Reproductions:
 "Basketball" oil BC 7(11/12-76),38(c)
 "Egypt" mural BC 7(1/2-77),36(c)

FUDGE, BARBARA, see **JENKINS, BARBARA FUDGE**

FUDGE, JOHN, 1941- ; b. in Newark, NJ; painter
Published Reproductions:
 "One Instant After the Veritable Birth of Homo Sapiens" acrylic
 1970 NBAT

FULLER, META VAUX WARRICK, 1877-1968; b. in Philadelphia;
 sculptor
Biographical Sources: LAAA; MIAP; TNAP
Portrait: FFAA; HRABA
Published Reproductions:
 "African Slave Ship on the Way to America" sc NHB 30(3/4-77),
 680
 "Bacchante" plaster sc 1930 HRABA(c)
 "Dr. Solomon Carter Fuller" sc NHB 30(3/4-77),680
 "Emancipation" sc 1913 ATO; CRI 8(6-14),82; OPP 1(5-23),
 cover; SW 47(1-18),27
 "Ethiopia Awakening" bronze sc 1917 (Schomburg) AW 19
 (2-6-88),680; AWSR; FAAA; HRABA(c); LNIA; NHB 2(3-39),
 56; OPP 1(7-23),212; PMNA; STHR
 "Good Shepherd" plaster sc 1926 HRABA(c)
 "Henry Gilbert" plaster sc 1928 HRABA(c)
 "Immigrant in America" SW 47(1-18),31
 "Inspiration" relief OPP 1(7-23),211
 "Inspiration Urging Negro Youth" OPP 1(7-23),211
 "John" plaster sc 1899 FAAA; LNIA
 "Lazy Bones in the Shade" plaster sc HRABA(c)
 "Lazy Bones in the Sun" plaster sc HRABA(c)
 "Man Carrying Dead Body" SW 47(1-18),30
 "Man Eating Out His Heart" plaster sc 1905 HRABA(c)
 "Mary Turner" plaster sc 1919 HRABA(c)
 "Mother and Child" bronze sc HRABA(c); NHB 30(3/4-77),681
 "Oedipus" CL 44(1-08),57

"Refugee" plaster sc 1940 HRABA(c)

"Richard B. Harrison as 'De Lawd'" plaster sc 1937 (Howard)
AIS 5(Su/Fa-68),262; LAAA; PMNA

"The Secret Sorrow" sc NHB 30(3/4-77),681

"Silent Sorrow" CL 44(1-08),56

"The Talking Skull" bronze sc 1937 AWSR; FFAA(c); LNIA;
NHB 30(3/4-77),680

"The Talking Skull" bronze sc 1939 AV 3(6-88),25(c); EB 43
(2-88),38(c); HRABA(c); SRV 37(#1-88),26

"The Three Kings" bas relief CRI 23(12-21),cover

"Water Boy" bronze sc 1914 AWSR; CAAA; DANA; ENC 6
(1-3-77),3; FAAA; ILAAL; LAAA; SW 60(5-31),211; TNAP

"Water Boy" plaster sc 1930 HRABA(c)

"The Wretched" CL 44(1-08),55; SW 47(1-18),29

Further References:

"Meta Fuller Warrick: The Sculptor Rodin Admired," ENC 6
(1-3-77),3.

O'Donnell, W.F., "Meta Warrick, Sculptor of Horrors," WT 13
(11-07),1139-45.

Perkins, Kathy, "The Genius of Meta Warrick Fuller," NALF 24
(9-90),65-72.

FUNDI, IBIBIO (JO AUSTIN), 1929- ; b. in Boston; sculptor
Biographical Sources: AAA; LAAA
Portrait: BAOA-1
Published Reproductions:
"Non-Kinetic Motor" wood sc BAOA-1(c)
"Wooden Sketch" wood sc 1968 BAOA-1; LAAA
untitled construction BAOA-1(c)

GABRIEL, RAMON, 1911- ; b. in Virgin Islands; painter
Published Reproductions:
"Pool Room" SMIH (12-77),4

GAFFORD, ALICE, 1886- ?; b. in Tecumseh, KS; painter
Biographical Sources: AAA; BAOA-2; PKAU
Portrait: ABWA; BAOA-2; BAQ 4(#1-80),19
Published Reproductions:
"Still-Life" oil PKAU; TNAP

"Still-Life" BAQ 4(#1-80),18(c)
"Still-Life" BAQ 4(#1-80),19(c)
"Tea Party" oil 1968 BAOA-2
Further References:
"Alice Gafford," BAQ 4(#1-80), 17-20.

GALE, WEST, 1920- ; b. in New York City; painter
Biographical Sources: AAA
Portrait: BAOA-1
Published Reproductions:
 untitled oil BAOA-1

GAMBLE, GEORGE; painter
Published Reproductions:
 "Man with a Wheelbarrow" SA 72(6-73),30-1

GAMMON, REGINALD, 1921- ; b. in Philadelphia; painter
Biographical Sources: CBAM; LAAA; TCBA; WWAA,1991
Portrait: AN 65(9-66),49
Published Reproductions:
 "Dragon" BAQ 7(#3-87),14(c)
 "Electric Cowboy" acrylic ENC 6(1-17-77),35
 "Family Album" acrylic BAQ 2(Sp-78),35
 "Freedom Now" acrylic 1965 AAAC; AN 65(9-66),50; ILAAL;
 LAAA
 "Harlem" acrylic 1966 AAASN
 "Heaven's Above" BAQ 7(#3-87),59(c)
 "Homage to Henry O. Tanner, Painter" acrylic AAANB; BIC
 "Morro Head" sc BAQ 7(#3-87),61(c)
 "The Poet Inflamed" acrylic 1968 AG 13(4-70),24(c); CBAM
 "Scotsboro Boys" oil 1969 BAQ 8(#2-88),56; CVAH
 "Scotsboro Mothers" acrylic 1970 LAAA
 "Self-Portrait" oil 1960 BUNY
 "Tattooist's Dream" BAQ 7(#3-87),60(c)
 "Triptych" BAQ 7(#3-87),58(c)
 "The Young Jack Johnson" acrylic 1967 LAAA(c)

GANT, CHRISTINE, 1962- ; painter
Published Reproductions:

"The Old Dresser" SA 72(6-73),31

GARY, JIM; sculptor
Published Reproductions:
"Alligator" welded sc EB 31(10-76),140
"Big Metal Bird" welded sc EB 31(10-76),141
"The Coming of Spring" construction EB 31(10-76),142
untitled metal sc EB 31(10-76),140

GARRETT, ADOLPHUS; painter
Published Reproductions:
"Cotton Pickers" oil 1956 BAIH
"Returning Home" oil 1956 BAIH(c)

GASKIN, LEROY, 1924- ; b. in Norfolk, VA; sculptor
Biographical Sources: DENA; WWABA,1978
Portrait: DENA
Published Reproductions:
"Jamming" acrylic DENA

GATEWOOD, LAMEROL; b. in St. Louis, MO; painter
Published Reproductions:
untitled acrylic 1987 BC 21(#2-90),24(c)
untitled acrylic 1987 BC 21(#2-90),25(c)

GENTRY, HERBERT, 1921- ; b. in Pittsburgh; painter
Biographical Sources: AAA; WWAA,1991
Portrait: BAQ 3(#4-79),4
Published Reproductions:
"Blue Bird #3" oil 1978 BAQ 3(#4-79),11(c)
"Inner Strength #2" oil 1978 BAQ 3(#4-79),7(c)
"Inner Strength #3" oil 1978 BAQ 3(#4-79),6(c)
"The Onir" monoprint BE 12(12-82),59(c)
Further References:
Spaulding, Jacqueline, "Herbert Gentry," BAQ 3(#4-79),4-11.

GERAN, JOSEPH, 1945- ; b. in San Francisco; printmaker, sculptor
Biographical Sources: EBSU, LAAA; WCBI; WWAA,1991
Portrait: BAOA-1; ENC 5(4-5-76),33

Published Reproductions:
 "Ananse" pen,ink 1971 LAAA
 "God of Self" sc ARTF 9(12-70),84
 "Jalani (Mighty)" aluminum,ebony sc BAQ 1(Wi-76),33
 "The Mystic Cruise" bronze sc BAQ 1(Wi-76),33
 "Political Branches" charcoal EBSU
 "The Prophet" bronze/brass sc WCBI
 "Street King" red brass sc BAOA-1

GIBBS, EZEKIEL, 1889- ; b. in Richmond, TX; painter
 Biographical Sources: BHBV
 Portrait: BHBV
 Published Reproductions:
 "Church Meeting" oil,pencil 1988 BHBV
 "Farm Life" oil,water 1988 BHBV(c)
 "Harvest Time" oil,watercolor 1988 BHBV
 "Husband, Wife and Mule" oil 1988 BHBV
 "Tree of Life" oil,pastel 1985 BHBV

GILES, WILLIAM, 1930- ; b. in South Carolina; painter
 Published Reproductions:
 "Figure Blight" acrylic 1968 ART 42(5-68),60
 "3< totals 3" acrylic 1968 STU 173(4-67),211

GILLIAM, SAM, JR., 1933- ; b. in Tupelo, MS; painter
 Biographical Sources: CA; DCAA; LAAA; TNAP; WWAA,1991
 Portrait: TNAP
 Published Reproductions:
 "Abacus Sliding" acrylic 1977 (Denver) ART 52(2-78),150(c)
 "Abstraction" acrylic 1969 AAATC(c)
 "Ain't More than Music" acrylic 1988 (Bronx) AIM 78(3-90),170
 (c)
 "April 4, 1968" acrylic BC 3(5/6-73),27(c); ESS 4(11-73),22(c);
 ESS 4(12-73),29(c)
 "Arc" hanging AI 15(2-71),57
 "Arc Maker #1" AIM 71(Su-83),156(c)
 "Arc Maker #11" AIM 71(Su-83),156(c)
 "Autumn Surf" painted polypropylene 1973 ART 52(2-78),152;
 PEAA

"Balloons, Shutes, Days" acrylic 1980 AASN

"Baroque Cascade" acrylic 1969 AI 14(5-70),34; ART 52(2-78), 152

"Birch Block I" construction 1985 ART 60(12-85),114; ARTF24 (10-85),33(c);

"Blue Isolate" acrylic 1980 PTS

"Breeze" acrylic and aluminum paint 1967 AG 11(4-68),cover(c)

"Brown Reed" collage 1976 AIM 65(3-77),119(c); BAQ 4 (#4-81),18

"But Through" HW (3rdQ-68),15(c)

"Carousel Change" acrylic 1970 ARTF 9(9-70),57; FAAA; TIM 95(4-6-70),85(c)

"Carousel Form II" acrylic 1969 AATC; AG 13(2-70),29; AI 14 (5-70),34; AIM 58(9-70),57(c); AIM 67(11-79),76(c); AIM 74 (1-86),99(c); ARTF 9(9-70),58; AV 4(2-89),26(c)

"Carousel Form III" acrylic 1969 AI 14(5-70),34; DBLJ

"Chambre" 1987 AIM 75(5-87),67(c)

"Clear" acrylic 1967 AI 14(5-70),33; ARTF 6(3-68),63

"Cowl" acrylic 1970 ARTF 9(12-70),28

"Cranes" collage,acrylic ARTF 14(10-75),5(c); AN 74(3-75).42

"Dakar" 1970 AI 16(10-72),86; ARC 29(10-72),46

"Diagonal Suspension" construction AI 13(12-69),42

"Door Piece" hanging 1972 AN 72(1-73),43

"Evened Space" acrylic 1977 AI 22(2-78),80; ARTF 16(3-78),65

"Fire" litho 1972 ARTF 10(5-72),93(c)

"Flowered Wedding" NAE 14(Su-87),48

"For Day One" collage,acrylic 1975 ARTF 14(10-75),5(c)

"Genghis I" acrylic with aluminum powder 1969 ARTF 9(9-70), 58

"Herald" acrylic 1965 FAAA

"Indigo Danced" oil 1984 ART 59(2-85),79(c)

"Kimono" ART 53(5-79),15

"Lamont" 1977 AN 89(2-90),13(c)

"Lattice II" acrylic 1987 NAE 15(5-88)24A(c)

"Leah's Renoir" 1979 (Metropolitan) BAQ 4(#4-81),22(c)

"Life" acrylic 1970 ARTF 9(12-70),28

"Light Depth" hanging 1969 AG 13(4-70),28(c)

"Maine" acrylic 1969-70 AI 15(12-71),48

"Mazda" acrylic 1969 DBLJ; FAAA

"Memphis Jazz" oil 1984 ART 59(2-85),78(c)
"New River Rising" acrylic,canvas AV 4(2-89),30(c)
"Of Cities: American" ART 53(6-79),41
"Orion" acrylic 1983 EWCA(c)
"Painted Fingers" acrylic,canvas 1986 ICAA(c)
"Pantheon" ARC 73(5-84),234
"Pantheon II" acrylic 1983 AIM 74(1-86),105(c)
"Pantheon V" acrylic 1984 STHR
"Pinwheeled" acrylic,collage 1984 AIM 74(1-86),98(c)
"Ray 1" acrylic 1970 AI 17(2-73),21
"Restore" acrylic with powdered aluminum DBLJ
"Rouge" acrylic 1968 ARTF 7(9-68),62
"Saga" mixed media 1986 AV 2(6-87),18(c); SMI 18(5-87),188(c)
"Sawhorse Piece" construction 1972 AN 72(1-73),42
"Sculpture with a 'D'" enamel,aluminum 1983 AIM 74(1-86),102
 (c)
"Seahorses" hanging 1975 ART 52(2-78),153
"Shadow" acrylic 1988 BABC(c)
"Shift Again" acrylic 1968 CBAM
"Skeletal Curl" acrylic 1966 AI 14(5-70),66
"Slide" acrylic 1967 AIM 56(3-68),61(c)
"Solar Canopy" enamel,aluminum AV 4(2-89),29(c)
"Someplace to Someplace Else" ART 63(Su-89),79(c); NEA 17
 (9-89),54
"Spread" acrylic 1970 AWAP(c)
"Sticks Related" hanging 1972 AN 72(1-73),42
"Swing" 1969 ART 43(Su-69),50
"Tempo" acrylic 1965 ILAAL; TNA
"Tequila" mixed media 1979 APTE(c)
"Three Panels for Mr. Robertson" AI 19(6-15-75),94
"Through Expanses" acrylic 1968 AI 14(5-70),33
"To a Garden" acrylic 1976 ART 52(2-78),151(c)
"Triple Variant" hanging 1979 AIM 74(1-86),100
untitled acrylic 1965 LAAA
untitled acrylic 1971 CGB
untitled enamel,aluminum AV 4(2-89),29(c)
untitled enamel,aluminum 1983 AIM 74(1-86),102(c)
untitled enamel,aluminum 1985 AIM 74(1-86),103(c)
untitled watercolor NALF 8(Wi-74),281

"Waking Up" AIM 78(3-90),201
"Watercolor 4" watercolor,aluminum,powder 1969 (Modern Art)
 FAAA
"Wave Composition" enamel,aluminum,canvas AIM 74(1-86),101
 (c); AV 4(2-89),27(c)

GLOVER, ROBERT, 1941- ; b. in Chicago; painter, printmaker
Biographical Sources: AAA; BAOA-2
Portrait: BAOA-2
Published Reproductions:
 "Black and White" collage 1969 BAOA-2
 "City" linocut PANA
 "The Printed Word" collage 1969 BAOA-2
 untitled collage 1969 BAOA-2

GOLDING, WILLIAM O., 1874-1943; b. in Savannah, GA; painter
Published Reproductions:
 "Albatross" oil 1934 AIM 58(1-70),85(c)
 "Eddystone Light" oil 1934 AIM 58(1-70),85
 untitled oil AIM 58(1-70),84
Further References:
 "Rediscovery: William O. Golding," AIM 58(1-70),84-5.

GOODNIGHT, PAUL; illustrator, painter
Published Reproductions:
 "Blues in Blue" oil 1972 BAQ 5(#2-82),38(c)
 "Common Thread" pastel 1979 BAQ 5(#2-82),39
 "Does Anyone Know I'm Here" oil 1973 BAQ 5(#2-82),37(c)
 "Hydrants" oil 1976 BAQ 5(#2-82),40(c)
 "Salt Peanuts Don't Belong to Jimmy Carter" BAQ 5(#2-82),36(c)
 "Turn Up the Quiet--Tranquility" pastel 1980 BAQ 5(#2-82),41(c)
 "Young Boy in the Spirit of James Baldwin" pastel,charcoal 1980
 BAQ 5(#2-82),39

GORDON, ERMA; muralist
Published Reproductions:
 "Awakening" Houston mural 1968 BAIH(c)
 "Bison" terra cotta sc 1968 BAIH
 "Self-Portrait" casein 1968 BAIH(c)

GORDON, L. T.; painter
Published Reproductions:
"Cotton Pickers" oil 1957 BAIH(c)

GORDON, ROBERT GRAY, 1931- ; b. in New York City; painter
Biographical Sources: AAA; CBAM; WWAA,1991
Published Reproductions:
"Bronze Powder" mixed media 1966 CBAM
"Environment" mixed media 1970 AIM 58(9-70),65
untitled construction 1967 AIM 56(3-68),69(c)

GORDON, RUSSELL T., 1936- ; b. in Altoona, PA; mixed media
Biographical Sources: AAA; BDCAA; LAAA; WCBI
Published Reproductions:
"The Big Split" mixed media 1977 ART 52(6-78),54
"Earth Mother" etching 1970 AP 11(1971),31
"Ideas More Fun in the Bath" acrylic 1975 OSAE
"Jack in the Box Table" acrylic WCBI
"Kaleidoscopic Portrait Series #1" acrylic BDCAA(c)
"Kaleidoscopic Portrait Series #2" etching BDCAA(c)
"Kaleidoscopic Portrait Series #5 etching BDCAA; LAAA
"Kaleidoscopic Portrait Series #7" serigraph BAQ 2(Sp-78),22(c)
"Let's Call Thin" 1979 AW 11(2-23-80),20

GORELEIGH, REX, 1902-87; b. in Penllyn, PA; painter, printmaker
Biographical Sources: DANA; FSBA
Portrait: DANA; FSBA
Published Reproductions:
"Dean's Alley" watercolor 1938 LNIA
"Dune's Landslide" oil 1944 NAI
"House on Canal Road" oil 1958 DANA
"Jungle Dancer" watercolor 1957 DANA
"Marketplace, Helsinki" oil 1935 FAL
"Misery" watercolor 1940 FAL
"Planting" water,tempera 1943 AAATC(c)
"Plowin'" oil 1940 LNIA
"Quaker Bridge Road" oil 1959 FAL
"Self Portrait" oil 1935 (Harmon) AAAC; LNIA
"Still Life" watercolor,acrylic 1974 FAL

"Sunflower" oil 1967 FAL
"The Tomato Picker" serigraph FSBA
"The Twins" oil 1958 DANA

GOSS, BERNARD, 1913-66; b. in Sedalia, MO; painter, printmaker
Biographical Sources: AAA
Published Reproductions:
"Frederick Douglass" litho CNHB
"Musicians" watercolor 1939 LNIA

GOSS, MARGARET TAYLOR, see **BURROUGHS, MARGARET TAYLOR GOSS**

GOUVERNEUR, SIMON; painter
Published Reproductions:
"Shoal" oil 1982 STHR

GRANT, JOE; b. in Los Angeles; mixed media
Published Reproductions:
untitled construction 1986 CACE(c)

GRAVES, OSCAR, 1921- ; b. in Detroit; painter
Biographical Sources: AAA
Published Reproductions:
"Labor and Education" sc ND 16(11-66),53

GRAY, TODD; b. in Los Angeles; mixed media
Biographical Sources: EANE
Portrait: EANE
Published Reproductions:
"Anti Hero #1" print,charcoal 1984 EANE
"Utopia/Architecture" steel,print 1989 EANE(c)

GREEN, ANABELLE; painter
Biographical Sources: AAA; DENA
Portrait: DENA
Published Reproductions:
"Incense" oil DENA

GREEN, JAMES, 1939- ; b. in Chattanooga, TN; painter
 Biographical Sources: AAA
 Published Reproductions:
 "The Room" mixed media NBAT; BCR 3(Fa-71),17; BL 2
 (Fa-71),10

GREEN, JONATHAN; painter
 Portrait: AV 5(2-90),44
 Published Reproductions:
 "Boat Men" oil AV 5(2-90),50(c)
 "The Escorting of Ruth" oil AV 5(2-90),49(c)
 "First Born" oil AV 5(2-90),46(c)
 "First Sunday" oil 1985 AV 3(6-88),33(c)
 "Hip City" AV 5(2-90),cover(c)
 "The Mather School" oil AV 5(2-90),52(c)
 "The Shout" AV 5(2-90),44(c)
 "Tales oil 1988 AV 3(10-88),17(c)
 "Youths on Horse" oil 1985 AV 3(6-88),cover(c)
 Further References:
 Greene, Carroll, "Coming Home Again," AV 5(2-90),44-52.

GREEN, ROBERT H.,JR.,1930- ; b. in Okmulgee, OK; painter
 Biographical Sources: BAOA-1; EBSU
 Portrait: EBSU
 Published Reproductions:
 "There Is No Greater Love" oil BAOA-1

GREENE, DONALD O., 1940- ; b. in Youngstown, OH; painter
 Biographical Sources: AAA
 Portrait: BAOA-1
 Published Reproductions:
 "Antelers" oil BAOA-1
 "County Seat" oil BAOA-1

GREENE, MICHAEL, 1943- ; b. in Akron, OH; painter
 Biographical Sources: AAA
 Published Reproductions:
 "A Bird in the Hand" oil 1976 OSAE

GREY, JOSEPH E., 1927- ; b. in Lancaster, OH; painter
Published Reproductions:
 "Bull and Fighter" watercolor 1958 DANA
 "Composition #12" EB 13(4-58),33(c)

GRIFFIN, CHARLES RON, 1938- ; b. in Chicago; painter
Biographical Sources: BAOA-1; LAAA
Portrait: BAOA-1
Published Reproductions:
 "Bound Figure" mixed media 1971 LAAA
 untitled AVD
 untitled BFAA
 untitled mixed media BAOA-2(c)
 untitled sc BAOA-2(c)
 untitled mixed media BAOA-2(c)

GRIGSBY, JEFFERSON EUGENE, JR., 1918- ; b. in Greensboro,
 NC; painter
Biographical Sources: AAA; WWAA,1991; WWABA
Portrait: BAOA-1; EB 18(9-63),140
Published Reproductions:
 "Fertility" oil BAOA-1
 "The Hunter" oil 1959 DANA
 "No Vacancy" woodcut 1964 DBLJ; GAI

GRIST, RAYMOND, 1931- ; b. in New York City; graphic artist,
 painter
Biographical Sources: AAA; BE 6(12-75),48
Portrait: BAQ 4(#1-80),48
Published Reproductions:
 "Black Painting" oil 1979 BAQ 4(#1-80),52(c)
 "Land Sea Air" etching 1978 BAQ 4(#1-80),50
 "Looking over My Shoulder" oil 1979 BAQ 4(#1-80),52(c)
 "Skeletons in the Closet" oil 1979 BAQ 4(#1-80),53(c)
 untitled pastel BE 6(12-75),48(c)
 "Wanderer" oil 1979 BAQ 4(#1-80),49(c)
Further References:
 Gonzalez, Ruben, "Ray Grist, Painter," BAQ 4(#1-80), 48-54.

GUDE, MICHAEL; painter
Published Reproductions:
 untitled oil 1977 NALF 8(Sp-74),175

GUEST, ETHEL D., 1929- ; b. in Greensboro, NC; painter
Biographical Sources: FFAA
Portrait: FFAA
Published Reproductions:
 "Trip the Light Fantastic" oil 1978 FFAA(c)

HAILSTALK, JOHN T., 1894-?; painter
Biographical Sources: AAA
Published Reproductions:
 "Winter" oil 1926 PMNA

HAINES, CHARLES E., 1925- ; b. in Louisville; graphic artist,
 painter
Biographical Sources: AAA
Published Reproductions:
 untitled oil EB 12(4-57),56

HALL, HORATHEL D.; b. in Houston, TX; mixed media
Biographical Sources: AAA
Portrait: BANG
Published Reproductions:
 "Bird Face Mask" mixed media BANG

HALL, KARL; muralist, painter
Published Reproductions:
 "Bridge over Troubled Waters" Houston mural 1976 BAIH(c)
 "Going to Church" oil 1976 BAIH

HALL, WESLEY, 1934- ; b. in Toledo, OH; painter
Biographical Sources: AAA; BAOA-1
Portrait: BAOA-1
Published Reproductions:
 "Awareness" oil BAOA-1
 "Monumental Man" oil BAOA-1

HAMILTON, EDWARD N., JR., 1947- ; b. in Cincinnati; painter,
 sculptor
 Biographical Sources: WWABA
 Portrait: BAQ 4(#3-80),60
 Published Reproductions:
 untitled sc CRI 86(10-79),cover(c)
 untitled sc BAQ 4(#3-80),60(c)

HAMLIN-MILLER, EVA, 1911- ; b. in New York City; painter
 Published Reproductions:
 "Meditation Wall" acrylic 1975 FFAA(c)

HAMMONS, DAVID R., 1943- ; b. in Springfield, IL; painter,
 printmaker
 Biographical Sources: BDCAA; TNAP; WCBI
 Portrait: BAOA-1; TNAP
 Published Reproductions:
 "Admissions Office" mixed media WCBI
 "America the Beautiful" serigraph 1968 BAOA-1(c); WLB 43
 (4-69) 757
 "American Hang Up" body print BAOA-1(c)
 "Back to Black" monoprint 1969 BDCAA(c)
 "Black Boy's Window" 1968 CGB
 "Black First, America Second" oil AI 14(10-70),74; NACA
 "Blue Train" installation 1989 BAAL
 "Bottle Caps/Basketball Pole" mixed media 1988 NACA
 "Close Your Eyes and See Black" 1970 CGB
 "Couple" bodyprint and paint 1970 LAAA
 "Flag" body print and serigraph BAOA-1(c)
 "Flag Day" monoprint 1968 BDCAA
 "Gray Skies over Harlem" 1977 CGB(c)
 "How Ya Like Me Now?" AIM 78(2-90),35
 "Injustice Case" mixed media 1970 (Los Angeles) AP 11(1971),
 29; BAQ 2(Sp-78),17; CVAH; FAAA; NACA(c)
 "Laughing Magic" mixed media 1973 CGB
 "Marcus Garvey Vitamins" mixed media 1988 NACA
 "Mop Series I" monoprint 1965 ART 51(1-77),43
 "Nap Tapestry" installation CAS 1(10/11-77),47
 "Pray" body paint 1969 DBLJ

"Pray for America" serigraph,body print 1969 FAAA; TIM 96
 (4-6-70),80(c)
"P.S. 1" BE 6(12-75),44(c)
"Ragged Spirits" 1974 CGB
"Skillets in the Closet" assemblage 1988 NACA(c)
"Used Combs" plastic 1980 STHR
untitled 1976 CGB
untitled 1976 CGB
untitled installation 1989 VIS 4(Wi-89),26(c)
untitled mixed media NACA
untitled mixed media 1977 CGB
untitled mixed media 1977 CGB
untitled mixed media 1989 AIM 77(9-89),196(c)
untitled mixed media 1989 AIM 77(9-89),197(c)

HAMPTON, JAMES, 1909-1964; b. in Elloree, SC; mixed media
Biographical Sources: BFAA
Portrait: BFAA
Published Reproductions:
 "Throne" mixed media BFAA

HAMPTON, PHILLIP J., 1922- ; b. in Kansas City, MO; graphic
 artist, painter
Biographical Sources: AAA; BDCAA; EBSU; WWAA,1991
Portrait: AG 11(4-68),48; BAOA
Published Reproductions:
 "Actinozoan" AG 11(4-78),48
 "Bang! Abel" acrylic collage 1966 BAOA-1
 "The Banjo Lesson" oil (Hampton) DANA
 "Class Drawing" oil DANA
 "The Harbinger" oil 1959 DANA
 "Throne of the Third Heaven" WINT 18(Wi-83),283
 "A Weekend Song" oil 1968 BDCAA
 "Young Girls of Savannah" gouache 1954 DANA

HARDEN, MARVIN, 1935- ; b. in Austin, TX; graphic artist, painter
Biographical Sources: BDCAA; FAAA; LAAA; WWAA,1991
Published Reproductions:
 "A Fine and Private Place" drawing 1967 (Modern Art) CBAM;

FAAA
"I Celebrate Topanga (#6)" pencil ARTF 4(3-66),16
"Little Boys Are Very Impressionable" pencil 1967 FAAA
"Perfectly Logical & Inevitable" pencil 1967 ART 45(5-71),48;
 BDCAA(c)
"Ritual of Consumption..." pencil LAAA
"The Thing Seen Suggest" litho 1974 AN 74(1-75),89
"There Were Trees Here Before..." AW 13(3-27-82),1
"Unhurried Awareness..." pencil 1970 ARTF 9(5-71),89; FAAA
"The Uniqueness of Each Form..." pencil 1970 AI 15(6-20-71),34
untitled 1977 FIBO
"Untitled Image in the Gap of the Passage" AW 13(3-27-82),1
"What Can One Say About a Life So Suddenly Rushed, Soonly
 Hushed" pencil 1970 (Whitney) FAAA

HARDISON, INGE; b. in Portsmouth, VA; painter, sculptor
 Biographical Sources: AAA; WWABA,1978
 Published Reproductions:
 "Frederick Douglass" bronze sc LIB 4(4-64),17; ND 16(2-67),
 cover
 "Harriet Tubman" bronze sc LIB 4(4-64),17; ND 16(2-67),cover
 "A Slave Woman" bronze sc LIB 4(4-64),17; ND 16(2-67),53
 "W.E.B. DuBois" sc ND 16(2-67),53

HARDRICK, JOHN WESLEY, 1891-1968; b. in Indianapolis;
 painter
 Biographical Sources: AAA; ATO; MIAP; WWAA,1940
 Portrait: ATO
 Published Reproductions:
 "Aunty" oil 1933 DANA; OPP 11(3-33),70
 "Betty" oil 1938 LNIA
 "Blue Lagoon" oil (Indiana) ATO(c)
 "Judge 'X'" oil CRI 36(2-29),53
 "Portrait of a Ninety-Year-Old Mammy" oil MA 26(10-33),474
 "Portrait of a Woman" oil (Hampton) ATO
 "Salt Lick Creek--Brown County" oil (Indiana) ATO
 "Self Portrait" oil 1927 CRI 35(6-28),196; LNIA; SG 60(9-1-28),
 548
 "Two Boys Fishing" oil SW 57(3-28),125

HARLESTON, EDWIN AUGUSTUS, 1882-1931; b. in Charleston,
 SC; painter
 Biographical Sources: AAA; TCBAA; WWCA,1933
 Portrait: ATO
 Published Reproductions:
 "Aaron Douglas" oil 1930 (Gibbes) ATO
 "Bible Student" oil OPP 2(1-24),cover
 "Charleston Shrimp Man" oil AAAC
 "The Doughboy" oil 1920 ATO
 "Miss Bailey with the African Shawl" oil 1930 ATO(c)
 "The Old Servant" oil 1928 ATO; CTAL; DANA; LNIA; MA 23
 (9-31), 210; OPP 9(4-31),102; TCBAA; UA 5(6-53),183
 "Old Veteran" oil NHB 9(4-39),61; NHB 9(4-46),151
 "Portrait of Pierre S. DuPont" oil CRI 29(3-25),223
 "Portrait of the Artist's Wife" oil (Harmon) AAAC
 "The Soldier" oil OPP 2(1-24),21
 "A Type" oil OPP 2(1-24),21
 Further References:
 Allison, Madeline, "Harleston! Who Is E.A. Harleston?" OPP 2
 (1-24),21-2.

HARPER, ROBIN, see **ASANTEY, KWAI SEITU**

HARPER, WILLIAM A., 1873-1910; b. in Cayuga, Canada; painter
 Biographical Sources: AAA; LAAA; MIAP; TCBAA; TNAP
 Published Reproductions:
 "Afternoon at Montigny" oil 1905 AIS 5(Su/Fa-68),258; PMNA
 "The Banks of the Laing" oil VN 3(11-06),121
 "Dirty Dominoes #3" oil CH 31(12-71),52
 "Eventide" oil VN 3(11-06),122
 "Landscape" oil 1906 DANA
 "Patio" oil 1908 AAATC(c)
 "Provincial Landscape" oil 1908 LNIA
 "Sunlit Wall, Brittany" oil 1904 LNIA
 "Young Poplars and Willows" oil VN 3(11-06),120

HARRELL, HUGH, 1926- ; b. in Hampton, VA; painter, sculptor
 Biographical Sources: AAA

Portrait: NBA
Published Reproductions:
 "The Baby" drawing FRE 3(Sp-63),168
 "Callous Soul" plastic sc 1963 NBA
 "Dancer" drawing FRE 3(Sp-63),168
 "Janie" mixed media PANA
 "The Junkie" oil ILAAL
 "Lisa" drawing FRE 3(Sp-63),168
 "Trope" metal,cement sc 1964 NBA

HARRINGTON, OLIVER WENDELL, 1913- ; b. in Valhalla, NY;
 painter
Biographical Sources: AAA
Portraits: OPP 20(12-42),365
Published Reproductions:
 "Deep South" oil LIF 8(2-12-40),46
 untitled oil OPP 20(12-42),365
Further References:
 "America's Socio-Artist," OPP 20(12-42),365.

HARRIS, GILBERT S., 1931- ; painter
Biographical Sources: AAA
Portrait: DANA
Published Reproductions:
 "Grave Yard of Boats" oil EB 13(4-58),33(c)
 "Growing Plant" EB 13(4-58),33(c)
 "Nude" oil DANA

HARRIS, HOLLON L.; painter
Published Reproductions:
 untitled AN 52(5-53),26

HARRIS, JOHN TAYLOR, 1908- ; b. in Philadelphia; painter
Biographical Sources: AAA; MIAP; WWAA,1940
Portrait: BAOA-1
Published Reproductions:
 "Portrait" oil BAOA-1
 "Portrait" pastel BAOA-1

HARRIS, SCOTLAND J.B.; b. in Baltimore; printmaker
 Biographical Sources: AAA
 Published Reproductions:
 "Jazz Player" woodcut PANA(c)
 "Nude No. 3" woodcut 1967 ILAAL

HARRIS, WARREN L., 1917- ; b. in Philadelphia; painter, sculptor
 Biographical Sources: AAA
 Portrait: ILAAL
 Published Reproductions:
 "Mattie" plaster sc ILAAL

HARVEY, BESSIE, 1928- ; b. in Dallas, GA; mixed media
 Biographical Sources: BAAL; BIS
 Portrait: BAAL; BIS
 Published Reproductions:
 "Cat" wood sc CLAR 12 12(Sp/Su-87),44
 "The Family" mixed media 1988 BAAL(c)
 "Grandma and Grandpa" clay 1984 BIS(c)
 "The Healing" wood sc ARTF 25(5-87),97(c)
 "Mask" wood 1986 BAAL(c)
 "Tribal Spirits" wood,mixed 1988 BAAL(c)
 untitled mixed 1985 BAAL(c)
 untitled construction 1985 CLA 11(Fa-86),14(c)
 untitled clay 1985 BIS
 untitled clay 1984 BIS
 untitled clay 1984 BIS(c)
 untitled clay 1986 BIS

HASSAN, GAYLORD; painter, printmaker
 Published Reproductions:
 "Beach" mixed media 1980 BAQ 6(#1-84),36
 "The Brothers" woodcut BT (#5-71),49
 "Field" wire,rope,concrete 1983 BAQ 6(#1-84),37
 "The Majority" woodcut ESS 2(11-71),26
 "Notes From the Wind" wire,rope 1981 BAQ 6(#1-84),
 58
 "On Dangerous Ground" wire,rope 1981 BAQ 6(#1-84),39

"Remembering" hanging 1983 BAQ 6(1-84),41(c)
"12 Trees #2" installation 1979 BAQ 6(#1-84),35
untitled ESS 2(5-71),26(c)

HASSINGER, MAREN, 1947- ; b. in Los Angeles; sculptor
Biographical Sources: FFAA; YTCW
Portrait: FFAA
Published Reproductions:
"Beach" mixed media 1980 BAQ 6(#1-84),36
"Field" mixed media 1983 AIM 78(5-90),245; AW 16(12-11-82),
23; BAQ 6(#1-84),37; EWCA
"Forest" 1980 BAQ 7(#2-87),62
"Leaning" wire rope 1980 AW 13(12-11-82),4
"Message" 1977 FIB
"Notes From the Wind" wire,rope 1981 BAQ 6(#1-84),58
"On Dangerous Ground" wire, rope 1981 BAQ 6(#1-84),39
"Remembering" hanging 1983 BAQ 6(1-84),41(c)
"Twelve Trees #2" installation 1979 BAQ 6(#1-84),35
"Walking" cable,wire 1978 FFAA
"Weeds" wire rope 1986 BAQ 7(#2-87),61
"When the Time Came, There Were No Leaves" wire,rope,con-
crete 1988 AIM 78(3-90),169
Further References:
Hines, Watson, "Maren Hassinger," BAQ 7(#2-87),60-6.

HAWKINS, THELMA; painter
Published Reproductions:
"The Currency of Meaning #5" oil 1989 BAQ 9(#2-90),23(c)
"The Currency of Meaning #6" oil 1989 BAQ 9(#2-90),23(c)
"The Currency of Meaning #9" oil 1989 BAQ 9(#2-90),23(c)
"The Currency of Meaning #10" oil 1989 BAQ 9(#2-90),23(c)
"Landsite" oil 1988 BAQ 9(#2-90),22(c)
"The Well" oil 1988 BAQ 9(#2-90),22(c)

HAWKINS, WILLIAM; mixed media
Published Reproductions:
"Red Dog Running" enamel,masonite 1984 STHR(c)
"Trail-Riders" enamel,masonite 1984 STHR

HAYDEN, FRANK, 1934- ; b. in Memphis, TN; sculptor
Biographical Sources: AAA; TCNL; WWAA,1978; WWABA
Portrait: TCNL
Published Reproductions:
 "Seeking" fiberglass sc EB 29(12-73),39(c)
 untitled sc LA 35(8-67),162
 untitled sc LA 35(8-67),162

HAYDEN, KITTY L., 1942- ; Marlin, TX; painter
Biographical Sources: BAOA-1
Portrait: BAOA-1
Published Reproductions:
 "Blue Landscape" oil BAOA-1
 "Pink Landscape" oil BAOA-1

HAYDEN, PALMER C., 1893-1973; b. in Wide Water, VA; painter,
 sculptor
Biographical Sources: AAA; FAAA; HRABA; MIAP; NAI
Portrait: EB 18(9-63),131; HRABA
Published Reproductions:
 "Autumn, East River" oil 1934 PMNA
 "Bal Jeunesse" watercolor c1927 HRABA(c); NENY 20(3-87),74
 (c)
 "Banjo Player" oil ART 51(2-77),62
 "Baptizing Day" oil LAAA(c); LIF 21(7-22-46),65(c)
 "Barge Haulers" oil 1950 HRABA(c)
 "Berry Pickers" oil (Fisk) DBLJ
 "Big Bend Tunnel" (John Henry Series) oil (LAMAAA) HRABA
 (c)
 "Blue Nile" watercolor 1964 HRABA(c)
 "Boothbay East" watercolor c1950 HRABA(c)
 "Cafe l'Avenue" watercolor 1932 AAATC(c)
 "Christmas" oil c1939 AV 2(12-87),13(c); HRABA(c)
 "Died wid His Hammer in His Hand" oil (Smithsonian) FAAA;
 TNAP
 "Dress She Wore Was Blue" (John Henry Series) oil c1934
 (LAMAAA) AV 3(8-88),24(c); AW 19(2-6-88),1; EB(2-88),38
 (c); HRABA
 "Fetiche et Fleurs" oil 1926 (Fisk) AAAC; ATO; BAQ 1(Fa-76),

11; DANA; FAAA; ILAAL; LAAA; LNIA; SA 71(12-71), 23;
 SW 62(4-33),177; TCBAA; TIM 21(3-6-33),42
"56th Street" watercolor 1953 HRABA(c)
"Harbor Traffic" oil 1929 STHR
"He Laid Down His Hammer and Cried" oil BUNY
"His Hammer in His Hand" (John Henry Series) oil (LAMAAA)
 HRABA(c)
"Janitor Who Paints" oil 1937 (Smithsonian) ATO; LNIA;
 OAAL; STHR; TEAAA
"Janitor Who Paints" watercolor c1939 (Smithsonian) HRABA(c)
"John Henry on the Right..." oil 1947 (LAMAAA) HRABA(c);
 LAAA
"Just Back from Washington" watercolor 1938 HRABA(c)
"Marcus Garvey Parade" oil BAQ 8(#2-88),55(c)
"Midsummer Night in Harlem" oil 1938 (Fisk) AARE 3
 (11/12-76),113(c); AN 75(12-76),80; BAQ 3(#3-79),53; FAAA;
 ILAAL; LNIA; OAAL; NEWO 3(#1-76),32; RD 112(6-78),178
 (c); TCBAA
"Nous Quatre a Paris" watercolor 1930 (Metropolitan) HRABA(c)
"Old Military Prison--Paris" watercolor c1927 (Clark) ATO
"Quai at Concarneau" oil 1929 LNIA
"Sailing Boats" oil (Spelman) ATO(c)
"St. Servan, France" oil 1929 DANA; OPP 9(5-31),142
"The Schooners" oil 1926 ATO
"Steam Driller and John Henry" oil AAAC; LAAA
"Subway" oil c1930 HRABA(c); STHR
"Virginia Teamster" oil AV 1(11/12-86),31(c); BAWPA
"When John Henry Was a Baby" oil (Smithsonian) FAAA
"When Tricky Sam Shot Father Lamb" oil c1940 ENC 5
 (12-20-76),23; NAI; STHR; TCBAA
Further References:
Cavalier, Barbara, "Palmer Hayden," ART 51(5-77),25.

HAYDEN, WILLIAM MCKINLEY, 1916- ; b. in Lexington, NC;
 painter
Biographical Sources: AAA
Published Reproductions:
 "The Checker Game" oil (Harmon) AAAC
 "Still Life" oil 1939 LNIA

HAYES, VERTIS, 1911- ; b. in Atlanta; painter, sculptor
Biographical Sources: AAA; WWABA,1978; WWCA,1950
Published Reproductions:
"Pursuit of Happiness" oil ART 52(10-77),123,124
"Scales" oil 1939 LNIA

HAYNES, ANTHONY; painter, sculptor
Published Reproductions:
"Spring" oil 1970 BAIH(c)
"Sun Stool" terra cotta sc 1970 BAIH(c)

HAYNIE, WILBUR, 1929- ; b. in Camden, AR; painter
Biographical Sources: AAA; BDCAA
Published Reproductions:
"Life Style" acrylic 1965 EAAA
untitled AVD
untitled BFAA
untitled oil BDCAA(c)
untitled acrylic 1965 EAAA
untitled oil 1968 EAAA(c)
untitled acrylic 1970 EAAA(c)

HAZARD, BENJAMIN W., 1940- ; b. in Newport, RI; graphic artist,
painter, sculptor
Biographical Sources: AAA
Portrait: BAOA-1
Published Reproductions:
"Bird with Dead Mate" acrylic BAOA-1(c); ONPB
"Module Series 2" hanging sc 1970 BUNY
"Module Series II, Sweet Dreams" acrylic plastic 1974 LAAA(c)
"Self Portrait" acrylic BAOA-1(c)
untitled acrylic BAOA-1(c)

HECTOR, JUNE, 1938- ; painter
Biographical Sources: AAA
Portrait: DANA
Published Reproductions:
"Wild Flowers" oil 1958 DANA

HENDERSON, DION, 1941- ; b. in Detroit; painter
Biographical Sources: BAOA-2
Portrait: BAOA-2
Published Reproductions:
"Assassination" acrylic WJBS 1(3-77),29(c)
"In Memorial to Dr. Charles Drew" acrylic BAOA-2; WJBS 1
(3-77),29(c)
"React to White Actions for the Brothers and Sisters Murdered
Augusta, Jacksonville and Seattle" acrylic BAOA-2(c)

HENDERSON, NAPOLEAN; b. in Chicago; mixed media
Biographical Sources: AAA
Published Reproductions:
"Black Men We Need You" woven acrylic 1968 AWAP

HENDERSON, WILLIAM HOWARD (MIKE), 1943- ; b. in Mar-
shall, MO; painter
Biographical Sources: AAA; BAOA-2; LAAA; WCBI
Portrait: BAOA-2
Published Reproductions:
"Castration" oil 1968 BAOA-2(c); RAM 8(6-70),33(c)
"Catty Corner" acrylic 1976 OSAE
"Eastern Dreams" oil RAM 8(6-70),33(c)
"Feasting Dreams" oil RAM 82(6-70),34(c)
"The Great Masturbator" oil 1969 BAOA-2(c)
"Home" oil 1971 LAAA(c)
"Non Violent" oil 1968 BAOA-2(c); LAAA(c)
"Portrait of Hindu" oil (Oakland) WCBI
"Screaming" oil RAM 8(6-70),35(c)
"The Smile" oil DCBAA; RAM 8(6-70),34(c)
untitled oil 1970 (Oakland) ARTF 9(10-70),82
Further References:
Henderson, William, "Black Experience in Color," RAM 8(6-70),
33-5.

HENDRICKS, BARKLEY LEONARD, 1945- ; b. in Philadelphia;
painter
Biographical Sources: AA 40(7-76),34-9; AAA; WWAA,1978
Portrait: AA 40(7-76),34; BE 6(12-75),54

Published Reproductions:
 "Arriving Soon" oil,acrylic 1973 AA 40(7-76),34(c)
 "Bedroom Eyes" oil 1974 AA 40(7-76),34
 "Blood" oil,acrylic 1975 AA 40(7-76),35
 "Brother John Keys, Over" oil,acrylic 1971 AA 40(7-76),36
 "Brown Sugar Vine" oil 1970 DCBAA
 "Latin from Manhattan" 1981 AN 81(3-82),25; ART 56(3-82),30
 "Miss T." oil SA 70(11-70),30
 "Mr. Johnson (Sammy from Miami)" oil,acrylic 1972 AA 40
 (7-76),35
 "Napoleon" oil,acrylic 1972 AA 40(7-76),37(c)
 "New Michael" oil,acrylic AA 40(7-76),38(c)
 "Northern Lights" oil 1976 BC 11(10/11-80),102(c)
 "October's Gone: Goodnight" oil,acrylic 1974 AA 40(7-76),34;
 AIM 61(5/6-73),38
 "Sir Charles, Alias Willy Harris" oil,acrylic 1972 AG 16(5-73),
 85(c); NGR (1973),28
 "Slave" oil,acrylic AG 16(5-73),8
 untitled oil AN 75(5-76),109
 untitled BE 6(12-75),54(c)
 "Yocks" oil,acrylic 1974 AA 40(7-76),39(c)
Further References:
 Mangan, D., "Barkley Hendricks and His Figurative Drama," AA
 40(7-76),34-9.

HENRY, GREGORY, 1961- ; b. in Esequibo, Guyana; mixed media
 Biographical Sources: NGSBA
 Published Reproductions:
 untitled oil 1986 NGSBA(c)
 untitled oil 1986 NGSBA(c)
 untitled oil 1987 NGSBA(c)
 untitled oil 1987 NGSBA(c)
 untitled oil 1987 NGSBA(c)
 untitled wood,steel 1987 NGSBA(c)

HENRY, ROBERT; painter
 Published Reproductions:
 "Angela Davis" 1971 BCR 4(Fa-72),48

HERBERT, ERNEST, 1932- ; b. in Los Angeles; painter
 Biographical Sources: AAA; BAOA-2
 Portrait: BAOA-2
 Published Reproductions:
 "Black Anchor" acrylic BAOA-2
 untitled acrylic BAOA-2

HERRING, JAMES VERNON, 1887-1969; b. in Clio, SC; painter
 Biographical Sources: AAA
 Portrait: AJ 29(2-69),101
 Published Reproductions:
 "Campus Landscape" oil 1924 AARE 3(11/12-76),107(c); AIM
 65(3/4-77),64(c); AN 76(2-77),66(c); EB 32(2-77),12(c); ENC
 6(1-3-77),20(c); TCBAA(c)
 "Trees" woodcut 1956 BACW
 Further References:
 Green, Samuel L., "James Vernon Herring, 1887-1969," AJ 29
 (2-69),101.

HEWITT, MARK, 1919- ; b. in Barbados; graphic artist, painter
 Published Reproductions:
 "Spirit of the 366th" MA 36(5-43),190

HICKS, LEON N., 1933- ; b. in Deerfield, FL; printmaker
 Biographical Sources: AAA; BAOA-1; DIAA; WWABA,1978
 Portrait: BAOA-1; DIAA; ENC 5(11-8-76),33
 Published Reproductions:
 "Apogee" intaglio 1962 BAOA-1
 "Appalachian Sequela" intaglio 1967 AG 11(4-68),47;BAOA-1
 "Black Boy" intaglio 1961 BAQ 2(Sp-78),15; BAOA-1
 "Engraving VII" 1985 BAQ 7(#7-87),16
 "Little Bird" etching PANA
 "New Faces: Series I #2" intagio 1970 DIAA
 "New Faces: Series II #2" intaglio 1970 BAQ 6(#4-85),226; DIAA

HIGGINS, RENALDA; painter
 Published Reproductions:
 "Farming" CRI 85(5-78),cover(c)
 "Happy Days" CRI 85(11-78),cover(c)

HILL, HECTOR, 1934-1963; b. in New York City; painter
 Biographical Sources: AAA
 Published Reproductions:
 "Self Portrait" oil PKAU; TNAP

HINES, FELRATH, 1918- ; b. in Indianapolis, IN; painter
 Biographical Sources: AAA; CBAM; TCBAA
 Published Reproductions:
 "Morning" oil 1968 AG 13(4-70),28(c); CBAM
 "Sunburst" oil 1969 AAANB
 "Transition" oil 1953 TCBAA
 untitled oil 1964 AN 65(9-66),50

HINTON, ALFRED F., 1940- ; b. in Columbus, GA; painter
 Biographical Sources: WWABA
 Portrait: BANG
 Published Reproductions:
 "Imprisoned Landscape" oil BANG

HINTON, TIM; painter
 Biographical Sources: DENA
 Portrait: DENA
 Published Reproductions:
 "Agony of War" acrylic DENA

HOARD, ADRIENNE W.; b. in Jefferson City, MO; painter
 Biographical Sources: BAQ 2(Wi-78),50-1; EBSU
 Portrait: BAQ 2(Wi-78),48; FFAA
 Published Reproductions:
 "Africa at the Equator, Trip 1" acrylic 1972 BAQ 2(Wi-78),52(c)
 "Aurora" acrylic 1974 BAQ 2(Wi-78),53(c); FFAA(c)
 "Love Portrait" acrylic 1977 BAQ 2(Wi-78),49(c)
 "Passion's Dream Flower" oil,pastel NAE 13(4-86),21A(c)
 "Sun Ship" acrylic 1975 BAQ 2(Wi-789,49(c)
 "Sunrise on the Gold Coast" acrylic EBSU

HOBBS, G.W.; active in Baltimore in 1780s; painter
 Biographical Sources: AAA; FAAA; LAAA; NYDA
 Published Reproductions:

"Richard Allen" pastel 1785 (Howard) DANA; EB 28(9-73),52;
 FAAA; LAAA; PMNA

HOFFMAN, IRWIN, 1901- ; painter
 Published Reproductions:
 "Joe" oil AN 44(10-15-45),19
 "Mine Tragedy" oil EOA
 "Young Indian Artists" oil DIAMP
 Further References:
 Salpeter, Harry, "About Irwin Hoffman," COR 4(10-38),25-8.

HOLBERT, RAYMOND; b. in Berkeley, CA; mixed media
 Portrait: CACE
 Published Reproductions:
 "Lace and Olives" pencil 1985 CACE(c)

HOLDER, GEOFFREY LAMONT, 1930- ; b. in Port-au-Spain,
 Trinidad; painter
 Biographical Sources: AAA; WWABA
 Portrait: AA 53(11-89),38
 Published Reproductions:
 "Flowers" colored pencil 1986 AA 53(11-89),42(c)
 "Man in Water" pencil 1985 AA 53(11-89),40(c)
 "St. Lucian Women" oil SR 51(9-14-68),cover(c)
 "Tempo" oil 1963 BC 3(5/6-73),27; ESS 2(4-72),66(c); ESS4
 (11-73),22(c); ESS 4(12-73),29(c)
 untitled oil ESS 4(12-73),68
 "Veiled Women" pencil 1986 AA 53(11-89),43(c)
 "Woman in the Yellow Dress" oil AA 53(11-89),41(c)

HOLDER, ROBIN, 1952- ; b. in Chicago; mixed media
 Biographical Sources: BALF 19(Sp-85),14-15
 Published Reproductions:
 "Approach, 9" monoprint 1984 BALF 19(Sp-85),15

HOLLEY, LONNIE, 1950- ; b. in Birmingham, AL; mixed media
 Biographical Sources: NGSBA
 Published Reproductions:
 "Chains of a Dummy's Body" mixed media 1984 NGSBA(c)

"The Inner Suffering of the Holy Cost" mixed media 1988
 NGSBA(c)
"The Music Lives After the Instrument Is Destroyed" mixed
 media c1984 NGSBA(c)
"The Spirit of Man by the Chicken House Door" mixed media
 1987 NGSBA(c)

HOLLINGSWORTH, ALVIN C., 1928- ; b. in New York City;
 painter
Biographical Sources: AAANB; FAAA; LAAA; WWAA,1991
Portrait: AA 28(6-64),68; AN 65(9-66),48; BAOA-2; BAQ 2
 (Fa-77),5; DANA
Published Reproductions:
 "Attack at Dawn" litho 1967 AIM 56(3/4-68),104
 "Black Madonna" acrylic,collage AAANB
 "Blue Composition #2" BAQ 2(Fa-77),17
 "City Images" pen,ink DANA
 "Cry City" construction AAAC; AN 65(9-66),50
 "Cry City #2" AG 13(4-70),22(c); BC 3(5/6-73),27(c); ESS 4
 (11-73),22(c); ESS 4(12-73),29(c)
 "The Dancer" casein AA 28(6-64),73
 "Dream the Impossible Dream" litho 1967 AIM 56(3/4-68),104
 "Duo" litho 1967 AIM 56(3/4-68),104
 "Endless Summer" oil AG 11(4-68),21(c)
 "Eternal Question" slate assemblage BAQ 2(Fa-77),11(c)
 "Family Group" oil AA 28(6-64),71
 "Family Tree" litho BAQ 2(Fa-77),13
 "Family Tree" assemblage BAOA-2
 "Family Tree Rex" oil BAQ 2(Fa-77),10(c)
 "Flower Girl" DANA
 "Hallejah" BAQ 2(Fa-77),15(c)
 "Harbor" AAAC
 "Harlequin" litho AA 28(6-64),70
 "High School of Art and Design" pen,ink AA 28(6-64),72
 "Inner Reflections" oil,collage 1973 FAAA
 "The Loft Studio" ink AA 28(6-64),72
 "Lonely Boys" oil,collage 1964 AIS 5(Fa/Wi-68),409
 "Lonely Woman" woodcut AA 28(6-64),69(c); PANA
 "Love" BAQ 2(Fa-77),cover(c); BAQ 2(Wi-78),72(c); BAQ 2

(#3-78),56(c); BAQ 2(#4-78),69(c); BAQ 3(#1-79),64(c)
"Memorable Wall" oil,acrylic assemblage c1964 LAAA(c)
"Mogul's Wife" oil,acrylic 1965 CBAM
"Mother and Child" oil BAQ 2(Fa-77),9
"Observing the Monster" litho 1967 AIM 56(3/4-68),104
"Pilgrim's Progress" oil BAQ 2(Fa-77),14(c)
"Place in the Sun" 1969 FUF
"The Prophet" acrylic BAQ 2(Fa-77),7(c); EB 26(4-71),177
"Reflection No. 2" mixed media ILAAL
"Seascape" print AA 28(6-64),68
"Tomorrow" oil BAQ 2(Fa-77),12
"Trio" litho 1967 AIM 56(3/4-68),104
"Upward" oil 1975 AG 18(4-75),39
"View of the City" litho 1967 AIM 56(3/4-68),104
"Waiting" pen,ink DANA
"Why: Black Guernica" oil,acrylic collage AI 13(10-69),77;FAAA
Further References:
 Coombs, Orde, "Al Hollingsworth: Portrait of the Artist as a
 Believer," ESS 1(2-71),50-1.
 "The Themes of Alvin C. Hollingsworth," BAQ 2(Fa-77),4-17.

HOLMES, EDDIE, 1948- ; b. in Newark, NJ; painter
 Biographical Sources: AAA
 Published Reproductions:
 "Mood of Anguish" oil NBAT

HONEYWOOD, VARNETTE, 1950- ; b. in Los Angeles; painter
 Biographical Sources: LAAA
 Portrait: ESS 14(8-83),97
 Published Reproductions:
 "African Woman" acrylic BAQ 1(Sp-77),47
 "African Women" oil ESS 14(8-83),97(c)
 "Big Meeting" acrylic BAQ 3(#4-79),61(c)
 "Birthday" acrylic BAQ 2(#3-78),64
 "Dixie Peach" acrylic BAQ 2(#3-78),64(c)
 "The Family" AV 5(10-90),38(c)
 "From Sun to Sun" acrylic BAQ 1(Sp-77),48
 "Gossip in the Sanctuary" acrylic 1974 BAQ 1(Sp-77),46; LAAA
 (c)

"Jesus Loves Me" oil ESS 14(8-83),99(c)
"Old Fashioned Dinner Party" acrylic AV 2(12-87),20(c)
"Preacher's Pet" acrylic 1978 FFAA(c)
"Rapstreet" acrylic 1979 AV 2(10-87),45(c); BAQ 3(#4-79),61(c)
"Tub, Saturday Night" acrylic ABWA; BAQ 2(Sp-78),64(c)
Further References:
 Honeywood, Stephanie, "Varnette Honeywood; Art that Hits
 Home," ESS 14(8-83),97-99.

HOOKS, EARL J., 1927- ; b. in Baltimore, MD; painter
Biographical Sources: AAA; FSBA; LAAA; TCBAA; WWAA,1991
Portrait: FSBA; RCAF
Published Reproductions:
 "Bird Form" sc FSBA
 "Branch Vase" ceramic sc 1973 RCAF
 "Contemporary Commentator" ceramic sc 1974 RCAF
 "Female Torso #2" polyester sc 1968 LAAA
 "Head of Girl" ceramic sc FSBA
 "Louis Armstrong" clay plaque DANA
 "Man of Sorrows" marble sc 1950 (Fisk) TCBAA
 "Maternal Family" ceramic sc 1973 RCAF; SMIH 2(4-75),2

HORNER, RAY, JR., painter
Published Reproductions:
 "Family I" AV 2(12-87),24(c)

HOUZELL, PAUL; b. in Bambridge, GA; painter
Portrait: BC 19(#1-88),132
Published Reproductions:
 "Blind Drummer" oil BC 19(#1-88),132(c)
 "Kay Futrell" oil 1979 BC 19(#1-88),132(c)
 "Ladmixa in Gold" oil 1987 BC 19(#1-88),131(c)

HOWARD, HELENA; painter
Biographical Sources: DENA
Portrait: DENA
Published Reproductions:
 "Flamingos from Florida's Everglades" oil DENA

HOWARD, HUMBERT L., 1915- ; b. in Philadelphia; painter
 Biographical Sources: BAOA-2; WWAA,1978;
 Portrait: EB 18(9-63),132
 Published Reproductions:
 "Black Orpheus" oil collage BAOA-2(c)
 "Show Girl" oil DANA
 "Two Figures" oil collage BAOA-2(c)
 "Women Dressing" oil TEAAA
 "The Yellow Cup" oil 1950 (Pennsylvania) DANA
 Further References:
 "Leading Negro Artists," EB 18(9-63),132

HOWARD, JOHN M., 1912- ; b. in Alcorn, MS; painter
 Biographical Sources: AAA
 Portrait: DANA
 Published Reproductions:
 "Arkansas Landscape" oil 1950 DANA
 "Girl with Violin" oil ILAAL
 "Still Life" oil EB 1(7-46),49
 "The Violin" oil 1961 ILAAL

HOWARD, MILDRED; mixed media
 Biographical Sources: EANE
 Portrait: EANE
 Published Reproductions:
 "Chocolate Hearts and Mo Chocolate Hearts" collage 1978 BAQ
 2(#4-78),59
 "Memory Garden: Phase II" installation 1990 EANE(c)

HOWELL, RAYMOND, 1927- ; b. in Oakland, CA; mixed media,
 painter
 Biographical Sources: AAA
 Portraits: BAOA-1
 Published Reproductions:
 "The Brown Painting" oil BAOA-1(c)
 "From a Great Past" oil BAOA-1
 "Social Readjustment" oil BAOA-1

HOWELL, WILLIAM L. (BILL), 1942- ; b. in Jefferson City, TN;
 mixed media, painter
 Biographical Sources: AAA; AAANB
 Portrait: NBA
 Published Reproductions:
 "Black Family" woodcut BSH 2(3-72),3; BT (#4-70),3
 "Dream of a New Coming" mixed media 1968 AAANB
 "From Whence We Came" ABA 1(#1-72),2
 "Meditation" mixed media 1969 NBA
 "Thinking" mixed media 1969 NBA
 untitled mixed media 1969 NBA
 "We Are Africans" ink BT (#4-70),26

HUBBARD, CALVIN; muralist
 Published Reproductions:
 "Space Adventure" Houston mural BAIH(c)

HUDSON, HENRY MERCIER, 1908- ; b. in Lumkin, GA; painter
 Biographical Sources: AAA
 Published Reproductions:
 "Hannibal the Carthaginian" oil OPP 15(2-37),58

HUDSON, JULIEN; active in New Orleans in 1830s-1840s; painter
 Biographical Sources: LAAA; TCBAA
 Portrait: AAAC; PMNA
 Published Reproductions:
 "Colonel Jean Michel Fortier, Jr." oil 1838 (Louisiana) AAAC;
 DANA; FAAA; PMNA
 "Maid of the Douglas Family" oil c1840 PTS
 "Self-Portrait" oil c1839 (Louisiana) AAAC; DBLJ; FAAA;
 LAAA; PMNA; TAAP; TCBAA

HUFF, JAMES; b. in Elberton, GA; painter
 Portrait: ENC 5(10-18-76),32
 Published Reproductions:
 "Mother of Civilization" mixed media ENC 5(10-18-76),33
 Further References:

Andrews, Benny, "The Huffs, Pilgrims Who Search and Find," ENC
 5(10-18-76),32-3.

HUGHES, MANUEL, 1938- ; b. in Forrest City, AR; painter
 Biographical Sources: AAA; WWAA,1978
 Portrait: AJ 31(3-72),330; BAOA-1
 Published Reproductions:
 "The Chitlin Eater" oil 1969 LAAA
 "Group One" oil 1970 DCBAA
 "Study for Man #4" oil 1973 BUNY
 "Thrice Light" mixed media 1976 CGB
 untitled oil 1972 BAOA-1
 Further References:
 Andrews, Benny, "Manuel Hughes Paints the Subtleties," ENC 6
 (2-21-77),34.

HUMPHREY-MCDANIEL, MARGO, 1942- ; b. in Oakland,CA;
 painter, printmaker
 Biographical Sources: LAAA; WCBI
 Portrait: BAOA-1; FFAA
 Published Reproductions:
 "Checkin Out Pink and Yellow" litho 1974 BAQ 2(Sp-78),23(c)
 "The History of Her Life Written Across Her Face" pen,graphite
 1989 BABC
 "I'm Not Really Listening" litho BAOA-1(c); BAQ 6(#4-85),33(c)
 "Louis XV Versus Making Do" litho WCBI
 "The Marble Box" litho 1977 FFAA(c)
 "New Garden" oil BAOA-1
 "The Night Kiss" litho 1985 YTCW
 "A Second Time in Blackness" litho BAOA-1; LAAA; ONPB
 "Some Fields Have More Flowers than Grass" litho BAOA-1(c);
 ONPB
 untitled litho BAOA-1(c)
 untitled litho BAQ 6(#4-85),33(c)

HUNT, RAYMOND, 1947- ; b. in Montclair, NJ; painter
 Biographical Sources: NBAT
 Portrait: AJ 31(Sp-72),330

Published Reproductions:
"May Follows" oil 1971 NBAT

HUNT, RICHARD H., 1935- ; b. in Chicago; painter, printmaker,
 sculptor
Biographical Sources: BDCAA; GNNP3; TNAP; WWAA,1991
Portrait: EB 18(9-63),131; SEP 28(7-79),58; WCSS
Published Reproductions:
 "Active Hybrid" bronze 1983 EWCA(c)
 "Active Hybrid II" bronze sc 1984 AIM 74(4-86),98(c)
 "Arachne" welded steel sc 1956 (Modern Art) DANA; FAAA;
 PSMOMA
 "Bridge Across the Beyond" bronze sc 1978 BAQ 6(2-84),30
 "Bridge/Branching" cast bronze sc 1986 (Bronx) AIM 78(3-90),
 167(c)
 "Bronx Build" steel 1981 ART 58(3-84),29
 "Chase" welded steel sc 1965 AG 14(5-71),59; AI 13(10-69),77;
 ART 45(5-71),54; FAAA
 "Chase, 2nd Version" sc AN 68(Su-69),20
 "Construction" bronze and steel 1958 AMSG; ART 33(11-58),55
 "Construction" steel sc 1964 LAAA
 "Construction D" cottonwood and steel sc c1956 FAAA
 "Construction with Branching Forms" sc JET 19(4-61),31
 "Dynamic Pyramid" bronze sc 1974 CS
 "Eagle Columns" aluminum,bronze BAQ 7(2-87),22
 "Expansive Construction" sc 1972 CS; EB 29(12-73),37(c); EB
 33(10-78),162(c)
 "Extended Form" welded steel sc 1960 AIM 59(5-71),130
 "Extended Landform" cor-ten steel sc 1975 AN 75(2-76),116;
 ART 52(1-78),33
 "Extending Horizontal Form" steel sc 1958 (Whitney) AIPP
 "Extensions" litho 1983 AAATC(c)
 "Field Section" welded steel sc 1972 AG 18(Su-74),29
 "Figure" sc ART 35(12-60),53
 "Flyaway: Etoria" bronze 1987 AN 87(3-88),52
 "Form Carried Aloft, No. 2" bronze sc CMUB 49(11-62),289;
 CMUB 50(10-63),238; CMUB 57(4-70),123
 "Fox Box Hybrid" cor-ten sc 1979 CS
 "Fragmented Figure Construction" welded steel sc CMUB 57

(1-70),26; CMUB 57(1-70),26; CMUB 57(4-70),123
"Freedman Column" cast bronze 1986 BAQ 7(#2-87),19(c)
"From Here to There" steel sc CS
"Glider" welded aluminum sc 1966 ARTF 4(6-66),57
"Hero Construction" steel sc 1958 AN 57(11-58),19; DANA
"I Care" sc SIE 22(12-60),8
"I Have Been to the Mountain" cast bronze BAQ 6(#2-84),29;
 BAQ 7(#2-87),18(c)
"Icarus" welded steel sc 1956 FAAA; SIE 22(12-60),88
"Iceberg" steel 1982 AIM 72(4-84),86
"Insects" aluminum sc 1964 AI 13(10-69),77
"Jacob's Ladder" bronze sc 1977 AIM 73(4-85),100(c); CS
"John Jones" aluminum sc 1969 EB 24(4-69),82
"Large Hybrid" cast aluminum 1971 AN 78(2-79),45; CS; WCSS
 (c)
"Linear Spatial Theme" welded steel sc 1962 CMUB 57(4-70),
 126; FAAA
"Man on a Vehicular Construction" metal sc 1956 DANA; FAAA
"Medium Expansive Construction" metal sc ART 33(6-59),50
"Minor Monument, No. 1" welded steel sc 1963 AIM 52(8-64),63
"Minor Monument, No. 4" metal sc ARTF 3(2-65),39
"Multipedal Peregrination" welded steel sc AN 62(4-63),50
"Natural Form, No. 1" welded steel sc 1969 AG 13(4-70),28
 AJ 29(Fa-69),72; AN 67(Su-68),15; AP 96(8-72),104; FAAA
"Natural Form with Mountainous Section" welded steel 1965
 STHR
"Opposed Forms" sc AN 70(11-71),45
"Organic Construction" welded steel sc 1962 ARTF 9(6-71),88
"Organic Construction, No. 10" welded steel sc 1961 ASP
"Outgrowth" welded aluminum sc 1965 AG 11(4-68),38; HW 3
 (3rdQ-68),14
"Peregrine Forms" welded steel sc 1965 MMB 29(10-70),101
"Play" metal sc 1969 RD 112(6-78),185(c)
"Pointed Forms" welded steel sc 1966 SA 68(4-69),26
"Rock Form" welded aluminum sc 1966 ARTF 15(10-76),69
"Romance" welded steel 1975 ADMC
"Running Hybrid" steel sc 1965 ANA 4(5-69),17; AAAC
"Sea Wall" sc CS
"Sky Form II" metal sc 1957 AIM 46(9-58),15; AJ 31(Fa-71),93

"Slabs of the Sunburnt West" bronze sc CS
"Soaring Interchange" steel sc 1985 AN 88(3-89),64
"Standing Figure" welded steel sc 1956 FAAA
"Tube Form IV" metal sc ART 36(4-62),53
untitled steel construction LAAA
untitled pencil drawing (Golden State) BAQ 1(Wi-76),21
untitled sc AN 76(12-77),52
untitled litho PANA(c)
untitled litho 1969 AIM 58(11-70),12
untitled sc ARTF 6(5-68),20
untitled sc SEP 28(7-79),58
untitled sc SEP 28(7-79),61
untitled serigraph 1980 BAQ 7(#4-87),22(c)
"Wall Piece With Extending Forms" metal sc AN 59(12-60),53
"Why?" bronze sc 1974 BAQ 6(#2-84),21; BAQ 7(#2-87),20;
 LAAA
"Wing Forms" steel sc 1963 MAS
Further References:
"He Seeks the 'Soul' in Metal," EB 24(4-69),80-2.
"Richard Hunt," SR 58(11-15-75),16
Sykes, Leonard, "The Sculptor Who Draws in Space with Steel,"
 SEP 28(7-79),58-61.

HUNTER, CLEMENTINE, 1880-1988; b. in Natchitoches, LA;
 painter
Biographical Sources: AAA; TCBAA; TCNL
Portrait: FFAA; TCNL
Published Reproductions:
"Angels with Horns" WAJ 8(Sp/Su-87),24
"Baptizing" 1970 CLA 10(Fa-85),61
"Black Crucifixion" c1955 ANT 124(9-83),52
"Christ on the Cross" oil EB 24(5-69),146(c)
"Combing Her Hair 1945 CLA 10(Fa-85),45
"Cotton Ginning" oil 1975 TCBAA
"Cotton Picking" oil AV 3(10-88),28(c); WAJ 8(Sp/Su-87),23
"Crucifixion" oil 1967 DBLJ
"Funeral" oil c1960 AFATC(c); AV 3(10-88),27(c)
"The Funeral on Cane River" oil 1948 ANA 11(10-76),17; EB 32
 (2-77),35(c); MS 5(1-77),27(c); TCBAA(c)

"Gathering Gourds" oil BFPA
"Going to the Cotton Gin" oil 1960 AV 3(10-88),26(c)
"Grandfather" oil EB 24(5-69),146(c)
"Louisiana Syrup Makers" watercolor 1965 TCAFA
"Melrose Plantation" fabric 1940 BC 8(5/6-78),38(c)
"Man in Dress Going to a Party" oil 1945 AV 3(10-88),29(c)
"Nativity Scene" oil 1975 FFAA(c)
"New Baby" c1942 CLA 11(Wi-86),63
"Saturday Night" oil EB 24(5-69),145(c); WAJ 8(Sp/Su-87),25
"Two Nuns and a Priest" oil c1945 AV 3(10-88),28(c)
"Uncle Tom" EB 24(5-69),145(c)
untitled oil ENC 5(2-2-76),30
untitled sc EB 24(5-69),145(c)
"Wash Day" WAJ 8(Sp/Su-87),27
"Zinnias" oil CLA 13(Su-88),11(c)
"Zinnias, Looking at You" oil c1960 AV 3(10-88),27(c)
Further References:
 "The Primitive Art of Clementine Hunter," EB 24(5-69),144-8.
 Petterson, Diana, "Clementine Hunter: Pictures in My Mind,'" AV
 3(10-88),26-29.
 Rankin, A., "Hidden Genius of Melrose Plantation," RD 107
 (12-75),118-22.

HUNTER, ELLIOTT; muralist
Published Reproductions:
 "Wall of Dignity" Detroit mural FAAA(c); TNAP

HURLEY, ARNOLD, 1944- ; b. in Boston; painter
Biographical Sources: AAA
Published Reproductions:
 "Frederick Douglass" acrylic 1976 BAQ 8(#2-88),50(c)
 "Roland Hayes" oil 1977 BAQ 8(#2-88),51(c)

HUTSON, BILL, 1936- ; b. in San Marcos, TX; painter
Biographical Sources: AAA; FAAA
Published Reproductions:
 "Day One/Day Twenty" acrylic 1988 ICAA
 "Object at the Crossroads" painted cloth c1969 STHR

"Saga of the First Creation Crossing a Bone Path North by North-
east" oil 1971 (Newark) FAAA; NBAT

INGRAM, ZELL, 1910- ; b. in Cleveland; painter
Biographical Sources: AAA; AAANB
Published Reproductions:
"Nu Assis" oil 1965 SIE 35(12-70),192
"Seated Nude" oil 1965 AAANB; NBAT
"Workers" oil OPP 9(4-31),113

IRONS, SUE, 1943- ; b. in Chicago; sculptor
Biographical Sources: AAA
Published Reproductions:
"Chant" mixed media 1977 CGB
"I" installation 1977 CGB
"Inside/Outside" mixed media 1977 CGB
"Internal I" mixed media 1977 CGB
"Internal II" installation 1977 CGB
"Swing Low" installation 1977 CGB
"Water Composition 4" construction AI 15(6-20-71),35

JACKSON, A.B.(ALEXANDER BROOKS), 1925- ; b. in New Ha-
ven, CT; painter
Biographical Sources: WWAA,1978
Portrait: AA 32(2-68),46
Published Reproductions:
"The Beginner" charcoal AA 32(2-68),46
"Early American Porch People" sepia AIM 54(11/12-66),6
"Eastern Morn" sepia,chalk AA 32(2-68),49
"Minus Two" polymer AA 32(2-68),51
"Passerby/Through Leaded Windows" 1979 AA 44(11-80)
"Peanut Lady" chalk,charcoal AA 32(2-68),48
"Peanut Seller" charcoal AA 32(2-68),50
"Porch Cathedral" oil AA 32(2-68),49
"Porch People" oil AA 32(2-68),49
"Porch People Study" charcoal AA 32(2-68),51
"Seated Woman" oil AA 32(2-68),48
"Study" charcoal AA 32(2-68),50
"Veronica's Veil" oil AA 32(2-68),47

"Watching Sunday Go By" oil AA 32(2-68),48

JACKSON, GERALD, 1936- ; b. in Chicago; painter
Biographical Sources: AAA
Published Reproductions:
 "Duocoin Tapestry" oil 1969 AAANB
 "136 -- In Three Parts" latex 1971 NBAT

JACKSON, HARLAN, 1918- ; b. in Cleaburne, TX; painter
Biographical sources: AAA
Published Reproductions:
 "The Flight of the Eyes" oil 1951 BACW

JACKSON, HIRAM E., JR.; painter
Biographical Sources: AAA
Published Reproductions:
 "General Daniel 'Chappie' James, Jr." oil ENC 6(12-27-78),24
 (c); ENC 7(6-78),44(c)

JACKSON, MAY HOWARD, 1877-1931; b. in Philadelphia; sculp-
 tor
Biographical Sources: AAA; LAAA; MIAP; TNAP
Published Reproductions:
 "Brotherhood" sc CRI 17(4-19),cover
 "Bust of a Young Woman" plaster sc (Howard) AWSR
 "Dean Kelly Miller" plaster sc (Howard) DANA; LNIA; NHB 2
 (3-39)52; SW 58(4-29),168
 "Francis J. Grimke" plaster sc CRI 4(6-12),67; PMNA
 "Head of a Negro Child" marble sc 1916 ATO; LNIA
 "Paul Laurence Dunbar" sc 1919 ATO
 "Suffer Little Children to Come unto Me" sc AIS 5(Su/Fa-68),
 260
 untitled sc CRI 9(2-15),168
Further References:
 Holbrook, Francis," A Group of Negro Artists," OPP 1(7-23),211-
 13.

JACKSON, OLIVER L., 1935- ; b. in St. Louis; painter
Biographical Sources: AAA; WCBI; WWAA,1991

Portrait: CPNW
Published Reproductions:
"Black Tornado" 1981 ART 57(6-83),67(c)
"Blessing III" AW 13(10-16-82),5
"Sharpeville No. 10" acrylic WCBI
untitled OSAE
untitled ART 54(6-80),82(c)
untitled ARTF 19(11-80),110
untitled AIM 72(4-84),62(c); AN 83(4-84),26; AW 15(3-31-84),7
untitled #2 1985 AN 84(10-85),22(c)
untitled #3 AIM 67(10-79),133(c)
untitled #4 marble sc 1983 AIM 78(3-90),168(c); ARTF 17
 (Su-79),55(c)
untitled #7 oil,enamel SFMA
untitled #8 1985 FA #125(12/1-85/86),47
untitled wood,mixed media AV 1(11/12-86),27(c)
untitled 1978 AIM 72(10-84),46(c); AIM 72(Su-84),59(c); AW 15
 (10-27-84),12
untitled #11 enamel,canvas 1979 AW 13(10-23-82),1; TFYA
untitled oil 1986 CPNW(c)
untitled oil 1987 CPNW(c)

JACKSON, ROBERT M.; painter
Biographical Sources: AAA
Portrait: OPP 19(1-41),23
Published Reproductions:
"Barbara" oil OPP 18(8-40),cover
"Richmond Barthe" oil OPP 18(7-40),cover
"Woman in Red Hat" oil CRI 47(3-40),92
Further References:
"Our Cover Artist," OPP 19(1-41),23.

JACKSON, SUZANNE F., 1944- ; b. in St. Louis; painter
Biographical Sources: BAOA-2; LAAA; WCBI; WWAA,1991
Portrait: ACW; BAOA-2; DIAA; ENC 4(4-7-75),24
Published Reproductions:
"And When I Wake Up" acrylic BAQ 4(#3-80),9
"Animal" acrylic 1974 ACW; BAQ 4(#3-80),6(c)
"Apparitional Visitations" acrylic wash WCBI

"Baby Again" pencil 1981 NACA
"El Paradiso" acrylic 1984 NACA
"Escaped" acrylic wash 1970 BAOA-2; LAAA
"Grandparents" acrylic wash 1970 BAOA-2; LAAA
"Horse" acrylic BAQ 4(#3-80),15(c)
"Kiss Me" acrylic 1974 BAQ 4(#3-80),19(c); FFAA(c)
"Mae-Game" acrylic 1973 DIAA
"Malagasy" mixed media BAQ 4(#3-80),11(c)
"Mountain" acrylic AIM 64(7-76),21(c); BAQ 4(#3-80),14(c)
"Not Everything We See Is Real" acrylic 1969 BAQ 4(#3-80),4;
 NACA(c)
"Old Virgin's Vision" acrylic wash 1973 BUNY
"Ornithological Delicatessen" acrylic 1973 DIAA
"Passages" acrylic gouache AW 10(10-13-79),16; BAQ 3(#3-79),
 58(c)
"Shango, He Is My Love" acrylic 1972 ACW
"Spirit" Los Angeles mural BAQ 4(#3-80),cover,3(c)
"Splash" acrylic 1976 CGB(c)
"Talk" mixed media BAQ 4(#3-80),10(c)
"Things" pencil 1986 NACA
untitled acrylic wash BAOA-2
"Windsong" acrylic 1974 BAQ 4(#3-80),18(c)
"Witches, Bitches and Loons" acrylic 1972 BAQ 4(#3-80),7(c)
Further References:
 "Creating Her Own World," AN 73(11-74),38.

JACKSON, WALTER, 1940- ; b. in Holmes County, MS; sculptor
Biographical Sources: FAAA
Published Reproductions:
 "Lapis II" steel,plastic and light 1970 FAAA

JACKSON, WILLIAM; painter
Published Reproductions:
 "Numana" BC 7(1/2-77),33(c)

JACKSON-JARVIS, MARTHA, 1952- ; b. in Lynchburg, VA;
 mixed media
Biographical Sources: EWCA
Published Reproductions:

"Across the Universe and Back in the Blink of an Eye" acrylic
 1988 NGSBA(c)
"Arc of the Southern Sun" ceramic,wood 1989 NGSBA(c)
"Friend to Small Animals" acrylic 1987 NGSBA(c)
"Moon Dance" 1984 EWCA
"Path of the Avatar/Spiraling Passages" mixed media 1984 AV 2
 (6-87),19(c); SMI 18(5-87),188(c)
"Time Gatherer" clay,copper 1988 BABC(c)
"Time Gatherers VII" 1988 ICAA(c)

JAMES, BOB; painter active in the 1970s
 Published Reproductions:
 "Kojo" woodcut 1971 NBAT

JARRELL, WADSWORTH A., 1931- ; b. in Albany, GA; painter
 Biographical Sources: AAA; DIAA
 Portrait: DIAA
 Published Reproductions:
 "Coolade Lester" acrylic BW 19(10-70),82
 "Identity" acrylic 1974 BAQ 1(Fa-76),14(c)
 "Malcolm" acrylic 1971 DIAA
 "Revolutionary" acrylic 1971 DIAA

JASMIN, JOSEPH, 1923- ; b. in Haiti; painter
 Biographical Sources: BACW
 Published Reproductions:
 "Funerailles" oil BACW

JEFFERSON, ARCHIE; active in the 1970s; illustrator, painter
 Published Reproductions:
 "Mantantalus" ILAAL

JEFFRIES, ROSALIND, 1938- ; b. in New York City; painter
 Biographical Sources: BANG; BAOA-2; EBSU; WWABA
 Portrait: BANG; BAOA-2
 Published Reproductions:
 "Composition No. 3" charcoal ILAAL
 "Masks" BAQ 2(Wi-78),60(c); BC 7(3/4-77),39(c)

"Rebirth" oil BANG
untitled oil BAOA-2(c)

JEMISON, NOAH; painter
Published Reproductions:
"Divorce" 1977 CGB(c)
"A Feast of Liberty for the South African" encaustic BC 15
(11/12-84),44(c)
"The Mythological Allegory of the Real Chumpy-Do" 1977 CGB(c)
untitled composition ART 59(5-85),51(c)
"Walking Through the Universe" 1977 CGB

JENKINS, BARBARA FUDGE, 1942- ; b. in Newark, NJ; mixed
media; painter
Biographical Sources: AAA
Published Reproductions:
"Corridors" mixed media 1968 NBAT

JENKINS, FLORIAN, 1940- ; b. in Newark, NJ; painter
Biographical Sources: AAA
Published Reproductions:
"The Wonder of It All" conte crayon 1970 NBAT

JENNINGS, CHESTER; painter
Biographical Sources: DENA
Portrait: DENA
Published Reproductions:
"Practice Tee" acrylic 1972 DENA

JENNINGS, VENDA SEALS; painter
Biographical Sources: AAA; DENA
Portrait: DENA
Published Reproductions:
"Ms" oil DENA

JENNINGS, WILMER ANGIER, 1910- ; b. in Atlanta, GA; painter,
printmaker
Biographical Sources: AAA; ATO; MIAP; TCBAA
Portrait: ATO

Published Reproductions:
"Corner Light" litho 1935 LNIA
"De Good Book Says" linocut 1931 NA; NAHF; TCBAA
"Dead Tree" print c1946 (Atlanta) DANA
"Going Home" litho 1937 LNIA
"Head of a Girl" oil OPP 12(6-34),cover
"Hill Top House" woodcut 1939 BAQ 6(#4-85),9; LNIA
"The Land" woodcut 1937 DANA
"Landscape" oil ATO(c)
"Sanctuary" linocut 1946 (National Center) ATO
"Still Life" woodcut NBAT
"Still Life" woodcut 1937 LNIA
"Still Life" woodcut 1937 (Newark) ATO
"Storm Tree" woodcut 1946 (National Center) ATO
"Tug Boat" woodcut 1938 (National Center) ATO

JESSUP, GEORGIA MILLS, 1926- ; b. in Washington, DC;
painter, sculptor
Biographical Sources: AAA; DENA; WWABA,1978
Portrait: DENA
Published Reproductions:
"Carnival City" acryllic collage DENA

JOHANA, 1946- ; painter
Portrait: BAQ 3(#4-79),55
Published Reproductions:
"Creation" BAQ 3(#4-79),55
"Wonderland" BAQ 3(#4-79),55

JOHNSON, DANIEL LARUE, 1938- ; b. in Los Angeles; painter,
sculptor
Biographical Sources: AAANB; PKAU; TNAP; WWAA,1978
Portrait: TIM 97(4-12-71),64
Published Reproductions:
"Angel Spirit" steel,aluminum 1984 EWCA(c)
"Big Red" oil 1963 LAAA(c); DBLJ
"The Boy Wonder Dejohnette" oil 1969 AAANB; ART 44
(Su-70),32; FAAA
"Death of Tarzan" oil AG 13(4-70),22(c)

"Freedom Now, No. 1" assemblage 1963-4 PSMOMA
"Homage" oil SEP 18(3-69),50
"Homage to Rene d'Harnoncourt" sc 1968 FAAA; LOO 33
 (1-7-69),66(c)
"Over Here, Over There" mixed media 1970 SAH(c)
"Past Time" oil BAQ 1(Wi-76),15(c)
"Study" AIM 69(5-81),192(c)
"United States with Hole in Seattle and Midwest" clay AC 41
 (10/11-81),65
untitled 1961 PSIC
untitled wood,clay 1961 (SFMMA) SFMA
"Wendell" LOO 33(1-7-69),68
"Yesterday" oil 1970 ARTF 2(Su-64),39; FAAA; HCPT; LOO
 33(1-7-69),67
Further References:
 "Black Artists in a White Art World," LOO 33(1-7-69),66-9.

JOHNSON, ENID T.; painter
Biographical Sources: DENA
Published Reproductions:
 "Winter Night" acrylic DENA

JOHNSON, GRACE MOTT; active in the 1920s; sculptor
Biographical Sources: AAA
Published Reproductions:
 "Elephants" bas-relief AMA 14(2-23),59
 "Horses" sc AMA 14(2-23),61
 "Old Lion" sc AMA 14(2-23),61
Further References:
 "A Sculptor of Animals," AMA 14(2-23),59-61.

JOHNSON, HARVEY L.; muralist, sculptor
Published Reproductions:
 "Harvest" Houston mural 1971 BAIH(c)
 "Time to Reap and a Time to Sow" charcoal BAIH

JOHNSON, HERBERT; b. in Syracuse, NY; painter
Biographical Sources: EBSU
Published Reproductions:

"Brother's Ice Cream" oil BC 20(#4-90),180(c)
"The Direction" mixed media 1968 ONPB
"Girls at Play" oil BC 20(#4-90),180(c)
"Inferno Forest" oil BC 20(#4-90),180(c)

JOHNSON, JEANNE, 1940- ; b. in New York City; painter
Published Reproductions:
"Bobby" oil 1970 BCR 1(Fa-71),16; NBAT

JOHNSON, MALVIN GRAY, 1896-1934; b. in Greensboro, NC;
painter
Biographical Sources: BACW; LAAA; MIAP; TCBAA; TNAP
Portrait: NAHF
Published Reproductions:
"All Day Meeting--Dinner on the Ground" oil 1934 NAE 14
(6-87),28
"Arrangement" oil c1933 (Fisk) LAAA
"Arrangement--Still Life" oil 1934 (Clark) ATO
"The Bakers" watercolor NAHF
"Booker T. Washington" oil AD 8(5-1-34),6
"Chalet" serigraph BACW
"Come Up Sometime" LNIA; NAHF
"Convict Labor" oil 1934 LNIA; NAHF
"Conwill" wood,earth 1983 (New Orleans) NAE 14(6-87),30
"Dixie Madonna" AAC; NAHF
"Douglass" (Frederick Douglass Series #29) NAE 14(6-87),29
"The Elks" oil c1933 (Fisk) LAAA; LNIA
"Farmer and Wife" block print BACW
"Girl Reading" oil 1933 LNIA; OPP 13(7-35),204
"Going to Church" serigraph BACW
"Henderson" NA; NAHF
"Houses on Striver's Row" drawing SG 6(3-25),638
"Ill Wind" NA; NAHF; OPP 13(7-35),205
"Jenkin's Band" oil 1931 LNIA
"Marching Elks" oil LNIA
"Meditation" oil 1932 AMA 23(9-31),213; CTAL; DANA; FAAA
"Negro Masks" oil 1932 (Hampton) ATO(c)
"Negro Soldier" oil 1934 (Schomburg) ATO
"The Old Mill" oil 1934 (Hampton) ATO

"Orphan Band" oil 1934 (Schomburg) HRABA; STHR
"Picking Beans" watercolor AD 9(6-35),23; NA; NAHF
"Postman" oil 1934 (Schomburg) ATO; HRABA
"Roll, Jordan, Roll" oil 1933 ATO; LNIA; PMNA
"Ruby" oil 1933 PMNA
"Self Portrait" oil 1934 AAAC; AG 13(4-70),7; ATO; BAAL
 (c); CTAL; DES 44(12-42),12; ENC 5(12-20-76),24; LNIA;
 OPP 17(5-39),134; TCBAA; TEAAA
"Southern Landscape" oil 1934 ILAAL; LNIA
"Swing Low, Sweet Chariot" oil 1929 AD 3(1-29),5; CRI 36
 (2-29),54; SW 58(4-29),167
"Thinnin' Corn" oil 1934 DANA; NA; SG 28(3-39),224
"Turkeys at Roost" watercolor (Barnett) BACW
"Uncle Joe" oil 1934 LNIA
"Woman Washing" watercolor 1933 (Fisk) LAAA(c); NAHF;
 NBAT; SA 71(12-71),24
"Woman with Hat" oil 1932 LNIA
Further References:
Porter, James, "Malvin G. Johnson, Artist," OPP 13(4-35),117-18.
"Self-Portrait of the Late Malvin Gray Johnson," OPP 17(5-39),134.

JOHNSON, MARIE E., 1920- ; b. in Baltimore; mixed media,
 painter
Biographical Sources: AAA; FAAA; LAAA; WCBI
Portrait: BAOA-1; DIAA
Published Reproductions:
"Caribbean Spice Lady" acrylic construction 1973 BUNY
"Construction" mixed media 1968 ONPB
"Construction" mixed media BAOA-1
"Construction" mixed media BAOA-1(c)
"Construction" mixed media BAOA-1(c)
"Construction" mixed media BAOA-1(c)
"Dark Refuge" acrylic BAOA-1(c)
"Dream Preferred" construction 1968 BAOA-1(c)
"Family" polychromed wood BW 22(12-72),cover; EB 29(12-73),
 44(c)
"Hope Street" painted construction 1971 FAAA; WCBI
"Mrs. Jackson" mixed media 1968 FAAA
"Mother and Child" mixed media 1970 OSAE

"Papa, the Reverend" mixed media 1968 LAAA
"Silver Circle" mixed media 1973 DIAA

JOHNSON, MILTON, 1932- ; b. in Milwaukee, WI; painter,
 printmaker
Biographical Sources: AAA; AAANB
Published Reproductions:
 "Another Birthday" oil 1969 (National Center) AAANB; FAAA
 "Limited" woodcut 1958 FAAA

JOHNSON, SARGENT CLAUDE, 1888-1967; b. in San Francisco;
 printmaker, sculptor
Biographical Sources: LAAA; NAI; TCBAA; TNAP; WWAA,1940
Portrait: DANA; NAHF; NAI
Published Reproductions:
 "Abstract" conte crayon c1938 STHR
 "Anderson" plaster sc 1930 AAAC; LNIA
 "Boy's Head" terra cotta sc 1935 (San Francisco) DANA; NA
 "Chester" terra cotta sc 1929 (San Francisco) AAAR 39(5-31),12;
 AD 5(2-15-31),5; AMA 23(9-31),219; ATO(c); BAQ6(#2-84),
 13; ILAAL; LIF 21(7-22-46),63; LNIA; NHB 2(3-39),51; OPP
 17(7-39),213; PSSF; SFMA; SG 65(3-1-31),594
 "Conflict" terra cotta sc 1951 PSSF
 "Copper Mask" copper 1929 DANA; LNIA
 "Copper Masks" 1935 BAQ 6(#2-84),5
 "Defiant" drawing 1931 AD 7(3-1-33),18; TNAP
 "Divine Love" drawing AAAC
 "Elizabeth Gee" sc 1927 ATO; BAQ 6(#2-284),6
 "Esther" terra cotta sc 1926 (San Francisco) AD 4(5-1-30),15;
 LNIA; SFMA
 "Forever Free" lacquered cloth,wood 1936 (San Francisco) AARE
 3(11/12-76),105(c); AFSB(c); AN 76(Su-77),78; ARTF9(5-71),
 94; BAOA-1; BAQ 1(Fa-76),5; BAQ 6(#2-84),9;BC 11(#2-80),
 98;DANA; FHBI(c); LAAA; LATCM; LNIA; MS 5(1-77),24;
 PMNA; RD 112(6-78),181(c); SFMA; TCBAA
 "Girl's Head" terra cotta sc DANA
 "Head of a Boy" terra cotta sc AV 2(8-87),63(c); NAHF
 "Head of a Girl" sc NAHF
 "Head of a Negro Woman" CMO 26(3-78),75

"Hippopotamus" terra cotta sc 1939 (Howard) AWAP; NAI
"Incas" stone sc 1938 AD 13(3-15-39),42; LAAA
"Lenox Avenue" litho 1938 LAAA
"Mask" copper 1933 ATO; BAAL(c); SFMA
"Mother and Child" chalk 1934 (San Francisco) ATO; BAQ 3
 (#2-79),40; LNIA
"Negro Woman" terra cotta 1933 (San Francisco) ATO; BAQ 6
 (#2-84),9; HHR; LAAA; PSIC; SFMA
"Pearl" clay SW 62(4-33),175
"Polychrome Sculpture" wood sc BAQ 6(#2-84),15
"Sammy" terra cotta 1927 ATO; CRI 35(4-28),124; SG 60
 (9-1-28),548
"Singing Saints" litho 1940 (Oakland) AAATC; AOC; LAAA
"Standing Woman" terra cotta 1934 BAAL(c)
"The Walking Man, He's Going Places" clay sc 1965 (Oakland)
 TCBAA
"Woman's Head" stone sc SFMA
Further References:
 Arvey, Virginia, "Sargent Johnson," OPP 17(7-39),213-14.
 Montgomery, Evangeline, "Sargent Johnson," BAQ 6(#2-84),4-17.

JOHNSON, WILLIAM HENRY, 1901-1970; b. in Florence, SC;
 graphic artist, painter
Biographical Sources: HRABA: LAAA; NAI; TCBAA; TNAP
Portrait: HRABA; NAI
Published Reproductions:
 "At Home in the Evening" oil 1940 (Smithsonian) PMNA
 "Away in the Valley by Myself" oil 1939 ATO
 "Boy of Sad Face" ND 17(5-68)),88
 "Cafe" oil c1939 (Smithsonian) HRABA(c)
 "Cagnes-sur-Mer" oil c1929 (Smithsonian) ATO; LAAA
 "Chain Gang" oil 1939 (Smithsonian) HRABA(c); PTS(c); SMI
 9(6-78),120
 "Crispus Attucks" oil AAAC
 "The Descent from the Cross" gouache 1939 (Smithsonian) AG
 13(4-70),9(c); DBLJ; EB 23(2-68),cover(c); HW 7(3rdQ-68),14
 (c); LNIA
 "Farewell" oil AN 42(5-1-43),22
 "Farm Couple" oil ND 17(5-68),90

"Flowers to Teacher" oil c1940 AG 11(4-68),45
"Flowers to the Teacher" oil 1940 (Barnett) DANA; LNIA
"Girl in a Green Dress" oil 1930 PNAP
"Going to Church" serigraph 1940 AAAC; AAAT; AAAZ(c); AD
 17(5-1-43),27; AN (5-15-41),25; AV 1(9/10-86),43(c); AV 2
 (12-87),21(c); BACW(c); LAAA(c); SMI 2(11-71),39(c); STU
 197(#1005-84),8(c)
"Harbor Under the Midnight Sun" oil c1935 (Smithsonian)
 AARE 3(11/12-76),108(c); SMI 7(10-769,91(c); TCBAA
"The Honeymooners" watercolor (Fisk) OAAL; TCBAA
"House by the Hill" oil 1927 (Hampton) ATO
"Jacobia Hotel, Florence, S.C." oil 1930 (Smithsonian) AAAC
AP 95(2-72),145; ATO; LAAA; SMI 2(11-71),39(c)
"Jesus and the Three Marys" oil 1939 (Howard) DANA; HRABA
 (c); JAAUW 5(1#-58),1; STHR
"Jim" oil 1930 (Smithsonian) ATO; LNIA
"Jitterbugs" silkscreen c1942 DAAA; LAAA(c); NAE 17(10-89),
73
"Jitterbugs, No. 2" gouache NBAT
"Kerteminde Harbour, Denmark" oil 1930 DANA
"Lamentation" oil c1939 (Smithsonian) GAI; HRABA(c); LAAA;
 PSTCA; SMI 2(11-71),34(c)
"Landscape with Sun Setting, Florence, N.C." oil 1930 LAAA
"Landscape with Windmill" oil (Fisk) DAAA
"Li'l Sis" oil c1944 (Smithsonian) HRABA(c); JAAUW 51(3-48),
 170
"Lincoln at Gettysburg III" oil c1939 (Smithsonian) ITA
"Lincoln Freeing the Slaves" oil c1940 (Howard) AWAP
"Man in a Vest" oil c1939 (Smithsonian) AE 42(11-89),cover
 (c); TNMA(c)
"Minnie" oil 1930 (Smithsonian) LAAA
"Mom and Dad" oil 1944 SMI 2(11-71),38(c)
"Mount Calvary" oil c1939 (Smithsonian) AAAT; AARE 3
 (11/12-76),118(c); AV 3(6-88),24(c); EB 43(2-88),38(c);
 HRABA(c); LIF 2(7-22-46),65(c); NAI; SMI 7(10-76),90(c);
 TCBAA
"Mountain Blossoms" oil (Smithsonian) ATO
"The Nativity" oil LNIA
"New Born Babe" gouache c1939 AV 2(12-87),11(c)

"Nude (Mahlinda)" oil c1939 (Smithsonian) HRABA(c)
"Portrait of a Man (Olaf Gynt)" oil 1933 (Hampton) ATO
"Portrait of a Youth" oil 1921 SMI 2(11-71),36
"Red Cross Station" gouache c1942 (Smithsonian) HRABA
"Self-Portrait" oil 1929 (Smithsonian) AIM 78(12-90),128(c);
 ATO; HRABA(c); SMI 2(11-71),37(c)
"Self-Portrait" oil 1933 AAAC; AD 4(1-15-30),15; AP 95(2-72),
 146; LNIA
"Self Portrait" woodcut c1935 (Hampton) HRABA
"Self Portrait (Triple) oil 1929 (Hampton) HRABA(c)
"Self-Portrait With Pipe" oil AAAC; OPP 19(5-41),153
"Sonny" oil AIS 5(Su/Fa-68),266; AMA 23(9-31),215; CTAL
"Still Life" oil c1927 (Smithsonian) GAI; HRABA(c)
"Still Life" oil 1935 (Morgan) ATO
"Street Musicians" serigraph (Fisk) DAAA; LAAA
"Sun Setting, Denmark" oil c1935 GAI
"Swing Low, Sweet Chariot" oil c1939 (Smithsonian) HRABA(c)
"Thatched Roofs" oil ND 17(5-68),89
"Winifred" oil ND 17(5-68),90
"Woman Ironing" oil c1944 AAAT
"Young Man in Vest" oil 1939 (Smithsonian) TEAAA
"Young Pastry Cook" oil c1927 (Smithsonian) HRABA(c)
Further References:
 Breeskin, Adelyn. *William H. Johnson, 1901-1970.* Washington,
 DC: Smithsonian Institution Press, 1971.

JOHNSON-CALLOWAY, MARIE, 1920- ; b. in Baltimore; mixed
 media
Biographical Sources: FFAA
Portrait: FFAA
Published Reproductions:
 "Church Mothers" mixed media 1984 EWCA(c)
 "Silver Circle" mixed media 1973 FFAA(c)

JOHNSTON, JOSHUA, c1765-c1830; b. in Baltimore; painter
Biographical Sources: AFPR; FAAA; LAAA; TCBAA; TNAP
Published Reproductions:
 "Adeline Morton" oil 1810 ANT 101 (4-72),589(c)
 "Archibald Dobbin, Jr." (attrib) oil 1803 (Maryland) ANT 132

(9-87),527(c); AV 3(2-88),17(C)

"Basil Brown" (attrib) oil c1813 ANT 132(9-87),432(c)

"Benjamin Franklin Yoe and Son" oil 1810 AAAC; AG 11
(4-68),16;AG 13(4-70),3; ANT 132(9-87),529(c); FAAA; GAI;
HW 7(3rdQ-68),11(c); SBMAA; TEAAA

"Bennett Sollers" oil EBNPP

"Captain John Murphy" oil c1810 ANT 103(4-73),861(c)

"Captain Thomas Sprigg" (attrib) oil c1805 ANT 132(9-87),536(c)

"Catherine Anne Bowen" oil c1830 ST

"Charles Herman Wilmans" oil 1804 (Baltimore) AC 17(2-48),6;
ANT 128(11-85),987(C); EBNPP

"Charles John Strickler Williams" (attrib) oil c1805 ANT 132
(9-87)528(c)

"Charles Reeder" (attrib) oil 1815 ANT 132(9-87),536(c)

"Daniel Coker" oil AV 3(2-88),15(c)

"Edward and Sarah Rutter" oil c1805 ANPEN; FAAA; MMB 23
(4-65),285; OMAPP(c)

"Emma Van Name" oil ANT 133(4-88),777(c)

"Father and Son" oil 1800 PMNA; TAAP

"Hilmer Schumacher" (attrib) oil 1810 ANT 132(9-87),526

"In the Garden" (attrib) oil c1805 (Baltimore) AQ 31(Wi-68),
440; ANT 132(9-87),537(c); EB 23(2-68),116(c); OMAPP(c)

"Isabel Taylor" oil c1810 AATNM; ANT 103(3-73),493(c)

"The James McCormick Family" oil 1805 (Maryland) BE 6
(12-75),69; BFPA; DANA; EB 32(2-77),38; EBNPP; LIF 9
(12-9-40),76(c); LNIA; NHB 21(4-58),166; NW 3(#1-76),31;
PPA; SBMAA; ST; TCBAA

"John Spear Smith" oil c1797 AC 17(2-48),8; EBNPP; MHM 37
(6-42),145

"Kennedy Long Family" oil c1805 AAR; AJ 31(Fa-71),15; ANT
132(9-87),532(c); MHM 37(6-42),134

"Laura Winship McCausland and Her Son, Henry" oil c1815 AFPR

"Letitia Grace McCurdy" oil c1804 AAAZ(c); ALIA; ANT 121
(4-82),764(c); ARAN(9-88),46(c); CONN 212(11-182),148;
EBNPP; MHM 37(6-42),139

"Man of the Shure Family" oil c1810 MHM 37(6-42),142

"Margaret Moore" (attrib) oil c1812 AFPR

"Mary Buchanan Smith" oil c1797 EBNPP; MHM 37(6-42),145

"Mother and Daughter" oil AAAC; ANT 126(10-84), 754(c);
 TAAP
"Mrs. Abraham White and Daughter" oil 1810 (Chrysler) AG 19
 (12-75),76; ANPEN; CONN 92(6-76),158; EBNPP; FAAA;
 THYAC
"Mrs. Andrew Bedford Bankson and Son" oil c1804 AC 17(2-48),
 7; EBNPP; MHM 37(2-48),7; PMNA
"Mrs. Barbara Baker Murphy" oil c1810 (Smithsonian) ANT
 103(5-73),861(c); CBAR; ST(c)
"Mrs. Benjamin Yoe and Her Daughter" (attrib) oil 1807
 (Winston) ANT 132(9-87),529(c)
"Mrs. Hilmer Schumacher" (attrib) 1810 ANT 132((-87),526(c)
"Mrs. Hugh McCurdy and Her Daughters" oil c1804 AC 17
 (2-48),7; AN 44(6-45),25; ANT 121(4-82),764(c); MA 38
 (12-45),292; MHM 37(6-42),139; THFY
"Mrs. James Beatty" oil c1804 EBNPP
"Mrs. John Moale and Granddaughter Ellin" oil 1800 AC 17
 (2-48)8; ANT 123(3-83),625(c); ANT 132(9-87),525(c); DANA;
 EBNPP; SBMAA
"Mrs. Thomas Everette and Her Children" (attrib) oil 1818
 (Maryland) AAATC; ANT 132(9-87),535(c); PTS
"Mrs. West and Mary Ann West" oil c1805 AC 17(2-48),8
"Portrait of a Cleric" (attrib) oil c1810 (Bowdoin) AG 13
 (Fa-71),15; AIPP; BMIA; DAAA; FHBI(c); LAAA; NHB 31
 (2-68),15; PNAP; ST; TCBAA
"Portrait of a Man Writing with a Quill" oil 1850 KQ 9(12-69),
 183
"Portrait of a Negro Gentleman" oil AIM 52(6-64),75
"Portrait of a Woman with a Fan" oil c1805 KQ 9(12-69),183
"Portrait of Eliza White O'Donnell" oil ANT 113(5-78),949(c)
"Portrait of Isabel Taylor" oil c1805 (Newark) AA 37(4-73),5;
 AATNM
"Portrait of Mr. Shure" oil AC 11(2-42),15
"Sarah Maria Coward" oil c1804 ANT 135(1-89),102(c)
"Sarah Ogden Gustin" oil c1800 (Smithsonian) ANT 13(9-87),524
 (c); ST(c)
"Sea Captain John Murphy" oil c1810 ST(c)
"Thomas Sprigg" oil EBNPP
untitled oil ANT 105(1-74),60(c)

untitled oil c1815 ANT 105(1-74),60(c)
untitled oil AIM 54(11/12-66),99
untitled (attrib) oil AFPR(c)
untitled oil AV 3(2-88),18(c)
untitled (attrib) oil c1810 (Bowdoin) ANT 132(9-87),527
"The Westwood Children" oil 1807 (National Gallery) AIPP;
 ANP(c); ANT 124(9-83),488; APAS; AQ 23(S-60),192; BEAA;
 DBLJ; FAAA; NGAW; PMNA; SBMAA; TAAA; WAA
"Woman and Baby Wearing Green Gloves" oil c1800 ANT 118
 (9-80),397(c); KQ (12-69),173(c)
"Woman of the Shure Family" oil c1810 MHM 37(6-42),142
"Young Lady on a Red Sofa" oil c1810 AAR(c); AARE 1
 (7-10-74),105(c); ANA 11(10-76),19; AP 104(12-76),
 511(c); EB 32(2-77),33(c); ER 2(1-77),21(c); MS 5
 (1-77),26(c); NCFP(c); RD 112(6-78),180(c); TCBAA(c)
Further References:
 Greene, Carroll, "The Search for Joshua Johnston: Early America's
 Black Portrait Painter," AV 3(2-88),14-19.
 Hunter, Wilbur H., "Joshua Johnston: 18th Century Negro Artist,"
 AC 31(2-68), 6-8.
 Pleasants, J.Hall, "Joshua Johnston, the First Negro Portrait Paint-
 er," NHB 31(2-68),15-16.

JONES, BARBARA, see **JONES-HOGU, BARBARA**

JONES, BENJAMIN F., 1941- ; b. in Paterson, NJ; mixed media
 painter, sculptor
Biographical Sources: AAANB; BAAL; WWAA,1991; WWABA
Portrait: BAAL; NEW 75(6-22-70),89
Published Reproductions:
 "African Panorama" mixed media 1972 DIAA
 "Black Face and Arm Unit" mixed media 1971 ARAC 107(5-90),
 29(c); DIAA; STHR
 "Black Face Images" acrylic on plaster NAR 2(9-70),35
 "Black Leg" mixed media 1970 FAAA
 "Black People Rise" collage 1977 BC 11(#2-80),90
 "Blackman Hero" mixed media 1976 BC 12(#2-81),125(c)
 "Blackwoman Universe" mixed media 1973 BC 12(#2-81),124(c)
 "Brazilian Carnival" silkscreen 1981 BC 12(#2-81),124(c)

"Deliver the Funk" mixed media 1980 BC 12(#2-81),125(c)
"Five Black Faces" acrylic on plastics AAANB; ART 44(Su-70),
 32; FAAA
"High Priestess" mixed media 1972 BC 12(#2-81),125(c)
"High Priestess of Soul" mixed media 1970 APO 115(6-82),499;
 FAAA; NBAT
"Leg" acrylic on plaster 1969 AIM 58(9/10-70),62
"Malcolm" mixed media 1973 BC 12(#2-81),125(c)
"Remade in the USA" mixed media BC 12(#2-81),124(c)
"Stars II" mixed media 1983 (Newark) BAAL(c)

JONES, CALVIN, 1934- ; b. in Chicago; illustrator; painter
Biographical Sources: WWAA,1991
Published Reproductions:
 "Another Times Voice Remembers My Passion's Humanity" mural
 BC 11(10/11-80),100(c)
 "Black Leadership Print Series" EB 33(2-78),71(c); ESS 8
 (2-78),9(c)

JONES, DORCAS; painter
Biographical Sources: DENA
Portrait: DENA
Published Reproductions:
 "Peace" pastel DENA

JONES, FRANK A., 1900- ; b. in Clarksville, TX; mixed media
Biographical Sources: BHBV
Portrait: BHBV
Published Reproductions:
 "French House" pencil 1965 BHBV
 "Gambling Boat" pencil 1965 BHBV
 "Jap Devil House" pencil 1964 BHBV
 "Moon Devils" pencil 1965 BHBV
 "Three Story Military Drilling House" pencil 1964 BHBV
 "Wagon Wheel Devil House" pencil 1968 BHBV

JONES, FREDERIC, 1914- ; b. in Chicago; painter
Biographical Sources: AAA

Published Reproductions:
"Magnolia Seed" oil DANA

JONES, HENRY BOSEMAN, 1889-1963; b. in Philadelphia; painter
Biographical Sources: AAA; AAA3; MIAP; WWAA,1953
Portrait: ATO
Published Reproductions:
"Blues" oil 1938 LNIA
"Dance--Sixth Day of Creation" litho (Howard) ATO
"'Mom' Sammy" litho 1938 (Howard) ATO
"Narka" oil 1939 LNIA
"Old Death" AAAC
"Peckin" lino (Howard) ATO
"Tobacco Shed" linocut (Howard) ATO

JONES, JOHNNY; sculptor
Published Reproductions:
"Self-Portrait" terra cotta sc 1971 BAIH(c)

JONES, LAWRENCE ARTHUR, 1910- ; b. in Lynchburg, VA;
 graphic artist, painter
Biographical Sources: AAA; BAWPA
Portrait: PSBA
Published Reproductions:
"Crackers and Mules" etching BAWPA
"Mother and Child" oil FSBA
"Triptych: Past, Present, Future" oil FSBA
Further References:
Andrews, Benny, "Keeping Up with This Jones," ENC 6(7-18-77),
 34.

JONES, LEON, 1923- ; b. in Montclair, NJ; painter
Published Reproductions:
"Girl with a Ring" pastel 1970 NBAT; SA 71(12-71),25

JONES, LOIS MAILOU, 1905- ; b. in Boston; painter
Biographical Sources: BDCAA; EBSU; TCBAA; WWAA,1991
Portrait: AAL; BAOA; DANA; ILAAL
Published Reproductions:

"Ascent of Ethiopia" oil 1932 BAAL(c)

"Bird, Beast and Fish" acrylic EBSU

"The Blue Masque" EB 24(11-68),136

"Celine" watercolor 1940 FAL

"Challenge" collage 1969 AG 13(4-70),26(c); BDCAA; EB 24 (11-68),136(c); NHB 28(Su-65),204

"Chou-Fleur et Citronnelle" oil 1938 FAL

"Circus Tents" oil PMNA

"Coin de la Rue-Medard, Paris" oil DANA; DES 59(1-58),95

"Dahomey" acrylic 1971 BS 2(3-72),17

"Dance Mask" mixed media 1972 BAOA-1(c)

"French Scene" oil AAAC

"Girl from Tai Region" oil ENC 4(6-23-75),86; GAI; LAAA (c); TCBAA

"Grand Bois d'Illet" watercolor 1953 AWAP; BACW

"Green Apples" oil 1938 BACW; WAWC

"Haitian Peasant Girl" oil 1954 ESS 3(11-72),44

"Haitian Scene" oil BAOA-1(c)

"Initiation--Liberia" acrylic BAAL(c)

"Jennie" oil 1973 (Howard) ATO; DANA; FAAA; NAI

"Les Ancesters" oil 1982 (National Center) AAAZ(c)

"Les Fetiches" oil 1937 BAAL(c); FAL; STHR; WAIH

"Les Pommes Vertes" oil 1938 FAL

"Letitia and Patrick" oil 1964 (Howard) ILAAH; NHB 30 (10-67),6

"Lois Mailou Jones--Self Portrait" oil ESS 3(11-72),44

"The Lovers (Somali Friends)" casein 1950 AAAET(c); AAATC (c)

"Magic of Nigeria" oil 1971 BAAL(c); BAQ 1(Fa-76),7

"Magic of Nigeria" watercolor,ink 1971 (Howard) MN 60(1-82), 44

"Marche--Haiti" acrylic AG 11(4-68),46; BAOA-1(c); LAAA

"Mob Victim" oil 1944 AARE 3(11/12-76),113(c); ANA 11 (11-76),16; BC 8(9/10-77),50(c); RD 112(6-78),185(c); TCBAA(c); WA

"Moon Masque" acrylic collage 1971 BAOA-1(c); FAAA; LAAA; SA 79(10-79),57; WA

"Negro Boy" watercolor 1935 LAAA; NHB 9(4-46),152

"Negro Cabin, Sedalia, North Carolina" watercolor ATO

"Negro Youth" charcoal 1979 ATO; NHB 2(4-39),59
"Nude" charcoal 1927 ATO
"Old Street in Montmartre" oil DANA; DES 59(1-48),cover(c)
"Petite Ballerina" acrylic 1982 BAAL(c)
"Place du Tertre Montmartre: Paris" oil 1938 FFAA(c)
"Rue Norvins, Montmartre" oil 1938 (Brooklyn) FAAA; LNIA
"Rue Saint Michel" oil 1938 FAL
"Seventh Street Promenade" oil DES 52(2-51),10
"Soap Vendors--Haiti" watercolor GAI
"Speracedes, France" oil 1951 (Brooklyn) DANA; FAAA; TEAA
"Sunflowers" oil BACW
"Ubi Girl from Tai Region" BC 6(11/12-75),33(c)
"Vendeuses de Tissus de Haiti" oil AAANB
"Veve Voudou III" oil,collage 1968 BAAL(c); BDCAA(c); EB
 24(11-68),136(c); GAI
Further References:
Jones, Lois M. *Lois Mailou Jones Peintures: 1937-1951.*
 Tourcoing, France: Presses Georges Frere, 1952.

JONES, NATHAN; b. in Los Angeles; painter
Published Reproductions:
"Modern Cotton Picker" pencil AA 43(12-79),43
"Natalie Jean" pencil AA 43(12-79),41
"Old Timer" pencil AA 43(12-79),40
"Reflection of Time" pencil AA 43(12-79),42
untitled drawing BSC 6(3-75),cover
Further References:
Simpson, Nanette, "Painting with Pencil," AA 43(12-79),40-3.

JONES, TONNIE O., 1943- ; b. in Palo Alto, CA; sculptor
Biographical Sources: AAA; AAANB
Portrait: NBA
Published Reproductions:
"Call for Unity" oak sc 1969 NBA
"Fatima" oak sc 1969 (Brooklyn) AIPP; NBA
"The Sacrifice" oak sc 1968 NBA
"Unknown" wood sc 1970 AAANB; NEW 75(6-22-70),89
untitled wood sc 1970 AIM 58(9-70),58

JONES-HENDERSON, NAPOLEON, 1943- ; b. in Chicago; mixed
 media
 Biographical Sources: LAAA
 Published Reproductions:
 "Wholy People" mixed media 1972 LAAA(c)

JONES-HOGU, BARBARA, 1938- ; b. in Chicago; printmaker
 Biographical Sources: BDCAA
 Published Reproductions:
 "Black Men We Need You" 1973 MS 2(9-73),26(c)
 "I Am Better than You, M.F." serigraph BW 19(10-70),84
 "Land Where My Fathers Died" BC 11(10/11-80),102(c)
 "Relate to Your Heritage" silkscreen 1971 DIAA
 "Rise and Take Control" serigraph BW 19(10-70),89
 "Unite" serigraph 1970 BAQ 2(Sp-78),19(c); DIAA
 "Your Brother's Keeper" serigraph 1968 BDCAA(c)

JORDAN, JACK, 1925- ; b. in Wichita Falls, TX; graphic artist,
 painter
 Biographical Sources: BDCAA; EBSU; TCNL; WWAA,1978
 Portrait: BAOA-1; TCNL
 Published Reproductions:
 "African Dancers" assemblage AAAC
 "Black Lovers" BC 6(1/2-76),26(c)
 "Diana and Apollo" oil BAOA-1
 "Ghetto Family" welded sc EBSU
 "Going Home" linocut PANA
 "Madonna and Child" 1950 DANA
 "The Musician" DANA
 "Mythology of the Black Man" acrylic WJBS 1(3-77),31(c)
 "Negro, Banjo, and Soul" oil 1968 BDCAA
 "Soul Family" oil 1969 BDCAA
 "Swinging Ghetto Child" BC 7(11/12-76),38(c)
 untitled sc BAOA-1

JOSEPH, CLIFF, 1927- ; b. in Panama; painter
 Biographical Sources: AAANB; CBAM; FAAA; LAAA
 Portrait: BAOA-1
 Published Reproductions:

"Blackboard" oil 1969 AAANB; BAOA-1; BAQ 8(#2-88),64;
 ESS 1(8-70),68; FAAA; SA 70(11-70),30
"The Game" oil ABA 1(#1-72),8
"Heir to the Kiss of Judas" oil 1966 CBAM
"My Country Right or Wrong" oil 1968 FAAA; LAAA
"Separatists" oil 1966 AIS 10(Sp/Su-73),97

JOSEPH, RONALD, 1910- ; b. in St. Kitts; painter
Biographical Sources: AAA; NAI; TNAP
Published Reproductions:
 "Card Players" oil (Albany) NAI
 "Introspect" litho 1937 LNIA
Further References:
 "Charwoman's Son," TIM 13(6-24-29),42.

JOYNER, LEMUEL M., 1928- ; b. in Nashville, TN; painter
Biographical Sources: BDCAA
Published Reproductions:
 "Judgment" oil 1960 BDCAA(c)

JUDIE, EDWARD; sculptor
Published Reproductions:
 "Head" ironwood sc GAI
 "Head, No. 2" mesquite sc GAI

KABU, MICHAEL, 1948- ; b. in Los Angeles; painter
Published Reproductions:
 "Festival Nigra" oil c1977 BC 20(#3-90),177(c)
 "Passing Through" oil 1986 BC 20(#3-90),177(c)

KAUFMAN, ARTHUR; painter
Published Reproductions:
 "The Newly Born Lamb" oil CRI 72(6/7-65),363

KECK, CHARLES; sculptor
Biographical Sources: AAA
Published Reproductions:
 "Monument Sculpture" (Booker T. Washington) BAQ 8(#2-88),12

KEENE, CHARLES; painter
 Published Reproductions:
 untitled OPP 1(1-23),16; SG 49(12-1-22),326

KEENE, PAUL F., JR., 1920- ; b. in Philadelphia; painter
 Biographical Sources: AAA; BAOA-2; LAAA; WWAA,1991
 Portrait: BAOA-2
 Published Reproductions:
 "Atlantic City" oil EB 13(4-58),34(c)
 "The Cabinet of Doctor Buzzard" (Root Man Series, No.1) acrylic
 BAOA-2(c); LAAA(c)
 "Commentary #5" charcoal 1967 AG 11(4-68),22
 "Death Calls on the Root Man" (Root Man Series,No.2) oil
 BAOA-2(c)
 "The Family" oil 1951 AIM 43(2-55),34
 "Garden of Shango" oil BAOA-2(c); BC 7(9/10-76),42(c)
 "Landscape Series 75" AJ(Sp-82),33
 untitled Charlotte, NC mural BAQ 1(Wi-76),48

KENDRICK, JOHN A., 1952-82; painter
 Portrait: SMIH 2(4-75),3
 Published Reproductions:
 "H20 Ritual" oil,acrylic 1977 BC 13(#4-83),131(c)
 "Prelude" mixed media 1976 BC 13(#4-83),131(c)
 "Street Corner Symphony" mixed media 1975 BC 11(10/11),102
 (c); BC 13(#4-83),130(c)
 "Street Encounter" mixed media 1974 BC 13(#4-83),130(c)
 "Transitions" mixed media 1975 BC 13(#4-83),131(c)
 "Wall of Spiritual Aspiration" mural 1977 BC 13(#4-83),131

KENNEDY, HARRIET, 1939- ; b. in Cambridge, MA; mixed media,
 sculptor
 Biographical Sources: AAA; AAANB; WWAA,1991
 Published Reproductions:
 "Head of Michael" bronze sc 1970 AAANB

KENNEDY, LEON; painter
 Published Reproductions:
 "State of Mind" BCR 4(Fa-72),47

KERSEY, JOSEPH A., 1908- ; b. in Chicago; painter, sculptor
 Biographical Sources: AAA; MIAP
 Published Reproductions:
 "Anna" stone sc 1939 LNIA; PMNA
 "St. Francis and the Bird" terra cotta sc BACW
 "Spiritual Singer" stone sc CRI 49(8-42),261
 "Young Girl" sc DANA

KIAH, VIRGINIA JACKSON, 1911- ; b. in East St. Louis, IL;
 painter
 Biographical Sources: AAA; WWAA,1991
 Published Reproductions:
 "I Have the Blues" ceramic sc CRI 80(3-73),cover(c)

KING, HENRI UMBAJI, 1923- ; b. in Detroit; painter
 Biographical Sources: WWAA,1978
 Published Reproductions:
 "People of Allah" BC 7(1/2-77),36(c)

KING, JAMES DEWITT, 1941- ; b. in Chicago; sculptor
 Biographical Sources: AAA
 Published Reproductions:
 "Sculptural Exterior Forms" wood sc BAQ 2(#4-78),56(c)
 untitled sc ESS 7(7-76),92

KNIGHT, GWENDOLYN (MRS. JACOB LAWRENCE), 1913- ;
 b. in Barbados; painter, sculptor
 Biographical Sources: AAA; BAOA-2
 Portrait: BAOA-2
 Published Reproductions:
 "Dorothy II" oil BAOA-2
 "Young Man" clay sc 1970 BAOA-2

KNIGHT, ROBERT, 1944- ; b. in Newark, NJ; graphic artist,
 painter
 Biographical Sources: AAA
 Published Reproductions:
 "Ancient Lovers" acrylic 1970 NBAT; SA 71(12-71),28

KOLAWOLE, WILLIAM LAWRENCE COMPTON, 1931- ; b.
 in Beaumont, TX; painter, sculptor
 Biographical Sources: AAA; WWAA,1978
 Portrait: BAOA-1
 Published Reproductions:
 "Three for Davis" oil BAOA-1
 untitled PANA

LACY, BRENDA; sculptor
 Published Reproductions:
 "Architecture" Houston mural 1972 BAIH(c)
 "Owl" terra cotta sc 1972 BAIH(c)

LACY, JEAN, 1932- ; b. in Washington, DC; mixed media
 Biographical Sources: BAAL
 Portrait: BAAL
 Published Reproductions:
 "Little Egypt Condo/New York City" mixed media 1987 BAAL(c)
 "Night Migration" mixed 1988 BAAL(c)
 "Twins in the City" mixed media 1987 BAAL(c)
 "Welcome to My Ghetto Land" mixed media 1986 (Dallas) ARAC
 107(5-90),28(c)

LAGRONE, ROY E., 1922- ; graphic artist, painter
 Published Reproductions:
 "Shamba Bolongonga--African King of Peace" BC 12(#4-82),
 169(c)

LAMA, OMAR; painter
 Published Reproductions:
 "Christ" ink EB 26(4-71),180
 "Unite or Perish" ink BW 19(10-70),86
 untitled drawing BC 2(3/4-72),21
 untitled drawing BC 2(3/4-72),32

LANE, ARTIS; b. in Ontario, Canada; painter, sculptor
 Biographical Sources: AAA
 Published Reproductions:

"Cary Grant" oil AV 5(4-90),27(c)
"Dignity" clay 1980 BAQ 6(#2-84),48(c)
"Emerging Woman" sc AV 5(4-90),26(c)
"Flight" bronze sc 1984 BAQ 6(#2-84),53
"Hurdlers" bronze sc AV 5(4-90),28(c); BAQ 6(#2-84),51
"Michael Jordan" oil AV 5(4-90),cover(c)
"New Woman" bronze sc AV 5(4-90),22(c)
"Release" sc 1982 AV 5(4-90),25(c); BAQ 6(#2-84),46
"Rosa Parks" oil AV 5(4-90),24(c)
"Waiting" bronze sc 1983 BAQ 6(#2-84),47
Further References:
 Doktorcyzyk-Donohue, Marlena, "The Soul of Artis Lane," AV 5
 (4-90),22-28.

LANE, DOYLE, 1925- ; b. in New Orleans; muralist, sculptor
 Biographical Sources: AAA; BAOA-2
 Portraits: BAOA-2; SP 9(6-81),19
 Published Reproductions:
 "Enameled Plaque" enamel BAOA-2(c)
 untitled construction 1975 LAAA(c)

LARK, RAYMOND, 1939- ; b. in Philadelphia; painter
 Biographical Sources: AAA; WWA,1975; WWAA,1991; WWABA
 Portrait: BAOA-1; ENC 3(2-74),49
 "Bernard's Daddy" pencil 1971 ENC 3(2-74),49; LAAA
 "Frustration" pencil 1975 LEO 15(Wi-82),10
 "Hard Times" pencil 1975 LEO 15(Wi-82),10
 "Henrietta" oil SWA 19(10-89),190(c)
 "Howard H. McGee" graphite 1968 BAOA
 "Interesting Conversation" pencil 1980 LEO 15(Wi-82),12
 "Noguchi and the Chocolate Baby" graphite ENC 3(2-74),48
 "Nothing but Word" graphite ENC 3(2-74),49
 "Solitude" pencil 1975 LEO 15(Wi-82),12
 "Sweet Peaches" graphite 1968 BAOA-1; ENC 3(2-74),49;
 LEO 15(Wi-82),10
 "Tender Love" pencil 1975 LEO 15(Wi-82),11

LAWRENCE, CAROLYN MIMS, 1940- ; muralist
 Published Reproductions:

"Pass on the Legacy" acrylic BC 11(10/11-80),99(c)
"Pops" acrylic BW 19(10-70),81

LAWRENCE, JACOB, 1917- ; b. in Atlantic City, NJ; painter
Biographical Sources: CBAM; DCAA; GNNP3; LAAA; MRAA;
 NAIA; TCBAA; WWAA,1991; WWABA
Portrait: EB 18(9-63),131; ILAFF; TIM 61(2-2-53),50; TNAP
Published Reproductions:
 "After a While Some Communities..." (Migration of the Negro
 Series) tempera 1940 AI 16(12-72),37
 "Although the Negro Was Used to Lynching..." tempera (Modern
 Art) FAL; FOR 24(11-41),105(c)
 "Ambulance Call" oil DANA(c); STU 35(1-61),28(c)
 "American Revolution, 1963" oil MO 23(10-63),cover(c)
 "Among the Social Conditions..." (Migration of the Negro Series)
 gouache 1940 (Metropolitan) DBLJ
 "Anchor on Cart" AD 21(10-1-46),14
 "And the Immigrants..." oil SMBAA
 "And the Immigration Spread" oil FOR 24(11-41),105(c)
 "And the Immigrants Kept Coming" oil ANA 4(5-69),15; FOR 24
 (11-41),109(c); PNAP
 "And There Was Lynching" oil FOR 24(11-41),105(c)
 "Another Cause Was Lynching" (Migration of the Negro Series)
 tempera 1940 (Seattle) AIM 76(2-88),134(c); AH 22(12-70),34
 (c)
 "Another Great Ravager of Crops..." (Migration of the Negro Series)
 tempera 1940 FOR 24(11-41),103(c)
 "Another Journey Ended" (Harriet Tubman Series) gouache 1967
 BAQ 8(#2-88),54(c)
 "Another of the Social Causes..." tempera (Modern Art)
 PASMOMA
 "Another Patrol" (War Series) tempera 1947 (Whitney) AUSPS;
 FAEI; FTWM
 "Another Was the Treatment..." FOR 24(11-41),104(c)
 "The Apartment" gouache 1943 AIM 83(2-84),81(c)
 "At Times It Is Hard..." (Harlem Series) gouache 1942 VO 102
 (9-15-43),94(c)
 "The Attack" serigraph 1987 BC 19(#4-89),179
 "Bakers" 1945 MA 38(11-45),250

"Barber Shop" HG 90(12-46),122(c)

"Battling Slaves" gouache 1955 FFBA

"Beachhead" (War Series) tempera 1947 (Whitney) FTWM; RAR

"Blind Flower Vendor" watercolor 1946 BACW(c); FAL

"Boy with Kite (Hiroshima Series) AW 17(8-23-86),1

"Bread, Fish, Fruit" gouache 1985 AIM 74(7-86),45(c); AIM 74
 (8-86),15(c)

"Brooklyn Stoop" casein 1967 JJ 22(8/10-89),35(c)

"The Builder" BSH 9(9-77),cover

"The Builder" gouache 1971 BAOA-2

"The Builders" gouache ARTF 13(9-74),4(c); AIM 62(7-74),5
 (c); AV 2(12-87),17(c); BAQ 6(#4-85),55(c);EB 29(10-74),72;
 ESS 17(11-86),90(c); GAE; IOL(c); OAAL(c)

"Builders #1" gouache 1971 AAAJ 26(#1-86),18; AIS 10
 (Sp/Su-73),124

"The Builders #2" gouache 1973 AIM 83(2-84),85(c); AJ 33
 (Su-74),351

"The Builders #3" serigraph 1974 ARTF 13(5-75),25; ART 49
 (5-75),42

"The Builders #4" gouache AG 18(4-75),39

"Bundle of Sticks" brush,ink 1969 JJ 22(8/10-89),37

"Bus" SG 31(11-72),478

"The Businessmen" FOR 38(8-48),89(c); VO 95(2-1-50),151(c)

"Cabinetmaker" casein 1957 (Hirshhorn) AIM 68(2-80),15; AIM
 76(2-88),133(c); BSAP(c); HMSG(c)

"Cafe Comedian" casein 1947 MO 22(4-62),22

"Cafe Scene" watercolor c1930 ASAP; LIF 20(2-18-46),77(c);
 MA 38(11-45),252; PUSA(c)

"Carpenters" litho 1978 AIM 66(3/4-78),148; AN 77(3-78),148

"Catfish Row" tempera 1947 MRAA

"Catholic New Orleans" gouache 1941 (Berkeley) PSTCA

"Checker Players" SBMAA

"Chess Players" brush,ink c1947 JJ 22(8/10-89),36

"Child Labor and a Lack of Education..." gouache DBLJ; SBMAA

"The Child Toussaint Heard the Planter's Whip..." tempera SG
 28(3-39),225

"Children at Play" tempera AE 40(11-87),cover(c)

"The Children Go to School" gouache 1942 MOT 22(4-62),18

"A Christmas Pageant" tempera 1952 (Performance Series) AIM
42(12-54),287; NCAC
"Class in Shoe-Making" tempera SA 60(2-61),32
"Clown" tempera 1963 AG 11(4-68),17(c); FAL; FFBA
"Coming Home" (War Series) tempera 1946 (Whitney) FFBA
"Confrontation at the Bridge" serigraph 1975 BAQ 8(#2-88),58(c)
"Conspirators" tempera TIM 69(1-14-57),82
"Cramped into Urban Life..." oil FOR 24(11-41),107(c)
"Crossing the Delaware" ART 31(1-57),53
"Curtain" AN 51(2-53),73
"Dancing at the Savoy" (Harlem Series) gouache 1943 FAAA
"Daybreak--A Time to Rest" tempera 1967 AMNGA(c); AV 1
(2-87),35(c)
"Death" NAUA
"Death of Toussaint in Le Joux Prison" tempera LNIA
"Depression" tempera 1950 (Whitney) FAAA; NAIA; NAUA
"Douglass Edits North Star" SMI 18(6-87),59(c)
"Drama, Halloween Party" gouache 1950 AD 24(5-1-50),7; AN
49(5-50),18; PAPM(c)
"Dream Series, #5" tempera 1967 APPA
"Dreams #1" AW 17(8-23-86),1
"During the World War There Was a Great Migration..." (Migration
of the Negro Series) tempera 1940 (Phillips) AAAZ(c); FAA;
FHBI(c); FOR 24(11-41),103(c); LAAA; WAA
"Dust to Dust" gouache 1938 JJ 22(8/10-89),32(c)
"The Eviction" gouache 1936 (Texas) JAMC
"Firewood" oil 1938 PMNA; SG 31(11-42),478
"Frederick Douglass" SMI 18(6-87),58(c)
"Free Clinic" oil 1937 (Harlem Hospital) ASAP; FSBA
"Four Students" tempera 1961 MO 22(4-62),24
"The Free Man" (Frederick Douglass Series) FHBI(c)
"Fulton and Nostrand" tempera 1958 AIM 52(#2-64),42; AN 83
(2-84),82(c); ANY(c)
"Gee's Bend" FOR 38(8-48),89(c)
"General Toussaint L'Ouverture Defeats the English" gouache 1937
(Fisk) AV 1(2-87),32(c)
"Going Home" tempera 1946 AD 22(12-15-47),10; ANA 18
(1948),111; BAWPA

"Gradually Female Workers..." (Migration of the Negro Series)
FOR 24(11-41),108(c)

"Graduation" gouache 1948 AAATC; AV 2(10-87),43; AV 5
(4-90),44

"Haitian Declaration of Independence" tempera LNIA

"Handling Line" 1945 MA 38(11-45),254

"Harlem" AN 45(5-46),45; SG 31(11-42),478

"Harlem Society" gouache (Portland) AOTT

"Harriet Tubman" SMI 18(6-87),58(c)

"Harlem Society" gouache 1943 (Portland) ATPN

"He Was Hanged in Charleston" NEW 26(12-24-45),87

"Hiroshima" 1983 AAAZ(c); AN 83(2-84),86(c); AV 1(2-87),35(c)

"His Adventures Failing Him..." AQ 18(#4-55),408

"Holystoning the Deck" watercolor 1944 MA 38(11-45),251

"Ice Man" tempera 1936 AAAJ 26(#1-86),21

"In Every Home..." (Migration of the Negro Series) oil (Modern
Art) FHBI(c); SBMAA

"In Every Town..." (Migration of the Negro Series) gouache
1942 (Phillips) AIM 78(12-90),127(c); AV 1(1-87),31(c); DBLJ

"In Many Cities..." (Migration of the Negro Series) FOR 24
(11-41),107(c)

"In Many Places..." (Migration of the Negro Series) gouache
(Phillips) DBLJ; OHMB(c)

"In the Evening Evangelists Preach..." (Harlem Series) gouache
1943 DANA; NCAC

"In the North the Negro..." (Migration of the Negro Series)
oil (Modern Art) FOR 24(11-41),109(c); PASMOMA; SBMAA

"Interior Scene" tempera 1936 AAAJ 26(#1-86),22

"Ironers" gouache 1943 (Brooklyn) AIM 76(2-88),132(c); FHBI
(c); NENY 20(10-19-87),112(c)

"Jean Jacques the First of Haiti" BMQ 3(#4-38-9),10

"John Brown, A Man..." (John Brown Series) gouache 1946 FAAA

"John Brown Formed an Organization" oil AD 20(12-15-45),17;
AN 45(7-46),51; SBMAA; TIM 77(2-24-61),61(c)

"John Brown Formed an Organization..." (John Brown Series)
gouache 1946 (Detroit) AD 20(12-15-45),17; AN 45
(7-46),51; OAAL; SBMAA; TIM 77(2-24-61),61(c)

"John Brown Was Found Guilty..." (John Brown Series) gouache
1946 (Detroit) GAE; NEW 26(12-14-45),87

"Juke Box" oil (Detroit) AD 23(8-49),15; AD 27(5-15-53),21

"The Labor Agent..." (Migration of the Negro Series) tempera
 1940 AH 22(12-70),35; FOR 24(11-41),105(c)

"The Letter" (War Series) tempera 1946 (Whitney) AOT

"The Libraries Are Appreciated" gouache 1943 (Harlem Series)
 SSAA 4(Sp-90),35

"Library" tempera 1961 (Smithsonian) AAAC; AP 76(11-62),723;
 MO 22(4-62),23; NAUA; PIAM; SCJ 7(#1-88),7; TNMA(c)

"Library II" tempera AV 2(1-87),cover(c)

"Life of Toussaint" AD 15(12-15-40),12

"Lovers" gouache 1946 AV 1(2-87),34(c); TIM 77(2-24-61),62(c)

"Machinist Mate" 1945 MA 38(11-45),25

"Make-up" tempera 1952 HAGC

"Man with Square" gouache 1978 AV 1(2-87),35(c); SWA 16
 (7-86),80

"Many Families Were in Sorrow..." (Migration of the Negro Series)
 FOR 24(11-41),105(c)

"Many Whites Come to Harlem..." (Harlem Series) FAAA; NYT
 (9-1-46),21; PMNA

"Marionettes" 19152 AIM 71(8-23),95

"Market" gouache AN 63(2-65),17

"Menagerie" gouache 1964 FSBA

"Migration of the Negro" AN 83(2-84),80(c); SWA 16(7-86),80

"The Migrants Arrived in Great Numbers..." (Migration of the
 Negro Series) gouache 1942 (Modern Art) AH 22(12-70),37(c);
 DBLJ

"Migration" tempera AN 43(10-15-44),14; AN 47(12-48),47

"Migration of the Negro" (Migration of the Negro Series)
 gouache AITS(c); MAPA; NHB 30(10-67),9; STU 161(1-61),
 26

"The Migration Was Spurred..." (Migration of the Negro Series)
 tempera 1940 AH 22(12-70),17(c); FOR 24(11-41),105(c)

"Mistreatment by the Spanish Soldiers" (Toussaint L'Ouverture
 Series) oil 1938 (Fisk) SBMAA

"Most of the People Are Very Poor" (Harlem Series) gouache 1943
 ALIA; MO 22(4-62),17; NM 47(6-8-53),29; VO 102(6-15-43),
 95(c)

"Mothers and Fathers Worked Hard..." (Migration of the Negro

Series) watercolor 1943 AD 17(5-15-43),7; AD 19(2-1-45),8;
 MA 38(11-45),252
"Munich Olympic Games" gouache 1971 AG 15(5-72),W5; AI 16
 (5-20-72),42; AN 86(10-87),35(c); AV 3(Olympic issue-88),
 cover; BAAG; PR 33(11/12-79),41; SMI 18(6-87),61(c)
"Munich Olympic Games (Study)" gouache 1972 (Seattle) OIAE
"The Negro and the White Worker..." (Migration of the Negro
 Series) FOR 24(11-41),107(c)
"The Negro, Being Moved Suddenly..." (Migration of the Negro
 Series) BAQ 2(2-77),55; BAQ 5(#3-82),13; FOR 24(11-41),
 107(c); NHB 20(10-67),8
"The Negroes Who Had Been Part..." (Migration of the Negro
 Series) tempera 1940 DANA
"The Negroes Who Were Already..." (Migration of the Negro
Series) FOR 24(11-41),106(c)
"New Jersey" gouache 1984 ADMC; MA 40(1-47),25
"Nigerian Meat Market" gouache 1964 FFBA
"Night" gouache c1938 AFTM
"Night After Night" tempera 1952 STU 161(1-61),26; TIM 77
 (2-24-61),62(c)
"The 1920s: The Migrants Cast..." (Migration of the Negro Series)
 AIM 64(3-76),120(c); WEAL(c)
"Northbound" tempera 1962 GAI
"Occupational Therapy" AN 49(11-50),65
"On a Hot Summer Day About 1821..." (Harriet Tubman Series)
 tempera (Hampton) AV 1(2-87),32(c)
"One of the Largest Riots..." (Migration of the Negro Series)
 watercolor 1940-1 (Modern Art) AH 22(12-70),39(c); FOR 24
 (11-41),107(c); MA 38(11-45),252; PASMOMA; PMNA; STU
 161(1-61),26; TAB
"The Ordeal of Alice" tempera 1963 BAOA-2
"Other Rooms" 1977 ESS 17(11-86),90(c)
"Painters Playing Cards" AIM 51(4-63),41(c)
"Paper Sail Boats" tempera 1949 (Nebraska) APCS(c); FAL
"Parade" oil 1960 BC 3(5/6-73),27(c); ESS 2(4-72),66(c); ESS
 4(11-73),22(c); ESS 4(12-73),29(c); INS 96(2-87),42(c); TCBAA
"The People Live in Firetraps" (Harlem Series) gouache 1942 VO
 102(9-15-43),94(c)
"Photographer's Shop" watercolor 1951 CBAM

"Piano Lesson" gouache (New Jersey) GAI
"Pool Game" (Boston) DCBAA
"Pool Parlor" gouache 1942 (Metropolitan) AN 41(1-1-43),8;
 FAAA; FVVE; MA 38(11-45),253; OPP 21(1-43),18; PMNA; VVE
"Pool Player" 1956 STU 161(1-61),26
"Prayer" (War Series) tempera (Whitney) AN 43(10-15-44),14;
 FAAA
"Praying Ministers" tempera 1962 (Spelman) AG 13(4-70),8(c);
 AN 62(4-63),13; AV 1(2-87),32(c); FAAA; HW 7(3rdQ-68),
 13(c); TEAAA
"Prisoner of War" NAUA
"Race Riots Were Very Numerous..." (Migration of Negro Series)
 tempera 1940-1 (Modern Art) FAAA(c); LAAA(c)
"Radio Repairs" gouache 1946 AD 21(4-15-47),21
"The Railroad Stations..." tempera (Modern Art) PSMOMA
"Recreational Therapy" tempera 1949 FAL
"Reported Missing" (War Series) tempera 1947 (Whitney) FTWM
"Resisting Capture of Fugitive Slaves" AD 20(12-15-45),17; AN
 45(7-46),51
"Rooftops" gouache 1943 (Hirshhorn) AAAT; BABC
"Rooftops Seem to Spread For Miles" (Harlem Series) gouache
 VO 102(9-15-43),94(c)
"Seamstress" tempera 1946 AG 19(11-75),15; AN 47(6-48),64;
NAIA
"Sedation" casein 1950 (Modern Art) AD 25(11-150),16; AUSPS;
 PSMOMA
"Self Portrait" 1977 AN 83(2-84),80; SMI 18(6-87),66(c)
"She Nursed the Union Soldiers..." (Harriet Tubman Series)
 tempera 1939-40 AN 85(9-86),53; ARTF 13(9-74),66
"Shipping Out" AN 46(12-47),44
"The Shoemaker" watercolor 1945 (Metropolitan) FTCA
"The Slave" casein (Hampton) FHBI(c)
"Slave, Part 1, No. 5" ESS 17(11-86),91(c)
"Slave Trade Reaches Its Height..." tempera SG 28(3-39),225
"Slaves Were Driven to Revolt" tempera 1938 LNIA
"Slums" gouache 1951 NAIA(c)
"Sometimes to Keep Migrants..." (Migration of the Negro Series)
 FOR 24(11-41),106(c)

"The South That Was Interested..." (Migration of the Negro Series)
 tempera 1940 (Phillips) AI 16(12-72),37; AWAP
"Southern Conditions..." (Migration of the Negro Series) FOR 24
 (11-41),106(c)
"Square Dance" (Hospital Series) SMI 18(6-87),61(c)
"Street Clinic" gouache 1937 FAAA
"Street Orator" gouache 1936 AIM 76(2-88),133(c); NAUA
"Street Scene" watercolor 1961 BUNY
"Street Scene #1" gouache 1936 STHR(c)
"Street Scene--Restaurant" gouache c1936 ANY(c); ESS 17
 (11-86),91(c)
"Street to Mbari" gouache 1964 IBA; SMI 18(6-87)63(c)
"Struggle, No. 2" ink and gouache (Seattle) AAAJ 17(#1-86),23
"Studio" gouache 1977 AIM 76(2-88),131(c); AN 86(12-87),143
 (c); AW 17(8-23-86),cover
"Study for Kingdome Mural" gouache 1978 EWCA(c)
"Subway Acrobats" tempera 1959 AP 70(10-59),106; BAQ 1
 (Wi-77),26(c); BAQ 5(#3-82),33; MN 60(1-82),44; NW 3
 (#1-76),31
"Summer Street Scene in Harlem" 1948 AIM 78(12-90),30(c)
"Surgery" tempera 1953 (Harlem Hospital) ARTF 13(9-74),67
"Swearing In, No. 1" gouache 1977 JJ 22(8/10-89),34(c)
"There Had Always Been Discrimination..." (Migration of the
 Negro Series) gouache 1942 (Phillips) DBLJ
"There Were Race Riots..." (Migration of the Negro Series) FOR
 24(11-41),106(c)
"They Also Found Discrimination..." (Migration of the Negro
 Series) tempera 1940 AH 22(12-70),39
"They Also Made It Very Difficult..." (Migration of the Negro Ser-
 ies) gouache 1942 (Modern Art) DBLJ; FOR 24(11-41),106(c)
"They Did Not Always Leave..." (Migration of the Negro Series)
 tempera 1940 FOR 24(11-41),103(c)
"They Felt that Injustice..." (Migration of the Negro Series) FOR
 24(11-41),104(c)
"They Were Very Poor..." (Migration of the Negro Series) oil
 (Modern Art) CVAH; EB 23(2-68),120(c); FAAA; FOR 24
 (11-41),103(c); SBMAA
"This Is Harlem" watercolor NBAT

"Three Family Toilet" watercolor 1943 STHR

"Time to Rest" tempera 1967 (National Gallery) AMNGA(c)

"To Preserve Their Freedom" serigraph 1982 BC 19(#4-89),179(c)

"Tombstones" gouache 1942 (Whitney) AA 35(11-71),69; AARE
3(11/12-76),116(c); AIPP; AP 104(12-76),511(c); AN 42
(12-1-43),22; AN 70(3-71),3; AUSPS; BAQ 5(#3-82),15(c); BC
8(9/10-77),51(c); CCWM; DANA; DBLJ; EB 32(2-77),33(c);
FAAA; HWCP; HWCP; HWCPA; NAIA; SG 31(11-42),479;
NAE 15(12-87),56; RAR; SMI 7(10-76),93(c); SMI 18(6-87),56
(c); TCBAA; TIMAPN(c); TNAP

"Tools" litho 1977 AN 77(3-78),105

"Toussaint at Emmery" (Toussaint L'Ouverture Series) serigraph
1984 BAQ 9(2-90),cover(c)

"Toussaint Captures Dordon" (Toussaint L'Ouverture Series)
tempera 1938 LNIA

"Toussaint Defeats Napoleon's Troops at Ennery" (Toussaint
L'Ouverture Series) tempera 1938 (Fisk) BAQ 5(#3-82),49(c);
LNIA

"Toussaint L'Ouverture" (Toussaint L'Ouverture Series) tempera
AN 43(10-15-44),14

"Toussaint Orders the New Constitution" (Toussaint L'Ouverture
Series) tempera LNIA

"Toussaint Witnesses Slavery" (Toussaint L'Ouverture Series)
tempera LNIA

"Underground Railroad" drawing 1948 FAAA

untitled (Hampton) SMI 18(6-87),59(c)

untitled gouache 1976 ADMC

untitled oil 1958 ADMC(c)

"The Vast Numbers of Migrants..." (Migration of the Negro Series)
FOR 24(11-41),107

"Vaudeville" tempera 1951 (Hirshhorn) AHHA(c); DAHHA;
FAAA(c); HAR(c); MRAA; SMI 18(6-87),61(c); THYA(c); TIM
61(2-2-53),51(c)

"Village Quartet" tempera 1954 AV 2(10-87),39(c)

"Wash Day" 1942 ART 56(11-81),7(c)

"The Watchmaker" gouache 1946 FFBA

"We Declare Ourselves Independent" tempera 1956 AWAP

"The Wedding" tempera 1948 TIM 53(4-11-49),57

"Windows" gouache 1977 AIM 66(3/4-78),148; AN 77(3-78),
 105; BAQ 5(#3-82),57(c)
"Windows" litho 1977 AN 77(3-78),105
"Winter" 1946 AN 45(5-46),45
"The Worker" 1971 BAQ 3(#-79),47
"Worship" 1945 MA 38(11-45),250
"Workshop" litho 1972 OAAL
"Wounded Man" gouache 1968 AIM 76(2-88),130(c)
"You Can Buy Whiskey for Twenty-five Cents a Quart" (Harlem
 Series) MRAA; NEW 21(6-7-43),100; TMRAA
Further References:
 Escoffery, Gloria, "Jacob Lawrence: The Man and His Work,"JJ
 22(10/89),30-37.
 Fax, Elton. *Black Artists of the New Generation*. New York: Dodd,
 Mead, 1977.
 "Jacob Lawrence," BE 6(12-75), 66-8.
 Lewis, Samella, "Jacob Lawrence," BAQ 5(#3-82),4-45.
 Sullivan, Lester, "Lawrence's Style and the Series Form," BAQ 5
 (#3-82),46-50.
 Wheat, Ellen H. *Jacob Lawrence, American Painter*. Seattle: Uni-
 versity of Washington Pr., 1986.
 Williams, Milton, "America's Top Black Artist," SEP 23(8-74),
 75-8.

LAWRENCE, JAM, 1947- ; graphic artist
 Biographical Sources: LAAA
 Published Reproductions:
 "Growth of a Child" drawing 1970 LAAA

LAWSON, CLARENCE, 1909- : b. in Beaumont, TX; painter, sculp-
 tor
 Biographical Sources: AAA
 Published Reproductions:
 "Head of a Negro Girl" bronze sc (Chicago) PMNA
 "Malayan Village" oil 1939 LNIA

LEBLANC, LOUIS; painter
 Published Reproductions:
 "Bather" oil 1954 BAIH(c)

LEE, JAMES, 1927- ; painter, printmaker
Published Reproductions:
 "Cleo II" oil DCBAA

LEE-SMITH, HUGHIE, 1915- ; b. in Eustis, FL; painter
Biographical Sources: CBAM; NAI; TCBAA; TNAP; WWAA,1991
Portrait: AG 11(4-68),27; DANA ; EB 18(9-63),13
Published Reproductions:
 "Aftermath" oil 1948 (Johnson) CBAM; EB 29(12-73),38; FAAA
 "Animus Perdus" EB 13(4-58),33(c)
 "Artist's Life" litho 1938 LNIA
 "Boy on Roof" oil 1967 AG 13(4-70),17(c); EB 23(2-68),cover
 (c); FAAA; HW 7(3rdQ-68),14(c); LAAA; TEAAA
 "Boy with Tire" oil 1955 (Detroit) AAAC; BC 3(5/6-73),27
 (c); DANA; ESS 2(4-72),66(c); ESS 4(11-73),22(c); ESS 4
 (12-73),29(c); FAAA
 "Chicago Landscape" EB 13(4-58),33(c)
 "Cliff Grass" oil ILAAL
 "Confrontation" oil 1975 AA 42(10-78),53
 "Counterpoise II" oil 1987 AN 89(3-90),176; AV 5(8-90),27(c)
 "The Couple" oil 1989 AV 5(9-90),31(c)
 "Desert Elegy" AN 86(12-87),156; AV 5(8-90),cover(c)
 "Desolation" litho 1938 LNIA
 "Discussion on the Roof" oil c1956 AA 42(10-78),52
 "Entrance" oil 1956 AA 42(10-78),52
 "Festival's End" oil 1959 AG 11(4-68),29(c); DANA
 "Girl with a Portfolio" oil EB 45(2-90),135(c); ESS 20(2-90),115
 (c)
 "Hanging Club" oil 1954 BACW; FAL
 "Impedimenta" oil 1958 DANA
 "Indecision" oil 1982 AV 1(11/12-86),9(c); STHR
 "Interval" oil 1969 AA 42(10-78),50(c)
 "Landscape" oil 1943 MA 36(5-43),190
 "Lost Dream" AIM 78(2-90),168(c)
 "Man Standing on His Head" oil 1969 AA 42(10-78),49(c); AV
 5(8-90),31(c); DCBAA; FAAA
 "Man with Balloon" oil 1969 AA 42(10-78),50; AAANB; CRI
 77(4-70),cover; FAAA
 "Maypole" oil AG 16(1-73),6

"The Old Man" oil AWAP(c)
"The Other Side" oil AA 42(10-78),51
"The Other Side II" oil c1965 FAL
"Outing" oil 1960 AA 42(10-78),52; AG 16(1-73),24; GAI
"Passage" oil 1988 AV 5(8-90),28(c)
"Reflection" oil 1957 AAATC(c)
"The Scientist" oil c1950 FAL
"The Secret" oil 1987 BAAG
"Slum Song" oil 1944 BAQ 1(Wi-76),23(c); EB 32(2-77),38;
 LAAA; TCBAA
"Soliloquy" oil 1977 AA 42(10-78),48(c)
"Still Life with Oranges" oil 1975 FAL
"Summertime" oil 1989 AV 5(8-90),28(c)
"Two Girls" oil AG 12(1-69),47
"Unusual Landscape" oil 1943 (Atlanta) NAI
"Urban Renewal" oil 1975 FAL
"Waiting" 1987 AIM 75(9-87),121(c); FA #136(10-87),35(c)
"The Wall" oil 1989 AV 5(8-90),28(c)
"Woman with Pink Tam" oil BE 17(12-86),86(c)
"Young Man" OW 6(5-51),30
Further References:
Greene, Carroll, "Hughie Lee-Smith: Breakthrough," AV 5(8-90),
 26-31.
Wald, Carol, "The Metaphysical World of Hughie Lee-Smith," AA
 42(10-78),48-53.

LE FALLE, LIZZETTA, 1948- ; b. in Los Angeles; painter
Biographical Sources: BWSB
Published Reproductions:
"Sunday Morning, Friendship Baptist Church" ABWA

LEONARD, LEON LANK, SR.,1922- ; b. in Waco, TX; painter,
 sculptor
Biographical Sources: AAA; WWAA,1978
Published Reproductions:
"African Laborer" EB 13(4-58),34(c)
"African Mother and Child" EB 13(4-58),34(c)
"Pride of Eight" acrylic,watercolor EB 29(12-73),40(c)

LEVERT, BRUCE; painter
Published Reproductions:
"Illustration: Africa" BC 7(3/4-77),39(c)

LEVINE, EMMA AMOS, 1938- ; b. in Atlanta, GA; painter, print-
maker
Biographical Sources: AAA; AAANB; CBAM
Portrait: AN 65(9-68),48
Published Reproductions:
"Harvest II" etching PANA(c)
"Horizons" etching,serigraph 1968 CBAM
"The Ladies" etching,serigraph AAANB; FUF
"Runner with Cheetah and Streaks" acrylic 1984 BALF 19(Sp-85),
25
"Take One" 1985 ART 62(3-88),104
"Without Feather Boa" etching 1965 AN 65(9-66),50

LEWIS, EDMONIA, 1843-1900; b. in Albany, NY; sculptor
Biographical Sources: AMNCA; GNNP3; LAAA; MIAP; TCBAA
Portrait: AIM 62(7-74),72; WA
Published Reproductions:
"Abraham Lincoln" marble sc 1867 (San Jose) AAW; ANCS;
FAAA; GANS; PMNA; WAA
"Anna Quincy Waterston" marble sc c1866 ST
"Asleep" marble sc 1871 AIM 24(1-36),25; ANCS; FAAA; PMNA
"Awake" marble sc 1872 AIM 24(1-36),25; ANCS; FAAA;
PMNA; TCBAA
"Bust of a Woman" marble sc PMNA
"Charles Sumner" plaster sc 1876 DANA; LNIA
"The Dying Cleopatra" marble sc EB 32(2-77),36
"Forever Free" marble sc 1867 (Howard) AAJ 11(7-79),48; AIM
62(7/8-74),71; AP 87 (2-68),142; CRI 79(6/7-72),199; EB 23
(2-68),122; FAAA; FFAA; FHBI(c); GANS; LAAA; RD 112
(6-78),184(c); ST
"Hagar" marble sc c1871 (African Art) AG 11(4-68),15; AG 13
(4-70),2; AIPP; AWSR; DBLJ; FAAA; HW 7(3rdQ-68),12; ST;
TNAP; WA; WWAHC
"Henry Wadsworth Longfellow" marble sc 1879 (Howard) AAH;
LAAA; ST

"Heritage II" linocut BC 7(9/10-76),42(c)
"Hiawatha" marble sc 1868 AAJ 16(Su-84),62; ANCS; ANT 102
 (11-72),739; ENC 4(6-23-75),66; GANS; MWF
"Jacuna and Snakes" print 1984 ART 59(6-85),43
"James Peck Thomas" marble sc c1876 LNIA; NHB 2(3-39),51;
 NHB 9(4-46),152; PMNA
"Minnehaha" marble 1868 (Howard) AAJ(Su-84),63; ANCS;
 ANT 102(11-72),739; GANS; MWF
"Moses" marble sc 1875 ST
"The Muse, Urania" pencil 1862 AJ 9(11-77),104; AWSR; ST
"Old Indian Arrow Maker and His Daughter" marble sc 1872
 (Smithsonian) AAJ 16(Su-84),60; AIM 62(7-74),70; AMNCA;
 ANCS; AWA(c); AWSR; CBAR; ENC 4(6-23-75),66; FAAA;
 GANS; PMNA; ST; TAAP; TNAP; WAIH; WMF
"Poor Cupid" marble sc 1876 (Smithsonian) BAQ 4(#2-80),39;
 ST; WMF
"Young Octavian" marble sc 1873 ST
Further References:
Blodgett, Geoffrey, "John Mercer Langston and the Case of Edmon-
 ia Lewis: Oberlin, 1862," JNH 53(7-68),201-18.
Tufts, E.M., "Edmonia Lewis, Afro-Indian Neo-Classicist," AIM
 62(7-74),71-2.

LEWIS, EDWIN E.; b. in Philadelphia; painter
Biographical Sources: AAA
Published Reproductions:
 "Adam" EB 13(4-58),35(c)
 "Eve" EB 13(4-58),35(c)

LEWIS, FLORA CARNELL, 1903- ; b. in Atchison, KS; painter
Biographical Sources: TTT
Published Reproductions:
 "Christ and the Women at the Well" oil TTT
 "Farm Life" oil TTT

LEWIS, JAMES E., JR., 1923- ; b. in Phenix, VA; painter,
 sculptor
Biographical Sources: AAA; FAAA; WWABA,1978
Portrait: FSBA

Published Reproductions:
 "Black Soldier" bronze sc BAQ 6(#3-85),63
 "Broadway Median Strip Sculpture" FSBA
 "Fountain Sculpture" sheet bronze sc 1970 FAAA
 "Frederick Douglass" oil 1956 DANA; FAAA; NHB 20(1-57),75
 "Portrait of Judge William Hastie" sc FSBA
Further References:
 Fax, Elton. *Seventeen Black Artists*. New York: Dodd, Mead, 1971.

LEWIS, JOE; painter
Published Reproductions:
 "The First Time I Saw a Radio Like This" ARTF 38(3-90),112(c)

LEWIS, NORMAN, 1909-1983; b. in New York City; painter
Biographical Sources: FAAA; LAAA; NAI; TCBAA; WWAA,1991
Portrait: BE 6(12-75),59; EB 18(9-63),131
Published Reproductions:
 "Arrival and Departure" oil 1968 AIM 50(9-70),56(c); FAAA(c)
 "By the Sea" oil 1972 AV 4(6-89),20(c)
 "Cadenza" oil 1951 AN 56(1-58),30
 "Carnaval" oil 1965 ART 64(10-89),106; BACM
 "Cathedral" oil 1950 (Chicago) DANA
 "Composition" oil 1952 AIM 74(3-86),154; TCBAA
 "Dispossessed" oil 1938 LNIA
 "Every Atom" oil 1951 AG 13(4-70),18(c); FAAA
 "Fantasy" oil 1936 STHR
 "Four Figures" oil AN 43(2-1-45),16; NAI
 "Girl in the Yellow Hat" oil 1936 AV 4(6-89),22(c)
 "Harlem Turns White" oil 1955 BABC(c)
 "Heroic Evening" oil AAANB
 "Jumping Jive" EB 1(12-45),50
 "Madonna" oil 1934 AN 86(4-87),198; AV 4(6-89),21
 "Migrating Birds" oil 1953 (Carnegie) CM 30(1-56),11; DANA
 "Moon Madness" ink,oil 1952 STHR(c)
 "Night Walk" oil 1957 NIA
 "Number 7" oil 1973 AV 4(6-89),20(c)
 "Ovum" oil 1961 LAAA
 "Procession" oil 1964 AN 65(9-66),49
 "Processional" oil 1965 AV 4(6-89),23(c); FAAA; LAAA

"Street Music, Jenkins Band" oil 1944 (Schomburg) STHR(c)
"Study" oil 1954 AWAP
"Study in Blue and White" oil 1954 BACW
untitled BE 6(12-75),59(c)
"The Yellow Hat" oil 1936 BALF 19(Fa-85),cover; BCR 3
 (Fa-71),cover; EB 23(2-68),120; FAAA; HW 7(3rdQ-68),cover;
 LAAA; LNIA; NBAT; SA 71(12-71),24
Further References:
James, Curtia, "Norman Lewis: Pathfinder," AV 4(6-89), 19-23.

LEWIS, ROY; muralist
Published Reproductions:
 "Wall of Respect" mural 1967 BC 11(#2-80),100(c)

LEWIS, SAMELLA SANDERS; b. in New Orleans; painter, sculptor
Biographical Sources: AAA; BAOA-1; WWAA,1991
Portrait: BAOA-1; ESS 3(2-79),46
Published Reproductions:
 "Banyon" oil 1965 BAOA-1(c)
 "Boy with Flute" oil 1968 GAI
 "Burning Bush" oil 1964 BAOA-1(c)
 "Canefield" serigraph BAOA-1(c)
 "City" oil BAOA-1(c)
 "Field" BAQ 9(#1-90),57
 "Fruit" oil 1968 BAOA-1(c)
 "Garbageman" oil 1969 ESS 3(2-73),46; BAOA-1(c)
 "Heritage II" linocut BC 7(9/10-76),42(c)
 "Migrants" linocut 1967 AG 13(4-70),10; BAQ 2(Sp-78),12
 "Royal Sacrifice" oil 1969 BAOA-1(c);BAQ 2(#3-78),61; BAQ
 2(1#4-78),61; BAQ 3(#1-79),69; DBLJ; LAAA(c)
 "Sharecroppers" DES 46(9-44),21
Further References:
 "Portrait of Samella," ESS 3(2-73),46.

LIAUTAUD, GEORGES; b. in Haiti; sculptor
Published Reproductions:
 "Crucifixion" wrought iron sc LA 35(2-67),102

LIGHTFOOT, ELBA, 1910- ; b. in Evanston, IL; painter

Biographical Sources: AAA
Published Reproductions:
 "Portrait of a Child" oil 1938 LNIA
 "Toy Parade" mural (Harlem Hospital) ART 52(10-77),125

LILY, CHARLES; illustrator, painter
Published Reproductions:
 "Hannibal--Ruler of Carthage" BC12(#4-82),167(c); EB 33
 (12-77),82(c)
 "Idris Alooma--Sultan of Bornu" BC 12(#4-82),170(c); EB 36
 (2-81),74

LINDSAY, ARTURO; b. in Colon, Panama; sculptor
Portrait: BAQ 6(#2-84),58
Published Reproductions:
 "Mascara I" bronze sc 1981 BAQ 6(#2-84),61
 "Mascara III" bronze sc 1981 BAQ 6(#2-84),63
 "Mask" plaster sc BAQ 6(#2-84),59
Further References:
 Miller, James, "Ancestry and the Art of Arturo Lindsay," BAQ 6
 (#2-84),58-63.

LINTON, HENRI, 1944- ; b. in Alabama; painter
Biographical Sources: AAA; BDCAA
Published Reproductions:
 "Alone" oil 1968 (Atlanta) BDCAA(c)

LION, JULES, 1810-1866; b. in France; painter, lithographer
Biographical Soures: NYDA; TCBAA
Published Reproductions:
 "Child with Toy Dog" litho LPP
 "Portrait of John J. Audubon" litho 1860 AJ 36(Fa-76),58; CRI
 83(11-76),317; RD 112(6-78),180(c); TCBAA
 untitled litho LPP
Further References:
 Perry, Regina A. *Selections of Nineteenth Century Afro-American
 Art.* New York: Metropolitan Museum of Art, 1976.

LITTLE, JAMES; painter

Published Reproductions:
 "Ovambos" oil 1983 STHR

LLOYD, MARCIA; painter
Published Reproductions:
 untitled oil ENC 4(6-23-75),86

LLOYD, TOM, 1929- ; b. in New York City; sculptor
Biographical Sources: AAA; AAANB; CBAM; FAAA
Published Reproductions:
 "Caxambus" electronic light sc 1966 AN 67(11-68),15
 "Dalphon" sc ART 40(11-65),60
 "Mantara" electronic sc 1965 CBAM
 "Medevar II" electronic sc AG 11(4-68),33
 "Moskee" electronic sc 1967 AAAC; AG 13(4-70),24(c); AJ 31
 (Wi-71),189
 "Mousakoo" electronic sc 1968 FAAA
 "Reflections" collage AG 15(4-72),47
 "Resawan" light sc 1968 AIM 58(9-70),65
 "Veleuro" electronic sc 1968 ANA 35(1969),136; FAAA

LOCKARD, JON ONYE, 1932- ; b. in Detroit; painter
Portrait: ND 17(3-68),93
Published Reproductions:
 "The Black Messiah" oil ND 17(3-68),94
 "Interruption" oil ND 17(3-68),96
 "Plea for a Second Chance" oil ND 17(3-68),95
 "What Are You Going to Tell Them?" BBB 2(Wi-74),cover

LOCKE, DONALD,1930- ; b. in Stewartville, Guyana; sculptor
Published Reproductions:
 "Phoenix Bird" 1980 AV 4(10-89),40(c)
 "Pomona" sc 1985 AV 4(10-89),39(c)
 "The Room: An Environment with Fifteen Black Surfaces" instal-
 lation AV 4(10-89),38
 "Venus Seed" AV 4(10-89),40(c)
Further References:
 Hay, Vicky, "The Multifaceted Donald Locke," AV 4(10-89),37-
 40.

LOFTON, LIONEL; b. in Houston, TX; mixed media
 Portrait: BC 19(#2-88),119
 Published Reproductions:
 "Jazz Set" mixed media BC 19(#2-88),119(c)
 "Life Style" mixed media BC 19(#2-88),119(c)
 "Nightime Ragtime" mixed media BC 19(#2-88),119(c)

LOGAN, JUAN LEON, 1946- ; b. in Nashville, TN; sculptor
 Biographical Sources: DIAA; LAAA
 Portrait: BAOA-1; DIAA
 Published Reproductions:
 "Growth Process" steel sc 1973 DIAA; LAAA
 "Reconstruction Period" galvanized steel 1972 DIAA
 "Sadie" welded steel sc 1971 BAOA-1
 "Traditional Trap" steel sc 1972 AIM 62(11-74),41
 "Woman Reaching Out" steel sc 1971 LAAA

LONG, BERT, 1940- ; b. in Houston, TX; painter
 Portrait: FTA; SEP 28(5-79),71
 Published Reproductions:
 "Artists" acrylic 1985 AIM 75(4-87),191(c); FTA(c)
 "Faceless America" 1979 AIM 73(7-85),92(c)
 "Family" 1980 AN 79(12-80),127
 "Marriage Made in Hell" SEP 28(5-79),71
 untitled ART 64(12-89),20(c)
 untitled ART 64(Su-90),27(c)
 "Vision X" mixed media 1983 ART 58(12-83),59(c)
 Further References:
 Moore, Hank, "Cooking a New Recipe Through Art," SEP 28(5-79),
 66-72.

LONGSHORE, WILLIE F., 1933- ; b. in Roanoke, AL; painter
 Biographical Sources: AAA
 Portrait: BAOA-1
 Published Reproductions:
 "Gloria" pastel 1960 BAOA-1

LOPER, EDWARD L., 1916- ; b. in Wilmington, DE; painter
 Biographical Sources: AAA; BACW; NAI; WWAA,1953

Published Reproductions:
 "Back Yards" oil (Philadelphia) NAI
 "Behind the Tracks" oil 1939 PMNA
 "Quarry" oil DANA
 "Taking Down Clothes" oil 1939 LNIA
 "Twelfth Street Gardens" oil 1942 ILAAL
 "Under the Highline" oil 1944 NBAT

LORD, FRANCISCO P.; sculptor
 Biographical Sources: AAA
 Published Reproductions:
 "Frederick Douglass" plaster sc 1938 LNIA

LOTT, JESSE, 1951- ; b. in Ft. Knox, KY; mixed media
 Biographical Sources: NGSBA
 Published Reproductions:
 "Shamed Faced Woman" wood,metal 1976 NGSBA(c)
 "Tribute to Eula Love" mixed media 1984 NGSBA(c)
 "Woman" wire,glass 1976 NGSBA(c)

LOUIS, MORRIS; painter
 Published Reproductions:
 "2-69" acrylic 1959 (Corcoran) AWAP

LOVE, EDWARD, 1936- ; b. in Los Angeles; sculptor
 Biographical Sources: BAAL; BAOA-2; LAAA
 Portrait: BAAL; BAOA-2
 Published Reproductions:
 "Genesis" hydracal 1967 BAOA-2(c)
 "Mask for Mingus" welded steel 1974 BAAL(c)
 "Osiris" steel sc 1972 LAAA
 "Signs: Maximum Security Series" installation 1988 NGSBA(c)
 "Sweet Rockers" welded steel 1988 BAAL(c)
 "Totem for Senufo" welded steel 1974 BAAL(c)
 "Wailers" welded steel 1984 BAAL(c)

LOVELACE, NINA; painter
 Portrait: WJBS 4(#1-80),40
 Published Reproductions:

"Sister" WJBS 4(#1-80),40(c)

LOVELL, WHITFIELD, 1959- ; b. in New York City; painter
Biographical Sources: BALF 19(Sp-85),46-7
Published Reproductions:
 "Expulsion" pastel 1984 BALF 19(Sp-85),47

LOVING, ALVIN D., JR., 1935- ; b. in Detroit; painter
Biographical Sources: AAA; AAANB; WWAA,1991
Portrait: STU 179(4-70),187
Published Reproductions:
 "Abstract" AI 15(1-71),13; AIM 59(3-71),16; ARTF 9(3-71),16;
 ART 45(3-71),6
 "Billy's Comment" acrylic 1971 ART 45(3-71),66
 "Cube 31" acrylic 1971 FAAA
 "Cube #42" 1970 ART 44(Su-70),cover(c)
 "Diana: Time Trip, No. 2" sc 1971 AN 70(4-71),53
 "Lauri #8" AIM 73(4-85),202(c)
 "Luba" mixed media 1972 ARTF 10(6-72),86
 "Mercer Street #1" 1984 AN 84(1-85),18(c)
 "Mercer Street #7" ARTF 23(12-84),35; AIM 72(12-84),35; AN
 83(12-84),34
 "Paul" AI 18(Su-74),30
 "Roger" mixed media 1974 ARTF 13(9-74),83
 "Self Portrait" fabric 1984 EWCA(c)
 "Self Portrait, April 1984" mixed media 1984 STHR(c)
 "Shades of '73: Composition for 1980" wall hanging TIM 115
 (3-31-80),72(c)
 untitled SMIH (2-77),1
 untitled acrylic AN 70(3-71),75; ART 45(3-71),6; ARTF 9
 (3-71),16
 untitled mixed media AIM 61(9/10-73),100(c)
 untitled oil,collage c1975 AIM 78(3-90),217
 untitled mixed media CGB(c)
 untitled mixed media CGB
 "Wyn...Time Trip I" acrylic 1971 DCBAA; FAAA
 "Wyn II" mixed media 1971-2 FAAA
 "Wyn III" mixed media 1972 AI 16(5-20-72),57

Further References:
"Alvin Loving at William Zierler," AIM 61(9-73),110.
"Anthology of Recent Works by A. Loving at the Whitney," STU
179(4-70),187.

LOY, RAMON, 1896-?; b. in Havana, Cuba; painter
Biographical Sources: AAA
Published Reproductions:
"A Duet" oil 1939 LNIA

LUCKETT, WILLIAM EDWARD, 1897-?; b. in St. Charles, IL;
painter
Published Reproductions:
untitled oil CRI 36(10-29),341

LUTZ, JOHN CHORAM, 1908- ; b. in Hickory, NC; painter
Published Reproductions:
"Backwoods Burial" oil 1938 LNIA
"Portrait of the Artist's Sister" oil 1935 LNIA

MCALLISTER, DON; graphic artist, sculptor
Published Reproductions:
"Dream Deferred # 1" wood sc BC 9(#3-79),102(c)
"Free All the Gary Tylers" wood sc BC 9(#3-79),103(c)
"Mis-Education" wood sc BC 9(#3-79),103(c)
"Officer, Please Don't Shoot" wood sc BC 9(#3-79),102(c)
"Scientific Slavery" wood sc BC 9(#3-79),103(c)
"Self-Hatred and Despair" wood/metal sc BC 9(#3-79),103(c)

MCCALL, THEADIUS, 1949- ; b. in New York City; painter
Published Reproductions:
"Bless 'Em" pastel SEP 16(8-67),77
"The Faye Harlots" SEP 16(8-67),80
"Faye Harlot's Reluctant Sister" SEP 16(8-67),80
"The Gossiping Woman" SEP 16(8-67),76
"The Hebrew Prophet" SEP 16(8-67),80
"Lawd Have Mercy" SEP 16(8-67),77
"The Lawd's Child" SEP 16(8-67),76
"A Muchacha Rosa" SEP 16(8-67),77

"The Old Rabbi" SEP 16(8-67),80
"Pesos Hustlers" SEP 16(8-67),78,80
"The Rabbi" SEP 16(8-67),79
"Rubin the Fightin' Hurricane" ENC 6(6-6-77),36
"Wonder What They're Saying About Cousin Jeff Anna" ENC 6
 (6-6-77),36
Further References:
"The Subject Is People," ENC 6(6-6-77),36.
"Theadius McCall: Impatient Young Artist," SEP 16(8-67),76-80.

MCCANNON, DINDGA; b. in New York City; painter, printmaker
Biographical Sources: AAA
Portrait: ENC 6(8-1-77),35
Published Reproductions:
 "Robin" 1972 MS 2(9-73),26(c)
 untitled BCR 4(Wi-73),55
 untitled BCR 4(Wi-73),54

MCCLUNEY, EDWARD, JR.; printmaker
Biographical Sources: AAA; AAANB
Published Reproductions:
 "Howard" etching 1970 AAANB

MCCOWAN, JESSE; painter
Published Reproductions:
 "Holiday" tempera 1957 BAIH(c)

MCCRARY, SAM, 1943- ; b. in Mt. Clemens, MI; painter
Biographical Sources: FIBO
Published Reproductions:
 untitled 1976 FIBO

MCCULLOUGH, GERALDINE HAMILTON, 1928- ; b. in Edin-
 burg, AR; printmaker, sculptor
Biographical Sources: AAA; GNNP3; TNAP; WWABA,1978
Portrait: DIAA; EB 21(8-66),94; EB 19(6-64),113
Published Reproductions:
 "Apollonian Fall" EB 28(4-73),98
 "Black Diamond" woodcut PANA(c)

"Black Knight on a Unicorn" bronze sc 1965 EB 28(4-73),98
"Confrontation" welded sheet copper sc EB 28(4-73),98
"Housing Project Totem" welded sheet copper construction
 1963 DIAA; EB 28(4-73),98; GAI
"Malcolm X" etching EB 28(4-73),98
"Malcolm X" etching EB 28(4-73),98
"The Oracle" EB 29(12-73),37; EB 33(10-78),155(c)
"Our King" EB 28(4-73),94; EB 33(10-78),156(c); JET 43(2-1-73),
 7
"Phoenix" welded sheet sc EB 28(4-73),98; EB 19(6-64),114
"Ten-Four Goodbuddy" copper sc 1978 FFAA(c)
"Tower of Babel" EB 28(4-73),102
"War Dancers" construction 1965 EB 28(4-73),102
Further References:
"A Gold Medal for Talent," EB 19(6-64),113-20.
"Sculptor Looks at Martin Luther King," EB 28(4-73),94-104.

MCGAUGH, LAWRENCE, 1940- ; b. in Newton, KS; painter
Biographical Sources: AAA
Portrait: BAOA-1
Published Reproductions:
"Sleeping Man" oil BAOA-1
"World Scape" oil ONPB

MCGEE, CHARLES W., 1924- ; b. in Clemson, SC; painter
Published Reproductions:
"African Market" oil 1966 NBA
"Conversation" oil 1966 NBA
"Despondence" oil 1960 (Howard) DBLJ
"Hope" serigraph,oil CRI 78(8-71),cover(c)
"Ritual" oil 1966 NBA
"Square and Things" oil 1967 AG 11(4-68),19
"Untitled No. 1" charcoal 1969 (Detroit) DCBAA

MCILVAINE, DONALD W.; muralist, painter
Published Reproductions:
"Into the Mainstream" Chicago mural TIM 95(4-6-70),83(c)

MCINTOSH, KARL, 1940- ; b. in Tulsa, OK; painter, printmaker

Biographical Sources: BAOA-1
Portrait: BAOA-1
Published Reproductions:
 "The Afrindiland" graphite 1974 BAOA-1
 "Bang" watercolor BAOA-1
 "Who Do You Think You Are?" etching BAOA-1

MACK, JOSEPH L.; b. in High Point, NC; painter
Published Reproductions:
 "Four Freedoms" DES 46(9-44),21

MCKAY, EDWARD R.; b. in Lillington, NC; painter
Biographical Sources: DENA
Portrait: DENA
Published Reproductions:
 "Nigerian Mask" acrylic DENA

MCKINNEY, THOMAS A.; painter
Biographical Sources: AAA
Published Reproductions:
 "Paul Robeson" BAQ 5(#3-82),64(c)

MCMATH, ALEXANDER, 1945- ; b. in Clinton, SC; painter
Biographical Sources: OSAE
Published Reproductions:
 untitled acrylic 1975 OSAE

MCMILLON, ROBERT; painter
Published Reproductions:
 "Trane" BC 6(11/12-75),33(c)

MCNEIL, WILLIAM, 1935- ; b. in Austin, TX; painter, printmaker
Biographical Sources: AAA
Portrait: BAOA-1
Published Reproductions:
 "Libera Nos a Malo" woodcut PANA
 untitled oil BAOA-1
 untitled oil BAOA-1

MCNEILL, LLOYD G., 1935- ; b. in Washington, DC; painter
 Biographical Sources: AAA
 Portrait: AG 11(4-68),46
 Published Reproductions:
 "Pieces for Liberation" serigraph 1971 AWAP(c)
 untitled serigraph AG 13(4-70),37
 untitled watercolor AG 16(12-72),74
 "Wall Sculpture" AG 11(4-68),46

MAJOR, CLARENCE; painter
 Published Reproductions:
 "Pumping Gas" oil c1975 BALF 23(Su-89),cover

MAJORS, WILLIAM, 1930- ?; b. in Indianapolis, IN; painter
 Published Reproductions:
 "Big Blue" oil 1969 AG 11(4-68),32(c)
 "Ecclesiastes VII" etching 1965 AN 65(9-66),41
 "Ecclesiastes IX" etching AP 6(1966),25
 untitled oil AG 13(4-70),28(c)

MANN, DAVID, 1927- ; b. in Los Angeles; painter
 Biographical Sources: AAA
 Published Reproductions:
 "The Sink" assemblage ART 41(2-67),50
 untitled oil BAOA-1(c)
 untitled BAOA-1(c)
 untitled BAOA-1(c)

MARSHALL, ULYSSES, 1946- ; painter
 Biographical Sources: AAATC
 Published Reproductions:
 "The Little Red Schoolhouse" collage AV 2(10-87),45(c)
 "Sunshine Meets the Man" acrylic 1980 AAATC(c)

MASON, PHILLIP LINDSAY, 1939- ; b. in St. Louis; painter
 Biographical Sources: AAA; DIAA; WWAA,1978
 Portrait: BAOA-1; DIAA
 Published Reproductions:
 "Black Orpheus and the Butterfly" (Oakland) SEP 17(10-68),29

"Blues People" BAOA-1

"The Deathmakers" acrylic 1968 DBLJ; LAAA-1(c)

"In My Father's House There Are Many Mansions" SEP 17
(10-68),21

"Manchild in the Promised Land" acrylic 1969 AIM 58(9-70),62;
DCBAA

"Native Son" 1967 BAOA-1; SEP 17(10-68),20

"Odetta" 1967 BAOA-1

"Secret of the Golden Flower" acrylic 1974 DIAA

"So Many Things I Might Have Done but Clouds Got in My Way"
litho DCBAA

"Soul-er Eclipse" acrylic 1969 BAQ 2(Sp-78),2(c); BAOA-1
(c); DIAA

"With Everything on My Mind" litho DCBAA

"Woman as Body Spirit" acrylic 1969 BAOA-1(c); BAQ 2
(Fa-77),63(c); BAQ 2(Wi-78),70(c); BAQ 2(#4-78),71(c); BAQ
3(#1-79),71(c); BC 8(5/6-78),cover; LAAA(c)

Further References:
Mason, Phillip Lindsay, "Art and Black Consciousness, " ND 17
(6-68),22-3.

MATHEWS, LESTER NATHAN, 1912- ; b. in San Francisco;
painter, sculptor
Biographical Sources: AAA
Published Reproductions:
"Madonna" sc EB 4(11-48),30
"Mother of the Sea" sc EB 4(11-48),30

MATTHEWS, SHARON ANN; painter, sculptor
Published Reproductions:
"Ghetto" oil 1975 BAIH(c)

MAXWELL, WILLIAM, 1934- ; b. in Los Angeles; mixed media;
sculptor
Biographical Sources: AAA
Portrait: AAA
Published Reproductions:
"Jomo, No.1" ceramic sc BAOA-1
"Texture--La Corrida" mixed media BAOA-1

MAYES, GORDON; painter
Biographical Sources: AAA
Published Reproductions:
 "Target" mixed media NBAT

MAYES, MARIETTA (BETTY), 1939- ; b. in Newark, NJ; mixed media, painter
Biographical Sources: AAA
Published Reproductions:
 "Tusi Princess and Child" mixed media 1970 NBAT

MAYHEW, RICHARD, 1924- ; b. in Amityville, NY; painter
Biographical Sources: DCAA; LAAA; TNAP; WWAA,1991
Portrait: BC 19(#1-88),133
Published Reproductions:
 "Before the Storm" oil 1959 (Brooklyn) BMAP
 "Birth" oil 1968 FAAA; NBAT
 "Counterpoint" oil 1968 CBAM
 "Eclipse" oil AG 13(4-70),16(c)
 "Edge of the Woods" AN 58(11-59),20
 "Gorge" oil 1966 AG 11(4-68),25(c); FAAA(c); HW 7(3rdQ-68), 10
 "Intermezzo" oil 1970 AG 14(3-71),54
 "Iroquois Spring" oil ENC 5(3-8-76),35
 "Marshland" AJ 19(Fa-69),74
 "Meadow" oil BC 19(#1-88),133(c)
 "Mezzo Forte" oil AIM 59(3-71),124
 "Morning Bush" oil 1960 (Whitney) AN 60(1-62),39
 "Opus #1" ink ENC 5(3-8-76),35
 "Opus '79" oil 1979 STHR(c)
 "Rockland" oil 1969 TCBAA
 "Sentinels" oil 1965 AN 65(3-66),17; LAAA
 "Sonata in D Minor" oil 1970 AAANB; AIM 76(2-88),141(c); AN 86(10-87),28(c)
 "Sonorous" oil 1971 BUNY
 "Southern Breeze" oil 1983 BC 19(#1-88),133(c)
 "Time" oil 1969 AG 13(11-69),53
 "Time and Space" oil 1965 FAAA

"Vallamont" oil 1982 BC 19(#1-88),133(c)
"Vibrato" oil 1974 AAATC(c)
"West" oil 1965 TEAA
Further References:
Andrews, Benny, "The Ax Hits Richard Mayhew," ENC 5(3-8-76),
 34-5.

MAYNARD, VALERIE J., 1937- ; b. in New York City; printmaker,
 sculptor
Biographical Sources: WWAA,1978; WWABA,1978
Portrait: BANG; DIAA
Published Reproductions:
 "Anger and Heritage" sc AN 73(12-74),63
 "Artist Writing of the Future" 1972 MS 2(9-73),27
 "Ascension" sc BANG
 "Autumn in the City" oil CRI 81(10-74),cover(c)
 "I See Beauty in Your Mind" mural BC 11(10/11-80),10
 "I Was Trying to Get It All Down" print SMIH 1(10-74),2
 "Mourning for Maurice" wood sc SMIH 1(10-74),2
 "No Apartheid" paint 1988 BAQ 9(#2-90),58
 "No Apartheid" paint 1988 BAQ 9(#2-90),59
 "Rufus" mixed media 1971 BUNY; EB 29(12-73),42(c)
 untitled oil ENC 4(6-75),65
 untitled oil LIB 5(10-65),12
 untitled sc LIB 5(10-65),12
 untitled BS 2(1-72),cover
 "Vigil" bronze sc AW 14(4-23-83),16
 "We Are Tied to the Very Beginning" bronze sc 1970 ARTF 13
 (1-75),64; DIAA; SMIH 1(10-74),1
 "Women's Lament" wood sc 1973 DIAA

MEEK, VICTORIA SUSAN, 1950- ; b. in Philadelphia; painter
Biographical Sources: FFAA
Portrait: FFAA
Published Reproductions:
 "...And the Lynching of the 70's Comes in the Form of a Mighty
 Horse" 1980 FFAA(c)

MEEKS, LEON, 1940- ; b. in Brooklyn; mixed media

Biographical Sources: AAA
Portrait: BCR 3(Su-72),40
Published Reproductions:
 "The Moon" oil 1969 BCR 3(Sp-72),21

MEO, YVONNE COLE, 1929- ; b. in Seattle, WA; printmaker,
 sculptor
Biographical Sources: AAA
Portrait: BAOA-1
Published Reproductions:
 "Automation" assemblage BAOA-1(c)
 "Going My Way" acrylic BAOA-1(c)
 "Mother and Child" steel engraving 1967 ILAAL
 "No Way Out" Acrylic BAOA-1(c)
 "Strings" serigraph PANA(c)

MEYER, HELGA; painter, sculptor
Published Reproductions:
 "Freedom Fighter" sc CRI 77(2-70), cover(c)

MICHEAUX, GASTON; muralist; painter
Published Reproductions:
 "Evolution" mural 1959 BAIH(c)

MICKENS, CHARLES; b. in Beaver Dam, VA; painter
Biographical Sources: AAA
Portrait: DENA
Published Reproductions:
 "Winter Comes to Smith's Island" mixed media DENA

MIDDLETON, SAMUEL M., 1927- ; b. in New York City; mixed
 media
Biographical Sources: AAA; TCBAA
Published Reproductions:
 "Collage" mixed media DANA
 "Composition" mixed media (Fisk) TCBAA
 "Music" collage,ink 1967 STHR
 "Rehearsal" litho 1964 BAQ 2(Sp-78),5
 untitled #4 collage 1974 BALF 19(Sp-85),11

MILLAR, ONNIE, 1919- ; b. in New York City; sculptor
 Biographical Sources: BANG
 Published Reproductions:
 "Stone Figure--Child" sc BANG

MILLER, AARON, 1928- ; b. in Oklahoma; painter
 Published Reproductions:
 "Christ Dead on the Cross" mural EB 7(6-52),67
 "Christ Falls" mural EB 7(6-52),66
 "Christ Meeting His Mother..." mural EB 7(6-52),66

MILLER, ALGERNON, 1945- ; b. in New York City; sculptor
 Biographical Sources: AAA
 Published Reproductions:
 "Altarasun" painted metal 1970 AAANB
 "Third World Tree" painted wood 1970 DCBAA

MILLER, DON, 1923- ; b. in Chapleton, Jamaica; painter
 Biographical Sources: AAA; WWAA,1991
 Published Reproductions:
 "African Civilizations" GT 86(10-68),cover(c)
 "Children of Rio Bueno" silk screen 1967-8 NBAT
 "Menelek II--King of Kings of Abyssinia" BC 12(#4-82),169(c);
 EB 32(7-77),74(c)

MILLER, EARL, 1930- ; b. in Chicago; mixed media, painter
 Biographical Sources: AAA; CBAM; TNAP
 Published Reproductions:
 "Space Figure" acrylic 1969 CBAM
 "Stellar" acrylic TNAP
 untitled collage 1963 AN 65(9-66),51

MILLER, EVA HAMLIN, 1915- ; b. in Brooklyn; painter, sculptor
 Biographical Sources: AAA; WWAA,1978; WWABA
 Portrait: BAOA-1
 Published Reproductions:
 untitled BAOA-1

MILLER, GUY L., JR., 1909- ; b. in Indianapolis; sculptor

Published Reproductions:
"Congo Beauty" wood sc 1952 DANA

MILLER, JULIA B., 1940- ; b. in Lynn, NC; painter
Biographical Sources: AAA
Published Reproductions:
"Afro Man" serigraph 1968 NBAT

MILLES, CHARLES; muralist
Published Reproductions:
"Boston Mural" mural TIM 95(4-6-70),82(c)

MILLS, ARMSTEAD; painter
Published Reproductions:
"Malindy" oil 1965 BAIH(c)

MILLS, EDWARD; painter
Published Reproductions:
"Bolivar Point" acrylic 1975 BAIH
"Landscape with Youth" acrylic 1975 BAIH
"Requiem" oil 1975 BAIH(c)

MILLS, LEV T., 1940- ; b. in Wakulla County, FL; printmaker
Biographical Sources: LAAA; WWAA,1978
Published Reproductions:
"Gemini I" etching 1969 AAATC(c)
"I'm Funky but Clean" serigraph 1972 LAAA
"Merry Christmas" litho 1972 BAQ 6(#4-85),31
"Something's Coming" serigraph 1969 BAQ 2(Sp-78),15(c);
BAQ 6(#4-85),40(c)
"A Winner" serigraph 1972 BAOA-1(c); BAQ 1(Wi-76),30(c)

MILLS, PRISCILLA (P'LLA), 1918-1964; b. in Connersville, IN;
painter, sculptor
Biographical Sources: AAA; LAAA; PKAU
Published Reproductions:
"Star of Bethlehem" welded steel sc 1961 (Golden State) AV 2
(12-87),12(c); BAQ 1(Wi-76),20; LAAA

MITCHELL, CAROL; b. in Trenton, NJ; painter
Published Reproductions:
"Until" watercolor CRI 86(12-79),cover(c)

MITCHELL, CORINNE, 1914- ; b. in Baskerville, VA; painter
Biographical Sources: DENA; EBSU; WWABA
Portrait: DENA
Published Reproductions:
"Fiery Furnace" oil DENA

MITCHELL, TYRONE, 1944- ; mixed media
Published Reproductions:
"Horn for Wilfredo" polychromed wood 1987 ICAA(c)

MONROE, ARTHUR, 1935- ; b. in New York City; painter
Biographical Sources: AAA; EBSU; LAAA
Portrait: BAOA-1
Published Reproductions:
"Peruvian Bliss" oil 1968 OSAE
"Portrait" oil 1961 BAOA-1
"Self-Portrait" ink wash 1965 LAAA

MONTGOMERY, ELIZABETH; sculptor
Published Reproductions:
"Self-Portrait" terra cotta sc 1971 BAIH(c); BC 9(11/12-78),
48(c)

MOODY, RONALD C., 1900- ; b. in Kingston, Jamaica; sculptor
Biographical Sources: AAA
Published Reproductions:
"Heroic Head" mahogany sc LNIA
"A Seated Figure" wood sc CTAL; OPP 17(5-39),134

MOODY, TED, 1947- ; b. in Philadelphia; painter
Biographical Sources: AAA
Portrait: NBA
Published Reproductions:
"Ballet" oil 1969 NBA

"Flag" oil 1969 NBA
"Wall" oil 1969 NBA

MOORE, FRANK; painter
Published Reproductions:
"Street Corner" DANA

MOORE, RON, 1944- ; b. in Washington, DC; printmaker
Biographical Sources: BAOA-2
Portrait: BAOA-2
Published Reproductions:
untitled pencil drawing 1969 BAOA-2; LAAA

MOORE, SABRA, 1943- ; b. in Texarkana, TX; painter
Published Reproductions:
"Or" acrylic AG 13(4-70),53

MOORE, THEOPHILUS; painter, sculptor
Published Reproductions:
"Family" acrylic 1971 BAIH(c)
"Turtle" terra cotta sc 1971 BAIH(c)
untitled terra cotta sc c1971 BC 9(11/12-78),49(c)

MOORE, WILLIAM; painter
Published Reproductions:
"5th Ward Neighborhood" oil 1961 BAIH(c)

MOOREHEAD, LEEDELL, 1927- ; b. in Pine Bluff, AR; painter
Biographical Sources: AAA
Portrait: DANA
Published Reproductions:
"Across the Tracks" casein DANA

MOORHEAD, SCIPIO; active during the 18th century; painter
Biographical Sources: LAAA; TNAP
Published Reproductions:
"Phillis Wheatley" copperplate 1773 CRI 82(8/9-75),225; EB
21(8-66),90; EB 22 (10-67),59; EB 28(9-73),48; EB 30 (8-75),

105; FAAA; LAAA; LIF 5(10-3-38),51; SEP 19(1-70),18; SEP 18(8-70),53; SEP 22(9-73),59; TNAP

MORA, ELIZABETH CATLETT, see **CATLETT, ELIZABETH**

MORGAN, CLARENCE, 1950- ; b. in Philadelphia; painter
Biographical Sources: NGSBA
Published Reproductions:
 "La Fuente" charcoal,chalk 1989 NGSBA(c)
 "Linear Notation" mixed media BE 11(12-80),43(c)
 "Power of Influence" acrylic 1988 NGSBA(c)
 "Re-Experience of Gender" acrylic 1988 NGSBA(c)
 "Semiotic Manhunt" acrylic 1989 NGSBA(c)

MORGAN, NORMA GLORIA, 1928- ; b. in New Haven, CT; painter, printmaker
Biographical Sources: AAA; BAOA-2; TNAP; WWAA,1991
Portrait: BAOA-2; DANA; FSBA
Published Reproductions:
 "Alf, Man of the Moors" copper engraving 1964 AG 13
 (4-70),14; FAAA
 "Badenoch, Inverness" oil DANA
 "Cave Interior" engraving 1967 BAOA-2; DCBAA
 "Character Study" paint, ink AIM 47(#1-59),94; DANA
 "Dark Heights" engraving PANA
 "David in the Wilderness" engraving 1955-6 (Modern Art) FAAA;
 TNAP
 "Dunstanburgh Castle, Northumberland, England" etching 1968
 BAOA-2; IBA
 "Middle Dene Farm" DANA
 "Portrait of My Grandfather" engraving 1972 BALF 19(Sp-85),35
 "Rock Urchin" FSBA
Further References:
 Fax, Elton. *Seventeen Black Artists*. New York: Dodd, Mead, 1971.

MORGAN, SISTER GERTRUDE, 1902-80; b. in Lafayette, AL;
 painter
Biographical Sources: AAA; AAATC; BFAA
Portrait: AIAD; BFAA

Published Reproductions:
 "Book of Daniel" pencil,pastel,watercolor c1965 AWCF(c); FAAA
 (c)
 "Book of Revelation" oil BFAA
 "Christ Coming in His Glory" crayon and acrylic BFAA(c)
 "Come in My Room, Come on In My Prayer Room" tempera,acry-
 lic c1970 MWP(c)
 "Double Self Portrait" acrylic 1969 AFATC
 "God's Greatest Hits" tempera 1978 AAATC(c)
 "I've Done the Best I Can" watercolor 1969 AFATC(c)
 "Jesus Is My Air Plane" ink,watercolor c1970 AFATC(c); RFAA
 "Modern Inventions" oil 1970 AFATC(c)
 "New Jerusalem" pen,pencil,acrylic 1965 AIM 70(Su-82),33; AJ
 42(Wi-82),346; BFAA
 "New Jerusalem Mansion" acrylic (Schomburg) STHR
 "A Poem of My Calling" ink and acrylic BFAA(c)
 "Revelations 7" acrylic c1970 BFAA(c); RFAA
 "Revelations 18" tempera,crayon,ink DBLJ
 "The Saints Eternal Home" pen,pencil,watercolor BFAA(c)
 "There Is an Eye Watching You" pen,gouache BFAA(c)
 "The Throne of God" acrylic,ink c1973 CLA 11(Sp/Su-86),32
 "The Two Beasts of Revelation" pen,pencil,pastel c1965 AC 42
 (6/7-82),23(c); AWCF(c); BFAA(c)
 untitled tempera 1970 AFATC(c)
 "Vision of Death" ink and acrylic BFAA
Further References:
 Andrews, Benny, "Folk Art--A Proud Tradition," ENC 5(2-76),
 30-1.

MORRIS, PATRICIA ANN; sculptor
 Published Reproductions:
 "Self-Portrait" terra cotta sc 1970 BC 9(11/12-78),49(c)

MORRISON, KEITH ANTHONY, 1942- ; b. in Jamaica; painter
 Biographical Sources: WWAA,1991
 Published Reproductions:
 "Chariot" oil 1988 ICAA
 "Satin Doll" watercolor 1989 BABC(c)
 "Spirituals" watercolor 1986 SMI 18(5-87),188(c)

"Wreath for Udomo" oil 1986 AV 2(6-87),17(c)
"Zapoteka" oil 1983 BABC(c)
"Zombie Jamboree" oil 1988 ICAA

MORTON, LEE JACK; illustrator, painter
Portrait: FRE 6(#2-66),back cover
Published Reproductions:
 "Minister's Daughter" oil FRE 6(#2-66),cover
 "Portrait of Miss Churney" oil FRE 6(#2-66),193
 "Self Portrait" oil FRE 6(#2-66),back cover

MOSELY, JIMMIE LEE, 1927- ; b. in Lakeland, FL; painter,
 printmaker
Biographical Sources: AAA; BDCAA; EBSU
Portrait: BAOA-1; EBSU
Published Reproductions:
 "Boats at Deal Island" acrylic BAOA-1
 "Private Devotion" acrylic AG 11(4-68),48
 "Red Sun" serigraph PANA(c)
 "Tenement" oil 1951 BAIH(c)
 "Waiting to Vote" watercolor 1968 BDCAA

MOSLEY, DAVID, 1941- ; b. in Shreveport, LA; painter
Biographical Sources: SEP 19(3-70),39-41
Portrait: SEP 19(3-70),39
Published Reproductions:
 "Marcus Garvey" drawing BS 2(9-70),6
 "Patrice Lamumba" drawing 1969 BS 2(3-71),38
 "Portrait of Martin Luther King, Jr." SEP 19(4-70),
 42-3(c)
 untitled oil SEP 19(3-70),40(c)
 untitled oil SEP 19(3-70),41(c)
 untitled oil SEP 19(3-70),41(c)

MOSS, LOTTIE E. WILSON; b. in Niles, MI; painter, sculptor
Published Reproductions:
 "Abraham Lincoln and Sojourner Truth" oil CRI 10(8-15),cover;
 CRI 10(9-15),215

MOTLEY, ARCHIBALD JOHN, JR., 1891-1981; b. in New Orleans;
　painter
　Biographical Sources: AAA; BACW; ILAAL; LAAA; MIAP; NAI;
　　TCBAA; TNAP; WWAA,1962
　Portrait: ATO; DANA
　Published Reproductions:
　　"After Fiesta, Remorse, Siesta" oil 1959 AAATC(c); STHR
　　"Aline, an Octoroon" oil OPP 6(4-28),114
　　"The Argument" oil 1940 (Barnett) AV 1(9/10-86),42(c); BAAG;
　　　BACW(c); DAAA
　　"Barbecue" oil 1935 (Howard) FHBI(c)
　　"Black Belt" oil 1934 (Albany) DES 44(12-42),13; NAI; NEW
　　　13(2-6-39),26
　　"Blues" oil 1929 AV 1(#2-86),71(c); AV 1(#3-86),67(c); AW
　　　21(2-22-90),14; BABC; BC 3(5/6-73),27(c); ESS 4(11-73),22
　　　(c); ESS 4(12-73),29(c)
　　"Brown Girl After the Bath" oil 1931 TCBAA
　　"Chicken Shack, Chicago" oil 1936 (Harmon) BAQ 3(#3-79),49;
　　　DANA; FAAA; ILAAL; LAAA; LNIA; SG 28(3-39),224
　　"Dans la Rue, Paris" oil 1929 (Schomburg) ATO
　　"Gettin' Religion" oil 1948 (Chicago) DANA
　　"The Jockey Club" oil 1929 (Schomburg) ATO; DANA; FAAA;
　　　HRABA
　　"The Liar" oil 1934 (Howard) ATO; PMNA
　　"Mending Socks" oil 1925 (Ackland) AARE 3(11/12-76),108(c);
　　　ATO; BC 8(9/10-77),51(c); CRI 30(7-25),135; DANA; ENC 5
　　　(12-20-76),cover(c); MAA; OPP 4(9-26),297; RD 112(6-78),
　　　181(c); TCBAA(c)
　　"A Mulatress" oil CRI 30(7-25),136
　　"The Octoroon Girl" oil AD 3(1-29),6; CRI 36(2-29),53; ILAAL
　　"Old Snuff Dipper" oil 1928 AMA 23(9-31),214; CTAL; DANA;
　　　FAAA; LAAA; LNIA; SG 65(3-1-31),594
　　"Parisian Scene" oil 1929 (NYPL) AG 13(4-70),9(c); EB 23
　　　(2-68),121(c); FAAA(c); HW 7(3rdQ-68),13(c)
　　"Picnic" oil 1936 (Howard) BC 11(#2-80),99; STHR(c)
　　"The Picnic in the Grass" oil 1936 (Howard) DBLJ; LAAA
　　"Playground" oil BACW
　　"Playing Poker" oil PMNA
　　"Saturday Night" oil 1934 LNIA

"Self Portrait" oil NHB 2(4-39),61; NHB 9(4-46),151
"Sharks" oil AMA 27(1-34),37
"Stomp" oil 1927 DANA
"Syncopation" oil OPP 4(9-26),297; OPP 6(4-28),115
"United States Mail" mural 1936 DANA; FAAA
"Waganda Charm" oil OPP 6(4-28),115
"Woman Peeling Apples" oil 1924 (Schomburg) ATO; HRABA
Further References:
Jewell, Edward, "A Negro Artist Plumbs the Negro Soul," NYT
3-25-28, p. 8.

MULZAC, HUGH H., 1886-1971; b. in St. Vincent, Barbados;
 painter
Published Reproductions:
"Fruit Vendors" oil AN 51(9-52),48

MURCHISON, BETTY; painter
Published Reproductions:
"Erin and Leah" SMI 19(1-89),151(c)

MURRY, J.B., 1910- ; b. in Glascock County, GA; painter
Biographical Sources: BIS
Portrait: BIS
Published Reproductions:
 untitled mixed media BIS
 untitled mixed media BIS
 untitled mixed media BIS
 untitled mixed media BIS(c)
 untitled mixed media BIS(c)

NASH, TEIXERA, 1932- ; painter
Biographical Sources: LAAA
Published Reproductions:
 "Ain't No Mountain High Enough" oil AG 11(4-68),47
 "Figures" LAAA(c)

NATHANIEL, INEZ, 1911- ; b. in Sumter, SC; painter
Biographical Sources: AFATC
Published Reproductions:

"Double Portrait" pen,crayon 1977 AFATC(c); MWP(c)
untitled drawing ENC 5(2-2-76),30

NEAL, FRANK W., 1915- ; b. in Texas; painter
Biographical Sources: AAA
Published Reproductions:
"Anticipation" gouache AD 19(10-1-44),19
"Basket Carrier" oil 1934 NAI
"Sad Sack" oil SMIH (12-77),4

NEAL, GEORGE E., 1906-1938; painter
Biographical Sources: AAA
Published Reproductions:
"The Red House" DANA
"Still Life" MA 34(8-41),374

NEAL, JEROME; painter
Published Reproductions:
"Apathy of a Black Man" BC 2(11/12-71),24

NEAL, ROBERT L., 1916- ; b. in Atlanta; painter
Biographical Sources: AAA
Published Reproductions:
"Georgia Dwelling" oil 1939 LNIA
"Hills of Georgia" oil 1940 LNIA

NEALS, OTTO, 1931- ; b. in Lake City, SC; painter, sculptor
Biographical Sources: AAA; WWAA,1991
Portrait: BANG
Published Reproductions:
"Ancestral King" woodcut BT (#4-70),11
"Black Madonna" sc BANG
"Male Ancestry" wood sc EB 27(12-71),112
"The Prophet" EB 26(4-71),178(c)

NEGUNDI, SENGA, see **IRONS, SUE**

NEWSOME, ROBERT, 1926- ; b. in Monmouth, IL; sculptor
Biographical Sources: AAA

Published Reproductions:
"Hornblower" wood sc ONPB

NEWTON, JAMES E., 1941- ; b. in Bridgeton, NJ; printmaker
Biographical Sources: BAQ 3(#1-79),31
Portrait: BAQ 3(#1-79),31; WJBS 8(Sp-84),38
Published Reproductions:
"Am I Not a Brother" WJBS 8(Sp-84),38
"Frederick Douglass Rides Again" collograph BAQ 3(#1-79),31
(c); WJBS 8(Sp-84),38
"The Pill" collograph BAQ 3(#1-79),30(c)

NICHOLAS, ROCHELLE; b. in Los Angeles; painter
Portrait: CACE
Published Reproductions:
untitled oil 1986 CACE(c)

NICHOLS, JOHN; printmaker
Biographical Sources: AAA
Published Reproductions:
"Message from Home" BL 1(Sp-71),10
"United in Darkness" BL 1(Sp-71),11

NOMMO, ISAAC, 1940- ; b. in Atlanta, TX; painter
Biographical Sources: BAOA-2
Portrait: BAOA-2
Published Reproductions:
"Allah U Akbar" oil BAOA-2(c)

NOWLIN, OLIVER BROWN, 1941- ; b. in Syracuse, NY; painter,
printmaker
Biographical Sources: FIBO
Portrait: CACE
Published Reproductions:
"Lynn/Head in Motion" 1977 FIBO
untitled sc 1984 CACE

OBEY, TRUDELL MIMMS; b. in Nigeria; painter
Biographical Sources: AAA

Published Reproductions:
 "Full Bloom Magnolia" oil NAHF
 "Self-Portrait" oil 1975 BAIH(c)

OKWUMABUA, CONSTANCE, 1947- ; b. in Cleveland; painter
 Published Reproductions:
 "Epilogwu Dancers" acrylic BAOA-1

OLATUNDE, OSIRA; mixed media, sculptor
 Published Reproductions:
 "Oduduwa" copper panel BAQ 1(Wi-76),18(c)
 untitled aluminum panel AFA 3(Sp-70),24

OLIVER, KERMIT, 1943- ; b. in Refugio, TX; painter
 Biographical Sources: BANG
 Portrait: BANG
 Published Reproductions:
 "Fire Fighters" Houston mural 1967 BAIH(c)
 "Post-Civil War, Texas Black Legislators" mixed media 1967
 BAIH
 untitled drawing 1967 BAIH
 untitled oil BANG

OLU, YAOUNDE, 1945- ; b. in Chicago; printmaker
 Biographical Sources: EBSU; WWABA
 Published Reproductions:
 "Black Sunshine #3" print EBSU
 untitled drawing BC 2(3/4-72),24

OLUGEBEFOLA, ADEMOLA, 1941- ; b. in St. Thomas, Virgin Is-
 lands; graphic artist, mixed media, painter
 Biographical Sources: BAAL; BDCAA; LAAA; WWAA,1978
 Portrait: BAAL
 Published Reproductions:
 "The Blue-Eyed Pied Piper" oil 1965 STHR
 "Burden of Injustice" woodcut 1970 AG 13(4-70),14; AIM 58
 (9-70),66; BT (#5-71),53
 "Emerging Spirit" mixed media 1970 BAAL(c)
 "Equitorial Equinox" mixed media 1977 BAQ 3(#1-78),21

"Faces of Shango" woodcut BT (#4-70),3
"Gateway to Atlantis" collage 1977 BAQ 3(#1-78),21
"Jungle Rhythm #2" woodcut 1968 BAQ 2(Sp-78),21; BT
 (#4-70),28
"Olori My Son" acrylic 1969 BDCAA(c)
"Pharaoh's Journey" oil 1971 BUNY
"Prophesy" acrylic 1969 BAAL(c)
"Shango" construction 1969 BAAL(c); LAAA
"Shango Module #11" collage BC 11(10/11-80),100(c)

O'NEAL, MARY LOVELACE, 1942- ; b. in Jackson, MS; painter
 Biographical Sources: FFAA; YTCW
 Portrait: FFAA
 Published Reproductions:
 "Concessions to Illusion I" mixed media WCBI
 "Hammem (Moroccan Bath House)" mixed media 1986 ICAP(c)
 "Senseless Superstition, Meaningless Ritual" mixed media 1986
 ICAA
 untitled charcoal 1976 OSAE
 untitled mixed media 1979 FFAA(c)
 "Whales and Mermaids for Dinner" mixed media 1984 YTCW
 "Whaling II--Madonna and Red Whale" mixed media 1983 STHR
 "White Whale" acrylic 1983 EWCA(c)

OUBRE, HAYWOOD LOUIS; b. in New Orleans; painter, sculptor
 Biographical Sources: AAA; TNAP; WWABA,1991
 Portrait: BAOA-1
 Published Reproductions:
 "Bouquet of Voids" AG 11(4-68),48
 "The Christ" wire sc DES 69(Su-68),16
 "Conflict" pencil ILAAL
 "High Priest" wire sc DES 69(Su-68),16
 "Mother and Child" plaster sc DANA; ILAAL
 "The Prophet" wire sc BAOA-1; DES 69(Su-68),16
 "Ram" graphite BAOA-1
 "Seated Woman" 1964 (Atlanta) DANA
 "Self Portrait" etching 1948 (Atlanta) DANA
 "Young Horse" wire DANA; DES 69(Su-68),18
 Further References:

Oubre, Hawyard, "The Art of Wire Sculpture," DES 69(Su-69), 16-18.

OUTLAW, SIMON B.; painter
 Biographical Sources: AAA
 Published Reproductions:
 "Planes in Black and White" oil 1960 ILAAL

OUTTERBRIDGE, JOHN WILFRED, 1933- ; b. in Greenville, NC; painter,sculptor
 Biographical Sources: AAA; BDCAA; WCBI; WWAA,1991
 Portrait: BANG; BAOA-1
 Published Reproductions:
 "Aesthetics of Urban Blight" metal sc 1987 NACA
 "Birth Process" wood-metal construction BAOA-1
 "Black Heritage Doll Series" 1977 FIBO
 "Blow It" oil 1970 GAI
 "The Builder" sc WLB 43(4-69),759
 "California Crosswalk, Ethnic Heritage Series" mixed media
 1979 NACA(c)
 "Case In Point" oil 1970 GAI; NACA; VIS 4(Wi-89),25(c)
 "The Great American Eagle" metal and wood sc 1968 DBLJ
 "Lift Every Voice" mixed media EWCA(c)
 "Mogo Ghetto" carved sc BAOA-1; BDCAA(c)
 "The Old Folks" oil 1968 BDCAA(c)
 "Reclining Figure" wood-metal construction BAOA-1
 "Shopping Bag Society" oil 1970 BANG; GAI
 "Together Let Us Break Bread" chrome steel construction WCBI
 "Traditional Hang-up" 1969 NACA
 untitled construction 1969 FBA
 untitled construction 1968 FBA
 untitled mixed media SA 79(10-79),57
 "Warrior" AW 13(5-8-82),4

OVERSTREET, JOSEPH, 1934- ; b. in Conehatta, MS; painter
 Biographical Sources: AAA; LAAA; TNAP; WCBI
 Portrait: NBA; PKAU
 Published Reproductions:
 "Alpha and Omega" oil 1968 NBA

"Ancestral Tomb for Mr. White" acrylic 1969 AIM 58(9-70),61
"Benin Triptych" oil 1968 NBA
"Chieftain" acrylic ART 44(12-69),56(c)
"Crawling" oil 1968 NBA
"For Buddy Bolden" BE 20(12-89),6(c)
"Free Direction" acrylic 1971 AG 15(5-72),W1
"Gemini IV" canvas, acrylic,rope 1971 LAAA(c)
"Gods and Spirits" acrylic 1970 AG 15(10-71),47
"Indian Summer" 1969 FAAA
"Jazz in 4/4 Time" oil AAANB
"Justice, Faith, Hope, and Peace" acrylic 1968 BC 3(4/5-73),
 27(c); FAAA(c)
"Mahogany Hall (Storyville Series) serigraph 1989 AN 89(2-90),
 56(c)
"Mirage" canvas,ropes AG 15(2-72),52
"The New Jemima" construction 1964 BCR 1(Wi-72),42; FAAA;
 MIUA; SAH(c)
"North Star" acrylic 1967 BALF 19(Sp-85),45; STHR
"Power Flight" acrylic,canvas 1971 (Brooklyn) BMAP
"Second Line II" AV 412-89),63(c)
"Storyville Series: For Buddy Bolden" BAQ 8(#4-89),49(c)
"Strange Fruit" oil 1963 STHR
untitled acrylic 1970 BATG; NBAT
untitled oil 1968 NBA
untitled acrylic construction WCBI
untitled TIM 95(4-6-70),86
Further References:
 Jennings, C.L., "Joe Overstreet: Work-In-Progress," BALF 19
 (Sp-85),44-5.
 Reed, Ishmael, "The Black Artist: Calling a Spade a Spade," ART
 41(5-67),48-9.

OWENS, CARL; painter
Published Reproductions:
 "Affonso I--King of the Kongo" oil EB 31(3-76),72; EB 37(2-82),
 24-5(c)
 "Khama--King of Bechualand" BC 12(#4-82),170(c)
 "Leopards" BC 15(#1-84),37(c)

OWENS-HART, WINNIE R., 1949- ; b. in Washington, DC; mixed
 media
 Biographical Sources: FFAA; NGSBA
 Portrait: FFAA
 Published Reproductions:
 "Initiations: African American" sc 1978 FFAA(c)
 "Life Is a Beach...Howard Beach" ceramic 1988 NGSBA(c)
 "Take 1--Karma Series" ceramic 1982 NGSBA(c)
 "We Hear the Mask Series" ceramic,metal 1987 NGSBA(c)

PACE, LORENZO, 1943- ; b. in Birmingham, AL; sculptor
 Biographical Sources: BAOA-1
 Published Reproductions:
 "African Chief" sc BAOA-1
 "U.S. Mask" sc 1972 BAOA-1

PAJAUD, WILLIAM E., 1925- ; b. in New Orleans; painter, print-
 maker
 Biographical Sources: AAA; BDCAA; LAAA
 Portrait: BAOA-1; BAQ 4(4-81),49
 Published Reproductions:
 "As the Twig Is Bent" watercolor BAQ 4(4-81),58(c)
 "Belshazzar Vision" watercolor BAQ 4(4-81),54(c)
 "Cock's Crow" watercolor 1983 BC 18(#3-88),40(c)
 "Collards" watercolor BAOA-1(c)
 "Crawfish Vendor" BC 6(11/12-75),32(c)
 "Destruction by the Assyrian" watercolor BAQ 4(4-81),62(c)
 "Destruction of Schenacherib" watercolor 1981 BC 18
 (#3-88),40(c)
 "Ezekiel's Vision" watercolor BAQ 4(4-81),51(c)
 "Family Circle" oil 1969 BDCAA(c)
 "Hustlin' the Hustler" watercolor BAOA-1(c); BAQ 4(4-81),56
 "Jericho Falling" watercolor BAQ 4(4-81),59(c)
 "103rd St. Poultry Market" watercolor BAOA-1
 "One of You Shall Betray Me" watercolor BAQ 4(4-81),53(c)
 "Reapers" oil 1982 BC 18(#3-88),40(c)
 "Solid as a Rock" oil 1970 LAAA-1(c)
 "Southern Fisherman" oil 1975 FIBO
 "Twenty-third Psalm" watercolor BAQ 4(4-81),50(c)

untitled watercolor (Golden State) BAQ 1(Wi-76),24
"The Wages of Sin Is Bread" watercolor BAOA-1; BAQ 4(4-81),
 53(c)
"Watermelon Vendor" oil 1972 BAOA-1(c)
"Woman with Chicken" oil 1972 BAOA-1(c); BAQ 4(4-81),
 62(c)
Further References:
Tate, Mae, "William Pajaud," BAQ 4(4-81),49-63.

PALM, DENISE, 1951- ; b. in Philadelphia; painter
Biographical Sources: BAOA-2
Portrait: BAOA-2
Published Reproductions:
 "Struggle" oil 1969 BAOA-2(c)
 "Three Asses" oil 1970 BAOA-2(c)

PAPPAS, JAMES G., 1937- ; painter
Biographical Sources: AAA
Published Reproductions:
 untitled oil 1969 FUF

PARKS, CHRISTOPHER C.; sculptor
Published Reproductions:
 "Black American" sc NSR 19(Sp-70),12
 "Eve" sc NSR 19(Fa-70),9
 "14 Year Old Ballerina" sc NSR 24(Sp-75),8
 "Ingelora" sc NSR 24(Wi-75/6),21
 "Uptown" sc NSR 20(Sp-71),12
 "Yank" sc NSR 19(Su-70),15

PARKS, JAMES DALLAS, 1907- ; b. in St. Louis; painter, print-
 maker
Biographical Sources: AAA; BDCAA; WWAA,1978; WWABA
Portrait: BAOA-1; EBSU
Published Reproductions:
 "Artist Model" oil 1960 AJ 32(Wi-71),226; BDCAA(c); ILAAL
 "Missouri Village" watercolor 1965 BDCAA(c)
 "View over Monterrey, Mexico" watercolor 1959 BAOA-1

PARKS, LOUISE ADELE, 1945- ; mixed media, painter
 Biographical Sources: AAANB
 Published Reproductions:
 "Tapestry #4" mixed media 1970 AAANB
 untitled 1970 FUF

PARKS, VERNA, 1956- ; painter
 Published Reproductions:
 "Wall of Respect" mural BC 7(1/2-77),54

PARSONS, OLIVER; painter, sculptor
 Published Reproductions:
 "Brother Against Brother" acrylic 1971 BAIH(c)
 "Christ" oil (Howard) EB 26(4-71),178(c)
 "Owl" terra cotta sc1971 BAIH(c)
 "Pieta" terra cotta sc 1971 BAIH(c)
 "Railroad Tracks" oil 1971 BAIH(c)
 "Suffer the Little Children" pen,ink 1971 BAIH

PATE, JAMES E., 1961- ; mixed media, painter
 Published Reproductions:
 "My Sister Singing" pencil SA 79(10-79),36
 "Self Portrait" acrylic SA 79(10-79),35

PATIENCE, EDGAR, 1907- ; b. in Wilkes-Barre, PA; sculptor
 Published Reproductions:
 "George Washington" coal sc EB 4(9-49),4

PAYNE, JOHN B., 1932- ; b. in Pontotoc, MS; graphic artist,
 painter
 Biographical Sources: LAAA; TCNL; WWAA,1965
 Portrait: TCNL
 Published Reproductions:
 "Horney Box" wood sc 1969 LAAA(c)

PAYNE, LESLIE, 1907-1981; b. in Fairport, VA; mixed media
 Biographical Sources: BFAA
 Portrait: BFAA
 Published Reproductions:

"New York Lady" tin,copper,paint c1970 AC 42(6/7-82),22; BFAA
"Two Soldiers" mixed media c1970 BFAA

PECK, SANDRA; sculptor
Biographical Sources: AAA
Published Reproductions:
 "Black Madonna" enamel on copper EB 27(9-72),106

PENA, ALBERTO, 1900-1940; b. in Havana, Cuba; painter
Biographical Sources: MIAP
Published Reproductions:
 "Mater Dolorosa" oil 1935 LNIA
 "Paisaje" oil 1937 LNIA

PERKINS, ANGELA, 1948- ; b. in Chicago; painter
Biographical Sources: BWSB; WWABA
Portrait: BAOA-1
Published Reproductions:
 "Design" BAOA-1

PERKINS, MARION MARCHE, 1908-1961; b. in Marche, AR;
 sculptor
Biographical Sources: AAA; GNNP3; NAI; TCBAA; TNAP
Portrait: DANA; NAI
Published Reproductions:
 "The Clown Lives" c1955 STHR
 "Contemplation" stone sc EB 6(10-51),109
 "Don Quixote" stone sc DANA
 "Ethiopia Awakening" stone sc AD 22(7-1-48); EB 6(10-51),108
 "Figure at Rest" marble sc EB 6(10-51),109
 "Head" wood sc AD 29(1-15-55),15
 "John Henry" limestone sc 1943 EB 6(10-51),109
 "Man Looking Upward" stone sc EB 6(10-51),108
 "Man of Sorrow" marble sc 1950 (Chicago) DANA; EB 6(10-51),
 108; TCBAA
 "Moses" stone sc LIF 21(7-22-46),62; NAI
 "Mother and Child" marble sc EB 6(10-51),108
 "Seated Figure" stone sc EB 6(10-51),109
 "Study in Flight" stone sc EB 6(10-51),108

untitled sandstone sc 1951 EB 6(10-51),107
Further References:
"Marion Perkins," EB 6(10-51),107-13.

PERRY, MICHAEL KAVANAUGH, 1940- ; b. in Los Angeles;
 painter, printmaker
Biographical Sources: AAA
Portrait: BAOA-1
Published Reproductions:
 "Walking, Standing, Walking" intaglio BAOA-1; BAQ 6(#4-85),
 21

PHILLIPS, BERTRAND D., 1938- ; b. in Chicago; graphic artist,
 painter
Biographical Sources: AAA; BANG; WWAA,1991; WWABA
Portrait: BANG; BAOA-1; EBSU
Published Reproductions:
 "Body and Soul" oil BANG; SA 79(10-79),34
 "Breakthrough" oil 1973 BAOA-1
 "Her Imperial Highness" oil 1974 DIAA
 "Natural Growth" oil 1973 DIAA
 "Paul Robeson" oil SA 79(10-79),35
 "Stars, Bars and Bones" oil 1970 LAAA(c)
Further References:
 Fax, Elton C., "Bertrand D. Phillips: Painter," SA 79(10-79),33-5.

PHILLIPS, CHARLES JAMES, 1945- ; b. in Brooklyn; painter
Biographical Sources: BAAL; DIAA
Portrait: BAAL; DIAA
Published Reproductions:
 "Ancestral Dream" acrylic 1985 BAAL(c)
 "Bazu" acrylic 1973 BAAL(c)
 "Dance of Magic" acrylic ESS 2(5-71),54
 "Lotus on the Nile #2" acrylic 1984 BAAL
 "Majo" acrylic 1987 BAAL(c)
 "Mystical Unity" acrylic ARTF 13(1-75),65; DIAA
 "Spirits" acrylic 1986 BAAL(c)
 "Spirits of Resistance" acrylic 1986 BAAL(c)
 "Unity" acrylic BAQ 7(#4-87),3(c)

untitled ENC 7(3-20-78),38
untitled acrylic 1974 BAAL
"Water Spirits" acrylic BAQ 7(#4-87),6(c)
"Water Spirits" acrylic 1982 BAQ 7(#4-87),7(c)

PHILLIPS, HARPER TRENHOLM, 1928- ; b. in Courtland, AL;
 painter
Biographical Sources: AAA
Published Reproductions:
 "Fisherman" oil DANA
 "Lullabye" oil DANA

PHILLIPS, JAMES, see **PHILLIPS, CHARLES JAMES**

PHILLIPS, TED; painter
 "Frederick Douglass" oil NEWO 3(#1-76),32

PIERCE, DELILAH WILLIAMS, 1904- ; b. in Washington, DC;
 painter
Biographical Sources: BACW; BDCAA; DENA; WWAA,1991
Portrait: DANA; DENA; FFAA
Published Reproductions:
 "Daffodils" oil 1958 DANA
 "D.C. Waterfront, Maine Avenue" oil 1957 AWAP
 "Flowering Trees, Khartoum, Sudan" acrylic DENA
 "Guardian of the Shore" oil,acrylic BACW
 "Nature's Symphony" SMI 19(1-89),151(c)
 "Nebulae" watercolor 1982 AAATC(c)
 "Nebulae #2" acrylic FFAA(c)
 "Supplication" oil 1950 BDCAA
 "Tradesmen--Khartoum, Sudan" oil 1952 BDCAA(c)
 "Waterfront" oil 1958 DANA

PIERCE, ELIJAH, 1892-?; b. in Baldwin, MS; painter, sculptor
 Biographical Sources: AAA; BFAA
 Portrait: AC 42(6/7-82),24-5; AN 73(3-74),114; BFAA
 Published Reproductions:
 "Alligator" wood 1975 APO #118(9-83),262
 "American Heritage" wood 1918 AN 73(3-74),114

"Berry Tree" carved and painted wood BFAA
"Book of Wood" wood 1933 AN 73(3-74),114; EB 29(7-74),69
"Crucifixion" carved and painted wood 1940 AC 2(6/7-82),
 cover(c); BFAA(c); PORT 5(5-83),88(c); RFAA; TCAFA(c);
 TIM 119(3-1-82),70(c)
"Father Time Racing" wood relief 1938 AFATC(c)
"Horse and Rider" wood sc 1975 AC 42(6/7-82),25(c)
"I Am the Door" wood sc AFATC(c)
"Leroy Brown" carved and painted wood c1970 AC 42(6/7-82),25
 (c); BFAA
"Louis vs. Braddock" carved and painted wood c1950 AC 42
 (6/7-82),24(c); BFAA
"The Man That Was Born Blind Restored to Sight" wood sc 1938
 AFSB; RFAA; TCAFA
"Monday Morning Gossip" carved and painted wood 1935 BFAA
"Pearl Harbor" wood sc ENC 5(2-16-76),30
"Pearl Harbor and the African Queen" carved,painted wood
 1941 AJ 42(Wi-82),346; BFAA(c); FA #114(11-83),34(c)
"Presidents and Convicts" wood sc 1941 TCAFA
"Slavery Time" polychromed wood 1973 AIM 69(11-81),16; ARTF
 15(1-77),60; ART 51(9-76),54; ART 51(12-76),35; EB 29
 (7-74),68
"Story of Job" wood sc 1938 AFSB; RFAA
Further References:
"Elijah Pierce; Preacher in Wood," AC 42(6/7-82),24-5.

PIERCE, HAROLD, 1914- ; b. in Nowatta, OK; painter
Portrait: DANA
Published Reproductions:
"Debbie" oil DANA

PIERRE-NOEL, LOIS MAILOU JONES, see **JONES, LOIS
 MAILOU**

PIGATT, ANDERSON J., 1928- ; b. in Baltimore; sculptor
Biographical Sources: AAA; BAAL
Portrait: BAAL; NBA
Published Reproductions:
"Alone Together and Alone Again" wood (Schomburg) BAAL(c)

"America the Beautiful" pine sc 1967 NBA
"Caught in the Middle Earth" wood 1970 (Schomburg) BAAL(c)
"Sugar Hill Rose" pine sc 1966 NBA
"Visions of Revelations" pine sc 1968 NBA

PINCKNEY, STANLEY, 1940- ; b. in Boston; painter
Biographical Sources: AAA; AAANB; WWAA,1978
Portrait: BAQ 2(#4-78),65
Published Reproductions:
 "Animations" watercolor BAQ 2(#4-78),65

PINDELL, HOWARDENA, 1943- ; b. in Philadelphia; painter
Biographical Sources: AAATC; WWAA,1991
Published Reproductions:
 "Antoinette Series II" drawing ART 513-77),,29
 "Autobiography: Earth/Eyes/Injuries" mixed media 1987 ART
 64(9-89),77; ARTF 27(4-89),167; ARTF 28(3-90),114
 "Durga II: India" gouache,tempera 1984 BC 18(#3-88),44(c)
 "Family Ghosts" AIM 78(2-90),173(c)
 "Feast Day of Iemanja II, December 31, 1980" mixed media MTM
 (c)
 "Future: Memory Series 2" 1980 AIM 69(11-81),173; ART 55
 (4-81),75(c)
 "Gardens" mixed media 1983 EWCA(c)
 "Kyoto: Positive/Negative" litho 1980 NPFC(c)
 "Memory Test: Inflation" AJ 39(Su-80),282
 "Mountain: Reflection" acrylic 1982 STHR
 "One Side of Kyoto" AN 80(3-81),122
 "Paint Thickens" ARTF 14(6-76),46(c)
 "The Search/Chrysalis/Meditation" AN 89(2-90),162
 untitled acrylic 1972 BUNY
 untitled acrylic 1977 PEAA
 untitled acrylic 1979 ART 54(4-80),91(c)
 untitled synthetic polymer DCBAA
 untitled acrylic 1972 ARTF 11(4-73),88
 untitled mixed media ART 52(12-77),35
 untitled mixed media 1977 AIM 66(3/4-78),140(c)
 untitled mixed media 1977 AAATC(c)
 untitled #5 pen,ink 1975 MTM

untitled #76 watercolor,gouache 1975 AASC
untitled #83 1977 CGB(c)
untitled #85 ART 52(12-77),35
untitled #86 AIM 66(3-78),143(c)
untitled #88 1977 CGB
"War Cambodia" oil 1988 AIM 78(3-90),169

PINKNEY, ELLIOT, 1934- ; b. in Brunswick, GA; sculptor
Biographical Sources: BAOA-1
Portrait: BAOA-1
Published Reproductions:
 "Feeding Chickens" 1977 BAQ 2(Wi-78),71(c)
 "Happy Ride" 1976 BAQ 2(Wi-78),71(c); BAQ 2(#3-78),71(c);
 BAQ 3(#1-79),71(c)
 "Man on Horse" resin sc BAQ 1(Fa-76),26
 "Thanks Uncle" wood and styroform BAOA-1(c)

PINKNEY, JERRY, 1939- ; b. in Philadelphia; painter
Biographical Sources: AAA; AAANB; WWAA,1991
Portrait: AV 4(#2-89),46
Published Reproductions:
 "Harriet Tubman" watercolor,pencil 1984 AV 4(#2-89),47(c)
 "Moshoeshoe--King of Basutoland" oil BC 12(#4-82),170(c)
 "Mushroom" pen,ink 1970 AAANB
 untitled watercolor,pencil 1986 BC 12(#4-82),48(c)
 untitled watercolor,pencil BC 12(#4-82),49(c)

PIOUS, ROBERT SAVON, 1908-83; b. in Meridian, MS; painter
Biographical Sources: AAA; ATO
Portrait: ATO
Published Reproductions:
 "Harriet Tubman" tempera TEAAA
 "Portrait of a Singer" charcoal 1932 (Hampton) ATO; LNIA
 "Portrait of Roland Hayes" SW 60(5-31),214
 "Romare Bearden" pastel 1938 (Schomburg) ATO

PIPER, ADRIAN; mixed media
Published Reproductions:
 "Vanilla Nightmare #17" charcoal 1987 ARTF 28(3-90),113

"Vanilla Nightmare #18" charcoal 1987 AIM 78(3-90),166

PIPPIN, HORACE, 1881-1946; b. in West Chester, PA; painter
Biographical Sources: APTC; FAR; GNPP3; LAAA; MAPOC;
 MIAP; TTT
Portrait: DANA; MAPOC; TTT
Published Reproductions:
 "Abe Lincoln's First Book" oil 1944 AQ 32(S-69),234
 "After Supper, West Chester" oil 1935 CA; CRI 53(6-46),179;
 FAAA; MAPA
 "Amish Letter Writer" oil 1940 ARTF 5(3-67),43
 "The Artist's Wife" oil 1936 AFATC(c)
 "Birmingham Meeting House in Late Summer" oil 1940 HMSG;
 NBAT
 "Blue Tiger" oil 1933 AN 47(5-48),31
 "Buffalo Hunt" oil 1933 (Whitney) AUSPS; DBLJ; FAAA;
 PKAU; TNAP; WAAA
 "Cabin in the Cotton" oil AD 23(2-15-49),9; CRI 53(6-46),179;
 DANA; PIUS; SBMAA(c)
 "Cabin in the Cotton III" oil 1944 AAAT; AIM 65(9-77),118(c);
 AN 76(Su-77),75(c); FAAA; OAAL
 "Cabin Interior" oil SBMAA(c)
 "Christ" oil LNIA
 "Christ Crowned with Thorns" oil 1938(Howard) STHR
 "Christmas Morning Breakfast" oil 1945 (Cincinnati) AAR 3
 (11/12-76),115(c); AIM 65(3-77),65(c); AN 76(2-77),66(c); EB
 32(2-77),12(c); ENC 6(1-3-77),20(c); TCBAA(c)
 "The Crucifixion" oil 1943 RFAA
 "The Den" oil 1945 DANA
 "Domino Players" oil 1943 (Phillips) AFP; AIM 65(3-77),50
 (c); AN 76(4-77),3(c); ARTF 15(4-77),4(c); ART 51(4-77),81
 (c); DSAP; EB 1(12-45),46(c); ESS 4(11-73),22(c); ESS 4
 (12-73),29(c); FAAA; FAMTCA (c); MNA(c); TCBAA
 "End of the War" oil SBMAA
 "End of the War: Starting Home" oil 1931 (Philadelphia) ABP;
 FAAA; FFBA; LNIA; MMP; TTT
 "Fall Landscape" oil 1940 RD 112(6-78),181(c)
 "Family in the Kitchen" oil 1940 TCAFA(c)
 "Flower" AN 44(8-45),11

"Flower Study"　oil (Modern Art)　PMNA
"Flowers With Red Chair"　oil 1940　DANA(c); FFBA; SBMAA
"Gas Alarm Outpost"　AIM 77(10-89),95(c)
"The Getaway"　oil　CLA 13(Wi-88),5(c); LNIA
"Going Home"　gouache 1946　ILAAL
"Harmonizing"　oil 1944 FFBA; GGP
"Holy Mountain"　oil　BMIA; FAR(c); MAPOC; SBMAAA
"Holy Mountain I"　oil　1944 ANT 109(4-76),739; FFBA; VPTA
"Holy Mountain II"　oil 1944　AIM 57(7-69),61(c); LAAA(c);
　　PTCA; TCAA; TSAP
"Holy Mountain III"　oil 1945 (Smithsonian)　AIM 52(#3-64),82;
　　FAAA; FAR; HMSG(c); PNAP; RFAA
"The Hunter"　CONN 215(5-85),127(c)
"Interior"　gouache 1939　ANT 136(8-89),266(c); ILAAL; LIF 21
　　(7-22-46),64(c)
"I'se Comin'"　oil 1943　BCR 1(Wi-72),42
"John Brown Going to His Hanging"　oil 1942 (Pennsylvania)
　　AAAC; AFP(c); AG 13(4-70),5(c); ANT 121(3-82),705(c); AP
　　(c); APPA; ART 40(9-66),(30); CVAH; BFPA; DANA; ITA(c);
　　LIF 21(7-22-46),64(c); OAAL; PIAM; SACB(c); SBMAA(c);
　　TCAFA(c); TEAAA; TSAP; VPTA(c)
"John Brown Reading His Bible"　oil 1942　RFAA
"John Brown's Trial"　oil　AH 18(8-67),28(c); AHHA; DAHHA;
　　HAA
"Lady of the Lake"　oil 1945 (Metropolitan)　FTCA
"Lillies"　oil 1941　CA; ILAAL; NAI; NM (12-30-41),27
"The Love Note"　oil 1944　AFATC(c); ANT 136(10-89),694(c)
"Marian Anderson I"　oil 1941　AJ 31(Wi-71-2),41
"Marian Anderson II"　oil 1940　NEW 16(10-7-40),52
"Milkman of Goshen, New York"　oil 1945　PIUS
"Mr. Prejudice"　oil 1943　AIM 57(1-69),47; ANT 128(12-85),
　　1168; OAAL
"Night Call"　oil (Boston)　AJ 30(Fa-70),80; BHAP; CONN 174
　　(8-70),287; LAAA
"Nude"　ANT 101(4-72),583
"Peaceable Kingdom"　oil 1944　AFP(c)
"Portrait of Marian Anderson Singing"　oil 1941　AJ 31(Wi-71/2),
　　141
"Quaker Mother and Child"　oil c1940 (Rhode Island)　AN 43

(3-1-44),21; FAAA

"Roses with Red Chair" oil 1940 FAAA(c); SBMAA(c)

"Saturday Night Bath" oil 1945 (UCLA) AN 80(9-81),17(c); ANT 125(3-84),585(c); CRI 83(11-76),317; STHR; TCBAA

"Self-Portrait" oil 1941 AA 47(12-83), 103; AN 76(Su-77),74 (c); PSFA

"Shell Holes and Observation Balloon, Champagne Sector" oil (Modern Art) LNIA; MMP; PMNA

"Six O'Clock" oil 1940 AQ 34(Wi-71),517

"Street Orator" gouache 1936 ILAAL

"Temptation of Saint Anthony" AN 89(2-90),157

"The Trial of John Brown" oil 1942 ACP(c); ACPS(c); ALIA; ART 51(6-77),42; ARTF 15(Su-77),77; OAAL

untitled c1946 CLA 10(Fa-85),13(c)

"Victorian Interior" oil 1946 (Metropolitan) AAW; APTC; ESS 2(4-72),66(c); FAAA; WAA

"West Chester Courthouse" oil 1940 (Pennsylvania) AAAZ(c)

"Woman at Samaria" oil 1940 TTT

Further References:

Forgey, B., "Horace Pippin's Personal Spiritual Journey," AN 76(Su-77),74-5.

Rodman, Selden. *Horace Pippin; The Artist as a Black American*. Garden City, NY: Doubleday, 1972.

Stevens, M., "Pippin's Folk Heroes," NEW 82(8-22-77),59-60.

PITTS, BETTY, 1940- ; painter

Biographical Sources: AAA

Published Reproductions:

"Going Home" oil 1970 FUF

POGUE, STEPHANIE, 1944- ; b. in Shelby, NC; graphic artist

Biographical Sources: AAA; FFAA; WWAA,1978

Portrait: FFAA

Published Reproductions:

"Ancient Wall of Agra" etching 1982 BAQ 6(#4-85),26(c)

"Arabesque III" etching 1983 BALF 19(Sp-85),39

"Sea Storm" 1977 FFAA(c)

untitled DCBAA

Further References:

Bontemps, Jacqueline, "An Interview with Stephanie Pogue," BALF
 19(Sp-85),38-9.

POLK, NAOMI, 1892-1984; b. in Houston; painter
 Biographical Sources: BHBV
 Portrait: BHBV
 Published Reproductions:
 "Baptism" enamel,crayon 1961 BHBV
 "Lonesome Road" watercolor 1961 BHBV
 "Of Course I Live Forevermore" watercolor 1961 BHBV
 "Stick Doll" watercolor 1961 BHBV(c)
 "Those Reaching Hands" oil 1961 BHBV
 untitled watercolor 1961 BHBV

PORTER, CHARLES ETHAN, 1848- ?; painter
 Published Reproductions:
 "Mountain Laurel" oil BAAG

PORTER, JAMES A.,1905-1971; b. in Baltimore; painter
 Biographical Sources: BACW; LAAA; NAI; TCBAA; TNAP
 Portrait: ATO; NAI; DANA; FAAA
 Published Reproductions:
 "Boy of Port-au-Prince" oil 1946 OPP 24(Fa-46),180
 "Boy Reading" oil OPP 11(2-33),47
 "Bronze Figure" oil OPP 11(2-33),46
 "Cockfight" oil BAQ 1(Wi-76),47
 "Donkey Woman" oil 1946 OPP 24(Fa-46),178
 "Dorothy Parker" oil 1948 DANA
 "Farmer and His Wife" oil NAI
 "Haitian Market Women" oil 1947 DANA
 "In an Early Sketchbook" DANA
 "James V. Herring" oil 1923 (Howard) ATO
 "Man in White" oil BACW
 "My Mother" oil AAAC; LAAA
 "Nude" oil DANA
 "On a Cuban Bus" oil 1946 (Howard) AG 13(4-70),6; DANA;
 TEAAA
 "Portrait in Charcoal" SG 61(1-15-29),468
 "Portrait of Dorothy" oil 1957 DANA

"Primitive Bathers" oil 1933 AMA 27(1-34),37; ATO
"Revolution in Port-au-Prince" pastel 1946 OPP 24(Fa-46),210
"The Riot" oil 1938 LNIA
"Sarah" oil DANA
"Still Life" oil OPP 11(2-33),46; TCBAA(c)
untitled drawing DANA
"Woman Holding a Jug" oil 1933 AAAC; LNIA; SW 62(4-33),178
"Young Negro" pastel 1929 BACW

POWELL, GEORGETTE SEABROOKE, 1916- ; b. in Charleston,
 SC; painter
Biographical Sources: DENA; WWABA,1978
Portrait: DENA; FFAA
Published Reproductions:
 "Emilie" oil 1938 LNIA
 "Family" oil DENA
 "Recreation in Harlem" Harlem Mural ART 52(10-77),125
 "Tropical Motif" mixed media 1968 FFAA(c)

POWELL, JUDSON, 1932- ; b. in Philadelphia; painter, sculptor
Biographical Sources: AAA
Published Reproductions:
 "Barrel and Plow" construction 1966 ART 41(2-67),50
 "The Sink" construction 1966 ART 41(2-67),50
Further References:
 Secunda, Arthur, "The 'Junk'of Watts," ART 41(2-67),50.

POWELL, RICHARD; b. in Chicago; painter
Biographical Sources: BE 11(12-80),47
Published Reproductions:
 "Last Supper at Lung Fungs" BE 11(12-80),47(c)

PRESSLEY, DANIEL, 1918-71; b. in Wasamasow, SC; sculptor
Biographical Sources: AAA; BAAL
Portrait: BAAL; NBA; TCAFA
Published Reproductions:
 "Acapulco" wood sc 1970 BAAL(c)
 "The After Hour and the Soul Singers," pine relief 1969
 NBA

"Down By the Riverside" pine relief 1966 (Schomburg) BAAL
 (c); NBA
"The Hate Snake at the Garden Gate (Adam in Harlem)" pine relief
 1969 NBA
"Summer Day Chore" polychrome wood 1965 TCAFA
"When the Sharecropper Daughter Do a Dance" wood sc 1970
 BAAL(c)

PRICE, LESLIE KENNETH, 1945- ; b. in New York City; painter
 Biographical Sources: BAOA-2; EBSU; LAAA; WWAA,1991
 Portrait: EBSU; DIAA
 Published Reproductions:
 "Crisis Painting" oil 1974 DIAA
 "Divine Gift" oil 1974 DIAA
 "Perusa" oil 1971 LAAA(c)
 "Rebirth Universal" watercolor EBSU
 "Reflections on Being Black in New York" watercolor 1970
 BAOA-2(c)

PRICE, RAMON BERTELL, 1933- ; b. in Chicago; painter
 Portrait: WJBS 5(#1-81),41
 Published Reproductions:
 "Black Portrait--Male" WJBS 5(#1-81),42
 "Black Portrait--Female" WJBS 5(#1-81),42

PRIMUS, NELSON A., 1842-1916; b. in Hartford, CT; painter
 Biographical Sources: AAA; AAAET; DAAS; MIAP
 Published Reproductions:
 "Lizzie May Ulmer" oil 1876 (Connecticut) LAAA
 "Oriental Child" oil 1900 (Oakland) LAAA
 "Portrait of a Lady" oil 1907 AAAET(c)

PRINCE, ARNOLD, 1925- ; b. in Basseterre, St. Kitts, West
 Indies; sculptor
 Biographical Sources: AAA; WWAA,1978
 Published Reproductions:
 "The Virgin" limestone sc IBA
 "Zulu" white oak sc ILAAL

PROCTOR, E.; sculptor
 Published Reproductions:
 "Ball Player" sc EU (Fa-74),34
 "Family" sc EU (Fa-74),18
 "Looking Out" sc EU (Fa-74),36

PROPHET, NANCY ELIZABETH, 1890-1960; b. in Warwick, RI;
 sculptor
 Biographical Sources: BAAL; FFAA; MIAP
 Portrait: BAAL; CRI 36(12-29),407; NHB 9(4-46),151
 Published Reproductions:
 "Bust of a Negro Head" wood sc PHY 1(1stQ-40),315
 "Congolaise" wood sc 1930 (Whitney) AWSR; BAAL(c); CRI 39
 (8-32),259; FFAA(c); LNIA; PMNA
 "Discontent" wood sc (RISD) ATO; CRI 37(6-30),202; OPP 39
 (10-32),315
 "Head in Ebony" CRI 39(10-32),315
 "Negro Head" wood sc 1930 (RISD) ATO(c)
 "Sculpture in Wood" wood sc CRI 36(12-29),407; OPP 8(7-30),
 205
 "Silence" marble sc (RISD) ATO; OPP 8(7-30),205

PROSSER, RONNIE; printmaker
 Published Reproductions:
 "Cannonball" print EB 34(11-78),130
 "Dinah" print EB 34(11-78),130
 "Hendrix" print EB 34(11-78),130
 "Mahalia" print EB 34(11-78),130
 "Wes" print EB 34(11-78),130

PRYOR, WILLIAM C., 1949- ; b. in Fayetteville, GA; sculptor
 Biographical Sources: BAOA-2
 Portrait: BAOA-2
 Published Reproductions:
 untitled sc EB 27(9-72),99
 "Yomoko" steel sc 1970 BAOA-2

PURIFOY, NOAH, 1917- ; b. in Snow Hill, AL; painter, sculptor
 Biographical Sources: BAOA-2; LAAA; WCBI

Portrait: BAOA-2; FBA
Published Reproductions:
 "Barrel and Plow" construction 1966 ART 41(2-67),50
 "Burial Ground" 1988 NACA
 "Collemblage #3" oil CRI 78(7-71),cover(c)
 "The Eagle Is Also a Bird" mixed media 1988 NACA
 "Humpty Dumpty Sat on the World" metal sc 1969 BAOA-2(c)
 "The Sink" assemblage 1966 ART 41(2-67),50
 "Sir Watts" assemblage 1966 BAQ 3(#2-79),38; BAQ 8(#2-88),
 60; LAAA; MN 60(1/2-82),46
 "Six Birds" 1967 NACA
 "The Sound of One Hand Clapping" 1985 NACA(c)
 "Two Mops and a Guitar" 1988 NACA
 untitled assemblage WCBI
 untitled construction 1970 FBA(c); LAAA
 untitled metal on wood 1970 FBA
 untitled mixed media 1971 BAOA-2
 "Watts Riot" 1966 NACA(c)
 "Zulu #4" mixed media (Oakland) NACA
Further References:
 Secunda, Arthur, "The 'Junk' of Watts," ART 41(2-67),49-51.

PURVIANCE, FLORENCE V.; b. in Baltimore; painter
 Biographical Sources: AAA
 Published Reproductions:
 "Hills" watercolor LNIA

PURYEAR, MARTIN, 1937- ; b. in Washington, DC; sculptor
 Biographical Sources: WWAA,1991
 Published Reproductions:
 "Bodark Arc" 1982 AIM 72(4-84),91
 "Bower" sc ART 62(2-88),90(c); FA #103(Su-81),26
 "Circumvent" AIM 66(7-78),71
 "The Cut" 1988 NBEW(c)
 "Equivalents" installation 1979 ARTF 18(10-79),31
 "For Beckwourth" mixed media 1980 AIM 78(1-90),134
 "Greed's Trophy" wood,wire 1984 AIM 73(4-85),189
 "Keeper" wood,wire 1984 AIM 73(1-85),41; ARTF 23(1-85),12;
 ARTF 23(Su-85),115; AW 16(2-2-85),4

"Los Angeles 1984 Olympic Games" ARDE 41(5-84),224(c); GD
 #91(9-83),25
"M. Bastion Bouleverse" AJ 42(Sp-82),36; ARTF 18(10-79),28
"Maroon" mixed media 1988 AIM 78(1-90),134
"Mus" painted wood 1984 AIM 78(1-90),134; ART 62(2-88),91(c)
"On the Tundra" wood sc 1984 EWCA
"Pride's Cross" 1988 NBEW(c)
"Reliquary" ARTF 23(12-84),82
"Seer" sc ARTF 25(5-87),154
"Self" NAE 14(5-87),27
"Sentinel" fieldstone 1982 AIM 78(1-90),133(c)
"Sharp and Flat" pine sc 1987 BAAG
"She" installation 1979 ARTF 18(10-79),30
"Sleeping Mews" NAE 14(5-87),28
"Some Tales, Bask, Self" installation 1978 ARTF 18(10-79),28
"The Spell" sc AN 85(11-86),103(c)
"Stripling" wood sc 1978 ARTF 18(10-79),29
"Three Rings" wood sc CACF
untitled ARTF 18(5-80),23
untitled 1984 AW 15(5-12-84),2
untitled mahogany 1985 AIM 78(1-90),133(c)
untitled mixed media 1988 AIM 78(1-90),132(c)
untitled 1989 AIM 78(1-90),130(c)
untitled rope,oak 1973 AIM 62(1/2-74),110
untitled rope, cord 1987 ART 62(2-88),92
untitled wood 1978 ARTF 18(10-79),31
untitled wood 1978 ARTF 18(10-79),29
"Verve" wood sc AN 88(3-89),126(c); NBEW(c)
"Where the Heart Is" NAE 14(5-87),28

PUSEY, MAVIS, 1931- ; b. in Jamaica; painter, printmaker
 Biographical Sources: AAA; WWAA,1978
 Published Reproductions:
 "Dejyqea (Deiyqea)" STU 174(12-67),300
 untitled litho PANA(c)

RAMOS BLANCO, TEODORO, see **BLANCO, TEODORO
 RAMOS**

RAMSARAN, HELEN E., 1943- ; b. in Bryan, TX; sculptor
Biographical Sources: FFAA
Portrait: FFAA
Published Reproductions:
"Survivors" bronze sc 1976 FFAA(c)

RANDOLPH, JOSEPH; sculptor
Published Reproductions:
"Self-Portrait" terra cotta 1971 BC 9(11/12-78),49

RANGE, THOMAS; painter
Published Reproductions:
"Long Black Road" BC 2(11/12-71),25

RAWLINGS, FRANK H., 1924- ; b. in St. Paul, MN; painter
Biographical Sources: AAA
Published Reproductions:
"Attacked" paint and pencils DANA

RAY, JENNIFER; painter
Published Reproductions:
"Blues for Mr. Smith" BAQ 2(Wi-78),30(c)
"Fire" BAQ 2(Wi-78),31(c)
"Honey" BAQ 2(Wi-78),31(c)
"My Nephew" BAQ 2(Wi-78),30(c)

RAYSOR, MAXINE; painter
Published Reproductions:
"Streetscene" JBP 1(Fa-68),30
"Subway" JBP 1(Fa-68),30
untitled JBP 1(Fa-68),32

REASON, PATRICK HENRY, 1817-1850; printmaker
Biographical Sources: FAAA; LAAA; PMNA; TCBAA; TNA
Published Reproductions:
"DeWitt Clinton" pencil,wash 1835 (Howard) DANA; FAAA;
PMNA; TAAA; TNA
"Granville Sharp" engraving 1835 (Howard) DANA; FAAA;
PMNA; TCBAA

"Henry Bibb" copperplate 1848 (NYPL) AAAC; FAAA; TNA; TCBAA

"Henry Bibb" litho 1840 LAAA; PMNA

"Kneeling Slave" engraving 1835 EB 32(2-77),42; RD 112(6-78), 176; TCBAA

"New York African Free School" engraving 1830 FAAA; PNAP; TNAP

"Portrait of James Williams" engraving c1838 AIM 24(1-36),23

Further References:

Porter, James A., "Versatile Interests of the Early Negro Artists," AIM 24(1-36),16-27.

REDDIX, ROSCOE C., 1933- ; b. in New Orleans; mixed media, painter
Biographical Sources: AAA; BAOA-2; WWAA,1991
Portrait: BAOA-2
Published Reproductions:
"Let Not Your Heart Be Troubled" oil 1970 BAOA-2

REDVERS, DONALD A., see **REID, DONALD REDVERS**

REDWOOD, JUNIUS, 1917- ; b. in Columbus, OH; painter
Biographical Sources: AAA
Published Reproductions:
"Night Scene" oil 1941 (Modern Art) NBAT

REED, JAMES REUBEN, 1920- ; painter, printmaker
Published Reproductions:
"Depressed" oil DANA

REED, JERRY L., 1949- ; b. in Los Angeles; painter
Biographical Sources: BAOA-2
Portrait: BAOA-2
Published Reproductions:
"My Land" acrylic 1971 BAOA-2

REID, DONALD REDVERS; b. in British Guiana; graphic artist
Biographical Sources: AAA
Published Reproductions:

"Negro Worker" EB 1(7-46),46

REID, O. RICHARD, 1898-?; b. in Eaton, GA; painter
Biographical Sources: AAA; WWCA,1941
Published Reproductions:
 "John Barrymore as Hamlet" oil OPP 6(2-28),51
 "Portrait of Gordon Campbell, Sr." MES 6(7-24),232
Further References:
 Schuyler, George S., "Art and the Color Bar," MES 6(7-24),232

REID, ROBERT, 1924- ; b. in Atlanta; mixed media, painter
Biographical Sources: AAA; CBAM; WWAA,1978
Published Reproductions:
 "Agon II" oil,collage 1964-5 (Syracuse) FAAA; TNA
 "Big House With Falling II" oil,collage 1969 FAAA
 "A Doll's House" ART 42(12-67/68),54
 "A Falling #2" oil,collage AG 14(11-70),63; DCBAA
 "A Falling #4" oil,collage ART 45(11-70),58
 "Figures After Velasquez" AG 11(4-68),48
 "Figure at the Window" oil,collage 1967 CBAM
 "Figures on the Beach" oil,collage 1970 AIM 68(3-80),119(c);
 FAAA
 "Plumb Nellie, San Romano #2" collage 1979 AJ 40(Fa/Wi-80),385
 "Track" oil 1965 ILAAL
 "Two Figures" oil,collage 1971 AI 16(4-20-72),47

RENFRO, LEON, 1937- ; b. in Houston, TX; mixed media; sculptor
Biographical Sources: BAAL
Portrait: BAAL
Published Reproductions:
 "Shrine of Black Culture" BC 6(3/4-76),54(c)
 "Trees of Life" pen,ink 1977 BAAL(c)

REYNEAU, BETSY GRAVES; painter
Published Reproductions:
 "Charles Richard Drew" oil 1943 TNMP
 "George Washington Carver" oil (National Portrait) TNMP
 "Marian Anderson" oil 1943 (National Portrait) PAS
 "Paul Robeson as Othello" oil 1943 (National Portrait) PAS

RHODEN, JOHN W., 1918- ; b. in Birmingham, AL; sculptor
 Biographical Sources: AAA; TCBAA; WWAA,1991
 Portrait: EB 18(9-63),131; DANA
 Published Reproductions:
 "Blue Eyes--Indonesian Legend" wood sc 1965 DANA
 "Crucifix" sc NSR 18(Wi-69/70),10
 "Eve" sc JET 19(4-20-61),31
 "Female Figure" wood sc (Atlanta) DANA; ILAAL; SRV 37
 (#1-88),27
 "Invictus" wood sc DANA; UA 5(6-53),182
 "Laika (Russian Space Dog)" bronze sc 1958 SA 79(10-79),58
 "Paytoemahtamo, an American Indian Legend" bronze sc AAANB
 "Richanda" bronze sc 1975 ANA 11(10-76),15; TCBAA
 untitled sc CRI 56(5-49),153

RIBOUD, BARBARA CHASE, see **CHASE-RIBOUD, BARBARA DEWAYNE**

RICHARDSON, BEN, c1915- ; muralist, painter
 Biographical Sources: AAA
 Portrait: OPP 16(2-38),43
 Published Reproductions:
 "Renunciation" oil OPP 16(2-38),44

RICHARDSON, EARLE WILTON, 1913-35; b. in New York City;
 painter
 Biographical Sources: AAA; BAAL; MIAP
 Portrait: BAAL
 Published Reproductions:
 "Negro Pharaoh" oil 1934 (Schomburg) BAAL(c)
 "Profile of a Negro Girl" oil 1932 LNIA; OPP 11(3-33),81
 "Study for a Mural" oil (NYPL) TEAAA

RICHARDSON, ENID; painter
 Published Reproductions:
 "Me and My Chile" acrylic ESS 2(12-71),cover(c)

RICKSON, GARY A., 1942- ; b. in Boston; painter
 Biographical Sources: AAA; AAANB; FAAA; WWABA

Portrait: BAOA-1
Published Reproductions:
 "Africa Is the Beginning" Boston mural 1969 FAAA(c)
 "Boston Mural" mural ART 45(9-70),31
 "Capitalism in Organic Brown" oil 1970 AAANB; FAAA
 "Eastward Through the Westgate" oil 1970 FAAA
 "Mural" acrylic AN 68(9-69),30; ART 45(9/10-70),31; BAOA-1;
 FAAA

RIDDLE, JOHN T., 1933- ; b. in Los Angeles; painter, sculptor
Biographical Sources: BAOA-2; LAAA; WCBI; WWAA,1991
Portrait: BAOA-2
Published Reproductions:
 "Billy Rene" etching PANA
 "Bird and Diz" mixed media AW 20(8-26-89),1; WCBI
 "The Closet" acrylic 1977 BC 9(#1-78),83(c)
 "Clubs Is Trump" 1987 NACA
 "Control Force" metal sc (Golden State) BAQ 1(Wi-76),20
 "Dominoes" acrylic BAQ 1(Wi-76),19(c)
 "The Ghetto Merchant" mixed media NACA(c)
 "Made in Mississippi: Hoe" assemblage 1973 NACA
 "Made in Mississippi: Ken and Barbie" assemblage 1973 NACA(c)
 "Made in Mississippi: Bird and Diz" assemblage 1973 NACA
 "The Olympic Stand" acrylic 1972 BC 9(#1-78),82(c)
 "Patriot's Parade" oil 1969 BDCAA(c)
 "Proverb from Madagascar" serigraph 1979 BAQ 6(#4-85),36(c)
 "Proverb from Zimbabwe" serigraph 1980 BAQ 6(#4-85),37(c)
 "Saturday Morning" oil 1969 BDCAA(c)
 "Slot Machine #2 (Ancestral Series)" acrylic,collage 1988 NACA
 "Street Trial" welded steel sc 1968 BAOA-2(c)
 "A Sure Thing True to Form" acrylic 1977 BC 9(#1-78),82(c)
 "There's More at Stake than Just Attica" mixed media 1960
 NACA
 "The Three Ring Circus" acrylic 1977 BC 9(#1-78),82(c)
 "The Umbrella" acrylic BC 9(#1-78),83(c)
 untitled 1967 NACA
Further References:
 "Black Art," BC 9(#1-78),82-3.

RIDLEY, GREGORY, JR., 1925- ; b. in Smyrna, TX; painter,
 sculptor
Biographical Sources: AAA; BDCAA; TCBAA; WWAA,1978
Portrait: DANA
Published Reproductions:
 "African (Ashanti) Mask" oil 1964 (Fisk) TCBAA
 "Black Power" oil 1968 BDCAA(c)
 "Heads" sc (Atlanta) DANA

RINGGOLD, FAITH, 1934- ; b. in New York City; painter
Biographical Sources: AAA; CANO; LAAA; TNAP; WWAA, 1991
Portrait: FFAA; FSBA
Published Reproductions:
 "Animacules--Series #1" CMUB 68(5-81),153
 "Artist and Model" oil SEP 18(3-69),51
 "Atlanta" mixed media 1981 BALF 19(Sp-85),13
 "Aunts Edith and Bessie" mixed media 1974 LAAA
 "Bena and Buba" mixed media 1976 MTM(c)
 "Bernice Masks" 1974 WA
 "Bert and Dolores" 1973 CANO
 "Dancing on the George Washington Bridge" acrylic 1988 AN 88
 (2-89),29(c)
 "Die" oil 1967 AIM 58(9-70),63(c); AIS 11(#1-74),73; ART
 42(2-68),62; CVAH; MTM; LAAA
 "Fish on Spools" wood 1980 FA #114(11-83),35
 "Flag for the Moon: Die Nigger" oil 1969 FAAA(c)
 "The Flag Is Bleeding" oil 1967 AG 11(4-68),46; AJ 38
 (Wi-70/71),165; FAAA; FFAA(c); MIUA
 "For the Women's House" 1971 ARTF 19(11-80),41
 "God Bless America" oil 1964 MIUA(c)
 "Man" oil AG 13(4-70),28(c)
 "Miss Martha" 1978 construction AIM 72(11-84),154; AN 83
 (9-84),152
 "Mr. Charlie" oil 1964 ILAAL
 "Mrs. Jones and Family" mixed media 1973 TAM(c)
 "Mother Brown with Children" sc AIS 11(Sp/Su-74),98
 "Ms. Bert and Dolores" sc 1973 NALF 9(Su-75),43
 "Nana and Moma" mixed media 1976 MTM
 "Painting" oil FSBA

"Screaming Woman" mixed media 1981 STHR
"Tar Beach" NEA 16(2-89),55
"Weeping Women #2" 1973 MS 2(9-73),27(c)
"Who's Afraid of Aunt Jemima?" fabric 1983 MTM
"Woman Painting the Bay Bridge" AN 88(2-89),139
Further References:
"Exhibition at Spectrum Gallery," AN 69(8-70),72.
"Faith Ringgold at Spectrum," ART 44(2-70),61.
Lippard, L.R., "Faith Ringgold Flying Her Own Flag," MS 5 (7-76),
 34.

RIVERS, HAYWOOD "BILL", 1922- ; b. in Morven, NC; painter
Biographical Sources: AAA
Published Reproductions:
"Eclipse" oil (Boston) ART 44(Su-70),33(c); BLC
"Eclipse I" oil 1970 NBAT
"Eclipses" oil AAANB
"North Carolina as I Remember It" oil 1977 STHR
untitled oil 1952 TEAAA
untitled sc BCR 3(Sp-72),41
"Woman Smoking a Pipe" oil 1946 STHR
Further References:
Williams, Randy, "Ellsworth Ausby and Bill Rivers: Artists of the
 Soul," BCR 3(Sp-72),40-2.

ROACH, ARTHUR, 1935- ; b. in Perth Amboy, NJ; painter
Biographical Sources: AAA
Published Reproductions:
"Wounded Feelings" lithographic crayon 1970 NBAT

ROBERTS, LUCILLE MALKIA, 1927- ; b. in Hyattsville, MD;
 painter
Biographical Sources: BDCAA; DENA; LAAA; WWAA,1991
Portrait: BAOA-1
Published Reproductions:
"Black Heritage" acrylic 1969 BDCAA(c)
"Black Is Beautiful" BAOA-1
"Black Madonna" acrylic 1969 BDCAA(c)
"Celebration" acrylic DENA

"Emergence" acrylic BAOA-1
"Natural Woman" acrylic 1972 LAAA(c)

ROBERTSON, ROYAL, 1930- ; b. in St. Mary Parish, LA; painter,
 sculptor
Biographical Sources: BIS
Portrait: BIS
Published Reproductions:
 "Alien" concrete sc 1984 BIS
 "Holy Stop By" mixed media 1986 BIS
 "House of the Future" mixed media 1986 BIS(c)
 "Mrs. Deroted" mixed media 1985 BIS(c)
 "Vision 5:45 A.M." mixed media 1987 BIS

ROBINSON, AMINAH BRENDA
Published Reproductions:
 "I Have a Dream" AV 3(10-88),45(c)

ROBINSON, CHARLES ARAL, 1905- ; painter
Biographical Sources: AAA
Published Reproductions:
 "The Weary Blues" OPP 3(9-25),288

ROBINSON, JOHN N., 1912- ; b. in Washington, DC; painter
Biographical Sources: BACW
Portrait: DANA
Published Reproductions:
 "Anacostia Hills" oil 1944 (Howard) DANA
 "First Gallery" oil BACW
 "Mr. and Mrs. Barton" oil (Atlanta) SMIH 1(7-74),1
 "My Grandparents" oil DANA
 "Outdoor Art Fair" oil 1946 DANA
 "Self Portrait" oil AWAP; BACW
 "Spring Landscape" oil BACW

ROBINSON, PETER L., 1922- ; b. in Washington, DC; painter
Biographical Sources: DENA
Portrait: DENA

Published Reproductions:
"Red Desert" oil DENA

ROGERS, BRENDA, 1940- ; b. in Los Angeles; painter
Biographical Sources: AAA
Portrait: BAOA-1
Published Reproductions:
"Flower Pot" oil BAOA-1(c)
"Friends" oil BAOA-1(c)

ROGERS, CHARLES D., 1935- ; b. in Cherokee, OK; painter,
printmaker
Biographical Sources: WWABA
Portrait: BAOA-1
Published Reproductions:
"An Adaptation from the Theme of the Prodigal Son by Murillo"
woodcut PANA
"Child" oil 1964 BAOA-1(c)
untitled oil 1968 BAOA-1(c)

ROGERS, HERBERT; painter
Biographical Sources: AAA
Published Reproductions:
"Evelyn Rogers" OPP 9(7-31),cover

ROGERS, JUANITA, 1934-85; b. in Tintop Community, AL; mixed
media
Biographical Sources: BIS
Portrait: BIS
Published Reproductions:
"Lady and Dog" mixed media 1983 BIS(c)
"Shooting Pool" mixed media 1983 BIS
untitled mixed media 1983 BIS(c)
untitled mixed media 1983 BIS
untitled mixed media 1984 BIS

ROGERS, SULTAN, 1922- ; b. in Oxford, MS; mixed media
Biographical Sources: BAAL
Portrait: BAAL

Published Reproductions:
 "Corpse in Coffin" mixed media 1988 (Mississippi) BAAL
 "Female Blues Singer" wood sc 1988 (Mississippi) BAAL
 untitled wood sc 1985 BAAL(c)
 untitled wood sc 1986 BAAL
 untitled wood sc 1988 (Mississippi) BAAL
 "Vampire in Coffin" wood sc 1988 (Mississippi) BAAL

ROLLINS, BERNARD; painter
Portrait: BAOA-2
Published Reproductions:
 "Di Bau Cu ("Go to Vote")" oil BAOA-2

ROLLINS, HENRY C., 1937- ; sculptor
Biographical Sources: AAA
Published Reproductions:
 "Aunt Jemima" sc AG 11(4-68),46
 "Clay Figure" sc AG 11(4-68),48

ROSE, ARTHUR, 1921- ; b. in Charleston, SC; painter, sculptor
Biographical Sources: BDCAA; EBSU; WWABA
Portrait: BAOA-1
Published Reproductions:
 "The Family" oil 1969 BDCAA(c)
 "Fisherman Joe" BC 6(1/2-76),26(c)
 "Killer Whale" sc 1967 AG 17(3-74),62
 "The Predator" steel sc EBSU
 "Voodoo Doll" steel sc BAOA-1

ROSS, CHARLES; painter
Published Reproductions:
 "Reading By Lamplight" oil 1963 BAIH

ROSS, JAMES; painter
Published Reproductions:
 "The Block, 5th Ward" oil 1959 BAIH(c)

ROWE, NELLIE MAE, 1900-82?; b. in Fayette County, GA; mixed
 media, painter

Biographical Sources: AFATC; BFAA
Portrait: BFAA
Published Reproductions:
 "Black Fish" acrylic on wood 1981 BFAA
 "Fish" ink AFATC(c); BFAA
 "Fish on Spools" acrylic on wood 1980 BFAA; HG 154(7-82),10
 "My House" crayon 1979 AFATC(c)
 "Pig on Expressway" crayon 1980 AC 42(6/7-82),22(c); BFAA
 (c); PORT 5(5-83),90(c)
 "Purple Pig" mixed media 1975 BFAA(c)
 "Something That Hasn't Been Born Yet" ink,pencil 1979 BFAA
 "Two-Faced Head" mixed media 1980 BFAA(c)

ROWE, SANDRA; painter
 Portrait: AV 4(8-89),27-29; CACE
 Biographical Sources: AV 4(8-89),27-29
 Published Reproductions:
 "Backed into a Corner" installation 1982 CACE(c)
 "It Was Only Wonderful When They Were Dancing" 1989 AV 4
 (8-89),29(c)
 "Relationships: Lies and Truths" AV 4(8-89),28(c)
 "The Same Day Relative to the Same Day" acrylic 1987 AV 4
 (8-89),28(c)
 "S/he Thought the Sky Was Falling" drawing 1988 AV 4(8-89),
 27(c)
 "Sticks and Stones" AW 21(4-19-90),12

ROWLAND, NANCY, 1945- ; b. in Los Angeles; painter
 Biographical Sources: BDCAA
 Published Reproductions:
 "Sunset" oil 1967 BDCAA

RUSSELL, WINFRED J. painter
 Biographical Sources: AAA
 Published Reproductions:
 untitled OPP 1(1-23),17; SG 59(12-1-22),327

RYDER, MAHLER B., 1937- ; b. in Columbus, OH; mixed media,
 painter

Biographical Sources: AAA; CBAM; LAAA; WWAA,1978
Published Reproductions:
 "Boston Red (Malcolm X)" AAANB
 "The Great American Bus" ink 1969 DCBAA
 "RMB Enclosure" acrylic and fabric on wood LAAA
 "Taft" fiberglass on wood and plastic 1971 LAAA
 "21" mixed media DCBAA

SAAR, ALLISON, 1956- ; b. in Los Angeles; mixed media
 Biographical Sources: AWSR; WWAA,1991
 Published Reproductions:
 "Briar Patch" mixed media 1988 BAQ 9(#2-90),9(c)
 "Cleo" wood,tin 1987 BAQ 9(#2-90),7(c)
 "Diva" wood,tin,paint 1988 BAQ 9(#2-90),cover(c)
 "Dying Slave" mixed media 1989 BAQ 9(#2-90),5(c)
 "Fear and Passion" ART 57(10-82),24
 "Heathen Tea at Trumps" mixed media 1982 BAQ 9(#2-90),
 8(c)
 "Invisible Man" AN 85(1-86),109
 "L'Amarilla" mixed media 1986 VIS 1(Su-87),31(c)
 "Lazarus" monoprint 1988 AW 21(2-1-90),20
 "Leroy 'Phoenix' Lefeu" wood,tin 1987 AWSR
 "Love Potion #9" installation 1988 BAQ 9(#2-90),11(c)
 "Medicine Man Manual" mixed media 1990 BAQ 9(#2-90),11
 (c)
 "Queen of Sheba" wood,mixed media 1984 ARTF 23(11-84),105;
 BAQ 9(#2-90),7(c)
 "Sapphire" ARTF 24(4-86),111
 "Si J'etais Blanc" wood sc 1981 AW 21(2-1-90),1
 "Snake Charmer" wood,paint 1985 BAQ 9(#2-90),3(c)
 "Subway Preacher" mixed media 1984 STHR
 "Sweet Thang" mixed media 1983 BAQ 9(#2-90),9(c)
 "Traveling Light" mixed media 1983 BAQ 9(#2-90),10(c)
 "Uptown Bound" fresco 1988 BAQ 9(#2-90),9(c)
 "Wallflower" mixed media 1987 BAQ 9(#2-90),6(c)
 untitled AIM 73(10-85),174
 "Yo Mama" mixed media 1984 AIM 72(Su-84),42

SAAR, BETYE, 1926- ; b. in Los Angeles; graphic artist,

mixed media
Biographical Sources: LAAA; WCBI; WWAA,1991; WWABA
Portrait: BAOA-1; BE 6(12-75),60; FBA; FWCA
Published Reproductions:
 "Abandoned Gardens" AW 12(6-6-81),1
 "Africa" assemblage 1968 CBAM
 "Bessie Smith Box" assemblage 1974 MTM; PEAA
 "Betrothal" assemblage 1983 AW 15(1-14-84),4
 "Black Boy, Black Bird" assemblage 1973 STHR
 "Black Crows in the White Section Only" mixed media 1972 AN
 84(4-85),11; BUNY
 "Black Girl's Window" mixed media 1969 ESS 6(3-76),84
 "Blanco y Negro (And the Country's Goin' to the Dogs)" mixed
 media 1983 EWCA(c)
 "Box of Mementos" construction AN 75(5-76),111
 "Calling Card" mixed media 1976 AW 155-26-84),1
 "Dangerous Visions" collage 1984 NACA(c)
 "Dark Erotic Cream" mixed media 1976 ART 50(6-76),7
 "Dat Ol' Black Magic" mixed media 1981 AAATC(c)
 "Dr. Damballa's Ju-Ju" assemblage 1989 AW 21(2-1-90),1
 "Eclipse" mixed media 1977 BAQ 3(#1-78),7(c)
 "El Diablito" AN 80(9-81),233
 "Enigma of Eternity" collage AIM 69(5-81),171
 "Erotic Dream" mixed media 1972 BAQ 1(Su-77),24
 "Eshu (The Trickster)" mixed media 1977 LAAA
 "Fetish and Facade" mixed media 1988 NACA
 "Floating Figure with Seven Spades" mixed media 1977 NACA(c)
 "Gone Are the Days" mixed media 1970 FBA
 "Imitation of Life" assemblage 1975 MTM
 "In My Solitude" installation 1983 BAQ 6(#1-84),49(c)
 "Indigo Mercy" mixed media 1975 AJ 39(Su-80),292; BAQ 3
 (#1-78),15(c); MTM(c)
 "Is Jim Crow Really Dead?" assemblage WCBI
 "The Jewel of Gemini" drawing 1968 BAOA-1; FBA
 "LA--The Way We Were" GD 82(6-81),39(c)
 "Last Dance" mixed media 1975 CGB
 "Last Empress" assemblage 1988 ARTF 28(4-90),182
 "The Liberation of Aunt Jemima" mixed media 1972 ARTF 19
 (11-80),41; LAAA; NALF 9(Fa-75),cover

"Little Black Sambo" mixed media 1976 NACA

"Miz Ann's Charm" ESS 6(3-76),84

"Mojotech" mixed media 1987 AIM 78(3-90),166(c); AN 88 (3-89),126(c)

"MTI: Receives" assemblage 1977 BAQ 6(#1-84),45

"Mystic Window" intaglio,drawing AG 11(4-68),40; BAOA-1

"Night Games" AW 12(6-6-81),1

"Nine Mojo Secrets" assemblage 1971 LAAA(c); NACA(c)

"Ohne Hast, Ohne Rast" 1976 CGB

"On Our Way" 1986 AIM 78(7-90),147(c)

"Pajaro" mixed media 1989 VIS 4(Wi-89),24(c)

"The Protector: The Earth" mixed media collage 1977 BAQ 3 (#1-78),6(c)

"Remembered Gardens: San Francisco" AW 12(6-6-81),1

"Rendezvous" mixed media 1975 ART 50(6-76),7

"Samsara" etching PANA(c)

"Secrets and Revelation" installation 1980 BAQ 6(#1-84),46

"Shield of Quality" mixed media ART 50(1-76),27; STHR

"Shinta" mixed media 1977 AN 76(12-77),106; AW 10(4-28-79),5

"Smiles We Left Behind" assemblage 1976 FIBO; OAWA

"Somewhere Out There" assemblage 1976 BAQ 3(#1-78),8

"Spirit Catcher" assemblage 1976/77 AW 12(8-29-81),6; BAQ 3(#1-78),11(c)

"Stranger in a Strange Land" installation 1983 BAQ 6(#1-84), 47

"Thinking Back, Looking Forward" AW 12(6-6-81),1; AW 13 (5-22-82),6

"The Time Inbetween" 1974 PSIC; SFMA

"Time is a Matter of Choice" linocut assemblage 1979 FWCA(c)

"Toro Rojo" print BAQ 1(Wi-76),20

untitled EWTA(c)

untitled construction AW 10(4-21-79),3

"Veil of Tears" assemblage 1976 MTM

"View from the Palmist's Window" mixed media 1970 NACA

"The Vision of El Cremo" construction AG 13(4-70),22(c)

"Water's Edge" ART 64(4-90),117(c)

"Whitey's Way" mixed media 1969 DCBAA; NACA(c)

"Window of the Ancient Sarens" construction 1971 BAQ 2 (Wi-78),33

"Wizard" mixed media 1972 BAQ 1(Su-77),23(c); BAQ 3
(#1-78),5; ESS 6(3-76),84; FFAA(c)
Further References:
Andrews, Benny, "Jemimas, Mysticism, and Mojos: The Art of
Betye Saar," ENC 4(3-17-75),30.
Burke, Carolyn, "Images from Dream and Memory," AW 15
(1-14-84),4.
Conwill, Houston, "Interview with Betye Saar," BAQ 3(#1-78),
4-15.
Johnson, Channing, "Betye Saar's 'Hoodoo' World of Art," ESS 6
(3-76),84-5.

SALLEE, CHARLES, 1913- ; b. in Oberlin, OH; graphic artist,
painter
Biographical Sources: AAA; MIAP
Published Reproductions:
"Bedtime" oil 1940 PMNA
"Boogie Woogie" etching 1941 PMNA
"Nude Back" oil 1938 LNIA

SAM, JOE; mixed media
Portrait: CACE
Published Reproductions:
"The Artist and the Lover" mixed media 1989 AW 20(11-9-89),
17
"Blacksheepman" AW 16(3-9-85),4
"Can War" mixed media 1986 CACE(c)
"Moses in the Bull Rushes" AN 86(12-87),169; AW 18(10-17-87),4
"No Toxic Waste" AIC 3(3-90),68(c)
Further References:
Jenkins, Steven, "People of Color; Joe Sam's Symbols of Life-
style," AW 20(11-9-89),17.

SAMPLER, MARION, 1922- ; b. in Anniston, AL; painter
Biographical Sources: BDCAA
Published Reproductions:
untitled oil 1965 BDCAA(c)
untitled oil 1968 BDCAA(c)

SAMPLES, BERT, 1955- ; b. in Houston; painter
 Biographical Sources: BAAL
 Portrait: BAAL
 Published Reproductions:
 "Dawn of Orpheus" 1981 ART 84(Su-85),103; ARTF 23(4-85), 54
 (c)
 "Eulipian I" conte crayon 1983 BAAL(c)
 "Jubilee, Jubilee" acrylic 1983 BAAL(c)

SANCHEZ, JUAN; mixed media
 Published Reproductions:
 "Against Apartheid We Sing" mixed media BC 15(11/12-84),44(c)

SANDLER, EVE; mixed media
 Published Reproductions:
 "Cloud Elements" mixed media 1983 BAQ 9(#2-90),13(c)
 "Hikuptah" mixed media 1985 BAQ 9(#2-90),12(c)
 "Kalimba" mixed media 1982 BAQ 9(#2-90),13(c)
 "Opal Kite" mixed media 1985 BAQ 9(#2-90),13(c)
 "Prayer Series" installation 1988 BAQ 9#2-90),14(c)
 "Violin" mixed media 1984 BAQ 9(#2-90),12(c)

SANFORD, WALTER; painter
 Portrait: DANA
 Published Reproductions:
 "In the Beginning" OW 7(1-52)58
 "The Philosopher" oil ND 12(6-63),41
 "Seated Nude" oil 1959 DANA
 "Sun Ritual" oil 1958 DANA
 "Susan and Friend" DANA
 "Woman with Pearls" OW 7(1-52),58
 Further References:
 "Sanford and His World of Art," ND 12(6-63),40-3.

SAPP, FLOYD, 1939- ; b. in New York City; painter
 Portrait: SEP 19(3-70),45
 Published Reproductions:
 "Building of the Temple of Abu Simbel" oil SEP 19(3-70),43(c)
 "Christ" oil SEP 19(3-70),44(c)

"Creation of the Key of Life" oil SEP 19(3-70),44(c)
"David and Bathsheba" oil SEP 19(3-70),44(c)
"Goddess of Isis" oil SEP 19(3-70),43(c)
"The Last Supper" oil SEP 19(3-70),44(c)
"MX-EW" oil SEP 19(3-70),43(c)
untitled SEP 19(3-70),45

SAUNDERS, RAYMOND JENNINGS, 1934- ;b. in Pittsburgh;
 mixed media
 Biographical Sources: BDCAA; CBAM; LAAA; WWAA,1991
 Portrait: ENC 4(4-21-75),35; FWCA
 Published Reproductions:
 "African Series" colored pencils 1970 BAQ 1(Su-77),3(c)
 "African Series" colored pencils 1970 BAQ 1(Su-77),52(c)
 "African Series" colored pencils 1970 BAQ 1(Su-77),53(c)
 "American Dream" oil,collage 1967 AAASN; MIUA
 "Bill Jones Mother Is a Hore" oil 1968 FUF
 "Charlie Parker" 1977 SFMA
 "Celeste" mixed media 1986 CPNW(c)
 "Celeste Age 5 Invited Me to Dinner" mixed media AIM 75
 (9-83),28(c)
 "China Parts" mixed media 1987 AIM 78(3-90),170(c)
 "Collage" mixed media GD #82(6-81),39(c)
 "Colored" AW 20(5-27-89),cover
 "Copy" ARTF 18(12-79),82
 "Diego's World" oil 1963 AG 11(4-68),21(c)
 "Doctor Jesus" oil 1968 AAANB; ART 44(Su-70),20; CGB;
 FAAA
 "Dolls" AW 10(11-3-79),3
 "East/West" mixed media 1983 AIM 71(10-83),59
 "East to West" oil 1987 AIM 75(10-87),36(c)
 "Elizabeth, Marie's Sister" mixed media ARTF 12(6-74),23;
 WCBI
 "Friday Nights and Marie's Room" mixed media 1983 AIM 74
 (10-86),44(c)
 "Heart in the Orient" 1984 AIM 72(Su-84),60(c)
 "Icons and Gods" oil collage 1968 AAAC; AG 13(4-70),22(c)
 "In White America" drawing 1968 AJ 28(4-69),328
 "Jack Johnson" oil 1971 (Pennsylvania) AV 3(10-88),39(c);

GOY 119(3-74),305; ITA; LAAA(c)
"Layers of Being" mixed media 1985 CPNW(c)
"Malcolm" mixed media 1983 EWCA
"Marie" oil 1967 CBAM
"Marie's Bill" oil 1970 AAW; DCBAA; FAAA(c); WAA
"Mickey Mouse and Memorabilia" oil AN 75(3-76),88
"Mr. Charlie Gets Four Stars for Being a Nigger" oil ANA 4
 (5-69),16
"Mix" AW 10(11-3-79),3
"Mother and Child" oil 1961 (Howard) AWAP
"Neon II" drawing 1974 AN 74(5-75),55
"Night Town" oil 1963 (Texas) JAMC
"25th Street" oil,lacquer 1973 (Oakland) AOC(c)
"On Eva's Space and Time" 1986 AIM 74(7-86),18(c)
"1,2,3,4,5" oil 1974 AN 81(1-82),78; CGB; FWCA(c)
"Page from an African Notebook" colored pencil 1970 LAAA(c)
"Palace" oil 1972 DIAA
"Picture Neon" ART 49(5-75),20
"Piece No. 2" mixed media ART 47(3-73),83
"Plendalove" oil collage 1967 AAASN
"Present of My Past" AW 20(5-27-89),1
"Puppet Play from the Middle East" oil ENC 4(4-21-75),35
"Raggedy Story" mixed media 1975 ARTF 13(5-75),5(c)
"Red Star" oil 1970 AAATC(c); STHR(c)
"Sameness in Etcetera" AW 20(5-27-89),1
"7.5.6.3" pencil 1970 AG 14(3-71),55; ARTF 9(4-71),88;DCBAA
"Spanish Harlem/110th Street" AW 14(5-28-83),4
"Star" oil 1972 DIAA
"Still Life Mixed in with Other Voices" mixed media 1988
 CPNW(c)
"This Box is Our Box" 1972 CGB
"Three" oil 1967 BDCAA(c)
"Two Figures, Oaxacan Landscape" 1983 ARTF 23(3-85),46(c)
untitled 1976 OSAE
untitled mixed media AIM 75(6-87),48(c)
untitled oil,collage 1967 AG 11(4-68),35
"Walking in Bahia" AW 20(5-27-89),1
"Wedding" mixed media ART 41(5-67),60
"White Flowers, Black Flowers" 1986 ARTF 25(5-87),99(c)

"Winter Spring" AIM 68(2-80),135(c)
Further References:
Andrews, Benny, "Raymond Saunders: An Artist's Artist," ENC 4
 (4-21-75),35.
Saunders, Raymond. *Black Is a Color*. n.p.,1967.

SAVAGE, AUGUSTA CHRISTINE, 1900-1962; b. in Green Cove
 Spring, FL; sculptor
Biographical Sources: AAA; LAAA; MIAP; TNAP; WWAA,1940
Portrait: ATO; DANA; EB 21(8-66),90-4; OPP 1(7-23),24
Published Reproductions:
 "The Chase" wood sc AD 9(4-15-35),19
 "Faun" cement sc (DuSable) ATO
 "Gamin" bronze sc 1930 AG 13(4-70),7; ATO; AWSR; BAQ 1
 (Wi-76),46; BC 11(#2-80),98; CRI 39(1-32),461; EB 23(2-68),
 118; FFAA(c); FHBI(c)HRABA; LNIA; OPP 7(6-29),cover;
 SCJ 7(#2-88),4; SMIH (12-77),4; SRV 37(#1-88),27; STHR
 "Green Apples" bronze sc 1928 (Yale) ATO(c)
 "The Harp" SCJ 7(#2-88),4
 "La Citadelle--Freedom" bronze sc (Howard) ATO
 "Leonore" plaster sc 1935 LNIA
 "Lift Every Voice and Sing" plaster sc 1939 (Yale) AWSR; CRI
 46(4-39),cover; DANA; LAAA; OPP 17(5-39),133; WA
 "Marcus Garvey" bronze sc SBMAA
 "Pugilist" plaster sc (Schomburg) SBMAA
 "Realization" clay sc PMNA

SAWYER, ANN, 1914-; b. in Youngstown, PA; painter
Published Reproductions:
 "I Gotta Right" oil DANA

SCHENCK, SYDNEY, 1956- ; painter; b. in New Brunswick, NJ
Published Reproductions:
 "Sweet Grapes" EB 37(5-82),84
Further References:
 "Sydney Schenck: An Artist in Paris," EB 37(5-82),84.

SCHUYLER-KEY, VIVIAN, 1905- ; b. in Hempstead, NY; painter
Biographical Sources: FFAA

Portrait: FFAA
Published Reproductions:
 "God Bless the Child That's Got His Own" oil 1976 FFAA(c)

SCOTT, JOHN (JOHNNY); sculptor
 Published Reproductions:
 "Bars on the Landscape #1" painted steel,brass 1986 AV 1
 (11/12-86),27(c)
 "Ibegi for Brother Garrett" polychrome steel sc 1987 AIM 78
 (3-90),165(c); AW 20(10-7-89),4
 "Mother and Child" terra cotta sc 1972 BC 9(11/12-78),49
 "Rhodesian Box #7" BC 15(11/12-84),45(c)

SCOTT, JOHN TARRELL, 1940- ; b. in New Orleans; painter,
 printmaker
 Biographical Sources: DIAA; NGSBA; WWAA,1991
 Portrait: AN 85(5-86),73; DIAA
 Published Reproductions:
 "Alandra's Dream Tree" AN 85(1-86),113
 "Gates of Goree Seedless Grapes" wood,canvas 1980 BAQ 6
 (#2-84),43
 "Hare Fare" AN 76(9-77),68; AN 76(10-77),68
 "Ikhnaton's Rowboat" wood and brass 1984 AN 85(5-86),73(c)
 "Just Two" sc BAQ 6(#2-84),43
 "Moon Song" bronze sc 1978 AN 12-79),71; BAQ 6(#2-84),41(c)
 "Nigerian Impression #7: Goats" acrylic 1974 DIAA
 "Nigerian Impression #8: Plantain" acrylic 1974 DIAA
 "Ritual" bronze sc 1978 BAQ 6(#2-84),35
 "Rose Hammer" bronze sc 1971 BAQ 6(#2-84),41(c)
 "South African Shooting Gallery" BE 6(12-75),47(c)
 "Study for Martin Luther King's Monument" bronze sc 1975
 BAQ 6(#2-84),33
 "T 3 Till" welded steel 1988 NGSBA(c)
 "T 1 Thelonius" steel,aluminum 1988 NGSBA(c)
 untitled BC 3(#2-73),cover(c)
 "Zydeco" steel 1988 NGSBA(c)
 Further References:
 Tucker, Yvonne, "John T. Scott and the Black Aesthetic," BAQ 6
 (#2-84),32-43.

SCOTT, JOYCE, 1948- ; b. in Baltimore; sculptor
 Biographical Sources: NGSBA
 Portrait: AC 47(12/1-87/88),56
 Published Reproductions:
 "Ancha Melon" mixed media 1987 NGSBA(c)
 "Blue Baby Book, Cover" mixed media 1984 NGSBA(c)
 "Blue Baby Book, Page 1" mixed media 1984 NGSBA(c)
 "Blue Baby Book, Page 2" mixed media 1984 NGSBA(c)
 "Blue Baby Book, Page 3" mixed media 1984 NGSBA(c)
 "Death Hovers over South Africa" BC 15(11/12-84),45(c)
 "Nanny Now, Nigger Later" mixed media 1986 AC 47
 (12/1-87/88),56; NGSBA(c)
 "Nigger Now, Nigger Later" assemblage 1986 NAE 15(9-87),51
 "Scarecrow Knows Who Won the West" mixed media 1988
 NGSBA(c)
 "What You Mean, Jungle Music?" mixed media 1987 AC 47
 (12/1-87/88),57(c)

SCOTT, WILLIAM EDOUARD, 1884-1964; b. in Indianapolis;
 painter
 Biographical Sources: AAA; BACW; LAAA; MIAP; NAI; TNAP;
 WWAA,1940
 Portrait: ATO; NAI; NHB 9(4-46),149
 Published Reproductions:
 "At Bay" CRI 17(12-18),cover
 "Blind Sister Mary" oil 1931 (Schomburg) AAAC; ATO; FAAA
 "Booker T. Washington" oil 1916 (Tuskegee) FAAA
 "Cabins" oil CABW
 "Calabash for Market" oil 1932 LNIA
 "Christmas Dinner" oil AMA 27(1-34),36
 "First Communion, Port-au-Prince, Haiti" oil 1931 (Howard) ATO
 "Haitian Fisherman" oil 1931 LAAA
 "Haitian Man" oil TEAAA
 "Haitian Market" oil 1950 AAR 3(11/12-76),64(c); AIM 65
 (3-77),64(c); AN 76(2-77),66; ENC 6(1-3-77),20(c); RD 112
 (6-78),179(c); TCBAA(c)
 "Kenskoh Haiti" oil 1931 (Schomburg) FAAA
 "La Misere" oil 1913 (Indiana) ATO
 "Lagoon" litho 1912 AAAET

"Lord Will Provide" oil ILAAL; LAAA; NAI; TNA
"Night Turtle Fishing in Haiti" oil 1931 (Clark) ATO(c)
"Old Age" oil 1933 FAAA
"Old Woman" litho 1912 AAAET
"Rainy Day, Etaples" oil 1912 (Indiana) ATO
"Turkey Market" oil 1932 PMNA
"When the Tide is Out" oil 1931 AAAC; LAAA
Further References:
Holbrook, Francis C., "William Edouard Scott, Painter," SW 54
 (2-24),72-6.

SEABROOKE, GEORGETTE, see **POWELL, GEORGETTE
SEABROOKE**

SEARLES, CHARLES R., 1937- ; b. in Philadelphia; painter
Biographical Sources: AAA; BAAL; WWAA,1991; WWABA
Portrait: BAAL; NBA
Published Reproductions:
 "Dancer Series" acrylic 1975 ARAC 107(5-90),26(c); BAAL(c);
 BE 21(10-90),20(c)
 "Doris" acrylic 1969 NBA
 "Fantasy Animal I" wood,acrylic 1978 BAAL
 "Filas for Sale" acrylic 1972 (National Center) BAAL(c)
 "Flight of My Father" wood,acrylic 1980 BAAL
 "Idle Hours" acrylic 1969 NBA
 "Ife Dancers" acrylic 1974 BC 11(10/11-80),102(c)
 "News" acrylic 1970 DCBAA
 "Nigerian Impression #1: Goats" acrylic (Cornell) AN 73
 (12-74),63
 untitled 1975 MN 69(3/4-90),35(c)
 untitled mixed media 1969 NBA; NH 9(#4-69),40
 "Warrior" wood,acrylic 1987 BAAL(c)

SEBREE, CHARLES, 1914-85; b. in Madisonville, KY; painter
Biographical Sources: AAA; AAATC; BACW; NAI; TCBAA
Published Reproductions:
 "Blue Jacket" oil 1938 AAATC(c); BAWPA
 "Harlem Saltimbanques" oil,tempera (Smithsonian) RD 112
 (6-78),183(c); TCBAA

"Head of Woman" gouache DANA
"Moses" AMA 34(8-41),372
"New York Hat" 1938 LNIA
"Ritual Woman" (Chicago) DANA
"Still Life" oil ILAAL
"Two Women" oil BACW
"Young Model" SMIH (12-77),4

SEJOURNE, BERNARD, 1947- ; b. in Port-Au-Prince, Haiti; painter
Published Reproductions:
"Ti-Fi (Little Girl)" oil 1971 NBAT

SEPYO, JAMES; painter
Published Reproductions:
"Black Pharaoh" ESS 2(5-71),53
"Bull of the Cameroons" ESS 2(5-71),53

SETTLES, BENNIE; painter
Published Reproductions:
"Ghetto Vision" Houston mural 1978 BAIH(c)

SHANDS, FRANKLIN MCKENZIE, 1920- ; b. in Cincinnati; painter
Biographical Sources: WWABA
Published Reproductions:
"Hod Carrier" oil EB 1(8-46),48

SHARPE, FRANK, 1942- ; b. in Columbia, SC; painter, printmaker
Biographical Sources: AAA
Published Reproductions:
"Man: Amnesty" oil 1970 DCBAA

SHELTON, CHRISTOPHER, 1933- ; b. in New Orleans; painter,
 sculptor
Biographical Sources: FAAA
Published Reproductions:
"Air Afrique #3" construction 1971 FAAA; NBAT

SHERRILL, MILTON; b. in Mount Vernon, NY; painter, sculptor
Biographical Sources: WWAA,1991

Portrait: BAQ 6(#1-84),27
Published Reproductions:
 "Biofeedback Boogie" bronze sc BE 17(12-86),92(c)
 "Desiree IV" sc BAQ 6(#1-84),28
 "Jewel of the Universe" bronze sc BAQ 6(#1-84)33(c)
 "Life of Roland Hayes" clay model 1979 BAQ 6(#1-84),30
 "Roland Hayes" clay model 1979 BAQ 6(#1-79),31
Further References:
 "From Painter to Sculptor: Milton Sherrill's Progression," BAQ 6
 (#1-84),26-33.

SILLS, THOMAS, 1914- ; b. in Castalia, NC; painter
 Biographical Sources: CBAM; FAAA; WWAA,1991
 Portrait: AG 13(4-70),40; AN 71(3-72),48
 Published Reproductions:
 "Africa" oil 1968 CBAM
 "Cage" oil 1971 AN 71(3-72),48; FAAA
 "Composition" DANA
 "Drawing #2" oil 1969 AAANB
 "Feminine" oil 1968 AAAASN
 "Life" oil 1971 ART 46(3-72),66
 "Nightcap" oil 1970 AN 71(3-72),49; FAAA
 "Red Bar" AN 59(2-61),12
 "Red Berries" 1958 ARTF 1(7-62),11
 "Red Dream" AN 66(4-67),66
 "Sea" oil 1960 ILAAL
 "The South" oil 1968 (San Francisco) AG 13(4-70),28(c);
 FAAA(c);
 Further References:
 Campbell, Laurence, "The Flowering of Thomas Sills," AN 71
 (3-72),48-50.
 Jacobs, Jay, "Now I'm Boss," AG 13(4-70),40-1.

SIMMONS, GLORIA, 1948- ; b. in Easton, PA; painter
 Published Reproductions:
 "Plant Life" ABWA

SIMMS, CARROLL HARRIS, 1924- ; b. in Bald Knob, AR; painter,
 sculptor

Biographical Sources: AAA; BAAL; WWABA
Portrait: BAAL
Published Reproductions:
 "African Queen Mother" bronze sc 1968 (Texas Southern) BAAL;
 BAIH(c)
 "Angels" oil DANA
 "Christ and the Lambs" oil BAIH; DANA
 "He's Got the Whole World in His Hand" bronze 1983 EWCA(c)
 "Homage to a Shrine" bronze sc BAIH
 "Jonah and the Whale" bronze sc BAIH(c)
 "Men and the Universe" sc BAIH(c)
 "Old Couple Fishing" bronze sc BAIH
 "Prophet and Son" walnut sc BAIH
 "Weaver" bronze sc BAIH
 "Woman with a Bird" bronze sc BAIH(c)

SIMON, JEWELL W., 1911- ; b. in Houston, TX; painter, print-
 maker, sculptor
Biographical Sources: BAOA-1; BDCAA; WWAA,1991; WWABA
Portrait: BAOA-1; DANA
Published Reproductions:
 "Apparition" oil 1969 BDCAA(c)
 "The Early Birds" oil BAOA-1
 "February Lace" watercolor 1962 IBA
 "The Outing" watercolor DANA
 "The Tusi Princess" plaster sc CRI 80(1-73),cover(c)
 "Walk Together Children" mono-print 1964 BAOA-1; PANA

SIMON, WALTER AUGUSTUS, JR., 1913- ; b. in Brooklyn; painter
Biographical Sources: WWABA; WWE,1975
Portrait: DANA
Published Reproductions:
 "Apartment on Washington Street" DANA
 "Lines from Countee Cullen" acrylic,oil CRI 85(10-78),
 cover(c)
 "Looking over the Fence" drawing DANA
Further References:
 Reddick, L.D., "Walter Simon: The Socialization of an American
 Negro," PHY 15(#4-54),373-92.

SIMPSON, COREEN; painter
Published Reproductions:
"Self Portrait" BE 12(12-82),58(c)

SIMPSON, KEN, 1926- ; b. in Washington, DC; painter
Biographical Sources: AAA; DENA; WWABA
Portrait: BAOA-1; DENA
Published Reproductions:
"Sam" linocut DENA
"Thinking" woodcut BAOA-1; BAQ 6(#4-85),11

SIMPSON, MERTON DANIEL, 1928- ; b. in Charleston, SC; painter
Biographical Sources: AAA; BACW; FAAA; WWAA,1991
Portrait: EB 18(9-63),132; ILAAL
Published Reproductions:
"Confrontation" oil AAAC
"Confrontation 1" oil 1964 EB 23(2-68),cover(c); FAAA; TEAAA
"Confrontation IIA" oil 1964 FAAA
"Confrontation III" oil 1967 ILAAL
"Confrontation 20" oil 1968 AG 13(4-70),19(c); STHR
"Figurescape #14" BAQ 3(#2-79),22(c)
"Figurescape #16" BAQ 3(#2-79),29
"Figurescape #17" BAQ 3(#2-79),24
"Figurescape #18" BAQ 3(#2-79),25
"Figurescape #19" BAQ 3(#2-79),28
"Harlem Passage No. 2" oil 1964 FAAA
"Lady" BAQ 3(#2-79),23(c)
"Nude" oil DANA
"Old Lady" BAQ 3(#2-79),27
"Oriental Fable" oil 1959 DANA
"Sky Poem" oil AWAP
"Study in Red" oil 1949 BACW
untitled ART 58(10-83),55(c)
"Victim" oil 1965 AN 65(9-66),50
Further References:
Hollingsworth, A.C., "Merton Simpson, Artist," BAQ 3(#2-79),
 21-9.

SIMPSON, WILLIAM H., 1818-1872; b. in Buffalo, d. in Boston;

painter
Biographical Sources: FAAA; LAAA; TNAP
Published Reproductions:
"Bishop Jermain W. Loguen" oil 1835 (Howard) AAAC; AIM
 24(1-36),17; DANA; EB 23(2-68),116(c); FAAA;
 LAAA; LNIA;; PMNA; TAAP
"Portrait of B. Loguen" oil 1854 (Howard) EB 23(2-68),75(c)
"Portrait of Caroline Loguen" oil 1854 (Howard) AG 13
 (4-70),4; FAAA; LNIA; PMNA; TAAP

SINGLETARY, MICHAEL J., 1949- ; born in New York
Biographical Sources: EB 41(7-86),96; WWAA,1991
Portrait: EB 41(7-86),96
Published Reproductions:
"Meet Market" EB 41(7-86),98(c)
untitled EB 41(7-86),100(c)

SIRLES, NATHANIEL, 1956- ; painter, sculptor
Published Reproductions:
"African" JBP 1(Fa/Wi-71),81
"Drummer" sc 1970 JBP 1(Fa/Wi-71),80
"Prophet Brown" sc ARTF 9(6-71),92
untitled sc JBP 1(Fa/Wi-71),82

SLADE, MARGARET LOUISE, 1949- ; b. in Newark, NJ; graphic
artist, painter
Biographical Sources: AAA
Published Reproductions:
"The Imam" oil 1971 NBAT

SLATER, VAN, 1937- ; b. in in Arkansas; printmaker
Biographical Sources: BAOA-2; WWAA,1978
Portrait: BAOA-2
Published Reproductions:
"Barber Shop" woodcut 1970 BAOA-2; BAQ 6(#4-85),12
"Eula Seated" woodcut LAAA; PANA
"Sapphire" woodcut BAOA-2(c); BAQ 6(#4-85),18(c)

SLOAN, LOUIS B., 1932- ; b. in Philadelphia; painter

Biographical Sources: AAA
Published Reproductions:
 "Gathering Storm over Philadelphia" SA 70(11-70),32

SMITH, ALBERT ALEXANDER, 1896-1940; b. in New York City,
 d. in Paris; graphic artist, painter
Biographical Sources: ATO; WWCA3
Portrait: ATO; OPP 18(7-40),209
Published Reproductions:
 "Alexander Dumas" OPP 3(5-25),cover
 "Alexander Sergeyevitch Puskin" etching OPP 3(5-23),cover
 "Bilbas--Spain" SW 59(5-30),169
 "Catedral de Panama" OPP 6(6-28),207
 "Dancing Time" oil (Hampton) AD 5(2-15-31),7; ATO(c);
 OPP 18(7-40),208
 "Fantasy Ethiopia" OPP 6(6-28),cover
 "Francisco Xavier de Luna Victoria y Castro" OPP 6(6-28),208
 "Generations" oil 1929 AD 4(1-30),13; ILAAL
 "Laughter" litho 1928 ATO
 "Marketplace, Nice, France" ATO; OPP 11(3-33),80
 "Paul Lawrence Dunbar" etching OPP 3(11-25),cover
 "Pickin' Cotton" watercolor LNIA
 "Plantation Melodies" etching 1923 (NYPL) BAQ 2(Sp-78),7;
 CRI 19(8-20),184
 "Ponte Vecchio, Florence, Italy" SW 58(4-29),166
 "The Reason" drawing CRI 77(11-70),324
 "Sevilla" OPP 6(3-28),cover
 "Street in Rome" etching 1928 ATO
 "Toussaint L'Ouverture" oil OPP 1(7-23),24
Further References:
 McGleughlin, Jean, "Albert Alexander Smith," OPP 18(7-40),209.

SMITH, ALFRED J., JR., 1948- ; b. in Boston; painter
Biographical Sources: DIAA; WWAA,1978; WWABA
Portrait: BANG; DIAA
Published Reproductions:
 "Beginnings, Endings and Beginnings" oil 1974 DIAA
 "High Priestess" BC 7(5/6-77),cover(c)
 "Impressions of Karma" oil 1970 AAANB

"King and Queen of Harlem" oil 1973 DIAA
"Osei Tutu--King of Asante" BC 12(#4-82),21
"Pillars of the Temple" oil BC 7(5/6-77),30(c)
"Sophisticated Lady" oil BC 7(5/6-77),30(c)
"Stephanie" ink,wash BC 7(5/6-77),30(c)
"Sundancer" oil 1976 BC 7(5/6-77),30(c)
untitled oil BANG

SMITH, ALVIN, 1933- ; b. in Gary, IN; mixed media, painter
 Biographical Sources: WWAA,1978; WWE,1968
 Published Reproductions:
 "Dog Days" acrylic 1970 AI 15(6-20-71),cover(c) EAAA
 "Dreams Are of the Dreamer" painted wood construction 1969
 AG 13(4-70),53; AI 15(6-29-71),33; AIM 58(9-70),59(c)
 "Flow II" acrylic 1970 FUF
 "Impression of Karma" acrylic ESS 1(8-70),69
 "In the Land of God" acrylic AI 13(11-69),77
 "Indiana Fugue" acrylic 1971 EAAA(c)
 "Thermopylae" oil 1969 AG 13(4-70),54
 untitled acrylic ARTF 13(3-75),54
 untitled acrylic ARTF 13(3-75),55(c)
 "Untitled #5" beige and terra cotta sc 1975 CRI 82(6/7-75),212
 "Untitled Yellow #1" acrylic 1975 CRI 82(6/7-75),cover(c)
 Further References:
 Ghent, Henri, "Alvin Smith: Artist-Scholar Par Excellence," CRI
 82(6/7-75),211-13.

SMITH, ARENZO, 1939- ; b. in Pittsburgh; painter
 Biographical Sources: BAOA-2
 Portrait: BAOA-2
 Published Reproductions:
 "#3" mixed media 1969 BAOA-2

SMITH, DOLPHUS, 1933- ; b. in Memphis; painter
 Biographical Sources: WWAA,1991
 Published Reproductions:
 "CCC" oil SFAC

SMITH, FLOYD; muralist

Published Reproductions:
 "Drinking Gourd" Houston mural 1971 BAIH(c)

SMITH, FRANK E., 1935- ; b. in Chicago; printmaker
Biographical Sources: AAA; AAATC
Published Reproductions:
 "City" linocut PANA
 "Getting the Spirit" acrylic 1978 STHR
 "Jazzonia" c1983 ICAA(c)
 "On Wings of Kings" serigraph 1976 BAQ 2(Sp-78),20
 "River of Darkness" acrylic 1986 AAATC(c)
 "Tarbaby" acrylic 1974 STHR
 untitled litho BAQ 7(#4-87),31(c)

SMITH, GEORGE, 1941- ; b. in Buffalo, NY; painter, sculptor
Biographical Sources: AAA; BAAL; WWAA,1978
Portrait: BAAL
Published Reproductions:
 "Black Diamond Mind" steel sc 1981 BAQ 7(#2-87),13
 "Devouring Uroborus" AW 10(5-19-79),6
 "For Dragon" wood,paint BAQ 7(#2-87),11
 "Dual Kanaga" steel,paint 1985 BAAL
 "Enclosure" steel, wood sc 1978 BAQ3(#1-78),37
 "Fortified Mud Complex for Dogon" steel, mud,wood 1978
 BAQ 3(#1-78),35
 "Freedom Drummer" oil DNPB
 "Immortal" mixed media 1970 NBAT
 "In Search of Sorhum and the Journey Within" enamel on steel
 1988 AIM 78(3-90),166
 "Korobo" steel,paint 1985 BAAL
 "Lebe" steel sc 1985 BAQ 7(#2-87),cover(c)
 "Monuments to Dogon" steel sc BAQ 7(#2-87),7
 "Myshia Dance" construction 1978 BAQ 3(#1-78),32
 untitled mixed media 1971 BAOA-2(c)
 untitled mixed media 1975 BAQ 3(#1-78),33

SMITH, HOWARD, 1928- ; b. in Moorestown, NJ; mixed media
Biographical Sources: BAOA-2; BAQ 1(Wi-76),4-11
Portrait: BAQ 1(Wi-76),4

Published Reproductions:
 "Acrobats" silkscreen 1980 BAQ 4(#2-80),9; BAQ 8(#2-88),41;
 BAQ 9(#1-90),33(c)
 "Antelope" silkscreen 1980 BAQ 4(#2-80),7(c); BAQ 8(#2-88),
 46(c); BC 20(#1-89),158(c)
 "Applique" silk, velvet construction 1976 BAQ 1(Wi-76),7(c)
 "Applique" silk, velvet construction 1976 BAQ 1(Wi-76),11(c)
 "Black Angel" silk screen 1968 BAQ 1(Wi-76),cover(c); CR
 38(12-78),19
 "Blades" sc BAQ 1(Wi-76),8
 "Caryatids" silkscreen 1972 MN 60(1/2-82),46
 "Circe (Managanese Blue #4)" 1980 AIM 69(4-81),136(c)
 "Design Multiple" silkscreen 1968 BAOA-2(c); BAQ 1(Wi-76),
 10(c)
 "Design Multiple" silkscreen 1968 BAQ 1(Wi-76),6(c)
 "Design Multiple" silkscreen 1968 BAQ 1(Wi-76),5(c)
 "Design Multiple" silkscreen 1968 BAQ 1(Wi-76),5(c)
 "Design Multiple" silkscreen 1969 LAAA(c)
 "Design Multiple" silkscreen 1969 LAAA
 "Horseman" silkscreen 1980 BAQ 4(#2-80),cover(c); BAQ 8
 (#2-88),46(c)
 "Man" metal sc BAQ 1(Wi-76),8
 "Personages" silkscreen 1980 BAQ 4(#2-80),10; BAQ 8(#2-88),
 46(c); MN 60(1/2-82),46
 "Rose Madder #3" 1977 AIM 69(4-81),137(c)
 "Totem (Africa Series)" silkcreen 1980 BC 20(#1-89),158(c)
 "Totem I" silkscreen 1980 BAQ 4(#2-80),8
 untitled ink 1985 AN 85(4-86),158
 "Woman" metal sc BAQ 1(Wi-76),9
 "Woman with Flowers" silkscreen 1980 BAQ 4(#2-80),6; BAQ
 9(#2-90),cover(c)
Further References:
 "BAQ Interviews Howard Smith" BAQ 1(Wi-76),4-11.

SMITH, JOHN HENRY, 1879-?; b, in Norfolk, VA; sculptor
Biographical Sources: ND 8(2-50),48-9
Published Reproductions:
 "Clarence" sc EB 5(2-50),65
 "Family" wood sc 1940 FAAA

"Mr. Churchill" EB 5(2-50),65
"Rachel" sc EB 5(2-50),65
"Surprise" sc EB 5(2-50),65
"Tough Boy" wood sc 1938 EB 5(2-50),67; FAAA
Further References:
Fields, Sidney, "The Sun Can Rise Too Late," ND 8(2-50),48-9.
"John Henry Smith: Janitor and Sculptor," EB 5(2-50),65-7.

SMITH, MARVIN, 1910- ; b. in Nicholasville, KY; painter
Biographical Sources: AAA
Published Reproductions:
"Greenwood Lake" oil DANA
"Landscape" oil LNIA

SMITH, MARY T., 1904- ; b. in Copiah County, MI; mixed media
Biographical Sources: BIS
Portrait: BIS
Published Reproductions:
"C and W" enamel 1983 BIS
"Gas Man" enamel 1984 BIS(c)
"Jesus--I Came Back" enamel 1984 BIS
"I Was in a Rake" enamel 1983 BIS
"Mr. Big" enamel 1984 BIS(c)

SMITH, SUE JANE; printmaker, sculptor
Published reproductions:
"Priestess of Orosun" woodcut 1966 ILAAL

SMITH, VINCENT DACOSTA, 1929- ; b. in Brooklyn, NY; painter,
printmaker
Biographical Sources: BDCAA; TNAP; WWAA,1991; WWABA
Portrait: BE 6(12-75),58; TNAP
Published Reproductions:
"Black Caucus" oil and sand 1969 BDCAA(c)
"Black Power Conference" AG 13(10-69),41
"Drums, Pyramids, Shadows, and Slave Castles" mixed media 1983
EWCA
"Dry Bones (Fire from Diaspora)" oil,sand,rope 1984 ICAA
"Fort Jesus" collage 1984 BALF 19(Sp-85),27

"Home" oil,sand 1970 NBAT; SA 71(12-71),26
"Let It Be Like Men" oil,collage BUNY
"Molotov Cocktail" oil,sand 1967 AAANB
"Omar the Prophet" oil SMIH 1(4-74),3
"Sharecropper" oil 1967 OAAL
"Sharecropper's Shack" oil 1968 AAASN
"The Super" oil DCBAA
"Trinity Church of the Mountain of Light--Gondor" BC(11/12-75),
 32(c)
untitled BE 6(12-75),58(c)
"What's Happening, Baby?" oil 1968 FUF

SMITH, WILLIAM E., 1913- ; b. in Chattanooga, TN; graphic
 artist, painter
 Biographical Sources: AAA; WWW,1968
 Published Reproductions:
 "Bill Johnson as Emperor Jones" linocut BAQ 1(Wi-76),12; BAQ
 6(#4-85),15
 "Native Son" linocut BAQ 6(#4-85),15
 "Pay Day" linocut 1941 PANA; PMNA
 "Skinny Depressed" linocut 1938 LNIA
 "Sulking Boy" linocut 1938 LNIA

SMITH, ZENOBIA, 1933- ; painter
 Biographical Sources: LAAA
 Published Reproductions:
 untitled oil 1970 BC 7(9/10-76),42(c); LAAA

SNODDY, RUFUS; b. in Los Angeles; mixed media
 Biographical Sources: EANE
 Portrait: EANE
 Published Reproductions:
 "Aesthetics of the Future" acrylic,wood 199o EANE
 "The Great American Abstract" acrylic,wood 1987 EANE(c)

SNOWDEN, SYLVIA, 1942- ; b. in Raleigh, NC; painter
 Biographical Sources: AAATC; FFAA
 Portrait: FFAA
 Published Reproductions:

"M Street: Connie" mixed media 1978 FFAA(c)
"Mamie Harrington" acrylic 1985 AAATC(c)
"Michelle Haberon" mixed media 1985 ICAA
"Mountain Man" etching PANA

SOCKWELL, CARROLL L., 1943- ; painter
Biographical Sources: AAA
Published Reproductions:
"Agony" oil AG 11(4-68),47
"Black Painting" acrylic 1968 ARTF 7(12-68),65
"Crisis of the 60's" AG 13(4-70),23(c); HW 7(3rdQ-68),13(c)

SOLO, JUBA, see **THOMAS, WILLIAM O.**

SOLOWEY, BEN, 1900- ; painter
Published Reproductions:
"Peonies and Gladioli" oil CWDP

SORRELLS, EDGAR HENRY, 1936- ; printmaker
Biographical Sources: EBSU; LAAA
Portrait: EBSU
Published Reproductions:
"Initiation/Elevation" BC 6(11/12-75),32(c)
"Thoughts Concerning a Father/Son Form" graphite,modeling
paste 1969-72 LAAA

SPELLER, GEORGIA; painter
Published Reproductions:
"Mr. and Mrs. King Kong Fighting over the Soda in Her Head"
watercolor 1986 BAQ 7(#3-87),13(c)

SPELLER, HENRY, 1902- ; b. in Rolling Fork, MI; painter
Biographical Sources: BIS
Portrait: BIS
Published Reproductions:
"American Women" mixed media 1987 BIS
"Building with Flags" mixed media 1987 BIS(c)
"Man and Two Women" mixed media 1986 BIS(c)
"Man in Car" mixed media 1987 BIS

STARK, SHIRLEY, 1927- ; b. in New York City; sculptor
Biographical Sources: FFAA; WWAA,1978
Portrait: BANG; FFAA
Published Reproductions:
 "Arcana" sc BANG
 "Night Sea Journey" steatite 1977 FFAA(c)

STEPHENS, DAVID, 1941- ; b. in Washington, DC; sculptor
Published Reproductions:
 untitled plastic construction 1970 AIM 58(9-70),65

STEPHENS, LEWIS, 1931- ; b. in Atlantic City, NJ; painter
Published Reproductions:
 "Country" watercolor 1956 DANA

STEPHENS, WALTER; painter
Published Reproductions:
 untitled BC 6(11/12-75),32(c)

STEPHENSON, ERIK W.A., 1943- ; b. in St. James, Jamaica;
 painter
Biographical Sources: AAA
Portrait: NBA
Published Reproductions:
 "Self-Portrait, Mezzatendencies" oil 1968 NBA
 "To Ave--Come Tripping as We Go on Light Fantastic Toe"
 oil 1968 NBA
 "To Phylo--Changes" oil 1968 NBA

STEVENS, NELSON, 1938- ; b. in Brooklyn, NY; graphic artist,
 painter
Biographical Sources: AAA; DIAA; EBSU; WWAA,1991
Portrait: BAOA-2; DIAA
Published Reproductions:
 "All Praises Due" acrylic 1973 DIAA
 "Ascension to Future" AN 78(2-79),147(c); AN 78(3-79),131
 (c); AN 78(5-79),115(c); BAQ 3(#3-79),62(c)
 "The Black Worker" mural 1973 BAQ 2(Wi-78),26(c)
 "Hoo-Doo" acrylic 1974 DIAA

"I Am a Black Man" mural 1975 BAQ 2(Wi-78),27(c); SR 2
(2-15-75),cover(c)
"Jihad Nation" acrylic BW 19(10-70),83
"Malcolm X" mural ENC 7(9-18-78),31
"Our Nation Calls" acrylic 1971 BAOA-2(c)
"A Rite Spiritual Brother" acrylic BW 19(10-70),89
"Song of the New World Isis" AN 78(2-79),147(c); AN 78(3-79),
131(c); AN 78(5-79),115(c); BAQ 3(#1-79),65(c)
"Towards Identity" acrylic 1970 BAOA-2(c)
"Uhuri" BAQ 2(Wi-78),22(c)
Further References:
Smith, Robin C., "Performing Arts for the People," BAQ 2
(Wi-78),17-27.

STEWART, MARY K.; painter
Published Reproductions:
"Flight" oil BAIH

STOUT, RENEE, 1958- ; b. in Junction City, KS; mixed media
Biographical Sources: BAAL
Portrait: BAAL
Published Reproductions:
"Fetish #1" mixed 1987 BAAL(c)
"Fetish #2" mixed 1988 BAAL(c)

STRANGE, EDITH GRIMES; b. in Virginia; mixed media, painter
Biographical Sources: DENA
Portrait: DENA
Published Reproductions:
"Mother and Child" acrylic DENA
"Street Scene III" collage SMI 29(1-89),151(c)

STREAT, THELMA JOHNSON, 1912- ; b. in Yakima, WA; painter
Biographical Sources: AAA
Published Reproductions:
"Mother and Baby on Desert" gouache NAI
"Rabbit Man" gouache 1941 (Modern Art) NBAT

STROUD, RICHARD, 1940- ; b. in Tarrytown, NY; painter

Biographical Sources: AAA; AAANB
Published Reproductions:
"Wolf in Sheep's Clothing" oil ART 44(Su-70),20

STROY, DENNIS; sculptor
Published Reproductions:
"Soul Sister & Mate" wood sc AG 13(4-70),20(c)

SUGGS, CHARLES ELDRIDGE, III, 1939- ; painter
Biographical Sources: AAA
Published Reproductions:
"Feeling Groovy" oil 1970 FUF

SULTON, SHARON; mixed media
Published Reproductions:
"Fading of That Fabulous Olden Lady" drawing 1977 CGB(c)

SWEARINGEN, JOHNNIE S., 1908- ; b. in Campground Church,
TX; painter
Biographical Sources: BHBV
Portrait: BHBV
Published Reproductions:
"The Devil's Got the Church on Wheels" oil BHBV
"Noah's Ark" oil BHBV(c)
"Slavery Days" oil 1984 BHBV
"Triptych" oil 1979 BHBV

SWEETING, EARLE R.; muralist, painter
Portrait: OPP 9(12-31),385
Published Reproductions:
untitled mural JET 19(1-5-61),46
untitled mural JET 19(1-5-61),46
Further References:
"Art: Says Newsweek Ridiculed His Art, Asks $250,000," JET 19
(1-5-61),46.

SYKES, RODERICK; painter
Published Reproductions:
untitled mural BC11(#4-81),96

TALLEY, CLARENCE,; painter
 Published Reproductions:
 "African Girl with Vase I" acrylic BC 10(#1-79),78(c)
 "African Girl with Vase II" acrylic BC 10(#1-79),78(c)
 "African Girl with Vase III" acrylic BC 10(#1-79),78(c)
 "Black Prince" BC 7(#1-77),33(c)
 "Dance" acrylic BC 8(#1-78),40(c)
 "Dreaming of Becoming an Artist" acrylic BC 10(#1-79)78(c)
 "The Kiss" BC 7(3/4-77),39(c)
 "Lovers" acrylic BC 8(#1-78),40(c)
 "Seeking II" acrylic BC 10(#1-79),78(c)
 untitled acrylic BC 8(#1-78),40(c)
 untitled acrylic BC 10(#1-79),78(c)
 "Young Artist" acrylic BC 8(#1-78),40(c)

TANKSLEY, ANN, 1934- ; b. in Pittsburgh; painter
 Biographical Sources: FFAA
 Portrait: FFAA
 Published Reproductions:
 "Waiting Outside the Mosque" oil 1977 FFAA(c)

TANNER, HENRY OSSAWA, 1859-1937: b. in Pittsburgh, d. in
 Paris; painter
 Biographical Sources: BACW; BHBA; GNNP3; ILAAL; LAAA;
 TCBA; TNAP; WWCA,2-4
 Portrait: DANA; ILAAL; NHB 31(1-68),6
 Published Reproductions:
 "Abraham's Oak" oil c1897 (African Art) AIPP; ART 44
 (9/10-69),46; CBAR; EB 44(9/10-69),46; FAAA; NMAA; SAQ
 65(Au-66),466; TIM 94(7-11-69),59(c)
 "After the Storm" oil c1880 AAAET(c)
 "The Annunciation" oil 1898 (Philadelphia) AAAZ(c); AANC;
 AAR 4(7-77),(c); AEPLN; ART 44(9-10-69),46; ARTF 8
 (10-69),72; CL 45(10-08),405; DANA; HN 10(2-82),34; OUT
 64(4-7-00),795; ST; SW 31(12-02),663; SSAA 2(Sp-88),71(c)
 "Arab" oil (Golden State) BAQ 1(Wi-76),22(c)
 "The Arch" oil 11914 (Brooklyn) BMAP; TNAP
 "The Artist's Mother" oil 1897 ARAN (10-86),68(c);ARTF 8
 (10-69),72; AP(c); EB 24(10-69),60(c); FAAA; PMNA; TAAP;

TCAA; WAA

"At the Gate" oil AMA 18(5-27),263

"The Bagpipe Lesson" oil c1893 (Hampton) AV 1(7/8-86),21 (c);SW 31(12-02),665; SW 63(8-34),226

"The Banjo Lesson" oil 1893 (Hampton) ALIA;ARTF 8 (10-69),71; AV 1(7/8-86),20(c); AV 2(12-87),18(c); BEAA(c); BC 3(5/6-73),27(c); CONN 176(3-71),207; DANA; EB 32 (2-77),38; ENC 4(6-23-75),66; ENC 6(2-7-77),cover(c); ESS 4(11-73),22(c); ESS 4(12-73),29(c); ESS 7(2-77),32(c); FAAA; FHBI(c); LAAA; LNIA; NHB 31(1-68),7; PARU; PNAP; RD 112(6-78),178(c); SBMAA(c); ST; TIM 94(7-11-69),58(c); TSAP; VPTA

"Behold the Bridegroom Cometh" oil JAA

"Bishop Benajmin Tucker Tanner" oil 1897 FAAA

"Burning of Sodom and Gomorrah oil (High) APHM(c)

"Christ and Disciples" oil c1921 (Spelman) ART 44(9/10-69), 7; NHB 31(1-68),9

"Christ and His Mother Reading the Scriptures" oil AAAC

"Christ and Nicodemus" oil 1900 (Pennsylvania) DANA; FAAA; JAAA; LNIA; TAAP

"Christ at the Home of Mary and Martha" oil CM 44(4-70),139

"Christ Walking on the Water" etching 1910 AAAET; AN 67 (9-68),13

"Daniel in the Lion's Den" oil 1896 (Los Angeles) AAR 3 (11/12-76),106(c); ANPL; ATO; EB 24(10-69),60(c); ENC 5 (12-20-76),22; LAAA(c); MS 5(1-77),26(c); SMI7(10-76),89(c); ST; TCBAAA(c)

"Destruction of Sodom and Gomorrah" oil AN 66(12-67),47; ARIP(c)

"Disciples at Emmaus" oil CRI 27(4-24),257

"Disciples Healing the Sick" oil,tempera 1924 PMNA

"Disciples on the Sea of Galilee" oil NALF 8(Wi-74),278

"Etaples Fisherfolk" oil 1923 AN 29(11-15-30),26

"Fauna" oil (Hampton) AV 1(7/8-86),22(c)

"Fishermen at Sea" oil c1913 ST

"Five Wise and the Five Foolish Virgins" oil CL 45(10-08),407

"Flight into Egypt" oil 1898 (Howard) BACW(c); DIAB 55 (#2-77),106; LNIA; NHB 31(1-68),8; OW 6(5-51),31; TEAA

"Gate of Tangier" oil c1910 (African Art) AAAET; BS 1

"Ruth and Naomi" oil JAA

"The Sabot Makers" oil AAAC

"St. Germain-des-Pres" pencil 1894 AG 12(Su-69),11

"Salome with Head of John the Baptist" oil AISP; ARTF 8
(10-69),73

"The Savior" oil c1900 ST

"Scene, Tangier" oil 1910 ST

"The Seine" oil 1902 (Smithsonian) HAPNG(c); NGR (1972),16

"Street Scene, Tangier" oil c1910 ST

"Study for the 'Young Sabot Maker'" oil 1895 ST

"Study of a Young Man" chalk c1882 CM 44(4-70),138

"The Thankful Poor" oil 1894 ABA 1(#1-72),25; AV 2(2-87),
49; CONN 176(3-71),208; EB 37(12-82),38(c); IIBM; LAAA;
NCA

"Three Marys" oil 1910 (Fisk) AIM 65(3/4-77),64(c); AN 76
(2-77),66(c); CRI 83(11-76),316; ENC 6(1-3-77),28(c); LNIA;
SMI 7(10-76),89(c); TCBAA

"Two Disciples at the Tomb" oil 1906 AD 20(10-1-45),19; AM
32(12-39),707; JAA; LNIA; MA 32(12-39),707; MPAI(c); SAQ
65(Au-66),467; TCBAA

"The Wailing Wall, Jerusalem" oil DANA; RISD 72(10-85),33

"World War I Canteen" charcoal 1918 LAAA

"The Wreck" etching 1913 AAAET

"The Young Sabot Maker" oil 1895 AAAC; CONN 176(3-71),
208; EB 24(10-69),61(c); FAAA; ST

Further References:

Adams, Russell. *Great Negroes, Past and Present.* Chicago: Afro-
American Publishing Co., 1967.

Brawley, Benjamin. *The Negro Genius.* New York: Dodd, Mead,
1937.

Simon, Walter A., "Henry O. Tanner--A Study of the Develop-
ment of an American Negro Artist: 1859-1937," unpublished
Ph.D. dissertation, New York University, 1961.

TANNER, JAMES, 1941- ; b. in Jacksonville, FL; sculptor
Biographical Sources: AC 47(1-88),74-74; WWAA,1991
Published Reproductions:
"Bad Boy Jessie" ceramic sc 1982 EWCA
"Monkey Man" ceramic sc 1984 AC 47(1-88),74

"Shadow Sky Man" ceramic sc 1986 AC 47(1-88),75
"Who Says What" ceramic sc 1987 AC 47(1-88),75

TATE, RALPH M.; sculptor
Published Reproductions:
"JFK Doodle" welded metal sc AG 11(6-68),21

TAYLOR, BETTY BLAYTON, see **BLAYTON, BETTY**

TAYLOR, CARLTON; painter
Published Reproductions:
"Evolution or We Shall Overcome" oil ONPB

TAYLOR, CECIL; painter
Published Reproductions:
"Third Ward" watercolor 1963 BAIH

TAYLOR, JANET E.; painter
Biographical Sources: EBSU
Published Reproductions:
"Black Sunrise" acrylic EBSU

TAYLOR, LAWRENCE, 1938- ; b. in Brownsville, TN; sculptor
Biographical Sources: AAA
Published Reproductions:
"Booker T. Washington" NH 3(#2-63),10
"George Washington Carver" NH 3(#2-63),11
"Jane Addams" sc NH 3(#2-63),cover
"Sojourner Truth" NH 3(#2-63),11

TAYLOR, ROD A., 1932- ; b. in Washington, DC; sculptor
Biographical Sources: BAOA-2; WWAA,1978
Portrait: BAOA-2
Published Reproductions:
untitled sc BAOA-2
untitled sc BAOA-2

TAYLOR, WILLIAM (BILL),1927- ; b. in Atlantic City, NJ;
sculptor

Biographical Sources: AAA
Published Reproductions:
 "Mother and Child" wood sc TCBAA
 "Torso" wood,stone 1960 AWAP

TEMPLE, HERBERT, 1919- ; b. in Gary, IN; graphic artist,
 painter
Biographical Sources: WWABA
Published Reproductions:
 "Booker T. Washington" EB 30(8-75),132
 "Dr. Martin Luther King, Jr." oil EB 30(8-75),131
 "Dr. Mary McLeod Bethune" EB 30(8-75),133
 "Frederick Douglass" EB 30(8-75),132
 "Harriet Tubman" EB 30(8-75),130
 "The Hon. Elijah Muhammed" EB 30(8-75),134
 "Marcus Garvey" EB 30(8-75),132
 "Richard Allen" EB 30(8-75),130
 "Roy Wilkins" oil EB 37(11-81),112
 "Thurgood Marshall" oil EB 30(8-75),134
 "William E.B. DuBois" EB 30(8-75),133

TERRY, EMERSON; painter
Portrait: BAQ 4(#1-80),55
Published Reproductions:
 "Black Cowboy" BAQ 4(#1-80),55
 "Black Cowboy" BAQ 4(#1-80),56(c)
 "Black Cowboy" BAQ 4(#1-80),56(c)
 "Black Cowboy" BAQ 4(#1-80),57(c)

TERRY, EVELYN P., 1946- ; b. in Milwaukee, WI; graphic artist
Biographical Sources: EBSU
Portrait: BAOA-1
Published Reproductions:
 "America's Favor" serigraph EBSU
 "Grape Suckers" serigraph BAQ 6(#4-85),38(c)
 "Patricia Harris" oil AV 4(6-89),33(c)
 "Playing the Game Series: Grape Suckers" serigraph BAOA-1(c)
 "Playing the Game Series: The Beach" serigraph BAOA-1(c)

TESFAGIORGIS, FRIEDA H.; b. in Starkville, MI; painter
Biographical Sources: WWAA,1991
Published Reproductions:
 "Aunt Jemima's Matrilineage" pastel 1982 BAQ 9(#2-90),30(c)
 "Hidden Memories" pastel 1985 BAQ 9(#2-90),30(c)
 "Transformation" pastel 1985 BAQ 9(#2-90),31(c)

THOMAS, ALMA W., 1896-1978; b. in Columbus, GA; painter
Biographical Sources: BDCAA; FAAA; TCBAA; WWAA,1978
Portrait: AG 13(4-70),36; BE 6(12-75),53; DANA
Published Reproductions:
 "Antares" acrylic 1972 (Smithsonian) MTM(c)
 "Autumn Leaves Fluttering in the Wind" acrylic 1973 AASC(c)
 "Babbling Brook and Whistling Poplar Trees Symphony" acrylic
 1976 MTM
 "Circle of Flowers" oil 1969 AWAP(c)
 "Eclipse" acrylic 1978 AI 16(12-72),37; APO 115(6-82),500
 "Etude in Color" acrylic 1966 BACW
 "Flowers at Jefferson Memorial" acrylic TCBAA(c)
 "Garden of Blue Flowers Rhapsody" acrylic 1976 ART 5(1-77),
 42; OAWA
 "Georgetown Barge" oil BACW
 "Hydrangeas Spring Song" acrylic 1976 AN 81(5-82),142; STHR
 "Impression of the Azaleas in the National Arboretum" acrylic
 1968 BDCAA(c)
 "Leaves Outside a Window in Rain" watercolor 1966 AAATC(c)
 "Light Blue Nursery" acrylic 1968 (Smithsonian) AAAZ(c); AP(c);
 FAAA
 "Lunar Rendezvous" oil AG 13(4-70),21(c)
 "New Galaxy" acrylic BDCAA
 "The Pinks, Cherry Blossoms" acrylic 1970 WAWC
 "Red Flower Sonata" acrylic 1970 FAAA
 "Reflections of a Beautiful Sunset..." acrylic 1976 AIM 65
 (1/2-77),126
 "Snoopy See a Sunrise" acrylic 1970 FAAA
 "Spring--Delightful Flowerbed" oil CRI 77(5-70), cover(c)
 "Spring Flowers in Washington, D.C." oil 1969 DBLJ
 "Spring Scene in Washington" acrylic 1968 BDCAA
 "Still Life" oil 1923 BACW; DANA

"Study of a Young Girl" oil BACW
"Tenement Scene, Harlem" oil 1959 DANA
"Wind and Crepe Myrtle Concerto" synthetic polymer 1973 FFAA
 (c)
"Wind Dances with Flower Beds" acrylic 1968 AAANB
"Wind, Sunshine and Flowers" acrylic 1968 (Brooklyn) AG 15
 (5-72),42; BMAP
"Wind Tossing Late Autumn Leaves" acrylic 1972 AIM 64
 (11/12-76),14; AI 20(12-76),46; ART 51(10-76),41; OAWA
Further References:
Foresta, Merry A. *A Life in Art: Alma Thomas, 1891-1978.*
 Washington, DC: National Museum of American Art, 1981.
Marr, Warren, "Alma Thomas," CRI 77(5-70),189-93.

THOMAS, CHARLES L.; muralist
Published Reproductions:
 "Shrine of the Clowns" Houston mural 1967 BAIH(c)

THOMAS, JAMES "SON FORD", 1926- ; b. in Eden, MS; sculptor
Biographical Sources: BFAA
Portrait: BFAA; JAF 88(4-75),cover; LC
Published Reproductions:
 "Fish" clay 1984 BIS
 "Frog" clay 1984 BIS
 "Head" clay and paint 1977 (Memphis) BFAA
 "Head with White Hair and Blue Tie" clay,paint c1970 BFAA(c)
 "Man in Coffin" clay 1984 BIS(c)
 "Skull" clay 1987 BIS(c)
 untitled clay sc JAF 88(4-75),116
 untitled clay sc LC
 "Woman's Head with Wig" clay,paint c1975 (Memphis) BFAA(c)
Further References:
 "Vision in Afro-American Folk-Art: The Sculpture of James
 Thomas," JAF 88(4-75),115-31.

THOMAS, LARRY ERSKINE, 1917- ; b. in Baltimore; painter
Biographical Sources: BACW; DENA; EBSU; WWABA
Portrait: DENA
Published Reproductions:

"The Potter's Daughter" oil 1956 BACW
"Quest for Black" acrylic EBSU
"The Vital Force" acrylic DENA

THOMAS, MATTHEW, 1943- ; b. in San Antonio, TX; mixed
 media
 Biographical Sources: BAAL
 Portrait: BAAL; CACE; VIS 1(Sp-87),13
 Published Reproductions:
 "Absorption" mixed media 1987 BAAL
 "Cosmic Fire" acrylic 1986 VIS 1(Sp-87),13(c)
 "Pathways" mixed media 1986 CACE(c)
 "Symbol of Earth Soul II" mixed 1989 BAAL(c)
 untitled VIS 1(Sp-87),12(c)

THOMAS, ROY V.; painter, sculptor
 Published Reproductions:
 "Mother and Child" terra cotta sc 1971 BAIH
 "Self-Portrait" oil 1970 BAIH

THOMAS, WILLIAM O., ; painter
 Published Reproductions:
 "Judgement of Paris" oil 1954 AIM 58(9-70),55(c)

THOMPSON, CONRAD; b. in Mobile, AL; painter
 Biographical Sources: DENA
 Published Reproductions:
 "Whatever Happened to the Lincoln Colonnade?" acrylic DENA

THOMPSON, LOVETT; b. in Georgia; painter, sculptor
 Biographical Sources: AAANB; FAAA
 Published Reproductions:
 "The Junkie" wood sc 1970 (National Center) AAANB; ABA 1
 (#1-72),cover; FAAA

THOMPSON, MILDRED J.; b. in Jacksonville, FL; painter, sculptor
 Biographical Sources: BAQ 1(Sp-77),20; FFAA
 Portrait: BAQ 1(Sp-77),20; FFAA
 Published Reproductions:

"Coney Island" oil 1958 DANA
"Dancing in the Grass" wood sc BAQ 1(Sp-77),23(c)
"The Emperor's Nightingale" oil 1958 DANA
"In C Sharp Minor" wood sc BAQ 1(Sp-77),22(c)
"Mandala" etching 1978 BAQ 6(#4-85),24
"Muliebris" etching 1978 BAQ 6(#4-85),23
"Open Window Series" serigraph 1977 BAQ 1(Sp-77),3(c)
"Spruce Construction" construction BAQ 1(Sp-77),26(c)
"Spring Construction" construction BAQ 1(Sp-77),27(c)
"Spruce Construction" construction BAQ 1(Sp-77),30(c)
"Street Song" construction 1977 FFAA(c)
"Variation" construction BAQ 1(Sp-77),30(c)
Further References:
"Mildred Thompson, Sculptor," BAQ 1(Sp-77),20-31.

THOMPSON, PHYLLIS, 1946- ; b. in Washington, DC; painter
Biographical Sources: WWAA,1978
Published Reproductions:
"Mystical Unity" acrylic ARTF 13(1-75),56
untitled etching 1977 BAQ 2(Sp-78),25

THOMPSON, ROBERT ("BOB"), 1937-1966; b. in Louisville;
painter
Biographical Sources: AAA; AAANB; BCAA; FAAA; TNAP
Published Reproductions:
"Abundance and the Four Elements" 1964 AI 12(5-15-68),70;
ARTF 6(3-68),6
"An Allegory" oil 1964 (Whitney) AP(c); FTCA; FTWM
"Ascension to the Heavens" oil 1961 AAANB; AIM 71(2-83),28
(c); ART 57(4-83),35; HAR 2(Wi-67),13
"The Assistance of a Woman" oil 1960 ARAN 7(5-90),151; FFNY
(c)
"Bacchanal" oil 1964 ARTF 4(12-65),55
"Bathers" AIM 78(1-90),40(c)
"Bird Party" oil 1961 AIM 71(2-83),28(c); FFNY(c)
"Caledonia Flight" TNA
"The Dentist" oil 1963 FAAA; HAR 2(Wi-67),12
"Descent from the Cross" oil 1963 ART 50(12-75),48; ART 50
(1-76),42; MJMC

"Dr. Bird" gouache 1962 EAAA

"Ecco and Narcissus" oil 1965 AAASN; AI 13(10-69),77

"Enchanted Ride" oil 1961 MJMC

"Expulsion and Nativity" oil 1964 ART 50(3-76),49; FAAA; HAR 2(Wi-67),10; PSTCA

"Family Portrait" oil AJ 28(Sp-69),330; AN 82(4-83),161; AIM 71(5-83),139(c)

"Flagellation" oil AG 13(4-70),22(c)

"Garden of Music" oil 1960 AIM 71(5-83),140; FFNY(c)

"Homage to Nina Simone" oil 1965 ART 43(4-69),16

"Jitterbugs" 1942 BABC(c)

"The Journey" oil 1962 AIM 74(3-86),25(c); FFNY

"Judgment of Paris" oil 1964 AIA 58(Su-70),55; EAAA(c); HAR 2(Wi-67),14

"La Fete" oil 1964 (Hirshhorn) FFNY(c)

"Land of the Cockaigne" ARAN (10-86),78(c)

"Le Caprice" ART 60(9-85),65

"LeRoi Jones and His Family" oil 1964 (Hirshhorn) BABC; HMSG; MJMC

"Maidens" oil 1961 LAAA(c)

"Music Lesson" oil 1962 AAATC(c)

"North African Dream" oil 1963 HAR 2(Wi-67),14

"Nudes in the Park" AN 59(11-60)19

"Parnassus" oil (Metropolitan) FTCA

"Perseus and Andromeda" oil 1964 ARTF 28(4-90),177

"Portrait of LeRoi Jones" oil AN 67(3-68),64

"Portrait of Thelonius Monk" AIM 71(5-83),139

"Prayers in a Landscape" crayon 1966 MJMC

"Reclining Nude" crayon 1966 EAAA

"Red Cross" oil 1959 STHR(c)

"Sorcerer" 1964 AIM 76(3-88),40(c); AN 87(10-88),182

"The Spinning, Spinning, Turning, Directing" oil 1963 AIM 52(#2-64),130; ART 50(5-76),22 ; BALF 19(Sp-85),21; EAAA; HAR 2(Wi-67)12; MJMC

"Tree" BC 3(5/6-73),27(c); ESS 4(11-73),22(c); ESS 4(12-73)29(c)

"Well" oil 1960 DBLJ

Further References:

Siegel, Jeanne, "Robert Thompson and His Old Masters," HAR 2 (Wi-67),10-14.

THOMPSON, ROBERTA, 1928- ; b. in Pasco, WA; painter
Biographical Sources: BAOA-2
Portrait: BAOA-2
Published Reproductions:
"Nigerian Princess" casein 1958 BAOA-2(c)

THOMPSON, RUSS, 1922- ; b. in Kingston, Jamaica; painter
Biographical Sources: AAA; AAANB; CBAM
Published Reproductions:
"America, America" collage 1968 SEP 18(3-69),50
"Artist House" acrylic,collage 1974 DIAA
"Model With Route 9 W Fragments" mixed media 1973 BUNY
"My Breath Is One with the Clouds" acrylic AAANB
"Poor Room, Rich Room" mixed media 1968 CBAM
"Relatives" collage, acrylic, ink 1969 AG 13(4-70),54
"Space Warp" acrylic 1973 DIAA

THRASH, DOX, 1893-1965; b. in Griffin, GA; painter, printmaker
Biographical Sources: AAA; TCBAA; TNAP
Published Reproductions:
"Boats at Night" carborundum aquatint 1940 LNIA
"Cabin Days" carborundum print AAAC; SSAA 4(Sp-90),33
"Coal Yard" litho c1935 BCR 1(Fa-71),16; NBAT; SA 71(12-71)
23
"Defense Worker" carborundum print SSAA 4(Sp-90),33
"Deserted Cabin" carborundum print 1939 LNIA
"Freight Yard" litho SSAA 4(Sp-90),27
"Life" carborundum print 1940 BAQ 2(Sp-78),11; LNIA;
SSAA 4(Sp-90),34
"Marylou" carborundum print c1940 SSAA 4(Sp-90),31
"Morning Paper" etching SSAA 4(Sp-90),35
"My Neighbor" carborundum print 1937 LNIA
"Ridge Avenue" carborundum print 1936 LNIA
"Rugged Homes" carborundum print DANA
untitled carborundum print SSAA 4(Sp-90),36
untitled carborundum etching TCBAA
"Whiskers" carborundum etching SI 130(7-45),15

TOLLIVER, MOSE, 1915- ; b. in Pike Road, AL; painter

Biographical Sources: AFATC; BFAA; BIS
Portrait: BFAA; BIS
Published Reproductions:
 "Face of a Bearded Man" enamel,cardboard c1975 BFAA
 "Figure on a Bicycle" FA #114(11-83),34(c)
 "Figure with Turtle" enamel,wood c1975 BFAA
 "Gray Lady" 1983 BIS
 "Green Tree with Two Green Birds" housepaint 1980 BFAA
 "Man on String" 1983 BIS
 "Nall" housepaint 1984 BIS(c)
 "Plant Form" enamel,wood c1975 BFAA(c)
 "Robert Bishop" 1984 BIS(c)
 "Self-Portrait" paint,plywood 1978 BFAA(c)
 "Sexual Fantasy (Lady on Scooter)" enamel,plywood BFAA
 "Telma" paint,wood 1973 AFATC(c)
 "Woman with Fish Shape" enamel,wood 1975 BFAA

TOLLIVER, WILLIAM; mixed media, painter
 Portrait: BAQ 7(#3-87),17
 Published Reproductions:
 "Boy with Hat" mixed media AN 86(9-87),152(c)
 "Ceremony in Red" mixed media 1986 BAQ 7(#3-87),19(c)
 "Courting in the Cotton Field" mixed media 1986 BAQ 7(#3-87),
 22(c)
 "Dancers" mixed media 1986 BAQ 7(#3-87),21(c)
 "Going to Church" litho AN 86(9-87),149(c); AN 86(10-87),187
 (c); AN 86(11-87),209(c); AN 86(12-87),161; CONN
 217(12-87),76(c); CONN 218(1-88),29(c)
 "High Cotton" oil 1985 BAQ 7(#3-87),18(c)
 "Hints of Autumn" oil 1986 BAQ 7(#3-87),8(c)
 "Perifields" oil AN 86(11-87),209; AN 86(12-87),161; CONN 217
 (12-87),76; CONN 218(1-88),29
 "The Runner" oil 1985 BAQ 7(#3-87),23(c)

TOONE, LLOYD, 1940- ; b. in Chase City, VA; mixed media
 Biographical Sources: AAA; AAANB; CBAM
 Published Reproductions:
 "Life" collage 1969 BLC

TORRES, JOHN, JR., 1939- ; sculptor
 Published Reproductions:
 "The Anvil" sc 1964 FSBA
 "Horse Sketch" bronze 1963 ILAAL
 "The Monument" plaster sc 1963 ILAAL
 untitled sc SEP 17(7-68),28

TOWNS, ELAINE, 1937- ; painter
 Biographical Sources: AAA; EANE
 Portrait: EANE
 Published Sources:
 "Bust of Woman in Architectural Garden" oil 1989 EANE(c)
 "Central Avenue Breakdown" etching 1989 EANE
 "Leaping Figures" BAOA-1

TRAYLOR, BILL, 1854-1947; b. near Benton, AL; mixed media
 Biographical Sources: AAA; BAAL; BFAA
 Portrait: BAAL; BFAA
 Published Reproductions:
 "Black Billy" pencil, poster paint ART 60(10-85),46
 "Black Bulldog" pencil,paint 1939 AIM 75(5-87),75(c)
 "Black Elephant with Brown Ear" 1939 AN 88(3-89),177
 "Blacksmith Shop" pencil,crayon 1939 ARTF 24(3-86),123; BFAA
 "Black Man Holding Bag" AN 81(12-82),162
 "Blue Dog with Figures" ART 57(11-82),48
 "Blue Man with Pipe and Bottle" pencil, poster paint 1940 ART
 60(10-85),45; AWCF(c)
 "Cat" pencil,gouache 1939 BFAA
 "Chicken Charlie" pencil,poster paint 1939 ART 60(10-85),47
 "Construction with Pointing Man" AR 38(12-5-86),669
 "Dancing Man, Woman, and Dog" crayon,pencil c1939 MWP(c)
 "Drinker with Hat and Bottle" charcoal 1939 AN 81(5-82),142;
 BFAA
 "Fighting Dogs" ART 54(5-80),25
 "Figure and Dog Seated Outside House" tempera 1940 STHR
 "Figures Construction" gouache AWCF(c)
 "Horse" pencil,gouache c1939 CLA 15(Wi-90),29(c)
 "Horseman" drawing BE 6(12-75),45(c)
 "Man and Large Dog" pencil,gouache 1939 BFAA

"Man, Dog and Bird" watercolor APATC(c)
"Man on Mule" AIM 68(3-80),125
"Man with Yoke" pencil,gouache 1939 BFAA
"Mexican Man Waving" AW 16(1-5-85),6
"Mule with Red Border" pencil,crayon 1939 BFAA
"Pig" watercolor AFATC(c)
"Red House with Figures" pencil,crayon 1939 BFAA
"Seated Cat" AW 16(1-5-85),6
"Self-Portrait" pencil,crayon 1939 BFAA; FA #114(11-83),34
"Serpent" pencil,crayon c1939 AC 42(6/7-82),22; BAAL(c)
"Snake at the Crossroads" graphite,colored pencils c1939 BAAL
 (c)
"Turtle, Swimming Down" pencil,gouache 1939 BFAA
untitled AIM 76(5-88),97(c)
untitled drawing AN 87(2-88),61(c)
untitled drawing AN 87(2-88),62(c)
untitled drawing AN 87(2-88),63(c)
untitled drawing AN 87(2-88),64
untitled drawing AN 87(2-88),65(c)
untitled pencil 1938 AAATC
untitled pencil,gouache 1942 PORT 5(5-83),88(c)
untitled tempera 1938 AAATC(c)
"Untitled Exciting Event" 1941 ART 62(3-88),109
"Woman" watercolor AFATC(c)
"Yellow Chicken" pencil,crayon 1939 AC 42(6/7-82),22(c); BFAA
Further References:
 Cameron, Dan, "History and Bill Traylor," ART 60(10-85),45-7.
 Shannon, Charles, "Bill Traylor's Triumph," ARAN (2-88),60-5.
 Wallis, Rian, "Bill Traylor," ART 54(5-80),25.

TUCKER, CHARLES; painter
Published Reproductions:
 "African Drummer" oil AUSA

TUCKER, CLIVE; b. in Jamaica,; painter
Published Reproductions:
 "Wisp of an Evening: Cloud" AI 13(11-69),77

TUCKER, YVONNE EDWARDS, 1941- ; b. in Chicago; sculptor

Biographical Sources: FFAA
Portrait: FFAA
Published Reproductions:
 "The Initiate: Will She Survive the Burning Sands" ceramic
 sc 1980 FFAA(c)

TULL, CHARLENE, 1945- ; b. in Chicago; painter
Biographical Sources: AAA
Published Reproductions:
 "Heads of Flies" acrylic 1969 BAOA-2

TURNER, DONALD E.; b. in Terre Haute, IN; painter
Biographical Sources: NALF 7(Wi-73),118
Published Reproductions:
 "Brothers Keeper" oil NALF 7(Wi-73),126
 "From Civil Rights to Human Dignity" NALF 7(Wi-73),cover
 "Rainbow" NALF 7(Wi-73),119
 "Slave Woman's Burden" NALF 7(Wi-73),131
 "Survival" drawing NALF 7(Wi-73),142

TWIGGS, LEO F., 1934- ; b. in St. Stephen, SC; painter
Biographical Sources: AAA; WWAA,1991
Published Reproductions:
 "Blue Wall" batik 1969 BDCAA; SA 79(10-79),57
 "Commemoration #2" batik 1970 BAOA-2(c)
 "Commemoration #3" batik 1970 BAOA-2(c)
 "Commemoration IV" batik 1970 DIAA
 "Figure and Interior" BC 6(3/4-76),54(c)
 "Homage to Brother Andrews" batik AUSA
 "Marbles" batik CRI 79(8/9-72),cover(c)
 "Mother Image" batik 1973 DIAA

TYLER, ALFRED J., 1933- ; b. in Chicago; painter, graphic artist
Biographical Sources: AAA
Published Reproductions:
 "Dioula Woman of Trechville" ink 1969 BAOA-2; BS 2(1-72),21

TYLER, ANNA M., 1933- ; b. in Chicago; painter, printmaker
Biographical Sources: AAA

Published Reproductions:
 "Blackness of Winter" monoprint 1965 BAOA-2
 untitled monoprint 1969 BAOA-2

TYSON-MOSLEY, BARBARA, 1950- ; b. in Harrisburg, PA; mixed
 media
 Biographical Sources: AAATC
 Published Reproductions:
 "Infant Garment" mixed media 1987 AAATC(c)

UPSHUR, BERNARD, 1936- ; printmaker
 Biographical Sources: AAA
 Published Reproductions:
 "Africa Reborn" woodcut 1967 BAOA-2
 "Brooklyn Bridge" woodcut 1967 BAOA-2; BAQ 6(#4-85),7
 "Verranzano Narrows" woodcut 1965 BAQ 6(#4-85),9

URQUHART, JOHN; painter
 Biographical Sources: AAA
 Published Reproductions:
 "untitled oil OPP 1(1-23),17; SG 49(12-1-22),327

VANCE, FLORESTEE, 1940- ; b. in Ferriday, LA; painter
 Biographical Sources: AAA
 Published Reproductions:
 "Indian Headdress" BAOA-2(c)

VARNER, ERNEST; painter
 Published Reproductions:
 "The Dreamer" oil AV 2(2-87),16(c); AV 2(4-87),64(c)

VAUGHN, ROYCE H., 1930- ; b. in Cleveland; painter, sculptor
 Biographical Sources: AAA
 Published Reproductions:
 "Autumn Muscle" oil 1963 BDCAA(c)
 "The Boys" collage BAOA-1(c)
 "Charlie" oil ONPB
 "Glad Rags" collage BAOA-1(c)
 "Malcolm Spoke" oil BAOA-1(c)

VICTORY, GEORGE M., 1878-?; b. in Savannah, GA; painter
Biographical Sources: AAA
Published Reproductions:
"Schuylkill River" oil AD 16(12-15-41),5; NM 41(12-20-41),27

VITAL, HARRY; painter, sculptor
Published Reproductions:
"Awake My Child" BC 6(3/4-76),54(c)
"Birds and Cattle" oil 1972 BAIH(c)
"4th Ward Neighborhood" oil 1972 BAIH(c)
"Shrine" terra cotta 1972 BAIH(c)

WADDY, RUTH G., 1919- ; b. in Lincoln, NE; painter, printmaker
Biographical Sources: AAA
Published Reproductions:
"Daisies" oil 1966 BAOA-1(c)
"The Fence" linocut 1060 BAOA-1
"Fetish" linocut BAOA-1(c)
"The Key" linocut 1969 BAOA-1; BAQ 2(#3-78),25
"Listening and Learning" linocut 1970 BAOA-1(c)
"Matter of Opinion" linocut PANA(c)
"Pastoral" oil 1966 BAOA-1(c)
untitled linocut ONPB
untitled linocut 1969 BAOA-1(c)

WALKER, ANNIE, 1855-1929; b. in Washington, DC; d. in
Washington, DC; painter
Biographical Sources: AAA; FFAA
Published Reproductions:
"Figure Drawing" (Howard) PMNA
"La Parisienne" oil (Howard) 1896 AAAC; FFAA(c); PMNA

WALKER, CHARLES; painter
Published Reproductions:
"Rites of Passage" oil 1969 BAIH(c)

WALKER, CLINTON A., 1934- ; sculptor
Published Reproductions:
"Family Group" stone sc NH 2(#11-63),83

"Garden of Eden" welded metal NH 2(#11-63),85
"Mother and Child" NH 2(#11-63),cover

WALKER, EARL, 1911- ; b. in Indianapolis, IN; painter
Biographical Sources: AAA
Published Reproductions:
"32nd Street, Chicago" oil 1938 LNIA

WALKER, INEZ NATHANIEL, see **NATHANIEL, INEZ**

WALKER, LAWRENCE M. (LARRY), 1935- ; b. in Franklin, GA;
painter
Biographical Sources: AAA; BAOA-1
Published Reproductions:
"Children of Society 14" charcoal,conte BAOA-1
"Children of Society 17" charcoal,conte BAOA-1
"Growth I" acrylic BAOA-1(c)
"The Last Rites of the American Sex Hero" oil TFYA
"Microscope I" watercolor BAOA-1
"My Thoughts, My Ideas" BAOA-1(c)
"Phase II" mixed media WCSS
untitled oil BAOA-1(c)
untitled oil BAOA-1(c)

WALKER, RAYMOND (BO), 1952-86; painter, sculptor
Published Reproductions:
"Martin Luther King, Jr." bronze sc AV 3(2-87),44
untitled EB 28(12-72),44

WALKER, WILLIAM (BILL); b. in Birmingham, AL; painter
Biographical Sources: AAA
Portrait: BAOA-2
Published Reproductions:
"Faith" oil 1958 DANA
"Peace and Salvation" Chicago mural 1970 BAOA-2(c)
"Wall of Dignity" Chicago mural 1968 FAAA(c); TNAP

WALLS, BOBBY, 1948- ; b. in Modera, CA; printmaker
Biographical Sources: BAOA-1

Published Reproductions:
 "Harriet Tubman" litho 1972 BAOA-1(c); BAQ 6(#4-85),30(c)
 "Symbolic Woman" litho 1972 BAOA-1; BAQ 1(Wi-76),31(c);
 BAQ 6(#4-85),30(c)

WARBURG, DANIEL, ? - 1922; b. in New Orleans, d. in New
 Orleans; sculptor
 Biographical Sources: AAA
 Published Reproductions:
 "Holcombe Memorial" stone 1860 DANA; FAAA

WARBURG, EUGENE, c1825-59; b. in New Orleans, d. in Rome;
 sculptor
 Biographical Sources: AAA
 Published Reproductions:
 "John Young Mason" marble 1855 AAAC; DANA; FAAA; LAAA

WARD-BROWN, DENISE, 1953- ; b. in Philadelphia; mixed media
 Biographical Sources: NGSBA
 Published Reproductions:
 "Affirmation" wood 1988 NGSBA(c)
 "Ascent" bronze 1989 NGSBA(c)
 "Biting Through" wood 1988 NGSBA(c)
 "Poem" wood 1988 NGSBA(c)
 "Priority" wood 1988 NGSBA(c)
 "Say Amen" ARTA 1(Sp-84),27

WARE, EVELYN L.; b. in Washington, DC; painter
 Biographical Sources: AAA
 Published Reproductions:
 "Possessed" oil 1971 DENA

WARING, LAURA WHEELER, 1887-1948; b. in Hartford, CT;
 painter
 Biographical Sources: FFAA; WWAA; WWCA
 Portrait: FFAA
 Published Reproductions:
 "Alma" oil 1945 TCBAA(c)
 "Anna Washington Derry" oil 1922 (Smithsonian) AAAC;

ATO(c); AWA(c); CRI 35(5-28),163; LAAA; LNIA; NHB 19
(3-56),127; NHB 22(10-58),16; SW 57(3-28),123; SG 60
(9-1-28),549
"Beulah McNeill, Nurse" oil 1936 ATO
"Evangeline Hall" oil 1030 ATO
"Frankie" oil 1928 AAAC; LAAA; LNIA; NHB 22(10-58),16
"George E. Haynes" oil 1943 ATO
"Henry Thacker Burleigh" oil NPG
"James Weldon Johnson" oil 1945 DANA; NPG
"Jazz Dance I (Study)" watercolor,gouache 1939 FFAA(c)
"Little Brown Girl" oil AV 1(9/10-86),43(c); BACW
"Marian Anderson" oil 1944 (National Portrait) NPG
"Mother and Daughter" OIL 1925 CTAL; DANA
"Naomi Barnett Aden" oil 1947 AV 1(9/10-86),40; BACW
"Portrait of a Child" PRO 3(Sp-71),36
"Portrait of Alonzo Aden" oil 1947 BACW; DANA
"Portrait of Sadie Tanner Mossell Alexander" oil CRI 49(9-42),
290
"Portrait of Walter E. Waring" oil 1927 NHB 19(3-56),127
"Self Portrait" oil c1940 NHB 23(4-60),cover
"Sleeper Awakes" oil CRI 20(8-20),169
"Still Life" oil 1928 AAATC(c)
"Susan" oil 1926 ATO
"W.E. Burghardt DuBois" oil 1945 (National Portrait) DANA;
NPG

WARREN, MASGOOD ALI; sculptor
Biographical Sources: AAA
Published Reproductions:
"Tan Yank" sc EB 1(7-46),48

WASHINGTON, HORACE, 1945- ; b. in Atlantic City, NJ
Biographical Sources: OSAE
Published Reproductions:
"Mask Series" OSAE

WASHINGTON, JAMES WINSTON, JR., 1911- ; b. in Gloster,
MS; painter, sculpter
Biographical Sources: AAA; DCAA; WWAA,1991

Published Reproductions:
 "Burning the Sin Offering" stone sc 1974 AA 41(11-77),76
 "Eaglet" granite sc 1970 AA 41(11-77),75
 "Frederick Douglass" 1969 AA 41(11-77),41
 "Mexican Market" oil 1957 DANA
 "Nesting Bird" sc 1957 DANA
 "Obelisk" granite sc 1970 AE 21(10-68),10
 "Resting Owl" granite sc 1968 AA 41(11-77),79
 "Sin Offering" stone sc 1977 AA 41(11-77),79
 "Sitting Bird" sc 1956 DANA
 "Wounded Eagle" granite sc 41(11-77),75

WASHINGTON, MARY P., 1926- ; b. in Atlanta; mixed media
 Biographical Sources: AAA
 Published Reproductions:
 "Black Soul" EB 27(9-72),104(c)
 "Hope" collage BAOA-1(c)

WASHINGTON, TIMOTHY, 1946- ; b. in Los Angeles; painter
 Biographical Sources: AAA
 Published Reproductions:
 "African Montage" welded steel sc WLB 43(4-69),758
 "Christ" aluminum sc EB 26(4-71),180
 "Forty Acres and a Mule" mixed media NACA(c)
 "Futuristic Animal" mixed media 1989 NACA(c)
 "Induction and Suspicion" 1969 NACA
 "Introductionary Title: Energy" wood sc 1970 NACA(c)
 "One Nation Under God" mixed media AI 14(10-70),73; NACA

WATERS, RICHARD, 1936- ; b. in Boston; painter
 Biographical Sources: AAA
 Published Reproductions:
 "Tutankhamen" latex 1969 ART 44(Su-70),32

WATKINS, JAMES, 1925- ; b. in Macon, GA; painter
 Biographical Sources: AAA
 Published Reproductions:
 "Guitar Blues" oil 1962 BDCAA(c)
 "Widow Woman" oil 1959 BAOA-1

WATSON, CURTIS; painter, sculptor
Published Reproductions:
"Ancestors" acrylic 1970 BAIH
"Mother and Child" terra cotta 1970 BC 9(11/12-78),48(c)
"Shrine" terra cotta sc 1970 BAIH(c)

WATSON, HOWARD, 1929- ; b. in Pottsfield, PA; painter
Biographical Sources: AAA
Published Reproductions:
"Effreth's Alley" AG 11(4-68),48

WATSON, WILLARD, 1921- ; b. in Powhatten, LA; mixed media
Biographical Sources: BHBV
Portrait: BHBV
Published Reproductions:
untitled watercolor 1980 BHBV
untitled felt pen 1981 BHBV
untitled pen 1981 BHBV(c)
untitled pen 1981 BHBV
untitled pen 1980 BHBV

WAYTT, RICHARD, 1955- ; b. in Lynwood, CA; painter
Biographical Sources: AAA
Published Sources:
"Brain-Washed" ink BAOA-2

WEAVER, CLAUDE L., 1918- ; b. in Atlanta, GA; painter
Biographical Sources: AAA
Published Reproductions:
"Girl at Table" oil 1940 LNIA

WEAVER, STEPHANIE; painter
Biographical Sources: AAA
Published Reproductions:
"Bridal Shoppe 1972 MS 2(9-73),26(c)

WEBB, CLIFTON, 1950- ; b. in New Orleans; painter
Biographical Sources: LMW
Portrait: LMW

Published Reproductions:
 "Landscape" BE 6(12-75),46(c)
 "Target Series" mixed media 1979 BAQ 4(#1-80),2(c)
 "Tripodus Diaspora" copper,wood LMW(c)

WEBSTER, DEREK, 1934- ; b. in Honduras; mixed media; sculptor
Biographical Sources: BAAL
Portrait: BAAL
Published Reproductions:
 "Red Rider" wood sc 1987 BAAL(c)
 "Turtle" wood sc 1988 BAAL(c)
 untitled wood sc 1986 BAAL(c)
 untitled wood sc 1988 BAAL(c)
 untitled wood sc 1988 BAAL(c)

WEBSTER, EDWARD, 1900- ?; b. in Florence, SC; painter
Published Reproductions:
 "Girl on a Donkey" SEP 20(12-71),74
 "Going Out" SEP 20(12-71),74
 "The Nativity" oil 1956 SEP 20(12-71),74; TCBAA

WELLS, ALBERT, 1918- ; b. in Charlotte, NC; painter
Biographical Sources: AAA
Published Reproductions:
 "Georgia Winter" oil 1940 LNIA

WELLS, JAMES L., 1902- ; b. in Atlanta, GA; painter
Biographical Sources: ATO
Portrait: ATO
Published Reproductions:
 "African Fantasy" woodcut 1932 AG 13(4-70),11; AAAC; DANA;
 LAAA; LNIA; PRO 3(Sp-71),37
 "Barry Place" woodcut DANA
 "Boy's Head" print 1931 OPP 9(2-31),cover
 "Bridge Fantasy" woodcut PANA
 "Builders" lino 1929 BAAG
 "By the Lake" print 1935 LNIA
 "East River, New York" litho 1938 DANA; PMNA

"Escape of the Spies from Canaan" print 1933 AAAC; AAATC;
 LNIA
"Flight into Egypt" oil 1930 (Hampton) AD 6(2-15-31),7; ATO
 (c); SW 60(5-31),214
"French Farm House" oil 1933 LNIA
"The Good Samaritan" linocut c1932 ATO
"Hieratic Heads" blockprint c1929 (Howard) ATO
"Interlude" oil 1949 DANA
"Janus II" linocut DENA
"Landscape Senegal" litho AUSA
"Market Place" oil 1958 TCBAA
"Modern Industry" litho 1938 LNIA
"Negro Worker" litho AAATC
"Primitive Girl" woodcut (Fisk) BAQ 6(#4-85),8; LAAA
"Saint Anthony" woodcut 1965 (Fisk) TCBAA
"St. Francis and the Birds" oil 1957 ILAAL
"Shipyard" oil 1948 DANA
"Still Life" oil (Howard) ATO
"Street Scene" oil DANA
"Tam O'Shanter" oil MA 27(1-34),35
"Wanderers" oil 1930 ATO; CTAL; LNIA; MA 23(9-31),216;
 PMNA

WELTON, ROLAND, 1919- ; b. in San Francisco; painter
Biographical Sources: AAA
Published Reproductions:
 untitled BAOA-1
 untitled BAOA-1

WESSON, BARBARA; painter
Published Reproductions:
 "Miss Lady" AV 5(2-90),10(c)
 untitled NEWO 4(#4-78),8

WEST, PHEORIS; graphic artist
Published Reproductions:
 "Family" AV 2(12-87),25(c)
 "Labidi Shrine" acrylics 1976 BC 11(10/11-80),102(c)

WESTMORELAND, LAMONTE E., 1941- ; b. in Racine, WI;
 painter
 Biographical Sources: BAQ 1(Fa-76),48; BFAA; WCBI
 Portrait: BAQ 1(Fa-76),48; BFAA
 Published Reproductions:
 "And I Was Awaken" mixed media WCBI
 "Hinge Series" mixed media BAQ 1(Fa-76),49(c)
 "Target Series" mixed media 1979 BAQ 4(#11-80),2(c)

WHITE, CHARLES WILBERT, 1918-1979; b. in Chicago, d. in Los
 Angeles; painter, printmaker
 Biographical Sources: BDCAA; BHBA; GNNP3; ILAAL; LAAA;
 TNAP; WCBI; WWAA,1978; WWABA-1
 Portrait: BE 6(12-75),55;DANA; EB 18(9-63),131; NEWO 6
 (1/2-80),30
 Published Reproductions:
 "Anna Lucasta" crayon DANA; FFBA
 "Awaken from the Unknowing" charcoal 1961 AA 21(6-62),96;
 AN 60(10-61),14; EB 21(3-66),94; FRE 18(1stQ-78),cover; GT
 86(4-69),117
 "Birmingham Totem" Chinese ink drawing 1964 ARTF 2
 (4-64),48; BAQ 2(Fa-77),19; EB 23(2-68),116; FAAA; FRE 6
 (Wi-66),cover; SEP 18(3-69),48; TNA
 "Birth of Spring" charcoal 1961 AA 26(6-62),99; EB 21
 (3-66),94
 "Breath of Spring" ND 12(7-63),43
 "Centralia Madonna" pen,ink (Howard) NHB 30(10-67),7
 "C'est l'amour" drawing FRE 2(Wi-62),96
 "Contributions of the Negro to American Democracy" tempera
 1943 (Hampton) DANA; FAAA; LAAA
 "Elijah Gibbons" AIM 58(3-70),136
 "Exhausted Worker" oil 1935 OAAL
 "Exodus" litho 1966 ND 16(6-67),46
 "Embrace" tempera 1942 NAI
 "Exodus II" litho 1966 ND 16(6-67),46
 "Fatigue" oil 1940 MA 34(8-41),372; PMNA
 "Five Great American Negroes" oil 1941 FAAA; PMNA
 "Flying Fish" charcoal 1961 FRE 2(Wi-62),99; FRE 6(Fa-66),
 cover; ND 16(6-67),44

EB 21(3-66),94; ND 12(7-63),42; ND 16(6-67),45

"Nat Turner" 1950 FRE 8(Wi-68),cover

"Nat Turner, Yesterday, Today, & Tomorrow" ink 1968 (National Center) BDCAA; FFBA

"Native Son #2" ink 1942 (Howard) STHR

"Negro Youth" tempera 1942 EB 22(7-67),34

"Nocturn" drawing 1960 FRE 2(Wi-62),96; GT 86(4-69),119

"O, Mary, Don't You Weep" ink 1956 AA 26(6-62),98; ND 16 (6-67),42

"Paper Shelter" collage,ink 1965 AN 64(Su-65),17

"Paul Robeson" BSC 15(3/4-84),cover

"The Preacher" ink 1952 (Whitney) AAAC; BC 8(11/12-77),43; DANA; EB 33(12-77),15; ENC 6(12-12-77),23; ESS 8 (1-78),73; FAAA; TNAP

"The Prophet #1" litho 1975-6 AIM 65(3-77),64(c); AN(2-77), 66(c); BAQ 4(#1-80),33; EB 32(2-77),12(c); ENC 6(1-3-77),20 (c); FRE 1(1stQ-76),cover; SMI 7(10-76),86-7(c); TCBAA

"The Prophet #2" litho AW 14(2-4-84),16; AW 15(2-14-84),16; NHB 41(5/6-78),827

"Sammy Davis, Jr." drawing EB 29(3-74),42

"Seed of Love" ink 1969 (Los Angeles) ANA 11(10-76),9;TCBAA

"Shaping of Black America" oil EB 45(3-90),96; EB 45(11-90), 166

"Silent Song" charcoal 1968 (Oakland) AOC

"Skipping" drawing EB 22(7-67),35

"Sojourner Truth and Booker T. Washington" charcoal (Newark) AATNM; AATNM; AIPP; AJ 14(6-71),63; CONN 193(11-76), 246; DANA; NBAT; SA 71(12-71),21; SA 79(10-79),56

"Solid as a Rock" woodcut 1960 AA 26(6-72),100

"Song" oil 1952 ND 16(6-67),43

"Songs Belafonte Sings" ink 1963-4 EB 22(7-67),35

"Sounds of Silence" litho 1978 AAATC(c); AN 78(3-79),138(c)

"Southern News, Late Edition" litho GT 86(4-69),118

"The Spirituals" ink DAN

"Standing Woman" oil c1966 NACA

"Take My Mother Home" ink 1950 AA 26(6-62),97; RD 112 (6-78),185(c); TCBAA

"Techniques to Serve the Struggle" Chicago mural 1939 OAAL

"There Were No Crops This Year" crayon 1940 AAAC; DANA; LNIA

"Truth and Booker T. Washington" pencil 1918 NEWO 3(#1-76), 30

"Two Alone" oil 1946 (Atlanta) BDCAA(c); CVAH; EB 1(7-46), 46; TAB

"Two Brothers Have I Had on Earth..." charcoal EB 22(7-67),28

untitled oil EB 36(8-81),36

untitled oil 1973 NEWO 6(1/2-80),30

untitled EB 45(3-90),118

untitled conte crayon 1946 SSAA 4(Sp-90),37

untitled etching 1984 BAQ 6(#4-85),17

untitled etching 1984 BAQ 6(#4-85),25

"Wanted Poster Series #1" 1969 FRE 10(4thQ-70),cover; FRE 11(2ndQ-71),cover

"Wanted Poster Series #2" oil AG 13(4-70),15; FRE 10(2ndQ-70), cover

"Wanted Poster Series #4" oil 1969 (Whitney) BAWPA; CCWM; FAAA; FTWM; WCOC

"Wanted Poster Series #6" oil 1969 IMMA

"Wanted Poster Series #8" 1970 AG 18(5-75),50

"Wanted Poster Series L-11" litho 1970 NHB 41(5/6-78),826

"W.E.B. DuBois" charcoal OAAL

"Women" (Johnson) EB 29(12-73),38-9(c); EB 44(3-89),25

"Work" EB 22(7-67),26

"Worker" ND 16(6-67),cover

"Young Farmer" crayon 1953 ND 16(6-67),41

"Young Worker" crayon 1954 OAAL

Further References:

Fuller, Hoyt W., "Charles White, Artist," BW 12(7-63),40-5.

Hammond, Bert, "Charles White/ A Retrospective," BAQ 2 (Fa-77),18-21.

"Images of Dignity: The Drawings of Charles White," BW 16 (6-67),40-8.

Images of Dignity: The Drawings of Charles White. Los Angeles: Ward Ritchie Press, 1967.

"Jubilee for Charlie," EB 35(2-80),68-70.

Kaiser, Ernest, "A Charles White Bibliography," FRE 20(#3-80), 206-27.

Wolfe, Evelyn, "Charles White, Painter of Black Dignity," UW 3
 (12-69),21-3.

WHITE, CYNTHIA; painter
 Published Reproductions:
 "More Cousins from Shreveport" watercolor 1989 BC 20(#3-90),
 178(c)
 "Reunion" watercolor 1989 BC 20(#3-90),178(c)

WHITE, FRANKLIN A., JR., 1943- ; b. in Richmond, VA; painter
 Biographical Sources: DIAA; WWAA,1991
 Portrait: DIAA
 Published Reproductions:
 "Coleus" pastel 1976 AIM 65(5/6-77),50
 "Faucet" oil 1974 ARTF 13(1-75),64; DIAA
 "Print" 1973 ARTF 11(2-73),26
 "The Red Cap" oil 1970 DCBAA
 "Silver Chest" oil 1972 DIAA
 "Stereo" mixed media AG 15(10-71),70; ARTF 10(9-71),31

WHITE, GEORGE, 1903-1970; b. in Cedar Creek, TX; mixed media,
 painter
 Biographical Sources: AAA; AFATC; BFAA
 Portrait: BFAA
 Published Reproductions:
 "Butchering Pig" painted wood,mixed media 1968 BFAA
 "Emancipation House" mixed media 1964 BFAA
 "Land of Cotton" oil 1967 AFATC(c)
 "Old Hills of Kentucky" oil on carved wood 1966 BFAA
 "Old Pioneer Days" oil on carved wood 1962 BFAA(c)
 "One Bad Snake" painted wood 1965 BFAA
 "Standing Woman, Clothed Man" 1977 FA #11411-83),35
 "Wrestling" oil on carved wood 1968 BFAA

WHITE, J. PHILIP, 1939-1970; painter
 Biographical Sources: FUF
 Portrait: FUF
 Published Reproductions:
 "Deity" oil 1969 FUF

WHITE, JACK, 1940- ; b. in New York City; sculptor
 Biographical Sources: AAA; CBAM; TNAP
 Portrait: DIAA; TNAP
 Published Reproductions:
 "Afro-American Form #105" acrylic 1972 DIAA
 "Afro Mask--Shield Forms #7" acrylic 1971 DIAA
 "Dead Reckoning I" acrylic 1980 STHR
 "Deo-date" marble sc 1966 ART 43(3-69),62; ART 44(Su-70),
 33
 untitled bronze sc 1969 AAANB; ESS 1(8-70),68
 untitled wood,stone 1967 AG 13(4-70),2(c)

WHITE, JACK, 1931- ; b. in Raleigh, NC; painter
 Biographical Sources: ENC 7(2-21-78),32-33
 Portrait: ENC 7(2-21-78),32
 Published Reproductions:
 "Flight Series" oil ENC 7(2-21-78),32

WHITMORE, JOHN, 1948- ; b. in Los Angeles; painter
 Biographical Sources: AVD
 Portrait: AVD
 Published Reproductions:
 untitled AVD

WHITTEN, JACK, 1939- ; b. in Bessemer, AL; painter
 Biographical Sources: AAA
 Published Reproductions:
 "Black Monolith: Homage to James Baldwin" 1988 ICAA
 "Chinese Doorway" oil AIM 62(11-74),120(c)
 "Colored Hornet" acrylic ART 46(2-72),46(c)
 "First Frame" oil 1971 AN 70(4-71),54
 "Look Mom..." AN 63(2-65),20
 "Midnight Stripper" acrylic 1973 ART 47(2-73),57
 "Sigma I" acrylic 1978 ART 52(6-78),34
 "Summit: 1987: Dedicated to C. Wilmarth" 1987 ICAA(c)

WHYTE, GARRETT, 1915- ; b. in Mt. Sterling, KY; painter
 Biographical Sources: WWABA
 Published Reproductions:

"They Went North" tempera 1965 AG 11(4-68),39; BDCAA

WIGFALL, BENJAMIN LEROY, 1930- ; b. in Richmond, VA;
 painter
 Biographical Sources: AAA; FUF
 Portrait: FUF
 Published Reproductions:
 "Burning #3" FUF
 "Chimneys" oil 1951 AIPP
 "Secrets" etching AIM 44(2-56),54
 "Theme" woodcut AD 29(5-1-55),15
 untitled etching AIM 44(2-56),54

WIGGS, BERTIE; b. in North Carolina; painter
 Biographical Sources: DENA
 Published Reproductions:
 "Orbit" oil 1972 DENA

WILKINS, DEBORAH, 1952- ; b. in Berkeley, CA; graphic artist
 Biographical Sources: AAA; FFAA
 Portrait: FFAA
 Published Reproductions:
 "Conversation with a Blind Lady About Cinque" acrylic 1974
 OSAE
 "Heads" BCR 4(Fa-72),47; BS 3(#2-73),10
 "Living Eden" pen,ink 1974 FFAA

WILKINS, TIMOTHY, 1943- ; b. in Norfolk, VA; painter, sculptor
 Biographical Sources: AAA
 Published Reproductions:
 "Stormy Land" acrylic AG 16(4-73),68(c)

WILLIAMS, BILLY DEE; painter
 Published Reproductions:
 untitled oil EB 29(4-74),60

WILLIAMS, CHESTER LEE, 1944- ; b. in Durham, NC; sculptor
 Biographical Sources: BAQ 1(Su-77),54-9; WWAA,1991; WWABA
 Portrait: BAQ 1(Su-77),54

Published Reproductions:
 "Adam and Eve" resin sc BAQ 1(Su-77),57
 "Dozing III" bronze sc 1977 CRI 86(4-79),cover
 "Giraffe" sc CRI 86(4-79),132
 "Jonathan Gibbs" sc CRI 86(4-79),132
 "Martin, Malcolm, and You" aluminum,bronze sc 1971 BAQ
 1(Su-77),55
 "Outthrust" wood sc BAQ 1(Su-77),57(c)
 "Pellicle" sc BAQ 1(Su-77),56(c)
 "The Tongue" sc CRI 86(4-79),131
 "The Tongue" sc CRI 86(4-79),131
Further References:
 Ashdown, Ellen, "Chester L. Williams," CRI 86(4-79),129-32.
 "Williams at Shuster," ART 44(Su-70),62.

WILLIAMS, DOUGLAS R.; painter, sculptor
Published Reproductions:
 "Christ and St. Peter" oil ED 26(4-71),178(c)
 "Snail Bird" metal sc EB 27(9-72),90(c); ND 16(6-67),97

WILLIAMS, FRANK; b. in Inglewood, CA; painter
Biographical Sources: EANE
Portrait: EANE
Published Reproductions:
 "City Park" mixed media 1988 EANE(c)
 "Quiet Night" mixed media 1989 EANE

WILLIAMS, GEORGE, 1911- ; b. in East Feliciana Parish, LA;
 sculptor
Biographical Sources: BIS
Portrait: BIS
Published Reproductions:
 "Adam and Eve" wood 1984 BIS(c)
 "Crucifixion" wood sc 1985 BIS
 "Mand Woman" wood 1984 BIS(c)
 "Man" wood sc 1983 BIS
 "Statue of Liberty" wood 1986 BIS

WILLIAMS, GERALD, 1941- ; b. in Chicago; painter

Biographical Sources: AAA
Published Reproductions:
 "Children of the Sun" acrylic 1979 BC 11(10/11-80),102(c)
 "Nation Time" EB 29(12-73),44(c)
 "Wake Up" acrylic BW 19(10-70),87

WILLIAMS, JEROME, 1950- ; sculptor
Published Reproductions:
 untitled sc SEP 14(6-65),20

WILLIAMS, JOSE, 1934- ; b. in Birmingham, AL; graphic artist
Biographical Sources: AAA
Published Reproductions:
 "Black Ghetto" serigraph 1968 AG 11(4-68),39

WILLIAMS, LAURA G., 1915- ; b. in Philadelphia; painter
Biographical Sources: AAA; BAOA-1
Portrait: BAOA-1
Published Reproductions:
 "Figure" BAOA-1(c)
 "Red Figure" oil BAOA-1(c)
 untitled BAOA-1(c)

WILLIAMS, MATTHEW; painter
Published Reproductions:
 "The Crucifixion" oil ESS 5(5-74),107
 "The Crying Black Child" oil EB 29(12-73),35(c); ESS 4(12-73),
 91
 "Mother and Child" oil ESS 5(11-74),87
 "Super Fight" oil ESS 5(11-74),87

WILLIAMS, MICHAEL KELLY; mixed media
Published Reproductions:
 "Myth of Osiris" monoprint 1984 BC 21(#2-90),26(c)

WILLIAMS, PAT W., 1949- ; b. in Philadelphia; mixed media
Biographical Sources: NGSBA; WWAA,1991
Published Reproductions:
 "Accused/Blowtorch/Padlock" mixed media 1987 NGSBA(c)

"Move" installation 1988 ART 63(3-89),84; NGSBA(c)
"Negro Poster Girl" mixed media 1989 NGSBA(c)

WILLIAMS, RANDY; mixed media
Published Reproductions:
"Homage to the Edge of a Corner" mixed media 1977 CGB
"Merchants and Masterpieces" mixed media 1977 CGB
"Not for Profit" mixed media BE 6(12-75),47(c)
"Studies in Music" SMIH (2-77),1
"untitled October #1" mixed media 1977 CGB

WILLIAMS, ROY LEE; mixed media
Published Reproductions:
"Old Fashioned Kitchen" litho 1979 BAIH

WILLIAMS, TODD, 1939- ; b. in Savannah, GA; painter, sculptor
Biographical Sources: AAA; WWAA,1978
Published Reproductions:
"Autumn" wood sc 1970 DCBAA
"Coney Island" welded steel,iron sc 1964 ILAAL
"Ligion" AF 133(12-70),64
"Plastik" WERK 56(11-69),779
untitled 1970 AG 14(11-70),25

WILLIAMS, WALTER HENRY, 1920- ; b. in Brooklyn, NY; paint-
er, printmaker
Biographical Sources: AAA; TCBAA
Published Reproductions:
"Black Madonna" collage 1974 STHR
"Dawn" oil AIM 44(2-56),38
"Fighting Cock" woodcut 1950 (Howard) BAQ 2(Sp-78),5
(c); DANA; STU 158(10-59),66
"Hard Time Blues" wood 1963 AIS 5(Fa/Wi-68),429
"Harvest" woodcut 1965 AG 11(4-68),21(c)
"Mother and Child Ikon #1" collage DAAA
"New Day" oil AN 53(2-55),35
"Pawnshop" oil AIM 44(2-46),38
"Poultry Market" oil 1953 (Whitney) AAAC; AIM 44(2-56),39;
BC 3(5/6-73),27(c); DANA; ESS 2(4-72),66(c); ESS 4(11-73),

22(c); ESS 4(12-73),29(c); TCBAA
"Southern Landscape" oil collage 1963-4 TCBAA(c)
"Summer Night Song" sc DAAA
"Third Avenue El" gouache 1955 AAATC(c); STHR

WILLIAMS, WILLIAM T., 1941- ; b. in Cross Creek, NC; painter
Biographical Sources: AAA; FAAA; WWAA,1991
Portrait: AV 1(11/12-86),26
Published Reproductions:
 "Bleecker Street" ART 55(2-81),154
 "Cape Split" acrylic 1980 EWCA
 "Cross Creek" AN 84(Su-85),100
 "Deli-Bud" 1979 AASN
 "Double Dare" acrylic 1984 ICAA
 "Elbert Jackson, L.A.M.F. Part II" synthetic polymer 1969
 (Modern Art) CGB; FAAA(c)
 "Equinox" acrylic 1974 AV 26-87),18(c); STHR
 "George Washington Carver Crossing the DuPont River" steel
 1970 SAH(c)
 "It's the Time of the Mind in the Middle of the Day" acrylic
 AN 70(4-71),52
 "Mr. Lewis" ART 55(2-81),155
 "Note to Marcel Proust" acrylic 1984 AV 1(11/12-86),26(c);
 SMI 18(5-87),188(c)
 "Palm Cafe" AIM 69(5-81),143(c)
 "Sophie Jackson L.A.M.F." acrylic 1969 CGB; STHR
 "Summer '79" ART 55(2-81),154
 "Sweets Crane" 1969 ART 44(4-70),16
 "Taxi Dancers" acrylic 1978 AW 13(12-11-82),4
 "Tune for Nila" ART 55(2-81),155
 untitled 1969 ART 43(5-69),22
 untitled ARTF 9(5-71),78
 untitled LIF 71(9-24-71),78
 untitled AG 15(4-72),cover(c); AG 15(4-72),cover(c)

WILLIAMS, YVONNE ARLENE, 1945- ; b. in New York City;
 painter
Biographical Sources: AAANB

Published Reproductions:
"Drawings" charcoal 1963 AAANB

WILLIAMSON, PHILEMONA; painter
Portrait: ESS 18(8-87),91
Published Reproductions:
"Drum of Water" oil ESS 18(8-87),92(c)
"Innocence" oil ESS 18(8-87),92(c)
"Night Birds Meet" oil ESS 18(8-87),92(c)
"See What You Made Me Do" oil 1988 BAQ 9(#2-90),60(c)
untitled oil ESS 18(8-87),92(c)
untitled oil 1988 BAQ 9(#2-90),61(c)

WILLIAMSON, STAN, 1911- ; b. in Chicago; painter
Biographical Sources: AAA
Published Reproductions:
"Glass Objects" ink 1959 DANA
"Houses in Chicago" 1959 DANA
"Old Dwellings" oil,casein DANA

WILLIS, ELLIS, 1913- ; b. in Hines County, MS; painter
Biographical Sources: BIS
Portrait: BIS
Published Reproductions:
"His Truth Is Marching On" oil AV4(2-89),51; AV 5(2-90),5(c);
EB 44(2-89),43(c); EB 45(1-90),85(c); ESS 19(1-89),107(c)
"Hog Killing" tempera 1984 BIS
"Mother and Child" tempera 1983 BIS(c)
"This Is It" tempera 1983 BIS
untitled collage 1983 BIS

WILLIS, LUSTER, 1913- ; b. in Terry, MS; painter
Biographical Sources: AFATC; BFFA
Portrait: BFAA; LC
Published Reproductions:
"Cut-Out Red Figure, Hands Raised" pencil,tempera c1970 BFAA
"Lady in the Rain" tempera 1963 BFAA
"Man in White Glasses" tempera 1976 FA #114(11-83),35
"Mummie of the Stone Age" watercolor c1970 AWCF(c); BFAA

(c); BIS
"Music at Home" ink,tempera c1974 BFAA(c)
"Night Ladies" poster paint 1981 AFATC(c)
"This Is It" tempera c1970 BFAA(c); LC
"Two Good Friends" ink,tempera c1980 BFAA
untitled watercolor LC
untitled wood sc LC

WILSON, A.B.; active 1840-1860; painter, printmaker
Published Reproductions:
"Bishop Daniel Payne and Family" oil 1848 FAAA
"John Cornish" litho 1860 PMNA

WILSON, EDWARD N., 1925- ; b. in Baltimore; sculptor
Biographical Sources: AAA; WWAA,1991
Portrait: DANA
Published Reproductions:
"Action Without Direction" AIS 5(Fa/Wi-68),417
"The Cybele" sc 1954 EB 32(2-77),36; TCBAA
"Figure Study" 1967 AIS 5(Fa/Wi-68),412-13
"Figure Study #2" SC 70(11-70),414
"John Fitzgerald Kennedy Monument and Park" granite 1967 AIS
 5(Fa/Wi-68),415
"Minority Man" wood 1957 DANA
"Second Genesis" alumnium cast sc 1971 AJ 31(Sp-72),334;
 ENC 5(4-19-76),29
"Seven Seals of Silence" bronze sc 1968 CBAM; TCBAA
"Trio" synthetic aluminum DANA

WILSON, ELLIS, 1899-1977; b. in Mayfield, KY, d. in New York;
 painter
Biographical Sources: AAA; BACW; LAAA; NAI; TCBAA; TNAP
Portrait: ATO; EB 18(9-63),132; DANA; ILAAL; NAI
Published Reproductions:
"African Mask" oil (DuSable) ATO
"Bird Vendor" oil 1953 DANA; LAAA
"Chinese Lily" oil c1934 (DuSable) ATO(c)
"Edisto Family" CRI 55(6-48),176
"Field Workers" oil (Smithsonian) AAAC; TEAAA

"Fisherman's Wives" oil c1944 (Howard) ATO
"Fisherwoman" oil AG 11(4-68),48
"Flower Vendor" oil BACW; EB 37(2-82),62(c)
"Funeral Procession" oil 1940 (Fisk) TCBAA
"Harvest" oil LAAA(c)
"His Truth Is Marching On" oil AV 4(2-89),51; AV 5(2-90),
 5(c); EB 45(1-90),84(c)
"Iron Market" oil OW 9(5-54),67
"Island Cemetery" oil ILAAL
"Marchande" oil DANA
"The Matriarch" oil BACW
"Paysannes" oil DANA
"St. Marc, Haiti" oil 1954 DANA
"Salvaging" oil NAI
untitled oil OW 9(5-54),68

WILSON, FRED, 1932- ; b. in Chicago; printmaker, sculptor
Biographical Sources: BAOA-2
Portrait: BAOA-2
Published Reproductions:
 "Buffalo Man" AV 2(4-87),40(c)
 "Far Above the Crowd" sc AV 2(4-87),39(c)
 "Grapes of Wrath" clay,wood AV 2(4-87),41(c)
 "Jezebel, Daughter of the Wind II" AV 24-87),40(c)
 "Protection" stone sc 1962 BAOA-2
 "Three in One" woodcut PANA(c)
 "Woman of the World" clay sc 1967 BAOA-2(c)
Further References:
 Simmons, Rita, "The Keys to the Kingdom," AV 2(4-87),38-42.

WILSON, GEORGE LEWIS, 1920- ; b. in Windsor, NC; painter
Biographical Sources: AAA; WWAA,1991
Published Reproductions:
 "Mother and Child" oil 1962 ILAAL
 "Tender Cave" oil (Johnson) BW 22(2-73),cover(c); EB 20
 (12-73),42(c)

WILSON, HENRY; muralist
Published Reproductions:

"Revelations" Houston mural 1975 BAIH(c)

WILSON, JOHN WOODROW, 1922- ; b. in Boston; painter, print-
maker
Biographical Sources: AAA; LAAA; NAI; TNAP; WWAA,1991
Portrait: DANA; EB 18(9-63),132; NAI
Published Reproductions:
 "Adolescence" litho 1945 BAQ 2(Sp-78),9; NBAT
 "African Princess" oil EB 1(12-45),50
 "Black Despair" AN 46(4-47),40
 "Black Soldier" oil 1943 AN 42(4-15-43),7; MA 36(5-43),190
 "Breadwinner" litho 1942 OAAL
 "Child Playing" AG 11(4-68),46
 "Deliver Us from Evil" litho 1945 BAQ 2(Sp-78),10
 "Father and Child" litho 1965 AP 11(1971),26
 "Father and Son" charcoal 1961 BAQ 1(Fa-76),25
 "Incident" mural 1961 DANA; FSBA; OAAL
 "La Calle" litho PANA(c)
 "Lovers" oil EB 1(12-45),50
 "Martin Luther King" Washington, DC mural AA 50(1-86),110
 "Mother and Child" oil 1943 AV 2(10-87),42; DANA; NAI
 "Mother and Child" oil (Carnegie) AD 19(2-1-45),8; DANA;
 LIF 21(7-22-46),65(c)
 "Mother and Child" oil (National Center) FRE 13(2ndQ-73),
 cover; FRE 15(3rdQ-75),cover; GAI
 "My Brother" oil 1942 DANA; RD 112(6-78),185(c); TCBAA
 "Portrait of Clare" oil 1945 PHY 6(2ndQ-45),119; TIM 45
 (4-9-45),185(c)
 "Roxbury Landscape" oil (Atlanta) DANA; TEAAA
 "Roxbury Rooftops" watercolor 1954 (Atlanta) BDCAA(c)
 "Roz" pastel 1972 LAAA
 "Standing Figure" sc 1950 EWCA
 "Trabajadores" oil 1973 LAAA(c)
 "William Monroe Trotter" drawing PHY 7(3rdQ-46),236
Further References:
 Fax, Elton C. *Seventeen Black Artists.* New York: Dodd, Mead,
 1971.

WILSON, STANLEY, 1947- ; b. in Los Angeles; painter

Biographical Sources: AAA
Portrait: AVD
Published Reproductions:
 "Ancestral Fragments" 1980 AW 11(11-1-80),6
 "Atlas for the Americas on Earth Mound" installation 1986
 CACE(c)
 "Shaman's Shrine" AW 14(4-16-83),14
 untitled AVD

WINDLE, LINDA; sculptor
Published Reproductions:
 "Self-Portrait" terra cotta sc 1967 BC 9(11/12-78),49(c)

WINSLOW, EUGENE; painter
Biographical Sources: AAA
Published Reproductions:
 "Charles Waddell Chestnutt" NALF 2(Su-68),21
 "Harriet Tubman" LJ 98(11-15-73),3423; SLJ 20(11-73),21
 "Jan Ernst Matzeliger" LJ 98(11-15-73),3423; SLJ 20(11-73),21

WINSLOW, VERNON, 1911- ; b. in Dayton, OH; painter
Biographical Sources: AAA; NAI; TCNL
Portrait: NAI; TCNL
Published Reproductions:
 "Migratory Sharecroppers" tempera NAI

WINTERS, CEDRIC, 1909- ; sculptor
Published Reproductions:
 "Head of a Negro" CRI 38(12-31),426
 untitled sc CRI 38(12-31),428

WOOD, VIOLA, 1949- ; b. in Nashville; sculptor
Biographical Sources: FFAA
Portrait: FFAA
Published Reproductions:
 "Festival Form" ceramic sc 1975 FFAA(c)

WOODRUFF, HALE ASPACION, 1900-1980; b. in Cairo, IL;
 painter, printmaker

Biographical Sources: BACW; BHBA; LAAA; NAI; TCBAA; TNAP
Portrait: BAAL; EB 18(9-63),131; NAI; CRI 77(1-70),7
Published Reproductions:

"Abstract Composition" oil 1931 (Atlanta) LNIA

"Alexander Sabes Petion" oil PHY 2(3rdQ-41),201(c)

"American Land of Many Moons" oil 1954 DANA

"Amistad Murals: Amistad Captives on Trial at New Haven,
 Connecticut, 1840) oil 1939 (Talladega) AV 4(2-89),40
 (c); BAQ 8(#2-88),2(c)

"Amistad Murals: Mutiny Aboard the Amistad" oil 1939
 (Talledega) BAAL(c); BAQ 8(#2-88),6(c); BCR 3(Sp-72),44;
 CRI 46(4-39),111; DANA; FAAA; GAI; LAAA; OAAL; PHY
 2(1stQ-41),5

"Amistad Murals: The Amistad Slaves on Trial at New Haven"
 oil (Talledega) BAAL; DANA; FAAA; LAAA; PHY 2
 (1stQ-41),5(c)

"Amistad Murals: The Return to Africa, 1842" oil (Talledega)
 AAAZ(c); BAQ 8(#2-88),7(c); DANA; FAAA; LAAA; PHY 2
 (1stQ-41),5(c)

"Ancestral Memories" oil 1967 AG 13(4-70),13(c); EB 23
 (1-68),120; FFBA; LNIA; NAE 15(11-87),55; SA 70(11-70),31

"Artists" (Art of the Negro Mural) oil (Atlanta) GAI

"Art of the Negro" Atlanta mural oil SA 79(10-79),28

"Atlanta Landscape" oil 1936 FAAA; LNIA

"Autumn Impression" oil 1926 ATO

"Banjo Player" oil 1927 ATO; OPP 8(2-30),38

"Boy" oil DANA

"By Parties Unknown" woodcut 1935 AP 11(1971),24; LNIA

"Capers" oil 1953 FAL

"Caprice" oil 1962 AAATC(c)

"Card Players" oil 1930 AIS 5(Su/Fa-68),271; ATO; BE 6(12-80),
 cover(c); FAAA; LNIA; PMNA; TAB

"Celestial Gate" oil (Spelman) EB 35(F-77),35(c); FFBA;
 TCBAA(c)

"Chartres" watercolor 1928 (Hampton) ATO

"Cigarette Smoker" oil (Hampton) ATO

"Countee Cullen" oil 1926 DANA

"Dissipation" (Art of the Negro Mural) oil (Atlanta) BAAL;
 GAI

"Fetiche et Fleurs" oil 1933 LAAA
"Figure" oil 1957 ART 32(9-58),56; FAAA
"Figure Study" charcoal SA 79(10-79),29
"Flowers" oil NAI
"Fog and Rain in the Rockies" watercolor 1939 LNIA
"Forest Fire" watercolor 1936 FAAA; FAL
"Galaxy" oil (Atlanta) FFBA
"Georgia Landscape" oil c1934 (Smithsonian) ATO
"Giddap" block print DANA
"Girls Skipping" oil DANA
"The Great Gate" oil ENC 7(4-3-78),31
"Influences" (Art of the Negro Mural) oil (Atlanta) GAI
"Interchange" (Art of the Negro Mural) oil (Atlanta) GAI
"Landscape" oil MA 23(9-31),216
"Landscape" oil MA 27(1-34),36
"Landscape" SA 79(10-79),29(c)
"Landscape" CTAL
"Landscape" oil 1937 STHR
"Landscape and Still Life on Table" gouache 1928 FAL
"Landscape Near Vence, France" oil 1928 FAL
"Landscape with Constellation" oil ENC 7(4-3-78),31
"Landscape with Green Sun" oil 1966 (Ebony) LAAA
"Leda" oil 1961 LAAA
"Muses" oil BAAL
"Native Forms" (Art of the Negro Mural) oil (Atlanta) GAI
"Negro Boy" oil 1938 AV 1(9/10-86),42(c); BACW; DANA;
 GAI; HW 7(3rQ-68),13(c); LNIA
"The Negro in California--Settlement and Development"
 mural 1949 (Golden State) AV 3(6-88),38(c); CRI 56(12-49),
 369; LAAA; TNAP
"Old Farmhouse in the Beauce Valley" oil 1928 OPP 9(5-31),143
"Oracle" oil 1973 GAI
"Parallels" (Art of the Negro Mural) mural (Atlanta) GAI
"Paris Landscape" watercolor 1927 (Hampton) ATO
"Playground" oil 1972 GAE
"Poor Man's Cotton" watercolor 1944 (Newark) AATNM(c);
 AATNM(c); BC 3(5/6-73),27(c); BCR 3(Fa-71),18; ESS 2
 (4-72),66(c); ESS 4(11-73),22(c); ESS 4(12-73),29(c); FAL;
 NBAT; SA 71(12-71),22

"Provencal Landscape" oil 1930 MA 23(9-31),216

"Quartet" oil AD 27(9-53),20

"Red Landscape" oil (Johnson) EB 27(9-72),93(c); EB 29(12-73),
 42(c)

"Results of Good Housing" oil 1941 (High) AE 39(9-86),cover
 (c)

"Return to Africa" oil 1842 AV 4(2-89),41(c); BAAL

"Returning Home" block print 1935 DANA; GAI; LNIA

"School in Georgia" oil 1945 AD 19(4-15-45),15

"Sharecropper" oil 1938 NAE 15(11-87),55

"Shrine II" oil 1967 FFBA

"Southern Scenes I" drawing PHY 7(2ndQ-46),146

"Southern Scenes II" drawing PHY 7(2ndQ-46),254

"Sunday Promenade" block print 1939 DANA; LNIA

"Suzetta" oil 1939 LNIA

"The Teamster's Place" watercolor 1934 DANA

"Three Musicians" woodcut 1936 LNIA

"Three Tiered Gate" oil 1974 GAI

"Totem" DANA

"Trio" oil 1976 STHR

"Vertical Landscape" AD 29(11-1-54),25

"Vignettes" oil 1968 (Newark) AAANB

"The Washer Woman" oil 1927 NHB 2(4-39),61; SW 59
 (4-30),167

untitled mural TNA

"The Yellow Bird" oil (Atlanta) AD 25(4-15-51),13

Further References:

Hewitt, John, "Hale A. Woodruff: Artist and Educator," SA 79
 (10-79),28-29.

Stoelting, Winifred, "Hale Woodruff, Artist and Teacher:
 Through the Atlanta Years," unpublished Ph. D. dissertation,
 Emory Universty, 1980.

WOODS, ROOSEVELT (RIP), 1933- ; b. in Idabel, OK; mixed
 media, painter

Biographical Sources: BAAL; WWAA,1991

Portrait: BAAL

Published Reproductions:

"Cows Never Wear Masks" charcoal 1988 BAAL

"Grass Moon" serigraph (Tucson) GAI
"Hunger" charcoal GAI
"Intergroup Meeting" DANA
"It Seems that I've Been Here Before" acrylic 1988 BAAL(c)
"Materials and Me" collage DANA
"On This Night the Snake Will Not Get Wet" acrylic 1988 BAAL
(c)
"Un Beso de Amor" crayon GAI
untitled woodcut GAI

WOODSON, SHIRLEY A., 1936- ; b. in Pulaski, TN; painter
Biographical Sources: FFAA; WWAA,1991; WWABA
Portrait: FFAA
Published Reproductions:
"As He Lay Sleeping" oil,plaster 1989 BAQ 9(#2-90),26(c)
"Beach Scene" gouache ILAAL
"I'll Be Watching You" acrylic 1987 BAQ 9(#2-90),27(c)
"Nile" acrylic 1987 BAQ 9(#2-90),27(c)
"Self-Awareness" acrylic,gouache 1975 FFAA(c)
"Shiled of the Nile" acrylic 1984 BAQ 9(#2-90),26(c)

WOODWARD, BEULAH, 1895-1964; b. in Cooks County, OH;
painter, sculptor
Biographical Sources: AAA
Published Reproductions:
"Creation" wood sc (Golden State) BAQ 1(Wi-76),20
"Sir Perry M. Smith" sc ABWA
Further References:
Arvey, Verna, "By Her Own Bootstraps," OPP 22(1/3-44),17

WRIGHT, BERNARD, 1938- ; b. in Pittsburgh; painter, sculptor
Biographical Sources: AAA; BAOA-1; WWAA,1991
Portrait: BAOA-1
Published Reproductions:
"Three Women" oil BAOA-1(c)

WRIGHT, DMITRI, 1948- ; b. in Newark, NJ; painter
Biographical Sources: AAA

Published Reproductions:
 "Black Couple in Bed Looking at TV" acrylic 1971 NBAT

WRIGHT, ESTELLA VIOLA, 1905- ; b. in Riceville, GA; sculptor
Biographical Sources: FFAA
Portrait: FFAA
Published Reproductions:
 "Jesus Before Pilate:'What is Truth'" plaster sc 1938 FFAA
 (c)

WRIGHT, GEORGE; sculptor
Biographical Sources: AAA
Published Reproductions:
 "Bronze Bag" bronze sc AG 13(4-70),26

WYATT, RICHARD; muralist
Published Reproductions:
 "The Insurance Man" oil BC 19(#2-89),118(c)
 "John" Los Angeles mural NEWO 6(#4-80),cover
 "Two Figures" oil BC 19(#2-88),118(c)
 "The Vision" oil BC 19(#2-88),118(c)

WYLEY, FRANK A., 1905- ; b. in Long Beach, MS; painter,
 printmaker
Published Reproductions:
 "Body-Bent" linocut 1946 PHY 7(1stQ-46),1

YARDE, RICHARD FOSTER, 1939- ; b. in Boston; painter
Biographical Sources: AAA; AAANB
Published Reproductions:
 "The Champion" oil 1974 MR 18(Au-77),522
 "Departure" watercolor 1975 MR 18(Au-77),520
 "Emperor" watercolor MR 18(Au-77),517
 "The Falls" oil 1975 MR 18(Au-77),524
 "Front" watercolor BAAG
 "Garvey's Ghost" oil MR 18(Au-77),523
 "One-Man Band" watercolor 1976 MR 18(Au-77),519
 "The Return" watercolor 1976 MR 18(Au-77),521
 "Sweet Daddy Grace" oil MR 18(Au-77),518

Further References:
 Koethe, John, "Black Is Political," AN 69(10-70),30.

YEARGANS, JAMES C., 1925- ; painter, printmaker
 Biographical Sources: AAA
 Published Reproductions:
 "Drought Victim" etching DCBAAA
 "No Room at the Hotel" 1965 AN 65(9-66),51
 "Three Dancers" woodcut 1967 AG 11(4-68),24(c)

YOAKUM, JOSEPH, 1886-1972; b. in Window Rock, AZ; painter
 Biographical Sources: BFAA
 Portrait: AIM 73(2-85),128; BFAA
 Published Reproductions:
 "C.S. Valentin Crater" watercolor 1964 AWCF(c); BFAA
 "Cycamon Valley Near Chillicothy, Missouri" AIM 65(1-77),57
 "East End of Lookout Mountain Near Amherst, Georgia" AIM 70
 (11-82),125
 "Imperial Valley in Imperial County..." colored pencil,pen MWP(c)
 "Jehol Mountain in Kuntsing Mountain Range" crayon,ink AIM
 73(2-85),128(c)
 "Mount Demavend, 18,934 ft., Near Mashhad, Iran" watercolor
 1966 STHR
 "Mount Olympus of Cumberland Mountain Range" pencil,pen
 1971 CLA 15(Wi-90),9(c)
 "Mount Siple in Ellsworth Highland District..." pencil,pen
 1970 AAATC(c)
 "Mt. Taum Sauk of Ozarks" pencil,pastel c1960 BFAA
 "Mt. Thousand Lakes in Bryce Canyon National Park Near
 Hanksville Utah" pen,pastel 1968 BFAA
 "Ozark Range at Kirkwood Missouri West Suburb of St. Louis
 Mount Dillon" pen and pastel 1964 AC 42(6/7-82),23 (c);
 BFAA; PORT 5(5-83),89(c)
 "St. Clair Oil Refinery" watercolor 1910 (Chicago) AIM 73
 (2-85),135(c)
 "San Gabril Mts., Big Pine California" mixed media c1964 ART
 60(10-85),140
 "Straits of Messina" pen,pentel 1968 AIM 73(2-85),135(c)

"View of the Arctic Ocean" watercolor,pen 1970 CLA 14
 (Wi-89),15(c)
"Waianae Mountain Range Entrance to Pearl Harbor and Hono-
 lulu, Oahu of Hawaiian Islands" pen,pastel 1968 BFAA

YOUNG, BERNARD, 1952- ; mixed media; painter
Biographical Sources: BAOA-1
Portrait: BAOA-1
Published Reproductions:
 "HLO" oil BAOA-1(c)
 "36th Street Mural" mural BAOA-1(c)

YOUNG, CHARLES A., 1930- ; b. in New York City; painter,
 printmaker
Biographical Sources: BDCAA; LAAA; WWAA,1978; WWABA
Published Reproductions:
 "Dashiki Madonnas" oil 1969 BDCAA(c)
 "Floral Tribute" oil AG 13(4-70),18
 "Ghetto Mother and Daughter" oil 1968 BDCAA(c)
 "Musicians" oil 1972 LAAA
 "Two Figures in Totem" oil 1970 BAOA-2(c)

YOUNG, CLARENCE EDWARD; painter
Biographical Sources: AAA
Published Reproductions:
 "A Loud Sound of Silence" oil ILAAL

YOUNG, KENNETH, 1933- ; b. in Louisville, KY; painter
Biographical Sources: AAA; WWAA,1991
Published Reproductions:
 "Red Dance" acrylic 1970 AIM 58(9-70),60(c)

YOUNG, MILTON, 1935- ; b. in Houston, TX; painter, sculptor
Biographical Sources: BAOA-2; LAAA; WCBI; WWAA,1978
Portrait: BAOA-2
Published Reproductions:
 "Come Live the Sun" acrylic BAOA-2(c)
 "Get Me There" acrylic 1971 LAAA(c)
 "One X One #16" limestone sc BAOA-2(c)

"Sweet Wett Abby" acrylic 1969 AI 14(Su-70),115
"Thirty-five Years in a Female Jail--Suite E" acrylic WCBI
untitled BAQ 2(#3-78),70(c); BAQ 2(#4-78),70(c); BAQ 3(#1-79),
 70(c); BAOA-2,96,cover(c)

ZUBER, BARBARA J., 1927- ; b. in Philadelphia; painter
 Biographical Sources: FFAA
 Portrait: FFAA
 Published Reproductions:
 "Basketball Players" acrylic 1978 FFAA(c)

BOOKS

The following is a selective list of books important in the understanding of the role of Black artists in the development of fine art in the United States. Books about individual artists are included with those artist entries, and do not appear here.

Abajian, James. *Black Contributions to the American West*. Boston: G.K. Hall,1974.

Adams, Agatha B. *Contemporary Negro Arts*. Chapel Hill, NC: University of North Carolina Press, 1948.

Afro-American Encyclopedia. North Miami, FL: Educational Book Publishers, 1974.

Alpha Kappa Alpha Sorority. *Afro-American Women in Art: Their Achievements in Sculpture and Painting*. Greensboro, NC: Alpha Kappa Alpha, 1969.

Aptheker, Herbert, ed. *A Documentary History of the Negro People in the United States*. Second ed. New York: Citadel Press, 1974.

Arnold, J.W. *Art and Artists in Rhode Island*. Providence, RI: Rhode Island Citizen's Association, 1905.

Atkinson, J. Edward. *Black Dimensions in Contemporary American Art*. New York: New American Library, 1971.

Bardolph, Richard. *The Negro Vanguard*. New York: Vintage Books 1959.

Barnett-Aden Collection. Washington, DC: The Barnett-Aden Gallery and the Smithsonian Institution, 1974.

Barr, Alfred, ed. *Painting and Sculpture in the Museum of Modern Art*. New York: Museum of Modern Art, 1942.

Baskin, Wade and Richard Runes, ed. *Dictionary of Black Culture.*
New York: Philosophical Library, 1973.

Bearden, Romare and Harry Henderson. *Six Black Masters of American Art.* Garden City, NY: Doubleday, 1972.

Bearden, Romare and Carl Holty. *The Painter's Mind.* New York: Crown, 1969.

Bergman, Peter M. *The Chronological History of the Negro in America.* New York: Harper, 1969.

Bethers, Ray. *Pictures, Painters, and You.* New York: Pitman Publishing Corp., 1948.

Biggers, John and Carroll Simms. *Black Art in Houston.* College Station, TX: Texas A & M University Press, 1978.

Black American Artists of Yesterday and Today. Dayton, OH: George A. Pflaum Pub., 1909.

Black Art--Ancestral Legacy; The African Impulse in African-American Art. Dallas, TX: Dallas Museum of Art, 1989.

Bontemps, Arna A. and Jacqueline Fonvielle-Bontemps. *Forever Free; Art by African-American Women, 1862-1980.* Alexandria, VA: Stephenson, Inc., 1980.

Bowdoin College. *The Portrayal of the Negro in American Painting.* Brunswick, ME: Bowdoin College, 1964.

Bowling, Frank, "Is Black Art About Color?" in Rhoda Goldstein's *Black Life and Culture in the United States.* New York: Crowell, 1971.

Bowling, Frank. *Profiles of Black Americans.* Rockville Centre, NY: Dexter and Westbrook, 1969.

Brawley, Benjamin. *The Negro Genius; A New Appraisal of the*

Achievement of the American Negro in Literature and the Fine Arts. New York: Dodd, Mead, 1937.

Brawley, Benjamin. *The Negro in Literature and Art in the United States.* Revised ed. New York: Dodd, Mead, 1934.

Brawley, Benjamin. *A Short History of the American Negro.* Fourth ed. New York: Macmillan, 1939.

Brown, Sterling. *The Negro Caravan.* New York: Dryden Press, 1942.

Brown, William Wells. *The Rising Sun; or, The Antecedents and Advancement of the Colored Race.* Boston: A.G. Brown, 1876.

Bruce, John Edward. *Eminent Negro Men and Women.* Yonkers, NY: Gazette Press, 1910.

Bullock, Ralph W. *In Spite of Handicaps.* New York: Association Press, 1967.

Butcher, Margaret J. *The Negro in American Culture.* Second ed. New York: Knopf, 1972.

Cahill, Holger and Alfred Barr, Jr., eds. *New Horizons in American Art.* New York: Museum of Modern Art, 1936.

Cederholm, Theresa D. *Afro-American Artists; A Bio-Bibliographical Directory.* Boston: Boston Public Library, 1973.

Chase, Judith W. *Afro-American Art and Craft.* New York: Van Nostrand Reinhold, 1971.

Clark, Claude. *A Black Art Perspective.* Oakland, CA: Merritt College, 1970.

Clarke, John H. *Harlem USA.* New York: Collier Books, 1971.

Clement, Clara E. and Laurence Hutton. *Artists of the Nineteenth Century: Their Works.* Boston: Osgood, 1885.

Coen, Rena N. *The Black Man in Art*. Minneapolis, MN: Lerner Pub. Co., 1970.

Cole, Natalie. *Arts in the Classroom*. New York: John Day, 1940.

Collins, James L. *Women Artists in America; Eighteenth Century to the Present*. Chattanooga, TN: n.p., 1973.

Cooper, William Arthur. *A Portrayal of Negro Life*. Durham, NC.: The Seeman Printery, 1936.

Cruse, Harold. *Crisis of the Negro Intellectual*. New York: William Morrow, 1967.

Daniels, John. *In Freedom's Birthplace; Study of Boston's Negroes*. Boston: Houghton Mifflin, 1941.

Dannett, Sylvia. *Profiles of Negro Womanhood*. 2 vols. Yonkers, NY: Educational Heritage, 1964, 1966.

Davis, John P., ed. *The American Negro Reference Book*. Yonkers, NY: Educational Heritage, 1966.

Denmark, James, "Black Artists in the United States," in Rhoda Goldstein's *Black Life and Culture in the United States*. New York: Crowell, 1971.

Dixon, Vernon J. and Badi Foster. *Beyond Black or White*. Boston: Little, Brown, 1971.

Dorsey, William. *Inspiration, 1961-1989*. Washington, DC: Smithsonian Institution Press, 1989.

Doty, Robert. *Contemporary Black Artists in America*. New York: Whitney Museum of American Art, 1971.

Dover, Cedric. *American Negro Art*. Greenwich, CT: New York Graphic Society, 1966.

Dowd, Jerome. *The Negro in American Life*. New York: Negro Universities Press, 1926.

Driskell, David C. *Black Dimensions in American Art*. New York: New American Library, 1970.

Driskell, David C. *Hidden Heritage*. San Francisco: Art Association, 1985.

Driskell, David C. *Two Centuries of Black American Art*. New York: Knopf, 1976.

Drotning, Phillip T. *A Guide to Negro History in America*. New York: Doubleday, 1968.

DuBois, William E.B. *Black Folk--Then and Now*. New York: Holt, 1939.

DuBois, William E.B. *Encyclopedia of the Negro*. Second ed. New York: Phelps-Stokes Fund, 1946.

DuBois, William E.B. *Gift of Black Folk*. Boston: Stratford Co., 1924.

DuBois, William E.B. *The Negro Artisan*. New York: Arno Press,1969.

Dunbar, Ernest, ed. *The Black Expatriates*. New York: Dutton, 1968.

Dunlap, William. *History of the Rise and Progress of Design in the United States*. Boston: Goodspeed, 1918.

Ebony (Periodical). *The Negro Handbook*. Chicago: Johnson Publishing Co., 1966.

The Ebony Handbook. Chicago: Johnson Publishing Co., 1974.

Fax, Elton C. *Black Artists of the New Generation*. New York: Dodd, Mead, 1977.

Fax, Elton C. *Seventeen Black Artists*. New York: Dodd, Mead, 1971.

Feelings, Tom. *Black Pilgrimage*. New York: Lothrop, Lee and Shepard, 1972.

Fine, Elsa H. *The Afro-American Artist; A Search for Identity*. New York: Holt, Rinehart and Winston, 1973.

Flomenhaft, Eleanor. *Celebrating Contemporary American Black Artists*. Hempstead, NY: FAMLI, 1983.

Ford, Alicia. *Pictorial Folk Art: New England to California*. New York: Studio Publications, 1949.

Franklin, John Hope. *From Slavery to Freedom*. Third ed. New York: Vintage Books, 1969.

Frazier, E. Franklin. *Black Bourgeoisie: The Rise of a Black Middle-Class*. New York: Macmillan, 1962.

Fuller, Thomas. *Pictorial History of the American Negro*. Memphis, TN: Pictorial History, 1933.

Gayle, Addison, Jr. *The Black Aesthetic*. Garden City, NY: Doubleday, 1971.

Gayle, Addison, Jr. *Black Expression: Essays by and about Black Americans in the Creative Arts*. New York: Doubleday, 1969.

Gerbrands, Adranius. *Art as an Element of Culture*. London: E.J. Bill, 1957.

Goldstein, Rhoda. *Black Life and Culture in the United States*. New York: Crowell, 1971.

Greene, Lorenzo Johnson. *The Negro in Colonial New England, 1620-1776*. New York: Columbia University Press, 1942.

Grigsby, J. Eugene, Jr. *Art & Ethics; Background for Teaching Youth in a Pluralistic Society*. Dubuque, IA: William Brown, 1977.

Guillaume, Paul and Thomas Munro. *Primitive Negro Sculpture.* New York: Harcourt, Brace, 1926.

Harmon Foundation. *Negro Artists: An Illustrated Book of Their Achievements.* New York: Harmon Foundation, 1935.

Hedgepeth, Chester M., Jr. *Twentieth-Century African-American Writers and Artists.* Chicago: American Library Association, 1991.

Holmes, Oakley N. *The Complete Annotated Resource Guide to Black American Art.* Spring Valley, NY: Black Artists in America, 1978.

Hornsby, Alton. *The Black Almanac.* Woodbury, NY: Barron's Educational Series, Inc., 1975.

Hudson, Ralph M. *Black Artists/South.* Huntsville, AL: Huntsville Museum of Art, 1979.

Huggins, Nathan I. *Harlem Renaissance.* New York: Oxford University Press, 1971.

Hughes, Langston. *A Pictorial History of the Negro in America.* New York: Crown, 1956.

International Library of Afro-American Life and History. Cornwell Heights, PA: Publishers Agency, 1976.

International Library of Negro Life and History. New York: Publishers Company, 1967-69.

Irving, Betty Jo and Jane A. McCabe. *Fine Arts and the Black American.* Bloomington, IN: Indiana University Press, 1969.

Janis, Sidney. *They Taught Themselves; American Primitive Painters of the 20th Century.* New York: Dial Press, 1942.

Johnson, Charles S., ed. *Ebony and Topaz: A Collectanea.* New York:

Opportunity Press, 1927.

Johnson, Charles S., ed. *The Negro in American Civilization*. New York: Holt, 1930.

Johnson, James Weldon. *Black Manhattan*. New York: Knopf, 1930.

Jordan, June. *Who Look at Me*. New York: Crowell, 1969.

Kellner, Bruce. *Harlem Renaissance: A Historical Dictionary for the Era*. New York: Methuen, 1987.

Lewis, Samella S. *Art: African American*. New York: Harcourt,Brace Jovanovich, 1978.

Lewis, Samella S. and Ruth G. Waddy. *Black Artists on Art*. Volume one. Los Angeles: Contemporary Crafts, 1969.

Lewis, Samella S. and Ruth G. Waddy. *Black Artists on Art*. Volume one, revised ed. Los Angeles: Contemporary Crafts, 1976.

Lewis, Samella S. and Ruth G. Waddy. *Black Artists on Art*. Volume two. Los Angeles: Contemporary Crafts, 1971.

Livingston, Jane. *Black Folk Art in America, 1930-1980*. Jackson, MS: University Press of Mississippi, 1984.

Locke, Alain. *Negro Art: Past and Present*. Washington, DC: Associates in Negro Folk Education, 1940.

Locke, Alain. *The Negro in Art; A Pictorial Record of the Negro Artist and of the Negro Theme in Art*. Washington, DC: Associates in Negro Folk Education, 1940. Reprinted, New York: Hacker, 1980.

Locke, Alain. *The New Negro, an Interpretation*. New York: Arno Press, 1968.

Logan, Rayford. *The Negro in American Life and Thought: The Nadir,*

1877-1901. New York: Dial, 1954.

Logan, Rayford. *The New Negro, Thirty Years Afterward*. Washington, DC: Howard University Press, 1955.

Logan, Rayford. *What the Negro Wants*. Chapel Hill, NC: University of North Carolina Press, 1944.

Majors, M.A. *Noted Negro Women, Their Triumphs and Activities*. Chicago: Donohue and Hennebarry, 1893.

Morsbach, Mabel. *The Negro in American Life*. New York: Harcourt, Brace, World, 1967.

Murray, Freeman. *Emancipation and the Freed in American Sculpture; A Study in Interpretation*. Washington, DC: Freeman Murray, 1916.

Myers, Carol L. *Black Power in the Arts*. Flint, MI: Board of Education, 1970.

The National Cyclopedia of the Colored Race. Montgomery, AL: National Publishing Co., 1919.

Negro Heritage Library. New York: M.W. Lads, 1964.

Ovington, Mary White. *Portraits in Color*. New York: Viking, 1927.

Parry, Ellwood. *The Image of the Indian and the Black Man in American Art, 1590-1900*. New York: George Braziller, 1974.

Patterson, Lindsay. *The Negro in Music and Art*. New York: Publishers Co., 1967.

Pearson, Ralph M. *The Modern Renaissance in American Art, Presenting the Work and Philosophy of 54 Distinguished Artists*. New York: Harper, 1954.

Ploski, Harry A. *The Negro Almanac*. New York: Bellwether Pub. Co., 1967.

Ploski, Harry A. *Reference Library of Black America*. New York: Bellwether Pub. Co., 1971.

Ploski, Harry A. and Ernest Kaiser, eds. *Afro USA*. New York: Bellwether Pub. Co., 1971.

Porter, James A. "Contemporary Afro-American Art," in *Colloquium on Negro Art*. Dakar, Senegal: Society of African Culture, 1968.

Porter, James A. *Modern Negro Art*. New York: Arno Press, 1969.

Porter, James A. "The Negro in Modern Art," in Rayford Logan's *The New Negro, Thirty Years Afterward*. Washington, DC: Howard University Press, 1955.

Porter, James A. *The Progress of the Negro in Art During the Last Fifty Years*. Pittsburgh: n.p., 1950.

Redding, Saunders. *The Negro*. Washington, DC: Potomac Books, 1967.

Reuter, Edward. *The American Race Problem; A Study of the Negro*. New York: Crowell, 1926.

Richardson, Ben. *Great American Negroes*. New York: Crowell, 1956.

Robinson, Armstead, et al. *Black Studies in the University: A Symposium*. New Haven, CT: Yale University Press, 1969.

Rodman, Selden. *Conversations with Artists*. New York: Devin Adair, 1957.

Roelof-Lanner, T.V. *Prints by American Negro Artists*. Los Angeles: Cultural Exchange Center, 1965.

Rollins, Charlemae. *They Showed the Way*. New York: Crowell, 1964.

Romero, Patricia W. *In Black America; 1968: The Year of Awakening*. Washington, DC: Association for the Study of Negro Life and Literature, 1969.

Rose, Barbara. *American Art Since 1900; A Critical History*. New York: Praeger, 1967.

Roucek, Joseph S. and Thomas Kiernan, eds. *The Negro Impact on Western Civilization*. New York: Philosophical Library, 1970.

Rouse, Mary J. *Art Programs in Negro Colleges*. Bloomington, IN: Indiana University, 1967.

Schoener, Allon, comp. *Harlem on My Mind: Cultural Capital of Black America, 1900-1968*. New York: Random House, 1968.

Shapiro, D. *Social Realism: Art as a Weapon*. New York: Ungar, 1973.

Shikes, Ralph E. *The Indignant Eye*. Boston: Beacon Press, 1969.

Smythe, Mabel. *The Black American Reference Book*. Englewood Cliffs, NJ: Prentice-Hall, 1976.

Stull, Edith. *Unsung Black Americans*. New York: Grosset and Dunlap, 1971.

Thompson, Robert F. *African Art and Afro-American Art: The Trans-Atlantic Tradition*. New York: McGraw-Hill, 1968.

Tillinghast, J.A. *The Negro in Africa and America*. New York: Macmillan, 1902.

Toppin, Edgar. *A Biographical History of Blacks in America Since 1528*. New York: McKay, 1971.

Vlach, John Michael. *The Afro-American Tradition in Decorative Arts*. Cleveland: Museum of Art, 1978.

Von Blum, Paul. *The Art of Social Commentary*. New York: Universe Books,1976.

Walker, Anne K. *Tuskegee and the Black Belt; A Portrait of a Race*. Richmond, VA: Dietz Press, 1944.

Walker, Roslyn. *A Resource Guide to the Visual Arts of Afro-Americans*. South Bend, IN: South Bend Community School Corp., 1971.

Welsh, Erwin. *The Negro in the U.S.: A Research Guide*. Bloomington, IN: Indiana University Press, 1965.

Weyl, Nathaniel. *The Negro in American Civilization*. Washington, DC: Public Affairs Press, 1960.

Wheadon, Augusta. *The Negro from 1863 to 1963*. New York: Vantage Press, 1964.

Williams, Ora. *American Black Women in the Arts and Social Sciences: A Bibliographic Survey*. Metuchen, NJ: Scarecrow Press, 1978.

Wilmerding, John. *American Art*. Pelican History of Art Series. New York: Viking, 1976.

Woodruff, Hale. *The American Negro Artist*. Ann Arbor, MI: University of Michigan Press, 1956.

Woodson, Carter. *The Story of the Negro Retold*. Washington, DC: Associated Publishers, 1959.

PERIODICAL ARTICLES

The following is a selective list of periodical articles important in the understanding of the role of Black artists in the development of fine art in the United States. Articles dealing with individual artists are not included here, but instead appear with the artist entries.

"Africa in America," *Horizon* 21 (6-78), 39.

"African Art, Harlem," *American Magazine of Art* 25 (10-32), 244.

"African Art Sparks Black Community," *Crisis* 77 (5-70), 189-91.

"Afro-American Art: 1800-1950," *Ebony* 23 (2-68), 116-23.

"Afro-American Slide Program," *Art Journal* 30 (Fa-70), 85.

Akston, Joseph J., "The Question of Black Art," *Arts* 46 (5-71), 5.

Albright, Thomas, "The Blackman's Gallery,"*Art Gallery* 12 (4-70), 42-4.

Albright, Thomas, "Life in a Visual Image,"*Art Gallery* 13 (4-71), 45-56.

Alexander, Margaret W., "Some Aspects of the Black Aesthetic," *Freedomways* 16 (#2-76), 95-102.

Allen, Cleveland, "Our Young Artists," *Opportunity* 1 (6-23), 16-18.

Allen, William, "In the Galleries,"*Arts* 42 (11-67), 58.

Allison, Madeline G., "Stories in Sculpture," *Opportunity* 2 (3-24), 81-3.

Alloway, Lawrence, "Art: Two Centuries of Black American Art," *Nation* 225 (7-23-77), 94.

"Amateur Artists," *Ebony* 5 (3-50), 44-6.

"American Negro Art at Downtown Gallery," *Design* 64 (2-42), 27-8.

"American Negroes as Artists," *Survey* 60 (9-1-28), 548-9.

Andrews, Benny, "The African Connection," *Encore* 6 (8-1-77), 35.

Andrews, Benny, "Art in 1976: Black and Bicentennial," *Encore* 6 (1-17-77), 35.

Andrews, Benny, "Black Artists: Getting It On," *Encore* 4 (8-18-75), 42.

Andrews, Benny, "Black Artists Say, Give Us More Space," *Encore* 3 (12-74), 45.

Andrews, Benny, "The Emergency Cultural Coalition," *Arts* 44 (Su-70), 18-20.

Andrews, Benny, "Critic in Search of a Cure," *Encore* 6 (2-6-77), 40.

Andrews, Benny, "Folk Art--A Proud Tradition, Part I," *Encore* 5 (2-2-76), 30-1.

Andrews, Benny, "Folk Art--A Proud Tradition, Part 2," *Encore* 5 (2-16-76), 30-1.

Andrews, Benny, "JAM Opens in New York," *Encore* 4 (4-7-75), 24.

Andrews, Benny, "New Colors, Old Canvas," *Encore* 4 (6-23-75), 64-6.

Andrews, Benny, "Positive Pull for Black Arts," *Encore* 4 (2-3-75), 38.

Andrews, Benny, "There's a Mural to This Story," *Encore* 8 (3-19-79), 38-9.

Andrews, Benny, "Two Centuries of Black American Art--Reason To

Rejoice," *Encore* 20 (12-76), 22-4.

Andrews, Benny, "The Whitney Takes a Step Back," *Encore* 5 (3-22-76), 28-9.

"Art Abroad," *Art Digest Newsletter* 5 (5-70), 9.

"Art Against Apartheid,"*Black Collegian*, 15 (11/12-84), 44-5.

"Art and the Negro," *Art News* 40 (5-1-14-41), 6.

"Art by Negroes," *Art Digest* 23 (10-15-49), 23.

"Art Education for Negroes," *Design* 66 (12-44), 23.

"An Art Exhibit Against Lynching," *Crisis* 42 (4-35), 107.

"Art of the Americas: From Before Columbus to the Present Day," *Art News Annual* 18 (1948), 111.

"Art of the Negroes at Grand Rapids," *Art News* 42 (3-1-43), 6.

"Artist in an Age of Revolution: A Symposium," *Arts in Society* 5 (Su/Fa-68), 219-37.

"Artists Portray a Black Christ," *Ebony* 26 (4-71), 176-8.

Ashton, Dore, "African and Afro-American Art," *Studio* 176 (11-68), 202.

"Atlanta's Annual," *Time* 45 (4-9-45), 65.

"Atlanta's Annual Exhibition of Painting and Sculpture by Negroes," *Time* 57 (4-9-51), 89.

Bachmann, Donna, "Evans-Tibbs Collection of Harlem Renaissance Artists," *New Art Examiner* 15 (11-87), 55-6.

Bailey, Peter, "Black Art's Amazing Fund-Raiser: Elma Lewis of Bos-

ton," *Ebony* 25 (6-70), 70-2.

Baker, Elizabeth, "Pickets of Parnassus," *Art News* 69 (9-70), 11-22.

Baker, James H., Jr., "Art Comes to the People of Harlem," *Crisis* 46 (3-39), 78-80.

Balch, Jack, "Democracy at Work; The People's Art Service Center in St. Louis," *Magazine of Art* 36 (2-43), 66-8.

"Baltimore: Art by Negroes," *Art News* 38 (2-11-39), 17.

"Baltimore Museum Becomes the First in the South to Stage Large Show of Negro Art," *Newsweek* 13 (2-6-39), 26.

Barnes, Albert, "Negro Art and America," *Survey* 53 (3-1-25), 668-9.

Barnes, Albert, "Negro Art, Past and Present," *Opportunity* 4 (5-26), 148.

Barnes, Albert, "Primitive Negro Sculpture and Its Influence on Modern Civilization," *Opportunity* 6 (5-28), 139-40.

"The Barnes Foundation," *Opportunity* 5 (11-27), 321.

Barr, P., and W. Bryant, "Education," *Arts in Society* 11 (Su/Fa-74), 344.

Batchelor, Carolyn, "Spiritual Sources and Passions," *Artweek* 17 (12-6-86), 6.

Bearden, Romare, "The Black Artist in America," *Metropolitan Museum of Art Bulletin* 27 (1-69), 245-60.

Bearden, Romare, "The Negro Artist and Modern Art," *Opportunity* 13 (12-34), 371-2.

Bearden, Romare, "The Negro Artist's Dilemma," *Critique* 1 (11-46), 16-22.

Bell, C., "Negro Sculpture," *Living Age* 306 (9-25-20), 786-9.

Bement, Alon, "Some Notes on a Harlem Art Exhibit," *Opportunity* 11 (11-33), 11.

Bennett, Gwendolyn, "The American Negro Paints," *Southern Workman* 57 (3-28), 111-12.

Bennett, Mary, "The Harmon Awards," *Opportunity* 7 (2-29), 47-8.

Berenson, R., "Different American Scene," *National Review* 26 (8-16-74), 930.

Berenson, R., "Not So Black: American Artists," *National Review* 29 (8-5-77), 896-7.

Berger, Maurice, "Issues and Commentary; Speaking Out," *Art in America* 78 (9-90), 78-85.

"Biggest Art Show," *Ebony* 1 (8-46), 46-8.

"Black American Art, 1750-1950," *Crisis* 83(11-76),316-17.

"Black Art," *Arts* 44 (12-69/1/70), 20.

"Black Art Inspires White Artists," *Literary Digest* 81 (5-31-24), 30.

"Black Art: What Is It?" *Art Gallery* 13 (4-70), 32-5.

"Black Artist in America: A Symposium," *Metropolitan Museum of Art Bulletin* 27 (1-69), 245-61.

"Black Artists: Two Generations," *School Arts* 71 (12-71), 21-8.

"Black Lamps: White Mirrors," *Time* 94 (10-3-69), 60-71.

"Black Madonnas," *Ebony* 14 (12-59), 142.

Blayton, Betty, "People Who Make Things Happen," *Art Gallery* 13

(4-70), 56-8.

Bloom, Janet, "5 + 1," *Arts* 44 (12-69/1-70), 56.

Bloomer, Jerry, "The Hudson River School Exhibition," *American Art Review* 1 (5/6-74), 25-35.

Bontemps, Alex, "Culture," *Ebony* 30 (8-75), 105.

Bontemps, Arna, "Special Collections of Negroana," *Library Quarterly* 14 (7-44), 187-206.

Borchers, L.H., "Negro Contributions to American Culture," *National Elementary Principal* 26 (9-46), 165-9.

Boswell, Peyton, Jr., "Fifth Annual at Atlanta University," *Art Digest* 20 (4-15-46), 3.

Bowling, Frank, "Black Art III," *Arts* 44 (12-69/1-70), 20-2.

Bowling, Frank, "Discussion on Black Art II," *Arts* 43 (5-69), 20-3.

Bowling, Frank, "Discussion on Black Arts," *Arts* 43 (4-69), 16-20.

Bowling, Frank, "It's Not Enough to Say Black Is Beautiful," *Art News* 70 (4-71), 53-5.

Bowling, Frank, "Letter from London: Caro at the Hayward," *Arts* 43 (3-69), 20.

Bowling, Frank, "The Rupture: Ancestor Worship, Revival, Confusion or Disguise," *Arts* 44 (Su-70), 31-4.

Bowling, Frank, "Shift In Perspective," *Arts* 43 (Su-69), 24-7.

Bowling, Frank, "Silence: People Die Crying When They Should Love; The Nature of Black Arts," *Arts* 45 (9-70), 31-2.

Braddell, A., "You Talkin' to Me? Teaching Afro-American Arts,"

School Arts 74 (2-75), 22-3.

"Bright Sorrow," *Time* 77 (2-24-61), 60-3.

Brown, Evelyn S., "The Harmon Awards," *Opportunity* 11 (3-33), 10.

Brown, M.W., "You See, This Is the Way It Is," *School Arts* 68
 (4-69), 30-3.

Burroughs, Margaret, "To Make a Painter Black," *Art Gallery* 11
 (4-68), 37-9.

Bushnell, D.D., "Black Art for Black Youth: Community Arts Move-
 ment in the Ghetto," *Saturday Review* 53 (7-18-70), 43-6.

Cade, L.R., "Significant Force in Black Art," *American Artist*
 36 (7-72), 13.

Caffin, Charles H., "Exhibition of the Society of American Artists,"
 International Studio 58 (1904), 261-72.

Campbell, M.S., "Critical and Cynical," *Art News* 74 (10-75), 81.

Canaday, John, "America's First Major Black Artist," *Carnegie
 Magazine* 44 (4-70), 138-9.

"Careers in Color Line," *Ebony* 1 (12-45), 47-50.

Carline, R., "Dating and Provenance of Negro Art," *Burlington
 Magazine* 10 (10-40), 115-23.

Carter, Francine, "The Golden State Mutual Afro-American Art
 Collection," *Black Art Quarterly* 1 (Wi-76), 12-23.

Catchings, Yvonne P., "Is Black Art for Real?" *Black Art Quarterly*
 2 (Sp-78), 41-3.

Catlett, Elizabeth, "The Negro Artist in America," *American Contem-
 porary Art* 4 (4-44), 20-1.

Catlett, Elizabeth, "The Role of the Black Artist," *Black Scholar* 6 (1-75), 10-14.

Catlett, Elizabeth, "A Tribute to the Negro People," *American Contemporary Art* 1 (Wi-40), 17.

Clements, Robert, "Black Students and the Visual Arts," *Negro Educational Review* 29 (7/10-78), 55-63.

Coates, Robert M., "Negro Art," *New Yorker* 17 (12-27-41), 52.

Coffin, Patricia, "Black Artists in a White World," *Look* 33 (1-7-69), 66-9.

Coleman, Floyd, "African Influences on Black American Art," *Black Art Quarterly* 1 (Fa-76), 4-15.

Coleman, Floyd, "Towards an Aesthetic Toughness in Afro-American Art," *Black Art Quarterly* 2 (Sp-78), 32-40.

"Color of God," *Ebony* 18 (1-63), 82-3.

"Comments: Negro Art Annual,"*Art Digest* 20 (4-15-46), 3.

Conlon, James E., and James E. Kennedy, "An Afro-American Slide Project," *Art Journal* 30 (Wi-70/1), 164-5.

"Contemporary Art," *Arts* 31 (10-56), 58.

"Contemporary Art at Marino Gallery," *Arts* 30 (10-56), 58.

Conway, M.D., "The Negro as an Artist," *Radical* 2 (1967), 39.

Cotter, Holland, "Black Artists: Three Shows," *Art in America* 78 (3-90), 164-71.

Craig, Randall J., "Focus on Black Artists," *School Arts* 70 (11-70), 30-3.

"Creative Art of Negroes," *Opportunity* 1 (8-23), 240-5.

"Creative Negroes: Harlem Has Its Artists Working Under Difficult Conditions," *Literary Digest* 122 (8-1-36), 22.

Cunningham, James, "Getting It On with the Get On: Old Conflicts and New Artists," *Arts in Society* 6 (11-3-69), 387-90.

Cureau, H.G., "The Art Gallery in the Negro College," *Art Journal* 32 (Wi-72/3), 172-4.

Cureau, H.G., "The Art Gallery, Museum: Their Availability as Educational Resources in the Historically Negro College," *Journal of Negro Education* 53 (4-73), 452-61.

Cureau, H.G., "The Historic Roles of Black American Artists: A Profile of Struggle," *Black Scholar* 9 (11-77), 2-13.

Daughtry, W.E., "A Quarter Century of Black Experience in the Fine Arts, 1950-1974," *Negro Educational Review* 27 (1-76),24-33.

Daval, J.L. "Geneve; Huit Artistes Afro-Americains," *Art International* 15 (10-71), 48-9.

Davis, Douglas, "What is Black Art?" *Newsweek* 75 (6-22-70), 89-90.

Decker, Andrew, "Price of Fame," *Art News* 88 (1-89), 96-101.

DeVore, Jesse, "Negro Art Theme Winning," *Crisis* 70 (6-63), 228-30.

"Dimensions of Black," *Artforum* 8 (5-70), 83-4.

"Directions in Afro-American Art," *Artforum* 13 (1-75), 64-5.

Dowd, Jerome, "Art in Negro Homes," *Southern Workman* 3 (2-01), 90-5.

Dows, Olin, "Art for Housing Tenants," *Magazine of Art* 31 (11-38), 616-21.

Driskell, David C., "Art by Blacks; Its Vital Role in U.S. Culture," *Smithsonian* 7 (10-76), 86-93.

Driskell, David C., "Bibliographies in Afro-American Art," *American Quarterly* 30 (#3-78), 374-94.

Driskell, David C., "Black American Art," *Art and Artists* 11 (10-76), 8-19.

Driskell, David C., "Speakeasy," *New Art Examiner* 15 (9-87), 13-25.

Drummond, Dorothy, "Coast-to-Coast," *Art Digest* 27 (3-52), 12.

DuBois, Guy P., "Art by the Way," *International Studio* 78 (3-24), 322.

DuBois, William E.B., "Criteria of Negro Art," *Crisis* 29 (10-26), 290-7.

DuBois, William E.B., "Social Origins of American Negro Art," *Modern Quarterly* 1 (10/12-25), 53-6.

"Editorial," *Art Gallery* 13 (4-70), A6-A7.

"Exhibit Negro Art," *Southern Workman* 53 (4-24), 149.

"An Exhibition by Black Artists," *Communication Art Magazine* 12 (4/5-70), 98-107.

"Exhibitions of the Month in New York City," *Independent* 65 (12-31-08), 1600-1.

"Exhibition Raises Questions Whether Negro Should Paint White," *Art Digest* 5 (2-15-31), 7.

Failing, Patricia, "Black Artists Today: A Case of Exclusion," *Art News* 88 (3-89), 124-32.

Fax, Elton C., "Four Rebels in Art," *Freedomways* 4 (Sp-61), 215-25.

"Federal Murals to Honor the Negro," *Art Digest* 17 (1-1-43), 15.

"Fifth Annual at Atlanta University: Awards," *Art Digest* 20
(5-1-46), 11.

"Fifty-Seven Negro Artists Presented in Fifth Harmon Foundation Ex-
hibit," *Art Digest* 7 (3-1-33), 18.

Fine, Elsa H., "The Afro-American Artist: A Search for Identity,"
Art Journal 29 (Fa-69), 32-5.

Fine, Elsa H., "Mainstream, Blackstream and the Black Art Move-
ment," *Art Journal* 30 (Su-71), 374-5.

"First Generation of Artists: Baltimore Museum of Art Exhibition of
Work by Negro Artists," *Survey Graphic* 28 (3-39), 224-5.

"First Negro National, Atlanta University," *Magazine of Art* 35
(5-42), 185.

"Fisk Art Center: Stieglitz Collection Makes it Finest in South," *Ebony*
5 (5-50), 73-5.

"Fisk University Dedicates Alfred Stieglitz Collection," *Crisis* 56
(3-50), 157-9.

Fiske, Frederick M., "Reflections from Within and Without," *Harvard
Art Review* 3 (Wi-68/69), 11.

Ford, N.A., "What Do Negroes Contribute to American Culture?" *Pro-
gressive Education* 20 (11-43), 340-1.

"Four Problems in the History of Negro Art," *Journal of Negro His-
tory* 27 (1-42), 9-36.

"Fourth Annual at Atlanta University," *Art News* 44 (4-15-45), 8.

Fuller, Hoyt W., "World Festival of Negro Art," *Ebony* 21 (7-66),
96-102.

Gaither, Edmund B., "The Evolution of the Afro-American Artist," *Artists Proof* 11 (1971), 24-33.

Gaither, Edmund B., "Toward Visible Participation," *Art Gallery* 13 (4-70), 44-6.

Gallagher, Buell G., "Talladega Library: Weapon Against Caste," *Crisis* 46 (4-39), 21.

Garfinkel, Perry, "Big Boom in Black Arts and Culture," *Sepia* 25 (9-76), 66-72.

Garver, T.H., "Dimensions of Black Exhibition at La Jolla Museum," *Artforum* 8 (5-70), 83-4.

Genovese, Eugene, "Harlem on His Back," *Artforum* 7 (1-69), 34-7.

Ghent, Henri, "And So It Is...," *School Arts* 68 (4-69), 21-6.

Ghent, Henri, "Black Creativity in Quest of an Audience," *Art in America* 58 (5-70), 35.

Ghent, Henri, "Brooklyn Museum," *Art in America* 61 (7/8-73), 19.

Ghent, Henri, "An Experiment Thrives in Brooklyn," *Art Gallery* 13 13 (4-70), 52-5.

Ghent, Henri, "Note to the Young Black Artist: Revolution to Evolution," *Art International* 15 (6-71), 33-6.

Ghent, Henri, "Quo Vadis Black Art?" *Art in America* 62 (11-74), 41.

"The Ghetto," *Negro Digest* 16 (8-67), 9.

Giddings, P., "Barnett-Aden Director Ealey Spreads the Wealth of Black Art," *Encore* 8 (3-19-79), 39.

Glueck, Grace, "New York Gallery Notes: Who's Minding the Easel?" *Art in America* 56 (1/2-68), 25.

Goffman, Kimball, "Negro Life is Art," *Arts Quarterly* 2 (9-39), 16-26.

"Gold Medal for Talent," *Ebony* 19 (6-64), 113-14.

Goldin, Amy, "Harlem Out of My Mind," *Art News* 68 (3-69), 52-3.

Green, Carroll, Jr., "The Afro-American Artist," *Art Gallery* 11 (4-68), 12-25.

Green, Carroll, Jr., "Afro-American Artists: Yesterday and Now," *Humble Way* 7 (#3-68), 10-15.

Green, Carroll, Jr., "Perspectives: The Black Artist in America," *Art Gallery* 13 (4-70), 1-29.

Grillo, Jean B., "Studio Museum in Harlem: A Home for the Evolving Black Esthetic," *Art News* 72 (10-73), 47-9.

Hagstrom, Frieda, "The Negro in the New Art Education," *Design* 43 (6-43), 21.

"Harlem Goes in for Art," *Opportunity* 17 (4-39), 23.

"Harmon Awards Announced for Distinguished Achievement Among Negroes in Fine Arts for 1929," *Art News* 29 (2-8-30), 17.

"Harmon Foundation Exhibition of Painting and Sculpture Art Center," *Art News* 30 (2-21-31), 12.

"Harmon Foundation Spreads Public Appreciation of Negro Art," *Art Digest* 9 (6-35), 23.

Hayes, Dorothy, "Black Experience in Graphic Design," *Print* 22 (11-68), 48.

Hazlitt, Gordon, "Scatteredly Talent," *Art Gallery* 11 (4-68), 40-2.

Henderson, Rose, "First Nation-Wide Exhibition of Negro Artists," *Southern Workman* 57 (3-28), 121-6.

Henderson, William, "Black Experience in Color," *Ramparts* 8 (6-70), 33-5.

Herring, James V., "The American Negro as Craftsman and Artist," *Crisis* 49 (4-42), 116-18.

Herring, James V., "The Negro Sculpture," *Crisis* 49 (8-42), 261-3.

Herskovitz, Melville J., "Negro Art: African and American," *Journal of Social Forces* 5 (12-26), 291-8.

Holbrook, Francis C., "A Group of Negro Artists," *Opportunity* 1 (7-23), 211-13.

Hughes, Langston, "Negro Artist and the Social Mountain," *Literary Digest* 90 (8-7-26), 25-6.

Hughes, Langston, "Negro Artist and the Social Mountain," *Nation* 122 (6-23-26), 692-4.

Hughes, Robert, "Going Back To Africa--As Visitors," *Time* 115 (3-31-80), 72.

"In a Black Bind," *Time* 97 (4-12-71), 64.

Jackson, David, "Black Artists and the WPA,"*Encore* 8 (11-19-78), 22.

Jackson, Dorothy, "The Black Experience in Graphic Design," *Print* 22 (11/12-68), 48-51.

Jacobs, Jay, "A Bridge to the Future," *Art Gallery* 13 (4-78), 50-1.

Jacobs, Jay, "Two Afro-American Artists," *Art Gallery* 11 (4-68), 26-31.

James, M.M., "Note on American Negro Art," *Negro History Bulletin* 19 (5-56), 179-80.

Johnson, Herschel, "New Generation and the Arts," *Ebony* 33 (8-78),

148-51.

Johnson, James W., "Race, Prejudice, and the Negro Artist," *Harper's* 157 (11-28), 769-76.

Johnson, Patrice, "Public Funding: Putting Black Artists 'On Hold'," *Encore* 7 (10-16-78), 22-5.

Johnson, Pauline, "James Washington Speaks," *Art Education* 21 (10-68), 8-11.

Johnson, Robert P., "Six Major Figures in Afro-American Art," *Michigan Academician* 3 (#4-71), 51-8.

Jones, Walter, "Critique to Black Artists," *Arts* 44 (4-70), 16-20.

"JPC Art Collection," *Ebony* 29 (12-73), 37-40.

Jubilee, Vincent, "The Barnes Foundation: Pioneer Patron of Black Artists," *Journal of Negro Education* 51 (Wi-82), 40-49.

Karenga, Ron, "Black Art: A Rhythmic Reality of Revolution," *Negro Digest* 17 (1-68), 5-9.

Kaufman, Arthur, "The Newly Born Lamb," *Crisis* 72 (6/7-65), 363.

Kay, Jane H., "Artists as Social Reformers," *Art in America* 57 (1/2-69), 44-7.

Keene, Paul, "Black Art: What Is It?" *Art Gallery* 13 (4-70), 32-5.

Kellogg, F.L., "By Their Works," *Survey Graphic* 65 (3-1-31), 594-5.

Kendrick, Ruby M., "Art at Howard University: An Appreciation," *Crisis* 39 (11-32), 348-9.

Kerr, Adelaide, "Record Breaking Exhibit by a Group of Artists," *Wilson Library Bulletin* 43 (4-69), 756-9.

Kiah, Virginia, "Black Artists," *Savannah Magazine* 10 (4-72), 14.

Koethe, John, "Boston--Black Is Political," *Art News* 69 (10-70), 30.

Kramer, Hilton, "Art," *Nation* 196 (3-23-63), 255-6.

Lane, James W., "Afro-American Art on Both Continents," *Art News* 40 (10-15-41), 25.

Lane, James W., "Negroes in Art," *Art News* 40 (12-15-41), 24.

Larsen, Susan C., "Two Centuries of Black American Art," *Ms.* 5 (1-77), 24.

Lawrence, Jacob, "The Artist Responds," *Crisis* 77 (8/9-70), 266-7.

"Leading Young Artists," *Ebony* 13 (4-58), 131-5.

"Leading Negro Artists," *Ebony* 18 (9-63), 131-2.

Lee-Smith, Hughie, "An Expression of Pride," *Art Gallery* 13 (4-70), 59-60.

LePage, P.C., "Arts and Crafts of the Negro," *International Studio* 78 (3-24), 477-80.

Levinsohn, Rhoda, "Dimensions in Black Art," *African Arts* 8 (Su-75), 73-6.

Lewis, Theophilus, "Frustration of Negro Art: Vitiating Influence of Color Prejudice," *Catholic World* 155 (4-42), 51-7.

Locke, Alain, "Advance on the Art Front," *Opportunity* 17 (3-39), 132-6.

Locke, Alain, "The American Negro as Artist," *American Magazine of Art* 23 (9-31), 210-20.

Locke, Alain, "Art of the Ancestors," *Survey* 53 (3-1-25), 673.

Locke, Alain, "Beauty Instead of Ashes," *Nation* 126 (4-18-28), 432-4.

Locke, Alain, "Freedom Through Art," *Crisis* 45 (7-39), 227-9.

Locke, Alain, "More of the Negro in Art," *Opportunity* 3 (12-25), 363-5.

Locke, Alain, "Negro Art in America," *Design* 43 (12-42), 12-13.

Locke, Alain, "Negro's Contribution to American Culture," *Journal of Negro Education* 8 (7-39), 521-9.

Locke, Alain, "The Negro in Art," *ALA Bulletin* 25 (11-31), 25.

Locke, Alain, "A Note on African Art," *Opportunity* 2 (5-24), 134-40.

Locke, Alain, "To Certain of Our Philistines,"*Opportunity* 3 (5-25), 155-6.

Locke, O.C., "Art and Black Studies," *School Arts* 72 (9-72), 46-7.

Long, Fern, "A Cultural Operations Crossroads," *Crisis* 52 (12-46), 367-8.

Long, Richard, "The Negro College Museum," *Art Gallery* 11 (4-68), 44-5.

Lowenfeld, Victor, "Negro Art Expression in America," *Madison Quarterly* 5 (1-45), 26-31.

Lowenfeld, Victor, "New Negro Art in America," *Design* 45 (9-44), 20-1.

Lumkin, G., and E. Shemitz, "Artist in a Hostile Environment," *World Tomorrow* 9 (3-26), 108-10.

McConathy, Dale, "Paint It Black," *Vogue* 157 (4-15-71), 127.

McIlvaine, Donald, "Art and Soul," *Art Gallery* 13 (4-70), 48-50.

Marr, Warren, II, "Second Renaissance?" *Crisis* 79 (6/7-72), 198-203.

Mason, Phillip Lindsay, "Art and Black Consciousness," *Negro Digest* 17 (7-68), 22-3.

Merman, Greta, "The Walls of Harlem, " *Arts* 52 (10-77), 122-6.

Montesano, Philip M., "The Mystery of the San Jose Statues," *Urban West* 1 (3/4-68), 25-7.

"Monuments to Two Greats," *Ebony* 2 (9-46), 35-9.

Moore, Anne R., "Black Art," *Essence* 1 (8-70), 66-9.

Moore, Trevor W., "Sanguinary Saga," *Christian Century* 88 (7-14-71), 864.

Mora, Elizabeth C., "Negro People and American Art," *Freedomways* 1 (Sp-61), 74-80.

Morrison, Alan, "New Surge in the Arts," *Ebony* 22 (8-67), 134-6.

Morrison, Alan, "Women in the Arts,*Ebony* 21 (8-67), 134-6.

Morrison, Keith, "Chicago's Eclectic DuSable Defining Afro-American Culture," *New Art Examiner* 4 (5-77), 9.

Morrison, Keith, "The Emerging Importance of Black Art in America," *New Art Examiner* 7 (6-80), 1,4-5.

Moss, Robert F., "Arts in Black America," *Saturday Review* 3 (2-7-76), 6-7.

Motley, Willard F., "Negro Art in Chicago,"*Opportunity* 18 (1-40), 19-22.

Murphy, Charles P., "Humanities, Art, and the Black Student," *Integrated Education* 8 (9-70), 53-6.

Murray, Freeman, "Representations of the Emancipation in American Art," *Opportunity* 2 (4-24), 20.

"The Museum: Its Role and Responsibility," *Art Gallery* 13 (4-70), 60-3.

Neal, Larry, "Any Day Now: Black Art and Black Liberation," *Ebony* 25 (8-70), 54-8.

"Negro Art," *Crisis* 20 (10-20), 284.

"Negro Art," *Opportunity* 4 (5-26), 142.

"Negro Art Exhibit," *Southern Workman* 51 (12-22), 542-3.

"Negro Artist Comes of Age, Exhibition in Albany," *Art News* 43 (2-1-46), 16.

"Negro Artists Show," *Art News* 43 (1-1-45), 9.

"Negro Artists: Their Works Win Top U.S. Honors," *Life* 21 (7-22-46), 62-5.

"Negro as an Artist," *Literary Digest* 86 (9-19-25), 29-30.

"The Negro Comes of Age," *Art News* 42 (2-1-45), 25.

"The Negro in Art," *Art Digest* 18 (6-1-44), 15.

"Negro in Art," *Magazine of Art* 35 (4-42), 147.

"The Negro in Art from Africa to America," *Negro History Bulletin* 2 (3-39), 49.

"The Negro in Art: How Shall He Be Portrayed?" *Crisis* 33 (11-26), 28-9.

"Negro Portraits," *Survey* 49 (12-1-22), 326-7.

"Negroes as Artists," *Nation* 123 (7-14-26), 36-7.

"New Native Art," *Life* 34 (5-4-53), 106-7.

Newton, James E., "Slave Artisans and Craftsmen: The Roots of Afro-American Art," *Black Scholar* 9 (11-77), 35-42.

Nichols, John, "Black Art," *Black Lines* 1 (9-71), 27-36.

"Nineteen Young American Artists," *Life* 31 (3-20-50), 51.

"Object: Diversity," *Time* 95 (4-6-70), 80-7.

"On Black Artists," *Art Journal* 28 (Sp-69), 332.

Parker, Patricia, "Two Centuries of Black American Art," *Black Collegian* 8 (9/10-77), 50-1.

Parks, James D., "An Experiment in Painting the Local Scene," *Design* 47 (2-46), 10-12.

Parrott, Wanda S., "Studio Watts Workshop," *Arts in Society* 5 (Fa/Wi-68), 510-19.

Peavy, Charles D., "The Black Art of Propaganda: The Cultural Art of the Black Power Movement," *Rocky Mountain Social Science Journal* 7 (1-70), 9-16.

Petrie, P.W., "Collectibles," *Black Enterprise* 12 (12-82), 58-60.

Pierce, Delilah, "The Significance of Art Experiences in the Education of the Negro," *Negro History Bulletin* 15 (3-52), 106.

Pierce, Ponchita, "Black Art in America," *Reader's Digest* 112 (6-78), 176-85.

Pierre-Noel, Lois J., "American Negro Art in Progress," *Negro History*

Bulletin 30 (10-67), 6-9.

Pincus-Witten, Robert, "Black Artists of the 1930's at the Studio Museum in Harlem," *Artforum* 7 (2-69), 65-7.

Pindell, Howardena, "Breaking the Silence," *New Art Examiner* 18 (10-90),18-23.

Porter, James A., "Afro-American Art at Floodtide," *Arts in Society* 5 (Su/Fa-68), 257-71.

Porter, James A., "Art Reaches the People," *Opportunity* 17 (12-39), 375-6.

Porter, James A., "Negro Art on Review at the National Museum, Washington," *American Magazine of Art* 27 (1-34), 33-8.

Porter, James A., "Versatile Interests of the Early Negro Artist," *Art in America* 24 (1-36), 16-27.

Powell, Richard J., "I, Too, Am America, Protest and Black Power: Philosophical Continuities in Print by Black Americans," *Black Art Quarterly* 2 (Sp-78), 4-25.

"Princeton Group Arts," *Crisis* 57 (2-51), 19-22.

Prophet, Elizabeth, "Art and Life," *Phylon* 1 (#4-40), 322-26.

"Pyramid Club, 10th Annual Exhibition of Paintings and Sculpture," *Art Digest* 24 (3-1-50), 9.

"Quest for a Black Christ," *Ebony* 24 (3-69), 170-3.

Quinn, S., "Elma Lewis: Keeping African Culture Alive in Boston," *Ms.*5 (5-77), 14-15.

"Racial Strength," *Time* 57 (4-9-51), 89.

Ransaw, L.W., "Changing Relationship of the Black Visual Artist to

the Community," *Black Art Quarterly* 3 (#3-80), 44-56.

Reed, Ishmael, "The Black Artist: Calling a Spade a Spade," *Arts* 41 (5-67), 48-9.

Rich, Daniel, "Fifty Years at Chicago," *Magazine of Art* 32 (12-39), 704-9.

Richardson, Ben, "New Horizons for the Negro Artist," *American Contemporary Art* 7 (Wi-46), 8-10.

Riley, Clayton, "Creative Black Men," *Ebony* 27 (8-72), 134-9.

Robbins, Warren, "The Museum of African Art and Frederick Douglass Institute," *Art Gallery* 13 (4-70), 55-6.

Robbins, Warren, "Tapping Cultural Roots," *Art Gallery* 13 (4-70), 56.

Roberts, Lucille, "Progress in Art," *Negro History Bulletin* 9 (4-46), 149-52.

Robinson, Louie, "Two Centuries of Black American Art," *Ebony* 32 (2-77), 33-42.

Rose, Alvin W., "Negro Art and the Great Transformation," *Negro History Bulletin* 23 (11-59), 60-3.

Rose, Barbara, "Black Art in America," *Art in America* 58 (9-70), 54-67.

Rouse, Mary J., and Douglas Reynolds, "Art Education in the Negro Colleges," *Arts in Society* 5 (Fa/Wi-68), 419-30.

Rustin, Bayard, "The Role of the Artist in the Freedom Struggle," *Crisis* 77 (8/9-70), 260-3.

Sadik, Marvin, "Preview: The Negro in American Art," *Art in America* 52 (3-64), 74-83.

"Sampler: Black American Art," *Americana* 4 (11-76), 25.

"San Francisco," *Artforum* 9 (10-70), 82.

"Saturday Morning Art Class," *Negro History Bulletin* 5 (4-42), 158.

Schuyler, George S., "Negro Art Hokum," *Nation* 122 (6-16-26), 662-3.

Schwatz, Barry N., "The Metropolitan Museum of Art: Cultural Power in a Time of Crisis," *Metropolitan Museum of Art Bulletin* 27 (1-69), 50-5.

Schwartz, Therese, "The Political Scene," *Arts* 46 (4-71), 19.

Scott, John, "The Ceremony of the Land,"*Arts in Society* 10 (Fa/Wi-73), 33-9.

Seigel, Judy, "Faith Ringgold--What Do Black Women Want?" *Women Artists News* 13 (Su-88), 5-6.

Shapiro, Meyer, "Race, Nationality, and Art," *Art Front* 2 (3-36), 10.

Siegel, Jeanne, "Why Spiral?" *Art News* 65 (9-66), 48-51.

Simon, Leonard, "The American Presence of the Black Artist," *American Art Review* 3 (11/12-76), 104-19.

Sims, Lowery, "Black Americans in the Visual Arts," *Artforum* 11 (4-73), 66-70.

Sims, Lowery, "The Mirror, the Other," *Artforum* 28 (3-90), 111-15.

"Six Paintings of City Life," *Arts Quarterly* 2 (12-39), 13-19.

Smith, Hughie Lee, "Negro Artist in America Today," *Negro History Bulletin* 27 (2-64), 111-12.

Smith, Lucy, "Some American Painters in Paris," *American Magazine*

of Art 18 (3-27), 134-36.

Spriggs, Edward, "A New Phenomenon," *Art Gallery* 13 (4-70), 46-8.

Stahl, Annie, "The Free Negro in Ante-Bellum Louisiana," *Louisiana Historical Bulletin* 25 (4-42), 301-95.

"Studio Watts Learning Center for the Arts," *Art Journal* 29 (Fa-69), 35.

"The Subject is People," *Encore* 6 (6-6-77), 36.

Tarshis, Jerome, "Blackman's Art Gallery, San Francisco," *Artforum* 9 (12-70), 85.

Taylor, Kymberly, "Artnotes: Black Artists Fault Writers for Critical Arrogance," *New Art Examiner* 17 (Su-90), 56

Temple, Herbert, "Evolution of Afro-American Art: 1800-1950," *Ebony* 23 (2-68), 116-22.

Thompson, Robert F., "An Introduction to Transatlantic Black Art History," *Journal of Asian and African Studies* 9 (3/4-74), 192-201.

Thompson, Robert F., "Keeping Things Cool," *New Yorker* 44 (11-9-68), 52-5.

Thurman, Wallace, "Negro Artists and the Negro," *New Republic* 52 52 (8-31-27), 37-9.

Tighe, M.A., "Vital Visions of Folk Artistry," *House and Garden* 154 154 (7-82), 10.

"To Encourage Negro Art," *Crisis* 29 (11-24), 11.

"Treasures of Africa and Black America in Los Angeles," *Sunset* 157 (9-76), 52-4.

Tully, J., "Black Folk Art in America," *Flash Art* 114 (11-83), 32-5.

Twiggs, Leo F., "Black Artist as Teacher and Pan Africanism," *Negro Education Review* 23 (1-72), 35-7.

Ulansky, Gene, "Mbari--The Missing Link," *Phylon* 26 (3-65), 247-54.

Usseau, Arnoud d', "The Negro as Artist," *American Contemporary Art* 5 (Wi-46), 7.

Van Proyen, Mark, "Trail Blazers in Harlem," *Artweek* 19 (2-6-88), 1.

Vlach, John M., "Afro American," *Art and Artists* 12 (4-78), 12-17.

Von Blum, Paul, "A Convergence of Conscience," *Black Art Quarterly* 2 (Fa-77), 54-9.

"Wall of Respect," *Ebony* 23 (12-67), 48-50.

Ward, Francis, and Val Gray Ward, "The Black Artist--His Role in the Struggle," *Black Scholar* 2 (1-71), 23.

"Washington's African Museum," *Negro Digest* 14 (12-64), 44-8.

Werner, Alfred, "Black Is Not a Colour," *Art and Artists* 4 (5-69), 14-17.

"What Is Black Art?" *Newsweek* 75 (6-22-70), 89-90.

Wheat, Ellen, "Jacob Lawrence and the Legacy of Harlem," *Archives of American Art Journal* 26 (#1-86), 18-25.

Whipple, Leon, "Letters and Life; The Negro's Artistic Awakening," *Survey* 5 (8-1-26), 517-19.

Williams, H.W., "Atlanta University Annual Exhibit; A Note on Its Ultimate Impact," *Phylon* 39 (6-78), 169-70.

Williams, Randy, "The Black Art Institution," *Black Creation* 6

(1974/5), 60-2.

Williams, Randy, "The Black Artist (A Brief Perpsective)," *Black Creation* 1 (Wi-72), 16-19.

Williamson, Katya, "Black Perspectives," *Art Week* 14 (5-28-83), 5.

Willig, Nancy T., "Angel and Heritage," *Art News* 73 (12-74), 62-3.

Wilson, Edward, "CAA and Negro Colleges," *Art Journal* 28 (Wi-68), 228.

Wilson, J., "Afro-America Abstraction: P.S. 1, New York," *Art in America* 68 (Su-80), 157.

Wilson, J., "Afro-American Art in the Twentieth Century," *Art in America* 68 (10-80), 35.

Winslow, Vernon, "Is There a Negro Artist in the House," *Opportunity* 20 (7-42), 213-14.

Winslow, Vernon, "Negro Art and the Depression," *Opportunity* 19 (2-41), 40-2.

Wolf, Ben, "Negro Art Scores Without Double Standards," *Art Digest* 19 (2-1-45), 8.

Woodruff, Hale, "My Meeting with Henry O. Tanner," *Crisis* 77 (1-70), 7-12.

Woodruff, Hale, "Negro Artists Hold Fourth Annual in Atlanta," *Art Digest* 19 (4-15-45), 10.

Wortz, Melinda, "Black Art and Mannerist Geometry," *Art News* 75 (12-76), 80-2.

Wylly, Campbell, "New Voices," *Art Gallery* 11 (4-68), 33-6.

Yonker, D., "Tribute and a Dream," *Artweek* 10 (10-13-79), 16.

Young, Joseph E., "Two Generations of Black Artists," *Art Inter-national* 14 (10-70), 74.

BIBLIOGRAPHIES

The following publications are full-length bibliographies concerned with Black art and artists. In addition, many of the books and articles cited elsewhere have excellent bibliographies.

Aul, Billie. *An African-American Bibliography: The Arts; Selected Sources from the Collections of the New York State Library.* Albany, NY: New York State Library, 1990.

Bakenwell, Dennis C. *The Black Experience in the United States.* Northridge, CA: San Fernando Valley State College Foundation, 1970.

Cederholm, Theresa D. *Afro-American Artists; A Bio-Bibliographical Directory.* Boston: Boston Public Library, 1973.

Davis, Lenwood and Janet L. Sims. *Black Artists in the United States; An Annotated Bibliography of Books, Articles and Dissertations on Black Artists, 1779-1979.* Westport, CT: Greenwood Press, 1980.

Harvard College Library. *Afro-American Studies: A Guide to Resources of the Harvard University Library.* Cambridge: Harvard University Press, 1969.

Holmes, Oakley N. *The Complete Annotated Resource Guide to Black American Art.* Spring Valley, NY: Black Artists in America, 1978.

Igoe, Lynn Moody, with James Igoe. *250 Years of Afro-American Art; An Annotated Bibliography.* New York: Bowker, 1981.

McPherson, James M. *Blacks in America; Bibliographical Essays.* New York: Doubleday, 1971.

Miller, Elizabeth W. *The Negro in America; A Bibliography.* Cam-

bridge: Harvard University Press, 1966; revised ed., 1970.

Porter, Dorothy B. *The Negro in the United States, A Selected Bibliography.* Washington, DC: Library of Congress, 1970.

Smith, Dwight. *Black American History; A Bibliography.* Santa Barbara, CA: American Bibliographic Center, 1973.

West, Earle H. *A Bibliography of Doctoral Research on the Negro, 1933-1966.* Ann Arbor, MI: University Microfilms, 1969.

Williams, Ora. *American Black Women in the Arts and Sciences: A Bibliographic Survey.* Metuchen, NJ: Scarecrow Press, 1978.

Work, Monroe N. *Bibliography of the Negro in Africa and America.* New York: Octagon, 1965.

DOCTORAL DISSERTATIONS

This section contains a listing of all known doctoral dissertations completed at American universities which are concerned with Black art and artists. Dissertations about individual artists are not included in this section unless they contain considerable relevant information about the general subject.

Benson, J.R., "Five Questions Important to Black Art and Education," unpublished Ph.D. dissertation, Claremont Graduate School, 1977.

Biggers, John, "Contributions of the Negro Woman to American Life and Education," unpublished Ed.D. dissertation, Pennsylvania State University, 1953.

Campbell, Mary S., "Romare Bearden: A Creative Mythology," unpublished Ph.D. dissertation, Syracuse University, 1982.

Chavis, Marlene S., "Ten Michigan Afro-American Visual Artists: A Commonality of Experience, Diversity of Expressions," unpublished Ph.D. dissertation, University of Michigan, 1986.

Coleman, Floyd, "Persistence and Discontinuity of Traditional African Perception in Afro-American Art," unpublished Ph.D. dissertation, University of Georgia, 1975.

Davis, Donald F., "Contributions of Four Blacks to Art Education in the South: 1920-1970," unpublished Ph.D. dissertation, Arizona State University, 1983.

DePillars, Murray Norman, "Afro-American Artists and Art Students: A Morphological Study in the Urban Black Aesthetic," unpublished Ph.D. dissertation, Pennsylvania State University, 1976.

Donaldson, Jeff R., "Generation '306'---Harlem, New York," unpublished Ph.D. dissertation, Northwestern University, 1974.

Fine, Elsa, "Education and the Afro-American Artist: A Survey of the Educational Background of the Afro-American and His Role as a Visual Artist," unpublished Ph.D. dissertation, University of Tennessee, 1970.

Fox, James E., "Iconography of the Black in American Art (1710-1900)," unpublished Ph.D. dissertation, University of North Carolina, 1979.

Gordon, Allan Miran, "Cultural Dualism on the Theme of Certain Afro-American Artists," unpublished Ph.D. dissertation, Ohio State University, 1969.

Govan, Sandra Y., "Gwendolyn Bennett: Portrait of an Artist Lost," unpublished Ph.D. dissertation, Emory University, 1980.

Griffin, Barbara J., "The Fragmented Vision of Claude McKay: A Study of His Works," unpublished Ph.D. dissertation, University of Maryland, 1989.

Hammond, L.K., "The Life and Works of William Henry Johnson, 1901-1970," unpublished Ph.D. dissertation, Johns Hopkins University, 1975.

Holmes, Oakley N., "Black Artists in America: An Introduction to Seven Internationally Recognized Black Visual Artists," unpublished Ed.D. dissertation, Columbia University, 1973.

Jeffries, Rosalind, "Arthur Carraway, Charles Searles, and Houston Conwill: Work of Three North American Black Painters," unpublished Ph.D. dissertation, Yale University, 1979.

Jenkins, Harvey, "Black Aesthetics: Cognition in Cultural Context," unpublished Ph.D. dissertation, University of Wisconsin, 1983.

Jordan, Jack E., "Past, Present, and Future of the National Conference of Artists," unpublished Ph.D. dissertation, University of Michigan, 1975.

Keer, Judith, "God-Given Work: The Life and Times of Sculptor Meta Vaux Warrick Fuller, 1877-1968," unpublished Ph.D. dissertation, University of Massachusetts, 1986.

Logan, Oscar L., "Concepts and Values Affecting the Transmission of a Black Visual Aesthetic: Styles of Art Instructors in Historically Black Colleges and Universities," unpublished Ph.D. dissertation, University of Wisconsin-Madison, 1982.

MacArthur, Carol J., "Black Artistic Enterprises: Exploring Career Alternatives for Minority Artists," unpublished Ed.D. dissertation, Columbia University Teachers College, 1982.

Manier, A.C., "Past and Present American Black Painters' and Sculptors' Contributions to American Culture from 1619 to the Present," unpublished Ed.D. dissertation, Wayne State University, 1975.

Meo, Yvonne, "Survey of Traditional Arts of West Africa and Contemporary Black American Art: A Study of Symbolic Parallels and Cultural Transfer," unpublished Ph.D. dissertation, Union Graduate School, 1975.

Norwood, Tom, "Study of the Status of Exposure to Works by Black Artists in Nebraska Public Schools and Institutions of Higher Education," unpublished Ph.D. dissertation, University of Nebraska, 1975.

Oren, Michael, "The Regrouping of the Avant-Garde: Some Contemporary American Groups and Their Work," unpublished Ph.D. dissertation, University of Massachusetts, 1980.

Ransaw, L.A., "Black Mural Art and Its Representation of the Black Community," unpublished Ph.D. dissertation, Illinois State University, 1973.

Shaw, L.A., "Ratings of Black Artists' Works and the Degree of Their Inclusion in Selected University Courses," unpublished Ed.D. dissertation, Illinois State University, 1978.

Simon, Walter A., "Henry O. Tanner--A Study of the Development of an American Negro Artist: 1859-1937," unpublished Ed.D. dissertation, New York University, 1960.

Smith, Alvin, "A Selective Illustrated Survey of Fine Art by Afro-Americans: 1945-1973," unpublished Ed.D. dissertation, Columbia University, 1973.

Spellman, Robert C., "A Comparative Analysis of the Characteristics of Works and Aesthetic Philosophies of Selected Mainstream and Blackstream Afro-American Artists," unpublished Ph.D. dissertation, New York University, 1973.

Staats, Florence, "Toward a Black Aesthetic In the Visual Arts," unpublished Ed.D. dissertation, Columbia University, 1978.

Stoelting, Winifred, "Hale Woodruff, Artist and Teacher: Through the the Atlanta Years," unpublished Ph.D. dissertation, Emory University, 1980.

Tillery, Tyrone, "Claude McKay: Man and Symbol of the Harlem Renaissance, 1889-1948," unpublished Ph.D. dissertation, Kent State University, 1981.

Wheat, Ellen, "Jacob Lawrence (New York; Harlem; Art Workshops; WPA)," unpublished Ph.D. dissertation, University of Washington, 1987.

Williams, Althea B., "The Social Milieu and the Black Artist in America---1900-1940," unpublished Ph.D. dissertation, University of Oregon, 1972.

Williams, Hobbie, "The Impact of the Atlanta University Exhibition of Black Artists (1942-1969) on Black and Non-Black People," unpublished Ed.D. dissertation, University of Pittsburgh, 1973.

Young, Walter B., "Black American Painters and the Civil Rights

Movement: A Study of Relationships, 1955-1970," unpublished Ed.D. dissertation, Pennsylvania State University, 1972.

AUDIO VISUAL MATERIALS

This list includes commercially available audio visual materials related to Black art and Black artists. The information includes the title, date, format, length, sound, color or black and white, and producer. A separate list of producers of audio visual materials follows.

"Afro-American Art"
 filmstrip color Educational Dimensions

"The Afro American Artist"
 16mm film 15 min color Pyramid

"Afro-American Artists"
 55 35mm slides color Metropolitan

"Afro-American Artists"
 40 35mm slides sound Prothmann

"Amistad II Exhibition"
 1975 16mm film color sound Positively Black

"Art of Henry Ossawa Tanner"
 18 2x2 slides color Sandak

"The Artist as Adversary"
 80 35mm slides color Sandak

"Augusta Savage"
 filmstrip sound SVE

"Bernie Casey: Black Artist"
 1971 16mm film 21 min sound color ACI

"Black Art"
 filmstrip color sound Scholastic

"Black Artists"
26 35mm slides color Prothmann

"The Black Artists"
1969 16mm film sound color 28 min Hichman

"Black Artists in America"
12 study prints Shorewood

"Black Artists in America, Pt.1"
1969 16mm film 20 min sound color Macgowan

"Black Artists in America, Pt. 2"
1972 16mm film 40 min sound color Macgowan

"Black Artists in America, Pt. 3"
1973 16mm film 34 min sound color Macgowan

"Black Artists in America, Pt. 4"
1975 16mm film 44 min sound color Macgowan

"Black Artists of the U.S.A."
1977 16mm film 25 min sound color Handel

"The Black Arts"
filmstrip sound color SPA

"Black Dimensions in American Art"
16mm film 11 min sound color AIMS

"The Black Experience"
35mm slides color Sandak

"Black Has Always Been Beautiful"
1972 16mm film 17 min sound color Indiana

"Black Modern Art"
1976 16mm film 22 min sound color Tricon

"Black Perspectives in the Arts"
 1977 16mm film 60 min sound color First Water

"Black Renaissance"
 1969 16mm film 30 min sound bw HRAW

"Black Renaissance"
 1970 filmstrip color EAV

"The Black Renaissance of the 20s and the Rise of Militancy"
 filmstrip bw color HRAW

"Black Woman Artist"
 audio tape 62 min Pacifica

"Brush and Chisel"
 1976 16mm film 10 min sound color Positively Black

"Charles White: A Black Artist Speaks"
 audio tape 46 min Pacifica

"Contemporary American Black Artists"
 21 35mm slides color EAV

"Contemporary Art by Afro-Americans"
 10 study prints Prothmann

"Contemporary Black Culture"
 16mm film sound bw 30 min HRAW

"Contemporary Black Painters and Sculptors"
 filmstrip color Educational Dimensions

"Contemporary Black Painters and Sculptors"
 20 35mm slides color sound Educational Dimensions

"The Creative Twenties"
 1969 16mm film sound bw 30 min HRAW

"Elizabeth Catlett"
 1978 16mm film sound color 28 min Contemporary Crafts

"Ellis Wilson"
 15 .35mm slides color Prothmann

"Eyes of the City"
 1975 16mm film sound color 10 min Positively Black

"Five"
 1971 16mm film sound color 30 min Seagram

"Harlem in the Twenties"
 1969 filmstrip color Encyclopaedia Britannica

"Harlem in the Twenties"
 1971 16mm film sound color 10 min Encyclopaedia Britannica

"Harlem Renaissance"
 videotape color sound GPITVL

"Harlem Shadows"
 1969 16mm film bw sound HRAW

"Head and Heart: Tom Feelings"
 1977 16mm film color sound 27 min New Images

"Henry O. Tanner: Pioneer Black American"
 1972 16mm film color sound 12 min Disney

"Jacob Lawrence"
 30 35mm slides color Prothmann

"Jacob Lawrence"
 12 35mm slides color Prothmann

"Jacob Lawrence: Migrations and Toussaint L'Ouverture"
 32 35mm slides color Metropolitan Museum

"Joe Overstreet"
 filmstrip color sound Scott

"John Outerbridge--Black Artist"
 1977 16mm film color sound 21 min Contemporary Crafts

"Made in Mississippi: Black Folk Art and Crafts"
 16mm film color sound 20 min Southern

"The Negro and Art"
 1933 16mm film bw silent 17 min GSA

"Negro Art From the Harmon Foundation"
 178 35mm slides bw Harmon

"Paintings by Afro-American Artists"
 20 prints Prothmann

"Paintings of Romare Bearden"
 50 35mm slides color Educational Dimensions

"Palmer Hayden"
 14 35mm slides color Prothmann

"Recent Afro-American Sculpture"
 20 35mm slides color Prothmann

"Religious Pictures by William Johnson"
 6 35mm slides color Prothmann

"Richard Hunt--Sculpture"
 16mm film color sound Encyclopaedia Britannica

"Right On/Be Free"
 16mm film color sound Film Fair

"Romare Bearden"
 20 35mm slides color Educational Dimensions

"Sculpture of Richard Hunt"
20 35mm slides color Educational Dimensions

"Survey of 15 Contemporary Afro-American Artists"
40 2x2 slides color Prothmann

"Thing of Beauty"
16mm film sound color Fisk

"Three Black Artists: Samella Lewis, John Riddle, and William Pajaud"
16mm film 28 min color sound Contemporary Crafts

"Twenty-four Hour-Day Life of Benny Andrews"
16mm film 28 min color sound Nafasi

"Twenty-six Afro-American Artists"
26 35mm slides color Prothmann

"Two Centuries of Black American Art"
16mm film 30 min color sound Brooklyn

"Two Centuries of Black American Art"
16mm film 26 min color sound Pyramid

AUDIO VISUAL PRODUCERS AND DISTRIBUTORS

Names and addresses of companies are given for identification purposes only because audio visual materials tend to go out-of-print quickly. Items may be located through libraries and rental agencies.

ABC	American Broadcasting Co. 1330 Avenue of the Americas New York, NY 10019
ACI	ACI Media 35 W. 45th St. New York, NY 10036
AIMS	Aims Instructional Media Services 6901 Woodley Ave Van Nuys, CA 91406
Brooklyn	Brooklyn Museum Resource Center Eastern Parkway Brooklyn, NY 11238
Contemporary Crafts	Contemporary Crafts 5271 W. Pico Blvd. Los Angeles, CA 90019
Disney	Disney Educational Corp. 500 S. Buena Vista St. Burbank, CA 91505
EAV	Customer Service Dept. Educational Audio Visual Inc. Pleasantville, NY 10570
Educational Dimensions	Educational Dimensions Corp. Box 126 Stamford, CT 06904

Encyclopaedia Britannica	Encyclopaedia Britannica Educ. 425 N. Michigan St. Chicago, IL 60611
Film Fair	Film Fair 10920 Ventura Blvd. Studio City, CA 90068
Films Inc.	Films Inc. 733 Green Bay Road Wilmette, IL 60091
Fine Arts	Fine Arts Films, Inc. P.O. Box 1010 Hollywood, CA 90028
First Water	The First Water 792 Columbus Ave. New York, NY 10025
Fisk	Acquisitions Librarian Special Collections Fisk University Nashville, TN 37203
GPITVL	Great Plains Instructional TV Library University of Nebraska P.O. Box 80669 Lincoln, NE 68501
GSA	General Services Administration National Archives and Records Serv. Washington, DC 20408
Guidance	Guidance Associates 41 Washington Ave. Pleasantville, NY 10570
Handel	Handel Film Corp.

8730 Sunset Blvd.
West Hollywood, CA 90069

Harmon Harmon Foundation
 598 Madison Ave.
 New York, NY 1022

Hichman Hichman (Paul E.)
 4219 Don Alegre Pl.
 Los Angeles, CA 90008

HRAW Holt, Rinehart and Winston
 383 Madison Ave.
 New York, NY 10017

Indiana Indiana University AV Center
 University of Indiana
 Bloomington, IN 47405

Macgowan Black Artists in America
 Macgowan Enterprises
 39 Wilshire Dr.
 Spring Valley, NY 10977

Metropolitan Metropolitan Museum of Art
 Fifth Avenue at 82nd St.
 New York, NY 10028

Modern Modern Talking Picture Serv.
 500 Park St. N
 St. Petersburg, FL 33709

Nafasi Nafasi Productions, Inc.
 850 7th Ave.
 New York, NY 10019

NBC-TV NBC-TV
 30 Rockefeller Plaza, Room 914
 New York, NY 10020

Pacifica	Pacifica Tape Library 5316 Venice Blvd. Los Angeles, CA 90019
Positively Black	Positively Black Programs NBC-TV 30 Rockefeller Plaza New York, NY 10020
Prothmann	Prothmann Associates 650 Thomas Ave. Baldwin, NY 11510
Pyramid	Pyramid Films Box 1048 Santa Monica, CA 90406
Sandak	Sandak, Inc. 180 Harvard Ave. Stamford, CT 06902
Scholastic	Scholastic Magazines 904 Sylvan Ave. Englewood Cliffs, NJ 07632
Scott	Scott Education Div. 104 Lower Westfield Rd. Holyoke, MA 01040
Seagram	Seagram Distillers Corp. 375 Park Ave. New York, NY 10022
Shorewood	Shorewood Reproductions 475 Tenth Ave. New York, NY 10018
Southern	Southern Folklore 1216 Peabody Ave.

Box 4081
Memphis, TN 38104

SVE Society for Visual Education
 1345 Diversey Parkway
 Chicago, IL 60614

Tricon Tricontinental Film Center
 333 Sixth Ave.
 New York, NY 10014

EXHIBITION CATALOGS

This section contains catalogs of exhibitions which were deemed not important enough to include for indexing, usually because of lack of national distribution. Additional exhibition catalogs may be located in the main list of works indexed as well as in the artist entries.

"African-American Art in Atlanta; Public and Corporate Collections," exhibition at the High Museum of Art, Atlanta, GA, May 11 - June 17, 1984. 16 p.

"Afro-American Abstraction," exhibition at the Municipal Art Gallery, Los Angeles, July 1 - August 30, 1982 (and other sites). 40 p.

"Afro-American Artists, New York and Boston," exhibition at the National Center of Afro-American Artists, Boston, May 19 - June 23, 1970.

"Afro-American Artists; North Carolina," exhibition at North Carolina Museum of Art, Raleigh, NC, November 9 - December 31, 1980. 92 p.

"Afro-American Artists Since 1950: An Exhibition of Paintings, Sculpture, and Drawings," exhibition at Brooklyn College, April 15 - May 18, 1969.

"Afro-American Tradition in Decorative Arts," exhibition at Cleveland Museum of Art, Cleveland, OH, February 1 - April 2, 1978 (and other sites). 175 p.

"Amistad II: Afro-American Art," exhibition at Fisk University, Nashville, TN, 1975.

"Amos, Richmond, and Truman Johnson," exhibition at Syracuse Everson Museum of Art, Syracuse, NY, February 27 - March 21, 1973.

"Art in Washington and Its Afro-American Presence: 1940-1970," exhibition at Washington Project for the Arts, Washington, DC,

April 2 - May 11, 1985. 109 p.

"Artists--Varying Directions; January 26, 1975 - February 23, 1975,"
 Otis Art Institute, Los Angeles.

"Aspects of the 70's: Spiral; Afro-American Art of the 70's," ex-
 hibition at the National Center of Afro-American Artists,
 Boston, May 17 - June 15, 1980. 20 p.

"Black Artists: Two Generations, Newark Museum, Newark, NJ,
 May 13 - September 6, 1971."

"Black on Black," exhibition at the Art Museum, St. Louis, MO,
 1982. 37 p.

"A Blossoming of New Promises; Art in the Spirit of the Harlem
 Renaissance," Emily Lowe Gallery, Hofstra University, Hemp-
 stead, NY. 28 p. 1981.

"Contemporary Black Artists in America," Whitney Museum of
 Modern Art, New York, April 6 - May 6, 1971.

"Contemporary Negro Art," Baltimore Museum of Art, February 3 - 19,
 1939.

"Directions in Afro-American Art," exhibition at the Herbert F.
 Johnson Museum of Art, Cornell University, Ithaca, NY, 1974.

"The Evolution of Afro-American Artists, 1800-1950," City Univer-
 sity of New York, 1967.

"An Exhibition of Artist-Teachers, 8 July - 21 August 1983," Museum
 of African American Art, Santa Monica, CA.

"Exhibition of Black Women Artists," University Center, Univer-
 sity of California, Santa Barbara, CA, May 5 - 17, 1975. 50 p.

"Exhibition of Paintings and Sculpture by American Negro Ar-

tists at the National Gallery of Art," Smithsonian Insti-
tution, Washington, DC, May 16 - 29, 1929.

"Festival in Black; Otis Art Exhibition; August 2 through
August 28, 1977," Otis Art Institute, Los Angeles.

"Five Younger Artists," Los Angeles Museum of Art, November 26-
December 26, 1965.

"Fragments of American Life," Princeton University Art Museum,
Princeton, NJ, January 25 - March 28, 1976.

"Louisiana Major Works, 1980," New Orleans Contemporary Art
Center, 1980.

"The Negro Artist Comes of Age; A National Survey of Contem-
porary American Artists," Albany Institute of History and
Art, Albany, NY, January 3 - February 11, 1945.

"The Negro in American Art: One Hundred and Fifty Years of
of Afro-American Art," exhibition at the University of Cali-
fornia at Los Angeles, September 11 - October 16, 1946.

"New Perspectives in Black Art," Oakland Museum, Oakland, CA,
October 5 - 26, 1968.

"Painting and Sculpture in California: The Modern Era," San
Francisco Museum of Modern Art, September 3 - November 4, 1976.

"Selections of Nineteenth Century Afro-American Art," Metro-
politan Museum of Art, New York, June 19 - August 1, 1976.

"Seven American Artists," exhibition at Cleveland Museum of
Art, Cleveland, OH; January 11 - February 13, 1983.

"A Stronger Soul Within a Finer Frame: Portraying African-Americans
in the Black Renaissance," University Art Museum, University
of Minnesota, Minneapolis, 1990. 64p.

"Ten Afro-American Artists of the Nineteenth Century," National Gallery of Art, Washington, February 3 - March 30, 1967.

"Thirty Contemporary Black Artists," Minneapolis Institute of Arts, 1968.

"Three Negro Artists: Horace Pippin, Jacob Lawrence, Richmond Barthe," Phillips Memorial Gallery, Washington, DC, December 14, 1946 - January 6, 1947.

"Tradition and Conflict: Images of a Turbulent Decade, 1963-1973," exhibition at Studio Museum, New York, January 27 - June 30, 1985.

"West Coast '76: The Chicago Connection," E.B. Crocker Art Gallery, Sacramento, CA, 1976.

"What It Is: Black American Folk Art from the Collection of Regenia Perry," exhibition at the Anderson Gallery, Virginia Commonwealth University, Richmond, VA, October 5 - October 27, 1982.

SUBJECT INDEX

ZULU
 Carraway; Collins; Purifoy